CARTIER
AND
ISLAMIC
ART

IN
SEARCH
OF MODERNITY

CARTIER
AND
ISLAMIC ART

IN
SEARCH
OF MODERNITY

Edited by
HEATHER ECKER
JUDITH HENON-RAYNAUD
ÉVELYNE POSSÉMÉ
SARAH SCHLEUNING

MUSÉE DES ARTS
DÉCORATIFS

DMA

The original spelling of the
quotations has been respected.
The transcription of Islamic proper
names has been simplified.
Numbers preceded by "LC" refer
to the catalogue raisonné of Louis
Cartier's personal collection of
Islamic art,
pp. 292-305.

CONTENTS

PREFACE

PIERRE-ALEXIS DUMAS
President of the Musée des Arts Décoratifs

For many years, Islamic art was viewed by the West as the ultimate expression of a singular value and rarity, the expression of a unique luxury, totally foreign to recognizable forms and well-known techniques. In the nineteenth century, under the combined effects of colonial conquests and the Industrial Revolution, Europe underwent a transformation and started to reassess its appreciation of knowledge, style, and the artistic expressions of civilizations beyond its own borders. In just a few decades, Islamic art became an object of study and a theme for museums, and provided inspiration for the creative fields that had been promoting the idea of a Musée des Arts Décoratifs since 1864.

Louis Cartier probably acquired such a remarkable knowledge and lasting love for Islamic arts by reading so many of these works on the subject, which began to be published in 1870. It may also have been during his visits to the *Exposition des arts musulmans*, organized by the Musée des Arts Décoratifs in 1903, along with return trips to its "Oriental rooms" opened in 1905, that he understood its innovative and aesthetic impact. At this time, the creative daring of Louis Cartier was matched by that of his more adventurous brother Jacques, who was traveling around India and the Persian Gulf.

By bringing together masterpieces from French national collections—the Musée du Louvre and the Musée des Arts Décoratifs—along with wondrous pieces from many other collections throughout the world, the *Cartier and Islamic Art* exhibition creates a dialogue with the most breathtaking creations by the Maison Cartier, supported by unprecedented and essential research into the company's archives. We fully realize the unique ambition of such a project, made possible through the initial impetus and generous support of the Maison Cartier, whose president, Cyrille Vigneron, as well as his staff, I cannot thank enough. The exhibition exists through an exemplary partnership with the Dallas Museum of Art, under the impetus of its director, Agustin Artaega, whose involvement was decisive to its success. This show would not have had such scope and depth without the commitment, knowledge, and enthusiasm of the curators who brought it to life: Heather Ecker, Judith Henon-Raynaud, Évelyne Possémé, and Sarah Schleuning. We are indebted to them for this twofold tribute, which honors the force of inspiration of a civilization so close to us, as well as the modern vision of a prodigious French jeweler.

PREFACE

CYRILLE VIGNERON
President and CEO,
Cartier

The art of the twentieth century gradually moved away from figurative representation to delve deeper into abstraction. Consequently, in the fine arts, the decorative arts, and architecture, research naturally turned to geometric shapes in the quest for an artistic language that would allow for new compositions.

The essentially non-figurative aesthetic of Islamic art was perceived as particularly modern in terms of its stylistic richness, evocative power, and limitless capacity for replication.

This richness, an almost infinite source of inspiration, was naturally incorporated into the Cartier style, especially in the foundational period popularly known as *Art Deco*—an enduringly fashionable era and style.

These observations invite us to reflect on the very notion of modernity. We perceive something as "modern" when its aesthetic and evocative qualities have the power to affect us today. In this respect, classical Islamic art, which can be admired in Granada, Cairo, or Istanbul, lies at the origins of modernity; but perhaps its primary significance is its timeless, universal dimension.

The power of Cartier design stems from its ability to draw from wide-ranging stylistic traditions, including Islamic art, and to assimilate something of their universal nature. Cartier designs are undatable; they are modern, contemporary, timeless, and globally appealing, able in their turn to inspire art lovers everywhere and in every period. This exploration of the direct influence of Islamic art on the Cartier style is an exegesis—an "etymological" analysis of Cartier's "stylistic grammar."

I extend my warmest thanks, for their contribution and generous support, to Pierre-Alexis Dumas, Sylvie Corréard, and Olivier Gabet from the Musée des Arts Décoratifs in Paris, and to Catherine Marcus Rose, William M. Lamont, Jr., and Agustín Arteaga from the Dallas Museum of Art. This exhibition would not have been possible without their precious help.

FOREWORD

AGUSTÍN ARTEAGA
The Eugene McDermott Director
of the Dallas Museum of Art

The Dallas Museum of Art is a relatively young institution, founded in 1903 as the Dallas Art Association at about the same time that Cartier moved to its prestigious residence at 13 rue de la Paix. It was also the moment that Louis-Joseph Cartier assumed the creative directorship of the Maison, securing its renowned position as one of the finest designers of "high jewelry" and by extension, definers of taste, in the world. Across the Atlantic, the modest beginnings of the city of Dallas and its newly founded art museum could not have anticipated that less than a century later the Dallas-Fort Worth region would be home to over five million people of all nationalities and origins (one of the ten largest metropolitan areas in the United States), and that the DMA would lead in the museum field through its magnificent collections and thought-provoking exhibitions, such as *Cartier and Islamic Art: In Search of Modernity*.

Unlike some of its peers, the DMA did not collect high jewelry in its early years, although it systematically sought precious, wearable, ancient, and non-European works. These objects became potent symbols, both to their wearers and to those who beheld them, expressing status and taste in the same way as jewels worn in Europe by monarchs and growing numbers of the bourgeoisie after the ruptures of the Industrial Revolution. They include exquisite works in gold from Mesoamerica and the Andean region, Island Southeast Asia, and Africa, such as the Asante sword ornament in the form of a spider that was the seed for the exhibition *The Power of Gold: Asante Regalia from Ghana*, presented in 2018.

In the past several decades, the DMA has hosted a number of temporary exhibitions dedicated to the art of jewelry. In 1990, *Gold of Three Continents* was a milestone, followed by the more archaeologically focused *Golden Treasures from the Ancient World*, and *Tutankhamun and the Golden Age of the Pharaohs*, which, in 2008, broke attendance records for the DMA. The Museum's interest in design continues to evolve, diversifying into new materials, makers, and meanings, including the groundbreaking 2014 exhibition, *From the Village to Vogue: The Modernist Jewelry of Art Smith*, where the DMA became one of the first museums in the

world to exhibit the work of an African American jewelry designer. In 2015, the Rose-Asenbaum Collection of Jewelry, consisting of over 700 objects by more than one hundred artists, came to the Museum, invigorating our jewelry collecting efforts. Our collecting of modern and contemporary jewelry is now concentrated in the pursuit of a wearable art, where the finest precious or unexpected materials give birth to unusual sculptural creations melding form and function. We are committed to exploring contemporary visions of jewelry, not only as historic signifiers of wealth and taste, but also through a spectrum ranging from the embodiment of personal ideals to conceptual global statements.

The Dallas Museum of Art is dedicated to representing the arts of global cultures in all of their traditional and emergent forms. In a city with a growing population of people of Middle Eastern origin and of the Muslim faith, over the past decade we have steadily built our representation of Islamic arts through exhibitions and, most importantly, through the presence of the Keir Collection of Islamic Art, which has been on loan since 2014. Exhibited in a privileged gallery space on our main concourse, exceptional works of art from this collection are rotated every four months. More recently, we have also started to incorporate the work of contemporary artists from the Islamic lands and their diaspora within the same space, placing historical and modern art in dialogue.

It is within this context that we are proud to collaborate in presenting *Cartier and Islamic Art: In Search of Modernity*, an undertaking that springs from a shared wish to explore the consequential influence of Islamic arts and architecture on European and American design. In an important sense, Islamic art, sometimes removed from its origins, was a fundamental source for Modernism. This oft-cited phenomenon, supported famously by Owen Jones's *Grammar of Ornament* and the work of nineteenth-century French theorists and craftsmen, has not been widely explored at the level of sources and mechanisms in the twentieth century. *Cartier and Islamic Art* does not pretend to encompass all of modern design, but rather the microcosm of a single creative source: Maison Cartier. We are proud to partner with the Musée des Arts Décoratifs, with Diller, Scofidio + Renfro, and with Cartier on a magnificent exhibition that seeks to investigate and better understand the processes through which Islamic art, in particular, inspired a new style of jewelry, suited to the modern moment and formative of an influential, and much imitated, mode of self-adornment.

We did not know when we began to work together on this project that we would experience a pandemic, with its concomitant economic downturn and political discontent, and an accompanying unprecedented public call for universal equality. It has been a stark reminder of the

conditions under which the modern age emerged, which were sometimes cataclysmic. The limitations under which much of the work on the exhibition had to be carried out served to recall those earlier times.

More than ever, in this time of constraint and uncertainty, I wish to acknowledge each and every colleague, friend, and collector who participated in the conception and realization of the exhibition at a moment when many institutions, like ours, had to find new ways to work outside our physical spaces and comfort zones, and under extraordinary stresses and pressures.

For their generous support in serving as presenting sponsor of the exhibition in Dallas, I extend my deepest gratitude to PNC Bank. I am thankful for their steadfast advocacy in providing rich artistic experiences and expanded arts access in Dallas and communities across the United States. The Dallas Museum of Art is supported, in part, by the generosity of DMA Members and donors, the National Endowment for the Arts, the Texas Commission on the Arts, and the citizens of Dallas through the City of Dallas Office of Arts and Culture.

In closing, I offer my heartfelt thanks and appreciation to Pierre Rainero and Renée Frank at the Cartier Heritage Department, to Olivier Gabet and the Musée des Arts Décoratifs, our co-organizing partner, to the four curators, Heather Ecker, Judith Henon-Raynaud, Évelyne Possémé, and Sarah Schleuning, and to our dedicated staff (for a listing of individuals from all three institutions, please see the end of this book). Their enthusiasm for this exhibition has been crucial to its success. This project brings not only new ideas, but also joy and delight, at a moment when they are much needed, and I am sure that, like us, our visitors will be seduced by the astounding beauty of Islamic art and the astonishing creative genius of the Maison Cartier.

MUTUAL ADMIRATION: ISLAMIC ART, THE MUSEUM, AND THE JEWELER

OLIVIER GABET
Director of the Musée des Arts Décoratifs

"Knowledge acquired in a foreign country can be like a motherland, and ignorance can be an exile experienced in one's own land." These words by Averroes still resonate with us today, nearly nine centuries after the birth of this Muslim philosopher and jurist from Córdoba. More than ever, our era needs knowledge and reflection, a sense of perspective and intelligence, as well as beauty and poetry. Over the last few decades, and even before the popularization of the concept of "globalization," historiography has been consistently promoting a vision of the world in movement, brilliantly illustrated in *Histoire du monde au xvᵉ siècle*, edited by Patrick Boucheron and published in 2009. Art history has also been influenced by this phenomenon, and has contributed significantly to its expansion, with the pertinent reminder that artists and works of art, particularly objects and inspirations, have also traveled.

The Islamic civilization occupies a unique position in the close-knit network of relationships between the Western world and societies beyond its borders, amplified over the centuries by the highly diverse cultural facets it offers, as well as its geography, stretching from the original Mediterranean Basin to more distant lands, from Andalusia to India. A highly political and aesthetically rich subject, the relationship between European artistic creation and Islamic art is anything but incidental, as reflected in the keen awareness of the historical context, from the diplomatic alliances between France during the reign of François I and the Ottoman Empire of Süleyman the Magnificent, to the colonial and imperialist conquests of the nineteenth and twentieth centuries—a mix of fascination, violence, and domination. While Edward Saïd's criticism of Orientalism remains a seminal work, many more recent exhibitions and studies have shown just how much the arts of Islam have shifted from "a passive object of study to that of an active subject of exchange," to use the words of Rémi Labrusse. His remarkable work has provided a much deeper understanding of the role and influence of Islamic art on Western art, both in Europe and across the Atlantic, notably in the mid-nineteenth century, a fascinating period that gradually ushered in the emergence of an understanding about these cultural identities that were so diverse,

as well as their assimilation in multiple artistic and aesthetic projects. Two exhibitions in France further cemented this phenomenon within a vibrant, intellectual environment: in 2007, at the Musée des Arts Décoratifs, with the show *Purs Décors? Arts de l'Islam, regards du xixe siècle*, at the same time as our collection joined that of the Louvre to form, through this generous loan, the Department of Islamic Art, inaugurated in 2012; and in 2011, at the Musée des Beaux-Arts de Lyon, with *Islamophilies. L'Europe moderne et les arts de l'Islam*. These two exhibitions followed another dazzling show, *Venise et l'Orient*, held at the Institut du Monde Arabe in 2006.

These three exhibitions *bore witness*, each in their own way, to Oriental art. In the art world, a significant role was probably given to the soon-to-be adulterated concept of Orientalism, in the form of fantasy and trinkets, imbued with a suspect level of curiosity, along with painting, including that of Jean-Léon Gérôme—whose work was reassessed in a major retrospective held at the Musée d'Orsay. In the decorative arts, however, the approach seemed distinctly different: as with the sustained, focused discovery of Japanese art, which occurred at about the same time, Islamic art shook up the status quo, specifically this hierarchy in the arts which had held sway for so many years. From Tokyo to Cairo, the miniature painter was viewed in the same way as the ceramicist, the glassworker became as captivating as the architect. Once the picturesque aspect of the exotic and distant art wore off, Islamic art, along with Japanese art, became a new paradigm and, for some, an absolute style. While the decorative arts seemed to be locked onto an endless, nearly vertiginous path of historicist revivals, drawn from a European legacy which then recreated these references into what quickly became a hackneyed eclecticism, Islamic art offered a brilliant and articulate vocabulary with infinite possibilities: the prospect of a revived modernity and a move toward abstraction. Here, it would be somewhat simplistic to brand this development as "cultural appropriation." The impact was profound and long-lasting because it went hand in hand with a recognition of its historiographic, intellectual, and museum aspects, in which the Musée des Arts Décoratifs, like its sister institutions in London and Vienna, played a decisive role. The Musée des Arts Décoratifs seems never to have lost sight of the fact that this art from beyond Europe, notably Islamic art, was enduring, in the face of changing tastes and styles, due to the museum's role—somewhat outside of national museums which gave it greater freedom—and through its hybrid status, in that collectors found an ideal place where their own passions coincided with the acquisition policies of museums. Such was the case with Jules Maciet, a connoisseur who considerably enriched our collections with his personal discoveries.

Starting in 1869, the Musée Oriental, organized by what was then known as the Union Centrale des Beaux-Arts Appliqués à l'Industrie, showcased these works, ones that were still relatively unknown and unappreciated. In 1880, the early manifestation of the museum, at the Palais de l'Industrie, allocated a large area to its "Oriental room," and from this point onward major acquisitions continued apace, including the Albert Goupil sale in 1888. Soon, the Union Centrale des Arts Décoratifs gave Gaston Migeon, curator of the decorative arts departments at the Louvre, the necessary resources to pursue his projects. They let him organize the historic 1903 *Exposition des arts musulmans*, held in the Pavillon de Marsan; his selection of works and their display was serious and restrained, providing the Islamic arts with genuine museum status. This was the case again in 1905, as they were given majestic galleries for the inauguration of the Musée des Arts Décoratifs—as recorded in a touching photographic album from 1907. The key actors involved with the institution included such enlightened and generous figures as Jules Maciet, the jeweler Henri Vever, and the industrialist Raymond Koechlin. After the German response in Munich, in 1910, Islamic art began to be viewed among connoisseurs as a type of "avant-garde conscience," in the words of Koechlin, echoing those of the Armenian dealer Dikran Kelekian, in 1909: "every principle of this seven hundred-year-old art is without exception in tune with the needs of contemporary artists."

This was the historical context at the time of the first exhibition of Persian and Mughal miniatures, held at the Musée des Arts Décoratifs in 1912 under the stewardship of two discerning collectors, Georges Marteau and Henri Vever. Among the donors was a Parisian jeweler whose company was becoming remarkably successful, Louis Cartier. Although the establishment had been in business for some years, it was Louis, the eldest of several brilliant siblings, including Pierre and Jacques, who, in a short span of visionary growth, crafted the enduring international fame of their family name, which is synonymous with creativity and luxury. The deep and genuine enthusiasm for Islamic art, one of the keys to their success, opened multiple doors: while his brother Jacques, predestined to be an explorer, traveled to India and the Persian Gulf in 1911–1912 to form relationships with the pearl merchants of Bahrain Island, Louis, relying on his sharp eye and keen sense of taste, was amassing a collection that would become one of the most remarkable of its kind in the twentieth century. This singular passion was not due to a soulless process of accumulation; it arose from the productive terrain of constant inspiration, which from India to Egypt, from Morocco to Iran, fueled a decidedly modern artistic expression, drawing on sources beyond well-worn European historical styles. While his gifted designer Charles Jacqueau created any number

of models inspired by the Maison Cartier's rich library, which included all the seminal works concerning the Islamic arts, Louis liked to incorporate the *apprêts*, subtly including them in fantastic pieces of jewelry.

One century later, the *Cartier and Islamic Art: In Search of Modernity* exhibition and its catalogue are exploring this history with precision, curiosity, generosity, and panache. This ambitious project, a unique and original collaborative effort between the Musée des Arts Décoratifs, the Musée du Louvre, the Dallas Museum of Art, and the Maison Cartier, is the result of efforts spanning several years to share the available knowledge and to meticulously study an entire aspect of the history of style—including the generous participation of multiple museums, notably the Musée du Petit Palais, which holds Charles Jacqueau's remarkable archives of drawings, a priceless resource. This process involved taking the necessary time to delve into the massive Maison Cartier Archives, to cross-check this information with public and private collections around the world, bringing to life the passions of a man, a family, and a business. These are placed squarely at the heart of this undertaking that recognizes and acknowledges the major role of Islamic art in the history of art and of the decorative arts—and then showcases the considerable and overwhelming élan these arts gave to the art of jewelry, through the insight and discernment of a few key people, from Louis Cartier to Jeanne Toussaint.

This project, coming nine years after the Islamic Arts galleries were inaugurated at the Musée du Louvre, is a milestone in the relationship between our museum and our large neighbor, a far-reaching cooperation resulting from the combination of our collections. For this I would like to recognize the contributions of Jean-Luc Martinez and Yannick Lintz. It is my pleasure to extend warm thanks and friendship to Agustín Arteaga, director of the Dallas Museum of Art, with whom this exhibition was designed and produced, and which continued unabatedly in the context and complications of a worldwide health crisis. This was due, in great measure, to the enthusiastic and generous support of the Maison Cartier, for whom this project has always been extremely important. My deepest thanks to Cartier's president, Cyrille Vigneron, and our gratitude to the entire company, particularly Pierre Rainero, Image and Heritage Director, along with Renée Frank, and all their staff. Their full support made it possible to obtain all the loans of works for this unprecedented collection. Another fortunate affinity led to the selection of an immensely talented architect, who has designed her first exhibition in France: I am delighted to be able to thank Liz Diller, of Diller Scofidio + Renfro design studio, and tell her just how much her work and her vision electrify the aesthetic power and modernity of the works on display, skillfully avoiding any "Thousand and One Nights" look, to borrow the words of Gaston Migeon. Finally,

we were able to earn the trust of so many people and institutions who loaned pieces through the talent and unwavering perseverance displayed by a quartet of curators, four exceptional women who deserve thanks commensurate with the depth of their commitment: Heather Ecker and Sarah Schleuning, curators at the Dallas Museum of Art; Judith Henon-Raynaud, curator in the Department of Islamic Arts at the Louvre; and Évelyne Possémé, chief curator at the Musée des Arts Décoratifs. To Évelyne Possémé I extend special thanks for her great knowledge, fueled by a passion for jewelry and Islamic art, a field to which she was introduced by the late, great Yvonne Brunhammer.

In a time marked by so many crises and upheavals, tensions, and misunderstandings, museums have a responsibility to help people see and understand, to discover and appreciate. In their era, Louis Cartier and his family were thrilled with the beauty of Islamic art, creating an endless repertoire of shapes and marvels; they, too, sparked enthusiasm and promoted what Henri Loyrette described in 2012 as "the luminous side of Islamic civilization."

Décoration arabe

A DEEP AND STRUCTURAL IMPRINT
ON CARTIER'S STYLE

PIERRE RAINERO

Director of Image, Style, and Heritage
Cartier

A new exhibition on Cartier's work is always an adventure. Deciding on an exhibition theme is a lengthy process that entails establishing contacts with new cultural institutions and new fields of expertise. It is rather like a voyage of discovery with its share of questions, doubts, and illuminating revelations, involving a whole team whose members complement, inspire, and enrich one another. Curators, experts, and exhibition designers all pool their skills in the search for an innovative approach and new material.

The idea of specifically exploring the links between Islamic art and Cartier design first emerged in the mid-2010s, by which time other cultural and historical influences, such as those of the Far East, Egypt, Persia, and India, had already been studied and researched in detail.

The first exhibition to focus on the influence of non-Western cultures, *The Art of Cartier*, was held at the Petit Palais in Paris in 1989. Other retrospective exhibitions were presented at the Metropolitan Museum of Art in New York, the British Museum in London (in 1997 and 1998), and more recently in China, with the latest to date at the Palace Museum in the Forbidden City of Beijing in 2019. A special mention should also go to the *Asia Imagined* exhibition at the Baur Foundation in Geneva in 2015, which showcased the influence of Asian art on Cartier design.

The impact of Asian, and especially Chinese, culture has therefore been explored in detail by numerous specialists. The abundance of Eastern-inspired jewelry and precious objects by Cartier, from the 1920s and 30s in particular, goes some way to explaining the enthusiasm of exhibition curators the world over.

The link between Islamic art and Cartier had never been investigated in this way. The Persian and Indian influences had each been studied, but the singularity and coherence of the Islamic repertoire and its profound and structural impact on Cartier design had yet to be brought to the fore.

From the time of Louis Cartier's first design experiments in the early twentieth century, it is possible to distinguish three categories of creative expression inspired by a culture other than his own, applicable to the entire range of Cartier products: jewelry, watches, clocks, decorative objects, and accessories such as handbags and vanity cases.

APPRÊTS: CLARITY
AND AUTHENTICITY OF ORIGIN

Louis Cartier amassed an eclectic private collection, as we know from the sales held after his death and as the present study by Judith Henon confirms. He was a curious and scholarly man of taste with wide-ranging interests recalling those of the Renaissance collector or *honnête homme* of the eighteenth century—a period represented in his collection by magnificent French furniture pieces, sometimes of royal origin.

The items in Louis Cartier's collection appear to have served three different purposes: to satisfy his personal pleasure; to inspire his designers (like the library he assembled for their use); and, when added to the Maison Cartier's stock of *apprêts*, to serve as primary components for new designs.

Indian jewelry was one of the first significant examples of this use of *apprêts*, to which Louis's younger brother Jacques contributed significantly, as Évelyne Possémé demonstrates here.

Carved Chinese jade items, lacquerware inlaid with mother-of-pearl, effigies of the Buddha, coral chimeras, Japanese *inrō* redesigned as vanity cases ... all reflect the singularity of the Cartier approach and creative vision, with its multiple levels of interpretation.

In addition to fragments and jewelry pieces from the Indian sub-continent, this exhibition also features Persian miniatures (usually cut out), elements of decoration, and engraved gems. The aesthetic effect was pleasing, and the reference to another culture all the more striking in the early twentieth century as it was unfamiliar to Westerners, who must have been intrigued as to the provenance of these unusual and attractive elements.

INSPIRATION FROM DRAWING

Another creative approach consisted in borrowing from other cultural sources, especially the decorative arts and architecture—sources analyzed in detail here by Heather Ecker.

Literature (especially works on the decorative arts and architecture), museum exhibitions and their catalogues, and foreign travel began to influence Cartier's creations as of 1904. This followed in the wake of the 1903 *Exposition des arts musulmans* at the Musée des Arts Décoratifs in Paris (the catalogue of which is held in the Maison Cartier Archives) and preceded Charles Jacqueau's arrival at the design studio in 1909. Jacqueau went on to develop the Islamic theme, at the request of his mentor Louis Cartier and also, very probably, out of personal inclination.

A great many objects were clearly influenced by Islamic art. It is worth noting that engraved emeralds were considered part of the stock of gems rather than of *apprêts*. Most of the regions that were home to Islamic forms of artistic expression were represented, from Al-Andalus to Mughal India, Morocco, Persia, Turkey, and Syria.

The Maison Cartier archives make no clear distinctions between them, using only vague and approximate descriptions, such as "Persian decor" and "Arab decoration." The descriptive texts were written by administrative staff rather than members of the design studio, but the creative inspiration was nonetheless clearly asserted.

The motifs, the colors and their associations, and sometimes the symbols are recognizably Islamic. Was this inspiration a sales argument? Aside from the specific thematic exhibitions of the 1910s, later pieces presented in isolation are harder to categorize, but there is undeniably a particularly abundant and varied body of designs of this nature.

THE DISCREET ADOPTION OF A NEW VOCABULARY

The vocabulary in question is one of forms and color associations. These were added gradually to a corpus that was already strongly present at the Maison Cartier in the early twentieth century and has continued to grow to the present day.

In addition to the pieces themselves, the preparatory material ("idea notebooks," sketches, drawings, etc.) and documents of communication (adverts, catalogues, invitations, etc.) cast light on the adoption of this new vocabulary; they are specifically analyzed here by Sarah Schleuning.

A great many of the pieces assembled for this exhibition underscore the importance of this third category, illustrating the extent of the Islamic influence on the Cartier style. In comparison with the other cultures that appealed to Louis, East Asian in particular, the various forms of Islamic art appear to have had the most profound and measurable impact on the creative language of the Maison Cartier, and this has continued to be true, probably due to the endless possibilities of geometric patterns. The triangular shape, for example, was a particularly original addition to the Western aesthetic language, especially in the field of jewelry.

It is interesting to see how these elements became physically part of the composition of individual jewelry pieces. The shapes were generally created by empty spaces, like shadow lines serving both to define and contrast with patterns that were generally paved with diamonds. The

jeweler's skill is also reflected in how the shapes were linked and articulated together to give a jewelry piece the flexibility and fluidity characteristic of Cartier. The relief effect is reminiscent of the zellige tiles and carved wooden panels that abound in North Africa, particularly the *mashrabiyya* designs that sculpt light in the same way as Cartier plays with diamonds.

As of 1904, the Maison Cartier began to create abstract, geometric pieces. These are seen as pioneers of a "modern" style that would be labeled *Art Deco* two decades later (in reference to the 1925 *Exposition Internationale des Arts Décoratifs et Industriels Modernes* in Paris). The Islamic influence on these new designs has rarely been mentioned or even noticed, although the connection with Japanese stylization has been underscored with regard to some of the pieces.

Thanks to the curators of this exhibition, a link has finally been established with the arts of the Islamic world—a link that is fundamental to Cartier's entire creative approach.

This experimentation with, and adoption of, new forms stemmed from an obvious spirit of curiosity that was deliberate and even systematic, but which made no mention of the origin of the forms it used; the single-minded goal was the creation of new designs and the discovery of new patterns, both in jewelry and the decorative arts as a whole. Here, we see the beginnings of the complex and gradual construction of a style that is remarkable for its intrinsic coherence, diversity of expression, and openness to change. The essence of the Cartier style has something of the nature of a universal creative language, or even of a living language. This ties in with the vision expressed by a contemporary of Louis Cartier, art historian Henri Focillon, author of *The Life of Forms in Art*: "What constitutes a style? First, its formal elements, which have a certain index value and which make up its repertory, its vocabulary and, occasionally, the very instrument with which it wields its power; second, although less obviously, its system of relationships, its syntax. The affirmation of a style is found in its measures."[1]

It is often said that the quintessence of the Cartier style stems from a keen and distinctive sense of proportion.

Three parameters help to explain the structural role of Islamic art in the creation and ongoing evolution of the Cartier style: firstly, preliminary research conducted in Louis Cartier's time on the fundamentals of this language of forms—a quest for the essence, reflected here in geometry, abstraction, and infinite light-pattern interactions; secondly, the remanence of these elements over time, once removed from their original context, withstanding changing tastes to demonstrate their enduring relevance; and, finally, the structural possibilities of this language, fostering new developments and creations.

With reference once again to Henri Focillon's *The Life of Forms in Art*, which this exhibition ultimately illustrates, it is important to consider the artistic context in which Islam developed, particularly around the Mediterranean during the seventh and eighth centuries—on the one hand a classical legacy, and on the other a contemporary influence, especially that of Byzantium.

In this light, it no longer seems contradictory that Islamic art forms should have become part of the Cartier vocabulary in the early twentieth century, at a time when Louis appeared to be founding the Cartier creative language on classical antiquity and a reinterpretation of the seventeenth and eighteenth centuries.

The famous engraver Charles-Nicolas Cochin (1715–1790), who toured Italy in 1749 with the future Marquis de Marigny and was influential in the development of Neoclassical taste in Europe, published an essay in *Mercure de France* (December 1754) entitled "Supplication aux orfèvres, ciseleurs, sculpteurs en bois" (A plea to silversmiths, goldsmiths, engravers, wood carvers): "We may at least hope that when things can be square without prompting outrage, artists will refrain from torturing them ... The true means of creating something new would be to use only squares and circles."[2]

1. *The Life of Forms in Art* (1934), translated by George Kubler, Zone Books, New York, 1992.

2. Charles-Nicolas Cochin, "Supplication aux orfèvres, ciseleurs, sculpteurs en bois pour les appartements et autres, par une Société d'Artistes,"

Mercure de France, December 1754, quoted in Hector Lefuel, *Georges Jacob, ébéniste du xviiie siècle*, Paris, Éditions Albert Morancé, 1923, p. 112.

CARTIER

—

A HISTORY

PASCALE LEPEU

Louis-François Cartier (1819–1904) began his career as a jeweler at Adolphe Picard's workshop in the very heart of Paris at 29 rue Montorgueil, near Les Halles. When Picard made the decision to move, he passed his workshop on to his best craftsman. Thus, Louis-François was able to establish himself in 1847 as the "successeur de M. Picard, fabrique de joaillerie, de bijouterie fantaisie, de mode et nouveautés."[1]

Business soon prospered and Louis-François sought to open his doors to private clients. In 1853, he established himself, in his own name, as jeweler and goldsmith. He decided to settle at 5 rue Neuve des Petits Champs to be as close as possible to the Palais Royal, the center of Parisian elegance at the time. Since the era of Napoleon I, cameos and Renaissance-style ornaments were in vogue, but the time had not yet come for sumptuous jewelry. Both the Puritan spirit and bourgeois tastes that characterized the reign of Louis Philippe (1830–1848) were still active. Under the Second Empire, things accelerated for Louis-François. In a Paris giddy with parties and balls, the Maison was distinguished by the imperial court. In 1856, Princess Mathilde, niece of Napoleon I and first cousin of Napoleon III, became a client. Her numerous purchases, totaling more than 200, reflected the fashion of the time: cameos, jewelry mounted with amethysts or opals, a turquoise scarab brooch, a ruby and pearl necklace, and Egyptian-style earrings are among those that appear in her account, carefully preserved in the Cartier Archives. An order for a tea service placed by Empress Eugenie in 1859 marked a key moment for Louis-François. That year, Cartier, now a supplier to the Imperial Household, moved to 9 boulevard des Italiens. His success was immediate. An affluent clientele, including a number of aristocrats, rushed to the boutique. Elegant women matched their jewelry to their outfits, the majority of which had been designed by Charles Frederik Worth, one of the founders of Parisian haute couture, with whom Louis-François naturally established a friendship.

Careful to ensure the prosperity of his young Maison, Louis-François trained up his son Alfred (1841–1925) from a young age, and his apprenticeship as a jeweler was complemented by a schooling in French, English, and history. The two men perfected the French "art of living" and elegance. Toward the end of his life, Louis-François immersed himself in the study of Ancient and Eastern languages and civilizations, a passion that would be passed on through generations of the Cartier family.

The year 1870 saw the end of the reign of Napoleon III. France was declared a republic, but the insurrection of the Paris Commune devastated the city. Cartier closed temporarily and Alfred moved to London where he received his first letters patent as a supplier to the Court of St. James. Having been named his father's partner in 1872, he returned to Paris in 1873 and ran the family business in a still troubled France.

Since the very beginning, Cartier has offered a wide variety of creations to its clients— this is indeed a constant trait throughout its history. Accessories and precious objects, such as toiletries or smoking paraphernalia, figured among the Maison's jewelry creations, and watches appear for the first time in the stock books from 1853. The Maison's clientele grew and jewels previously reserved for the heads of crowned rulers and the aristocracy now adorned the wives of wealthy industrialists, bankers, and investors. The Maison added another string to its bow as an antiquarian, reselling precious objects and antique jewelry to clients.

Alfred had three sons and one daughter: Louis (1875-1942), Pierre (1878-1964), Jacques (1884-1941), and Suzanne (1885-1960). In 1898, he named Louis partner. At the young age of twenty-three, Louis would encourage his father to move the boutique to rue de la Paix, known as the most beautiful street in Paris. Building upon Louis-François Cartier's friendship with Charles Frederick Worth, Louis married Andrée Caroline Worth in 1898, followed by Suzanne who would marry Jacques Worth. Both marriages sealed an alliance between the world of jewelry and haute couture.

The inauguration of the 13 rue de la Paix boutique in 1899 established Cartier as a creator, and not simply a retailer, with its own design studio. At the same time, Cartier revolutionized the field of jewelry by the extensive use of platinum in its creations. Although much more difficult to work with than gold, platinum has the immense advantage of not tarnishing like gold or silver, previously employed as the principal metals with diamonds. The use of platinum allowed Cartier to create the most refined of jewels, inspired by the eighteenth-century style of which Louis was a fervent admirer. Christened the "garland style,"[2] it became an emblem of the Maison, characterized by the virtuosity of its execution and the elegance of its design.

In 1902, the year of Edward VII's coronation, Cartier opened its London branch under the direction of Pierre Cartier. In 1904, the Maison received a Royal Warrant as official supplier to the British royal household. This was followed by warrants up until 1939 from no fewer than twelve other European royal courts.

As pioneering entrepreneurs, Alfred and his sons were already anticipating the Maison's presence on the international stage. Louis and Pierre set out on reconnaissance voyages to Russia and North America. In 1906, their brother Jacques Cartier, aged but twenty-two, took over Cartier London where he replaced Pierre who was called away on a mission further afield.

Portrait of Louis-François Cartier,
c. 1870
Cartier Paris Archives

Huge fortunes had been made in North America, and clients began crossing the Atlantic to bring back couture and jewelry from Paris. In 1909, having decided upon New York over St. Petersburg, Alfred opened a new branch for the Maison, the running of which he entrusted to Pierre. This third branch is what gave Cartier its truly global dimension; the Cartier style now declared itself, shining brightly, on both sides of the Atlantic. Alfred Cartier could be confident about the future of his business with his three sons in command. Louis, based in Paris, had without doubt the greatest influence on the Maison's style; Pierre, in New York, was a formidable businessman; and Jacques, in London, soon revealed himself as an expert in pearls and precious stones. Remaining extremely close despite their physical distance, these three cultured gentlemen, distinguished in their impeccable taste and with minds open to the world and the evolutions of the new century, decided together what was or was not worthy of the Cartier name.

Simultaneously, the importance of watchmaking was growing among the Maison's creations. Indeed, Louis anticipated the success of the wristwatch. In 1904, for his Brazilian friend, the aviator-dandy Alberto Santos-Dumont, who longed for an elegant watch more practical than the traditional pocket watch, Louis would create the renowned and eponymous wristwatch, the *Santos*. In 1912, Cartier unveiled its first mystery clock, called the *Modèle A*. On an onyx base, a block of rock crystal held a dial inside which two diamond-set hands appeared to float. This marvel of horology combines aesthetic audacity with technical prowess. In 1914, one of the Maison's greatest icons appeared on a wristwatch: the diamond and onyx panther-skin pattern.

Louis Cartier always distanced himself from the *Art Nouveau* style, and it was therefore natural that the idea for a more linear modern style began to develop in his mind. From 1904, the use of geometric motifs, including lozenges, squares, and circles set with precious stones, allowed for an infinite number of variations. For the first time, color prevailed in the Maison's creations, which until then had mainly been monochrome. This geometrization was at the same time modulated by a certain fascination for Eastern civilizations. The Islamic art exhibitions of 1903 in Paris and 1910 in Munich undoubtedly left their mark on Louis and his designers. From 1912 onwards, Cartier organized in London, followed by Paris, Boston, and New York, exhibitions dedicated to Eastern jewelry and *objets d'art*, unveiling to its clientele a new stylistic adventure for the Maison.

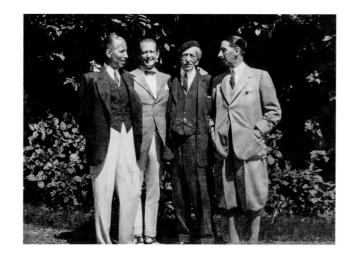

Alfred Cartier
surrounded by his sons, 1922;
left to right: Pierre, Louis
and Jacques

Cartier Paris Archives

Combining jewelry mastery and the desire for innovation, Cartier became a pioneer of a new style, known as *Art Deco* many years later, which marked a radical change in the aesthetic of the Maison's creations. Garland-style stomacher jewels gave way to pendants, ear pendants, and long necklaces that compensated in length for what they may have lost in width.

The 1920s saw a period of a certain emancipation of women; short hair and flowing clothes reigned. Women could now smoke or check their makeup in public! Cartier designed dazzling watchmaking creations, as well as accessories for women. Cigarette and vanity cases provided the designers with great freedom, thanks to their dimensions and volume. Another feature of Cartier designs was the use of antique fragments. Collected from specialized antique dealers by Louis, Jacques, and later on, Jeanne Toussaint, rare Egyptian faïence statuettes, delicate Persian and Indian miniatures, ancient Chinese jades, and precious Indian ornaments were offered to designers to include in their sketches and designs.[3] Indeed, true tributes to the artistic richness of other civilizations were born from these little treasures.

The 1930s saw the consolidation as well as the fall of *Art Deco*. Volumes changed and jewelry took on a third dimension. Gemstones, such as citrine, amethyst, peridot, and aquamarine, were used to create unique color combinations, and their large crystals were well suited to the almost architectural structures of these new creations. The period coincided with the return of yellow gold; previously used simply as a means for setting stones, this precious metal became an integral part of the design of the jewel, in some cases its sole component.

These years also belonged to Jeanne Toussaint (1887-1976), who left her mark on the Cartier style from the 1930s to the 1960s. In charge of accessories for the Maison since 1920, and of the S Department[4] since 1925, she was appointed Creative Director of Cartier Paris in 1933. The vital and delicate challenge of guiding the Maison's designers while strictly maintaining the Maison's demand for perfection fell to her. A new naturalistic style featuring fauna and flora began to develop and, in 1948, the panther, which was also Jeanne Toussaint's nickname, established itself for good in Cartier's lexicon of style, becoming one of the Maison's emblems.

A woman of remarkable taste—it would even come to be known as "Toussaint taste"—she continued the Maison's tradition of harmonizing haute couture and jewelry. Creations by Elsa Schiaparelli, Christian Dior, Gabrielle Chanel, and Cristóbal Balenciaga, all of whom were her friends, acted as canvases upon which she designed her jewels. These qualities made her a privileged spokesperson for the most elegant women of the era, the true queens of Café Society,[5] all of whom had a sense of style

as striking as her own. Exceptional pieces of jewelry would be born thanks to the relationships she established with such women. Daisy Fellowes, the Duchess of Windsor, Barbara Hutton, Mona Bismarck, and María Félix, to name but a few, chose or ordered jewelry as a reflection of their own power and personalities.

Jacques and Louis both passed away at the beginning of the 1940s. Pierre took over the Parisian branch and New York was left in the hands of Claude, Louis's son. In London, Jean-Jacques replaced his father, Jacques. Each branch, developed independently and the 1960s saw the sale of the New York and Paris branches. In the 1970s, Cartier created watches, jewelry, and objects that became more accessible, some of which, such as the *Love* bracelet or the *Santos* wristwatch, achieved global success. Between 1972 and 1979, the three branches were purchased one by one with the aim of reuniting them into one Maison in order to reestablish the pioneering spirit of its founders. It was decided that a new chapter was to be written in the Cartier story. Under the leadership of its directors, conscious of the significant cultural importance of the history of the Maison, the Cartier Collection was founded in 1983. Conceived as a heritage collection representative of the Maison's output since 1847, the Cartier Collection highlights the fact that the most magnificent jewels, watches, clocks, and precious objects are indeed true works of art. This vision was realized in 1989 with the first Cartier retrospective held at the Petit Palais in Paris, which attracted an impressive number of visitors. Since then, thirty-five exhibitions in collaboration with prestigious museums and cultural institutions around the world, such as New York's Metropolitan Museum of Art and London's British Museum, have welcomed this rich patrimony that is unique in the world.

Cartier and Islamic Art: In Search of Modernity joins the ranks of these major exhibitions, shedding new light on a stylistic adventure that is unveiled for the first time in its entirety to the public.

1. "Successor of Mr. Picard, creator of jewelry, costume jewelry, fashion, and novelties."

2. Neoclassical in inspiration, the artistic approach to jewelry known as the "garland style" is inextricably linked to Cartier. It was fashionable from 1899 until the mid-1910s and helped to establish the Maison's international reputation.

3. Gathered in a stock called *apprêts*; see Évelyne Possémé in this volume, pp. 126-139, 144-151,158.

4. Founded in the mid-1920s, the S Department (S for silver or *soir*) was responsible for designing useful objects often created with little to no jewelry ornamentation. It achieved considerable success during the great economic crisis of the 1930s.

5. Coined by Elsa Maxwell, the well-known American columnist and organizer of social events, the term "Café Society" refers to a cosmopolitan group of aristocrats, socialites, multimillionaires, and artists that in the mid-twentieth century met at fashionable restaurants and bars, or balls and receptions, setting the tone for the world of art and fashion. See Thierry Coudert in Paris, 2013, p. 37.

Jeanne Toussaint in her office,
13 rue de la Paix, c. 1952
Cartier Paris Archives

A
JOURNEY
INTO THE
CARTIER
ARCHIVES

VIOLETTE PETIT

The Cartier Archives provide a window into the creations of this Parisian jewelry Maison spanning over 170 years. The historical memory of Cartier's production is documented in great detail from the design phase to execution and sales. The archives are rich in illustrative materials, including drawings, graphics, plaster casts, and a large collection of photographs, along with accounting records that document the Maison's business operations with great precision. Three archive departments, reflecting the Cartier family genealogy and the jeweler's international expansion, with the opening of a London subsidiary in 1902 and another in New York in 1909, document the specific productions of the Parisian, London, and New York workshops, providing a unique vision of Cartier's output from 1847 to the present day.

While the archival collection is extensive, it nonetheless contains its share of mystery and the unknown waiting to be unearthed by whoever chooses to delve deeper. Given its large scope, no one person can pretend to have full knowledge of its contents. The substantial work undertaken by the curators of this exhibition, in partnership with the Cartier archivists, quickly evolved into a true research project, complete with a few false leads but, above all, many surprises and discoveries.

When this journey began, it was clear to all that the theme of Islamic art figured prominently in the history of Cartier's creations. Even a cursory analysis of its historic production, and a preliminary look through the inventories, revealed the importance of this theme for the Maison. It is reflected both in the volumes housed in Louis Cartier's library and in the travel accounts by the Cartier brothers and their employees, including that of the salesman Maurice Richard, who left for Persia in 1909, or the youngest member of the family, Jacques, who traveled to India in October 1911 and then continued his journey on to Bahrain.

These journeys constituted one of the points of departure for this meticulous investigation. Indeed, the archives contain the accounts written by the Cartier brothers and their collaborators who traveled around the world to meet their clients, as well as to search for precious materials and new sources of inspiration. Some take the form of typescript records; others are written in pencil on small loose sheets of paper that accumulated throughout the busy months of their trips. These accounts, sometimes written on the spur of the moment, provide the reader with vivid images of their adventures. It is impossible not to be moved by the account of the young Maurice Richard, who, when he left Paris for Tehran on February 3, 1909, began his story with the words, "My first journey." Independently of these individual stories, one of the questions raised within the framework of the exhibition was to understand the primary motivation of these

trips and the direct influences these explorations had on the ensuing production at Cartier. While Maurice Richard's trip was viewed as a relative failure, in the sense that the primary aim had been a commercial one and that Richard reached Tehran in the midst of a full-scale, constitutional revolution, it is interesting to note that the first Cartier pieces specifically mentioned as having an Islamic influence appeared that same year.

The archives relating to Jacques Cartier's trip to India and to Bahrain provide more tangible information. Jacques's journal, as well as the many letters he sent to his brothers Louis and Pierre throughout his trip, allowed researchers to fully retrace his entire journey. We know that he left Marseille on October 18, 1911, and reached India in November, just in time to attend the Delhi Durbar. His travels took him to Patiala, Agra, Bhopal, Bombay, and then to Karachi, before leaving for Bahrain. He returned to France in April 1912. Thus, it seems plausible that his return was related to the invitation announcing an exhibition of "Oriental jewels and *objets d'art* recently collected in India," opening on May 28, 1912, at the Cartier boutique in London. Jacques Cartier was the director of the London branch at the time, and it seems logical that he would first display his recent acquisitions in London.

While the initial reasons for his trip were to attend the Delhi Durbar, where many current and potential clients would be present, and to study the Bahrain pearl market, the account books from Jacques's trip to India also record his first acquisitions from local dealers of jewelry, described as "Oriental" or "Indian." Not random purchases, these acquisitions reflected a serious business strategy, and it was certainly no coincidence that in the three months preceding Jacques's return to Europe, an "Oriental" stock was created in Paris. The first entries in the stock book are dated February 1912. Initially comprising pieces already in Cartier's stock, and selected for the Oriental stock because of their style or origin, this category was expanded rapidly with new acquisitions, including those made by Jacques Cartier in India. An interesting example is a bowl in smoky topaz, described as an Indian-style piece, which was included in the list of purchases made by Jacques Cartier in Agra on February 22, 1912. It entered the Oriental stock on March 18 of the same year, while Jacques Cartier was still in India, proof that this specific stock was being formed concurrently with his trip.

The same topaz bowl was included in the *Exposition d'un choix de Bijoux Persans, Hindous & Thibétains*, offered for sale at the Paris boutique on 13 rue de la Paix, on June 2, 1913. The Cartier Archives have a copy of the catalogue for this exhibition, whose concept was replicated several months later during a similar exhibition organized in Boston on November 4, 1913, then later in the New York boutique at 712 Fifth Avenue, starting on

November 11 of the same year. These exhibition catalogues offer detailed descriptions of the items displayed, though without illustrations. While some of the objects had been identified by the archives in the past, the whole of the Paris exhibition had never been fully traced. A painstaking and systematic analysis of the registers of photographic negatives from 1913 uncovered a set of heretofore undocumented glass plate negatives in Cartier's photographic archives. A more in-depth study of this collection allowed researchers to virtually piece together nearly the entire exhibition of June 1913. Among the photographs was one of the discoveries of the present exhibition: a necklace described in the archives as a "Smoky crystal crescent pendant inlaid with colored stones, with a *bayadère* chain and emerald beads," which has been in the collection of the Musée des Arts Décoratifs since 1934. Without this thorough research, this unsigned piece could probably not have been identified as a work by Cartier, nor as having been included in the June 1913 exhibition.

The process of piecing together the 1913 exhibition and analyzing the "Oriental" stock provided confirmation of Cartier's already well-known attraction to distant cultures and to the East, bringing us to the decisive figure who was no doubt central to these coordinated initiatives. Although it was Jacques Cartier who traveled to India and Bahrain in 1911 and 1912, it was at the specific request of his brother Louis. The eldest of the Cartier brothers and the Maison's creative director, he oversaw both acquisitions and jewelry creations. His own penchant for Eastern civilizations, without doubt, had a considerable influence on the Maison's stylistic orientation.

Louis was a collector at heart. He collected rare books, Japanese *inrō*, Persian miniatures, and all sorts of objects that he set aside, in part, for his personal collection, but also to add to a separate stock, known as the *apprêts*. This term described artefacts that had already been part of a piece, including fragments of antique objects, which could be reused and integrated into new creations. To continue expanding his collection, Louis maintained close ties with Parisian antiquarians, illustrated by the many exchanges and invoices addressed to him still held in the archives. Among them are many from the Kalebdjian Frères, who were located—coincidentally?—in the building directly opposite the Cartier boutique at 12 rue de la Paix.

Letters and notebooks
on the theme of travel:
travel notebook of Jacques Cartier
and Maurice Richard in India
in 1911-1912, a trip to Russia,
for the 1912 Easter season
and letters to and
from India

Among the objects Louis Cartier purchased for his collection were two sixteenth-seventeenth-centuries pen boxes made of ivory, gold, and turquoise. These became the focus of research when the Musée du Louvre acquired them in 2018. Documenting these types of objects is not always an easy task. Louis Cartier's personal collection was not systematically recorded in the Maison's Archives, whose primary role has always been to preserve information relating to the business operations, therefore principally pieces for sale. Nonetheless, several glass plate negatives taken during 1912 and 1913, illustrating Persian inkstands and pen boxes, were found in a heretofore relatively undocumented part of the photographic collection; these included images of the two pen boxes now at the Louvre.

This discovery demonstrates the real depth of the Maison's photographic holdings. Cartier began to use photography in 1901. At the time, one photographer was responsible for recording all of the jewels as they left the workshops. Initially, only the most important pieces were photographed but by 1907 photography was used systematically. The Paris Archives contain nearly 40,000 glass plate negatives that document the history of its production. Alongside this primary group of images is another collection called "documents." This secondary collection comprises more than 10,000 glass plate negatives, covering material as varied as letters, drawings, and wax models, as well as objects that were not generally included in the stock, among which are certain pieces from Louis Cartier's own collection.

These same archives also contain some photographs of textiles and books, the plates of which also served as a source of inspiration for Cartier's designers. Louis Cartier had, in fact, amassed a large collection of books on the history of art and architecture that he made available to his designers to introduce them to antique or distant civilizations. This library, later expanded, is still preserved at Cartier. Notable items include the catalogue for the 1903 *Exposition des arts musulmans*, organized largely by Gaston Migeon,[1] at which Louis Cartier may have first encountered Islamic art.

Beyond his collections, Louis's tastes and his scholarly approach to Islamic art had a clear impact on Cartier's designs, an influence that started to become visible around 1908–1909. To understand the subtleties of this influence, it is necessary to start with Cartier pieces and to analyze them from the standpoint of motifs, forms, and volumes in order to identify those that illustrate this stylistic development. Several archival sources facilitated this approach, with the plaster casts providing a starting point.

Now kept at rue de la Paix, these models were made from completed pieces of jewelry. The casts would complement the photographs to provide a unique, three-dimensional record of the Cartier object.

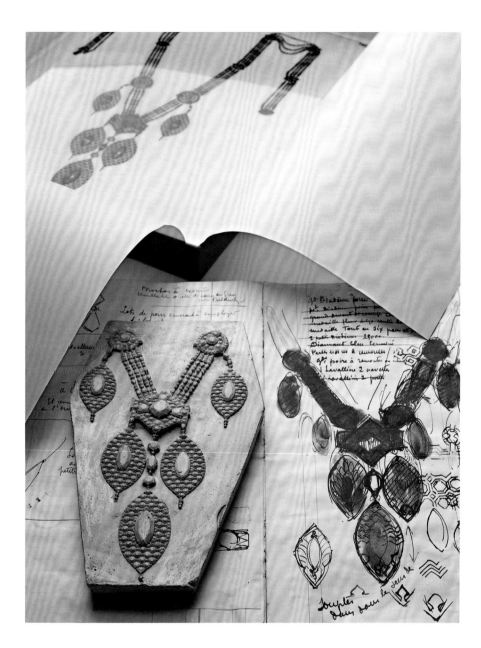

Devoid of any preciousness, the casts can be viewed as rough jewels, a nearly archaeological testimony of jewels, some of which no longer exist as they have either disappeared or been disassembled. A systematic analysis of this collection has allowed for the identification of emblematic shapes that has helped to define a typology of forms that can be considered to have been designed under relevant, Islamic influences.

The graphic collection also aided in this research. The first source were the notebooks maintained by Louis Cartier and his designers, which contained their ideas, sketches, and creative notes. These notebooks

Archive documents showing
a platinum and diamond necklace
made in 1910: *Cahier d'idées*
(Idea notebook) featuring
the first sketch of the necklace,
the glass plate negative, and the plaster
cast of the finished piece
of jewelry

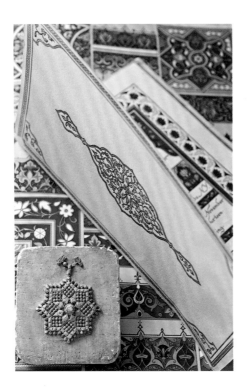

bear evocative names such as "Cahier d'idées" (Idea notebook) or "Idées nouvelles" (New ideas). Today, they offer a glimpse into the creative process underway at the time. In terms of drawings, the archives also preserve rich holdings, from initial sketches to execution drawings. The creations were traditionally drawn on tracing paper using gouache and watercolor, with a graphic pencil line accentuating the composition of the jewel. The jewel is always represented to scale, providing a precise and exact view of the dimensions.

Finally, researchers had to compare selected archival elements with records such as the stock books. These registers provided detailed information on each finished piece leaving the Cartier workshops. The production was thus recorded in chronological order as jewels moved from the workshops to Cartier's boutique. This included information such as the date of the entry into the stock, the name of the workshop, and the piece's identifying number engraved on the setting, as well as all the information concerning the sale. An analysis of the vocabulary used by Cartier to describe these objects, whose forms had already been identified as having an Islamic influence, provides a wealth of information.

Yet this approach has its limits. As the stock books were principally commercial, these descriptions were very likely written by the stock clerks, who were responsible for inventorying and describing the creations. It is therefore unlikely that Louis Cartier, or the designers, were responsible for the use of certain words. But this analysis does reflect an overall internal approach to the company's production by its staff. While certain descriptive terms appeared early on, with "Arab" being the most common, they soon disappeared from the records. By way of comparison, other influences, such as from China or Japan, for example, were described as such in a far more systematic way. This may reflect a certain difficulty the employees had at the time to identify the Islamic stylistic vocabulary, or else that this same vocabulary of forms soon became part of the Maison's aesthetic codes, disappearing in the case of contemporary creations, which were viewed above all as "Cartier" pieces.

This theory is partially confirmed by the communication tools that were used later by Cartier. The archives still retain records of advertisements, press articles, and sales catalogues sent out to clients. All these sources illustrate how the jeweler chose to communicate regarding its

An invitation to the exhibition held in 1913 in the salons on rue de la Paix in Paris, and a plaster cast of a pendant made in 1908

contemporary creations. Among other examples, there is a Cartier New York sales catalogue, dating from 1931, with a layout that replicates designs from a 1910 catalogue in Louis Cartier's library of the Yerkes collection of Oriental carpets,[2] even though the jewelry and accessories illustrated in the Cartier catalogue were entirely *Art Deco* in style. And finally, a Cartier advertisement published in a 1935 British edition of *Vogue* was found; it may have been inspired from the photographic prints that Jacques Cartier brought back from Cairo, either in 1929 at the time of the French exhibition in Cairo, or perhaps during a second trip that he made, apparently in 1932. Once again, travel abroad may have nourished the inspiration for advertising that was otherwise entirely contemporary in its graphic style. The 1930s demonstrated just how much the jeweler had fully assimilated the codes of Islamic art into its own identity.

This adventure revealed the wealth and complexity of the archives, which helped to resolve some of the questions raised within the framework of this exhibition. It was, above all, a human venture. The work was made possible by pooling the combined expertise of the curators with the in-depth knowledge of the archivists. While the archives have not yet disclosed all their secrets, by any means, this work has nonetheless significantly furthered our knowledge on a subject that had not, until now, been approached globally.

1. Paris, 1903;
 inv. Cartier BibCart 304.

2. Mumford and Yerkes, 1910;
 inv. Cartier BibCart 390.

ISLAMIC ART "REVEALED": A PATH TOWARD MODERN DESIGN

JUDITH HENON-RAYNAUD
ÉVELYNE POSSÉMÉ

After a long process, the study of Islamic art became established as a discipline in its own right in the early twentieth century, gradually disassociating itself from its initial links to nineteenth-century Orientalism with its inherent contradictions. Islamic works of art earned admiration for their intrinsic qualities, and the context of their production was brought to light and given its true place in the history of art. International political developments contributed to this process: the weakening of great, Islamic empires in the face of Western, colonial greed encouraged the exodus of works of art to Europe, and notably to Paris. Presented at the great exhibitions of the early twentieth century, these works—and the art of the book in particular—were received favorably, strongly impacting contemporary artists and creators of the time with the force of a "revelation" and sparking a vogue for all things Persian. One might ask if Islamic art was perceived by some as a means of awakening Western art from the torpor into which it had stagnated, and perhaps thereby helping to pave the way to modern design.

THE EASTERN REVELATION

It was through the great universal exhibitions, locales of exaltation of occidental powers, that the Western public encountered, for the first time, the artistic productions of nations then qualified as "primitive." High-quality collections amassed by travelers and art lovers alike were exhibited throughout the nineteenth century. London's Great Exhibition of 1851 showcased the splendors of India. The 1878 exhibition in Paris presented pieces of outstanding quality,[1] alongside less precious objects, or of ethnographic interest, in an Orientalist *mise-en-scène*.

In Europe, encounters with Islamic art heightened the impression of the decadence of the Western arts, of a society consumed by its headlong rush to modernity, no longer capable of its own creative production. Against this backdrop, the East appeared to European eyes as a rediscovered Middle Ages, but one already threatened by European domination.[2] Conscious of the imminent risk of the destruction and loss of these tangible and intangible cultures, scholarly Orientalists set their sights on protecting them. In addition to research, this involved the preservation of monuments[3] and the acquisition of works of art and architectural elements [P. 41],[4] as many people believed that the endangered culture of the East would hold the key to a rebirth of Western art.

In the final third of the nineteenth century, some large private and institutional collections of Islamic art were created both

PREVIOUS PAGE
Detail of a cigarette case
1928
(see p. 269)

in Europe and the United States.[5] An Islamic art market emerged in Paris; indeed, the French capital became the epicenter of this trade, which reached its peak around 1910. The principal factor that explains the city's role was the colonial expansion of France and its linguistic and cultural influence, particularly in Cairo and Istanbul, key cities for the commercialization of Islamic art.[6] The political context in Persia and in the Ottoman Empire in the early twentieth century helped to galvanize the Islamic art market, with an influx of art dealers and intermediaries who supplied the market with a large quantity of objects, some of exceptional quality.

A WORLD IN CRISIS THAT FAVORED THE TRANSIT OF WORKS OF ART TO PARIS

Major upheavals that challenged the Ottoman Empire in the late nineteenth and early twentieth centuries led to its collapse in 1922. An increased European presence in its territories contributed to the reconfiguration of a society faced with the challenges of modernity and numerous crises, and the Empire was gradually dismantled.[7] The 1838 Treaty of Balta Liman opened the Ottoman market to European commerce and thus foreign trade was shifted from Muslim to Christian control.[8] After the Crimean War (1853–1856), many Armenians emigrated to Istanbul and Izmir, as well as to Egypt, and developed branches of their trade in Europe, where the taste for Eastern artifacts offered promising business opportunities. To meet the demand, many Armenians abandoned their traditional professions to become antiquarians and art dealers. They played a key role in the rapidly expanding Islamic art market, becoming essential intermediaries based upon their family networks, mastery of languages, erudition, and knowledge of craftsmanship.[9] The Cartier stock books provide an idea of the role of these Paris-based Armenians: Louis Cartier bought from many of them, some of whom were his immediate neighbors [P. 42].[10]

Porch, dismantled
from a home in Cairo
Egypt, 15th century
Carved stone

Musée du Louvre, Paris,
département des Arts de l'Islam
On loan from the Musée des Arts Décoratifs
Gift of Gaston de Saint-Maurice
Inv. AD RI 2003.26.1

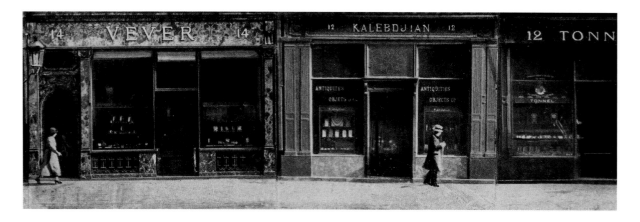

In the nineteenth century, Qajar Iran (1796–1925) collided with the economic interests of Russia and Britain. Its territories in Central Asia and the Persian Gulf were eroded by these rival powers. Modernization could not prevent the empire's financial difficulties and attendant decline. At the same time, from the second half of the nineteenth century onward, Persian antiquities acquired historical, political, and financial value. Archeological excavations (mostly carried out by foreign missions) proliferated.[11] The empire underwent a constitutional revolution from December 1905 to 1911[12]—a period of disruption and anarchy that hastened the exodus of national treasures (manuscripts and paintings), illegally excavated objects, as well as material from private collections.[13] From 1907 onward, a great number of Persian manuscripts reached the Paris art market, serving as a veritable revelation to art lovers competing with one another to buy the finest pages from dealers who disassembled manuscripts to increase the sale value of single folios.[14] The Western markets' growing appetite for Islamic works of art encouraged the Middle Eastern intermediaries (including members of the Jewish and Christian minorities) to act as brokers between the Iranians, who carried out excavations, and the foreign collectors and antiquarians.[15] The market was so strained that some travelers returned empty-handed from their trips to Iran. Such was the case with Henry-René d'Allemagne,[16] to whom Cesari (a Corsican adventurer and the then Inspector General of Customs for the Belgian authorities) explained in 1907 that hardly anything of interest remained on site, as it had all been "cleared out by the Armenians, who sent it straight to Paris or London."[17]

View of the rue de la Paix, Paris
Photograph, c. 1923
*La Renaissance de l'art français
et des industries de luxe,*
June 1923, p. 12

TOWARD A HISTORY OF ISLAMIC ART: THE DEVELOPMENT OF A DISCIPLINE

Under the aegis of a new institution, the Union Centrale des Beaux-Arts Appliqués à l'Industrie—created in 1864 and renamed the Union Centrale des Arts Décoratifs (UCAD) in 1882—a core group of art enthusiasts emerged who contributed to the development of a new discipline devoted to the study of Islamic art. The 1893 exhibition at the Palais de l'Industrie marked a watershed as the first show of "Muslim" art—a name that now prevailed over the earlier "Saracen" and "Arab" art. The works on display were of remarkable quality and the evident aims of the show were to trace the history of Eastern art and to stimulate Western creativity. However, its lukewarm reception testified to a change of attitude among art collectors, who criticized the Orientalist scenography and the mixing of artistic genres.

The 1903 *Exposition des arts musulmans*, organized in response, was the first scientifically rigorous event of its kind. It was put together by a young Louvre curator, Gaston Migeon, who was well known amongst the critical group of enlightened art amateurs. With the support of the UCAD and a network of Parisian collectors, he compiled a rigorous selection of works of art, in stark contrast with the cheap Orientalism of previous events. His exhibition garnered unprecedented enthusiasm from the connoisseur, prompting Oriental art collector Georges Marteau to comment: "One's eyes were not truly opened until 1903."[18] For the first time in France, from 1904 to 1905, Migeon taught a "history of the Muslim industrial arts" at the École du Louvre, resulting in the publication of the first *Manuel d'art musulman* in 1907: the first volume, on architecture, was written by French architect Henri Saladin; and the second, on the industrial arts, was the work of Migeon himself. The UCAD's second exhibition of Muslim art, held the same year, focused on textiles and paintings from the Safavid and Ottoman periods, borrowed from the collections of art dealer Dikran Kelekian and art collector Victor Goloubew.

One of the most significant early twentieth-century events that influenced the emerging discipline of Islamic art was held in Germany. Fully convinced of the importance of the field after the exhibition

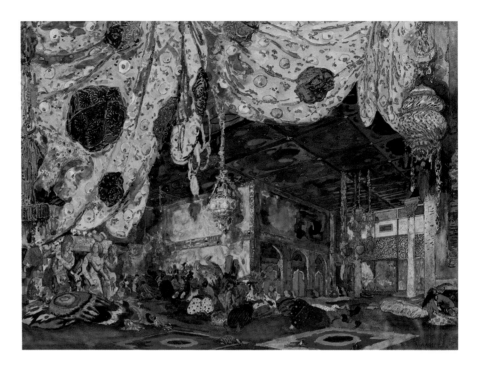

of 1903, a new department of Islamic art was established in the Kaiser Friedrich Museum in Berlin. In 1910, an unprecedented exhibition devoted to Islamic art was held in Munich, featuring 3,553 works from both institutional and private collections—French, in particular. The exhibits were arranged according to technique and geographical origins,[19] and presented in a vast, white cube space as independent, self-sufficient works of art. The aims of the curators were to stimulate contemporary, artistic creativity, and to put Islamic art on a par with all other artistic productions and demonstrate its intrinsic value [P. 43]. The objects were used for an educational purpose, namely, to establish the history of Islamic art. Some visitors—especially the French—were puzzled by the separation between the works of art and the sober presentation, but recognized the quality of the event and its importance to the field of Islamic art. One visitor was Henri Matisse, who described it as "extraordinary."[20]

Two years later, the French also made an impression with a thematic exhibition on Persian miniatures at the Musée des Arts Décoratifs. This hastily organized show was made possible thanks to the mobilization of the museum's network of collectors, including Louis Cartier; it featured almost 500 paintings and a number

Set design for the ballet *Shéhérazade*
Léon Bakst, Paris, 1910
Gouache, gold highlights, watercolor,
pencil on paper
54.5 × 76 cm
Musée des Arts Décoratifs, Paris
Inv. 2008.56.122

Tamara Karsavina
as Zobeïde in *Shéhérazade*
Performance at the Opéra de Paris, 1910
Photograph by Studio Talbot
Silver gelatin print
Musée des Arts Décoratifs, Paris
Gift of Jas Hennessy & Co., 2007
Inv. 2007.38.1368

of objects that are unfortunately missing from the commemorative catalogue by Georges Marteau and Henri Vever. Presenting a history of the Persian art of manuscripts from the twelfth to the seventeenth century, the exhibition testified to the rapidity with which the private collections represented were formed and to the significant influx of works of art into Paris, which became the hub of the Islamic art market.[21]

ISLAMIC ART AND CONTEMPORARY DESIGN: A PATH TO MODERNITY?

The exhibition of Persian miniatures in Paris in 1912 came as a veritable revelation to artists in Paris, who also had access to many paintings of outstanding quality in museums, exhibitions, and art galleries. The figures, landscapes, and colors inspired an iconographic repertoire of a new style of artistic expression in the first third of the twentieth century, as echoed in the press of the period: "Poiret, Iribe and so many others besides were doubtless inspired to create their pretty little ornaments by the exquisite Persian miniatures exhibited on Rue de Berri by Monsieur Demotte."[22]

Publishers were naturally receptive to this new style. Joseph Charles Mardrus's French translation from Arabic of *The Thousand and One Nights* was reprinted various times, abundantly illustrated in a very Orientalist manner by Léon Carré, and more symbolically and allusively by Edmund Dulac.[23] The latter illustrated many other books in his subtly colored "Persian" style, in particular, Léon Rosenthal's *Kingdom of the Pearl*[24] and the new edition of the *Rubaiyat of Omar Khayyam* [P. 50 AND 51].[25]

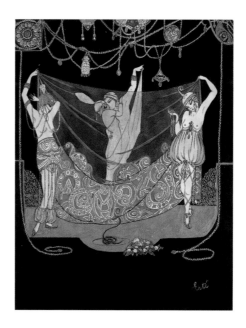

Persian clothing, turbans, and aigrettes inspired many fashion designers, notably Paul Poiret, who copied the ones he saw at the Victoria and Albert Museum in London in 1908. He was the first to introduce this fashion to Paris, but his inspiration was undoubtedly reinforced by the arrival of the Ballets Russes, which performed their first season in Paris in 1909.[26] Their first production, *Cléopâtre*, and most of all *Schéhérazade*, the following year, with sets and costumes by Léon Bakst, conjured up an imaginary East with an innovative and daring use of color and a host of both Russian and Eastern references [P. 44, TOP].[27] Bakst worked for Sergei Diaghilev and the Ballets Russes

Oriental dancers
Drawing for a magazine cover
Romain de Tirtoff, known as Erté
Paris, c. 1912
Ink, watercolor, and gold
highlights on paper
32 × 24.5 cm

Musée des Arts Décoratifs, Paris
Purchased thanks to the support of Les Amis
du Musée des Arts Décoratifs
Inv. 2021.55.1

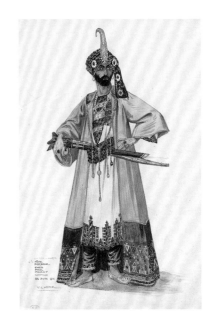

but also privately for the dancer Ida Rubinstein and, from the 1920s onward, for the Opéra de Paris under the direction of Jacques Rouché. His aesthetic was widely embraced, essentially copied by illustrators of the period including Paul Iribe, Georges Barbier, Georges Lepape, and Romain de Tirtoff (aka Erté) [P. 44, BOTTOM, AND 53], some of whom devoted entire publications to dance and dancers.[28] In those years, as Jean Cocteau said, "Elegant women were under Bakst's yoke."[29]

The Persian influence remained important in the performing arts. Although many theatrical references recalled nineteenth-century Orientalism, there were also some truly creative productions in which the presence of Persian art was a sign of modernity—such as the ballet *La Péri*, commissioned for the third season of the Ballets Russes in Paris in 1909–1910 and composed by Paul Dukas. The role of Iskender was supposed to be danced by Nijinsky, with Natalia Trouhanowa as the Péri (fairy), with sets and costumes by Léon Bakst, but Diaghilev cancelled the planned premiere on the grounds that the ballerina was not of the same standard as the male dancer. The one-act ballet was finally staged on April 22, 1912, at the Théâtre du Châtelet in Paris, with choreography by Ivan Clustine, and sets and costumes by the painter and fresco artist, René Piot. Some of Piot's extant drawings permit one to imagine this performance, designed by the artist in harmonies of blue.[30] One shows the character of Iskender wearing a turban and cloak copied closely from Persian paintings. Two other designs show the Péri, the fairy from whom Iskender stole the flower of Immortality, dressed in a splendid cloak with a peacock feather motif [P. 52].[31]

Other decorative art forms attest to the link between modernity and Islamic art: ceramics by Clément Massier [LEFT] and André Metthey; printed canvases of Rambouillet by André Groult and Georges d'Espagnat [P. 49 AND 57]; textiles and costumes by Paul Poiret [P. 55]; and designs by Guy-Pierre Fauconnet for the Maison Martine interior design company. Until the 1920s, French artists wavered between an orientalizing interpretation and a modernist expression, finding it difficult to break away from literal copying of a pseudo-Oriental folklore conveyed by the arts since the nineteenth century.

Victor Lhuer
à la fête persane de Paul Poiret
Victor Lhuer, Paris, 1911
Graphite pencil, gouache,
and white highlights on paper
29.5 × 21 cm
Musée des Arts Décoratifs, Paris
Inv. RI 2019.8.3.29

Decorative plate
Clément Massier, Golfe-Juan, 1890
Glazed earthenware
Diam: 36 cm
Musée des Arts Décoratifs, Paris
Inv. 5929

Some, however, had learned from Léon Bakst: "[...] I study the ornaments of the period of the production for which I am designing; I choose which is most significant element; I adopt it and repeat it in the textiles, the architecture, the jewelry. The ornamental device thus becomes a leitmotif, and I achieve a unity not only of color but also of line."[32]

The early twentieth-century zeitgeist was marked by the visual shock that came with the discovery of Eastern paintings—Persian and Indian, in particular—at a time when Islamic works of art were being presented in a new way that showcased their intrinsic artistic value and place in history. The great exhibitions of Islamic art seem to have achieved their goal as the Islamic influence became perceptible in every artistic field, from publishing to the performing arts, fashion, jewelry, and accessories. This trend found its way into bourgeois interior design in the form of objects, textiles, and decorations by contemporary designers. In 1929, the decorator Paul Follot, director of the design workshop connected with the Bon Marché department store in Paris, commissioned the Russian-born artist Mikhail Lattry to make a series of paintings inspired by Persian paintings, in a harmony of red and green, for the dining room of industrialist Pierre Foullon.[33] According to the journalist Francis Carco, writing in 1914, fashion was "[...] completely obsessed with Persia [...]."[34] Louis Cartier contributed to this trend; during a trip to Russia with Charles Jacqueau to prospect for new clients in 1911, he wrote to his father: "It seems to me that the selections of new items we should offer for sale must inevitably be the Russian or even Persian style."[35]

Mural (detail)
Mikhaïl Lattry
Pierre Foullon's dining room
Décor Paul Follot
Paris, 1929
Ferri sale, 2019

Pierre Foullon's dining room
Paul Follot, decorator
Paris, 1929
Ferri sale, 2019

1. Such as the Mamluk collection of the Comte de Saint-Maurice and some major Safavid works of art.

2. Paris, 2007, p. 39.

3. A Committee for the Conservation of the Monuments of Arab Art was created in Cairo in 1880.

4. For example, a Mamluk porch, on display at the Musée du Louvre (inv. AD RI 2003.26.1). After being dismantled when its original location was demolished, it was purchased by Comte Gaston de Saint-Maurice; its stones were packed in 1887 and sent to the Union Centrale des Arts Décoratifs to be presented at the *Exposition Universelle* 1889 (see Makariou, 2012, pp. 261–264).

5. In Paris, Islamic artifacts were displayed at the Louvre from 1860 onwards (grouped together with Western pieces, according to materials) and from 1865 at the Palais de l'Industrie, where the Union Centrale des Beaux-Arts Appliqués à l'Industrie presented collections of non-European art. Islamic works of art were also exhibited at the Musée de la Manufacture Nationale de Sèvres from 1876, at the Musée de Cluny from 1878, etc.

6. Paris, 2007, p. 64.

7. Greece obtained its independence in 1829; France moved into Algeria in 1830; Egypt gained autonomy from the Ottomans in 1840; the Balkan crisis of 1876 to 1878 led to the independence of Romania, Serbia, and Montenegro.

8. Lisbon, 2019, p. 55.

9. Ibid., p. 65.

10. The Armenian names that appear most often in the stock books include Dikran Kelekian, the Kalebdjian Frères, A. Sarkissian, and Maison Mélkoniantz.

11. In 1884, France signed the first archaeological agreement allowing it to excavate at Susa. In 1895, it obtained the monopoly on excavations in Persia, perpetuated in 1900 by the signature of the third archaeological agreement.

12. The Maison Cartier organized a trade visit to Persia in 1909. Maurice Richard arrived in Tehran during the revolution; he saw that the largest stores were closed and realized it would be difficult to find important pieces in such a situation (his travel diary is held in the Cartier Archives).

13. On this question, see the theft from the Golestan Library in Nasiri-Moghaddam, 2004, pp. 256–260.

14. One such unscrupulous dealer was Georges Demotte, whose name remains linked to the fourteenth-century manuscript of the Great Mongol Shahnama, which he purchased in 1910 and dismantled between 1911 and 1914, selling the pages to European, Russian, and American collectors.

15. In Iran, the profession of the art dealer was scorned and reserved for religious minorities (Jews and Christians); see Nasiri-Moghaddam, 2004, p. 263.

16. Henry-René d'Allemagne (1863–1950), an archivist-paleographer at the Bibliothèque de l'Arsenal in Paris, was a great scholar and a member of the first generation of early twentieth-century collectors of Islamic art, alongside Gaston Migeon, Raymond Koechlin, Henri Vever, Louis Gonse, etc.

17. Nasiri-Moghaddam, 2004, p. 270.

18. Marteau and Vever, 1913, p. 6.

19. An exhibition designed by Friedrich Sarre (a German archaeologist, Orientalist, and collector) and Frederick Robert Martin (a Swedish-born diplomat, collector, and art dealer who contributed to several major Islamic art exhibitions and produced scientific publications intended to promote and sell his own collection).

20. Peltre, 2006, p. 83.

21. "In the years that followed—especially in 1908 during the Revolution that shook Persia—Europe and Paris in particular received a large number of miniatures and manuscripts of far greater quality than the specimens formerly considered the finest. At present, this source seems very significantly diminished if not completely dried up. Private collections and royal libraries appear to have yielded their finest possessions and one must now go through many mediocre pieces before coming across an item of choice." Marteau and Vever, introduction to the exhibition catalogue, 1912, pp. 6 and 7.

22. The journal *Gil Blas*, June 27, 1913, p. 7, quoted by Vivet-Peclet, 2019, p. 151.

23. *Les Mille et une Nuits*, French translation by J.-C. Mardrus, illustrated by E. Dulac, Paris, Piazza, 1907 and French translation by J.-C. Mardrus, illustrated by Léon Carré, Paris, Piazza, 1926. Louis Cartier's library contains an edition illustrated by Barbier and another adapted by Hadji-Mazem and illustrated by Dulac, as well as 120 drawings and prints by Barbier.

24. Léon Rosenthal, *Au royaume de la perle*, illustrated by E. Dulac, Paris, Piazza, 1920.

25. The book, and its binding by Henry de Waroquier, entered the collection of the Musée des Arts Décoratifs in 1913 (inv. 19077 and 19286).

26. The Ballets Russes made a very strong impression on Cartier designer Charles Jacqueau, who kept his sketchbook to hand throughout the performances, collecting motifs, colors, and forms; see Nadelhoffer, [1984] 2007, p. 136.

27. On the Ballets Russes, see Paris, 2009; Nectoux, 2013; Paris, 2016.

28. Among others, Jean Cocteau and Paul Iribe, *Vaslav Nijinski*, Paris, Société générale d'impression, 1910; George Barbier, *Dessins sur les danses de Nijinski*, Paris, À la Belle Édition, 1913; George Barbier, *Vingt-cinq costumes pour le théâtre*, Paris, C. Bloch, 1927; George Barbier, *Album dédié à Tamara Karsavina*, Paris, Corrard, 1914.

29. "Masques. Jean Cocteau," supplement to issue no. 19 of the journal *Masques. Revue trimestrielle des homosexualités*, Paris, Masques, 1979.

30. Held by the Cabinet of Prints and Drawings at the Musée des Arts Décoratifs, donated by Jacques Doucet, 1919: sketch for Iskender's costume, inv. 21760.1; sketches for the Péri's cloak, inv. 21760.2 and 3.

31. The score for *La Péri* is considered Paul Dukas's most refined and accomplished work.

32. Interview with Léon Bakst in *Le Gaulois*, June 3, 1911; see Paris, 2017, p. 109.

33. Ferri sale catalogue, Hôtel Drouot, June 5, 2019, nos. 103 to 119. Our thanks to the new owners of the apartment for allowing us to admire these extraordinary paintings.

34. Carco, 1914, p. 2.

35. Letter from Louis Cartier to his father, Alfred, in January 1911 during a trip to Russia, quoted in Bachet and Cartier, 2019, vol. 1, p. 249.

Strip of upholstery fabric
Rambouillet textile factory
Georges d'Espagnat, designer
André Groult, manufacturer
Rambouillet, c. 1910
Linen, wood block printing, five
colors on an ecru background
144 × 83 cm
Musée des Arts Décoratifs, Paris
Inv. 29778

Shéhérazade

Edmond Dulac
Illustration for *Mille et Une Nuits*
Paris, H. Piazza, 1919

Bibliothèque nationale de France, Paris
RES-Y2-150

Histoire du roi Omar Al-Néman
et de ses deux fils merveilleux

Léon Carré
Illustration for *Mille et Une Nuits*
Paris, H. Piazza, 1926-1932

Bibliothèque nationale de France, Paris
RES–M. Y2. 214 (12)

Omar Khayyam, *Les Rubaiyat*

Binding and title page
Illustrations: Edmond Dulac
Binding: Henry Louis Alphonse de Waroquier
Paris, H. Piazza, 1912
Moroccan leather, silk,
heated gilding tool
31 × 24.6 cm

Musée des Arts Décoratifs, Paris
Purchased from Waroquier, 1913
Inv. 19286

La Perle du sanglier

Edmond Dulac
Illustration for *Au royaume de la perle*
by Léonard Rosenthal
Paris, Payot, 1926

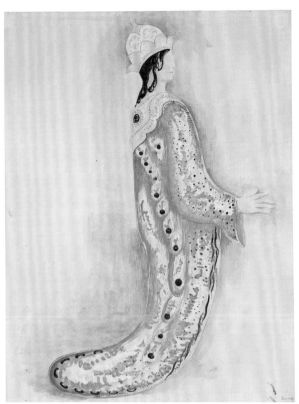
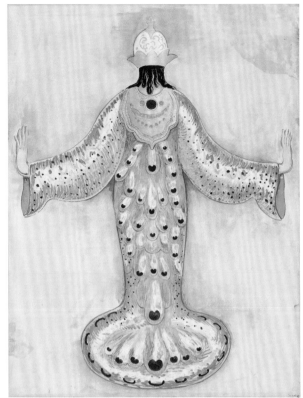

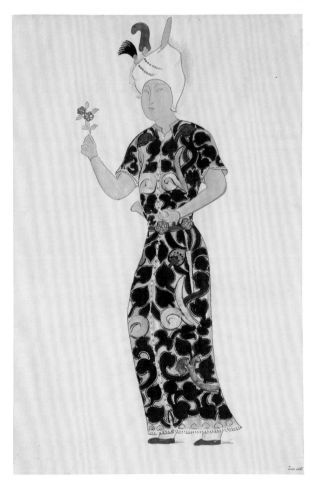

Costume designs for *La Péri*

Ballet by Paul Dukas
René Piot, Paris, 1912
Watercolor, gold highlights,
gouache on paper
57.2 × 43 cm
57.8 × 44.2 cm
Musée des Arts Décoratifs, Paris
Inv. 21760.3 et 21760.2

Costume design for Iskander
in *La Péri*

Ballet by Paul Dukas
René Piot, Paris, 1912
Watercolor, gold highlights,
gouache on paper
57.2 × 36.7 cm
Musée des Arts Décoratifs, Paris
Inv. 21760.1

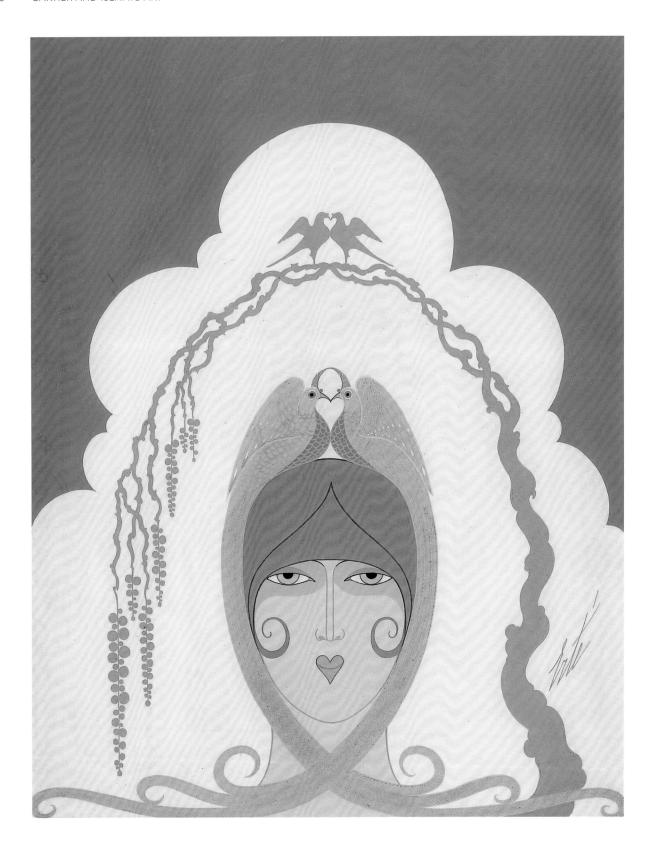

Vénus

Romain de Tirtoff, known as Erté
Cover for *Harper's Bazaar*, May 1925
Gouache
37 × 28 cm
Galerie Ary Jan, Paris

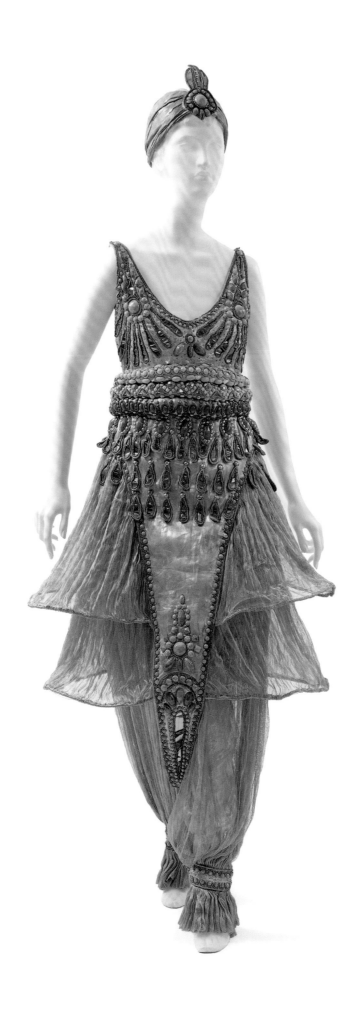

Fancy dress costume

Paul Poiret
Paris, 1911
Metal, silk, cotton

The Metropolitan Museum of Art, New York
Purchase, Irene Lewisohn Trust Gift, 1983
Inv. 1983.8a,b

Isfahan coat

Paul Poiret
Paris, 1907
Silk velvet, braid trim, embroidery
115 × 50 cm

Musée des Arts Décoratifs, Paris
UFAC Collection
Inv. UF 63-18-2

La Source or *Fontaine* coat

Paul Poiret
Rodier embroidery
Belt buckle by Paul Kiss
Haute couture, spring-summer 1924
Cotton cloth, gold and cotton
embroidery, metal
Length: 115 cm

Musée des Arts Décoratifs, Paris
UFAC Collection
Inv. UF 61-32-1

"Sweaters pour la maison
et pour la ville"

Jardin des modes nouvelles,
October 15, 1913, no. 7

Bibliothèque Forney, Paris
2013-310243

"Ornements de coiffures"

Jardin des modes nouvelles,
November 15, 1913, no. 8

Bibliothèque des Arts Décoratifs, Paris
JP 101

"Les étoffes nouvelles
pour les blouses"

Jardin des modes nouvelles,
November 15, 1912, no. 2

Bibliothèque des Arts Décoratifs, Paris
JP 101

Strip of upholstery fabric

Rambouillet textile factory
André Groult, manufacturer
Rambouillet, c. 1911-1912
Linen, woodblock printing
145 × 83 cm

Musée des Arts Décoratifs, Paris
Inv. 29783

PRECIOUS MANUSCRIPTS
AND
INLAID
OBJECTS

RECONSTRUCTING
LOUIS CARTIER'S
ISLAMIC
ART COLLECTION

JUDITH HENON-RAYNAUD

The Louvre's acquisition in 2018 of two exceptional ivory pen boxes that had belonged to Louis Cartier inspired this attempt to reconstruct his Islamic art collection, which has remained essentially unknown except to specialists in the Islamic art of the book, who know of it from the published paintings. Louis Cartier, whose training and profession gave him a keen eye, developed a passion for eighteenth-century furniture as well as Chinese and Japanese works of art. He was also a genuine bibliophile who sought and acquired many rare books, autograph letters, and manuscripts.[1] The Islamic pieces represent only a fraction of his collection but are mostly of outstanding quality. Louis was a discreet collector whose collection was never fully published, and the pieces he assembled throughout his life were dispersed after his death, mainly to the United States.

Louis Cartier's lifelong interest in Islamic art was sparked by two exhibitions—one held in Paris in 1903, the other in Munich in 1910—and by his assiduous frequenting of the Paris art market, where the finest examples of Persian and Indian manuscripts were to be found in the later 1910s. The origins of his personal collection of Islamic art are difficult to establish—especially as he often purchased Eastern pieces for the Maison Cartier—but the Munich exhibition seems to have acted as a catalyst. Louis Cartier is acknowledged as a lender to the 1912 exhibition of Islamic art at the Musée des Arts Décoratifs, as well as to other exhibitions that followed, offering works of outstanding quality and pedigree in ever larger numbers.

A number of resources have been useful in reconstructing his collection: the archives of the Maison Cartier (including stock books, invoices, and glass plate negatives), the catalogues of the exhibitions in which Louis participated, and specialist publications that reproduced his works. The dispersal of his collection and the discovery of unpublished documents found in private archives have made it possible to link disparate works together and to sketch the outlines of this remarkable collection, and of Louis Cartier's particular tastes.

LOUIS CARTIER AND ISLAMIC ART

Louis Cartier joined the family firm in 1898, at a time when it was managed by his father, Alfred, who succeeded his own father, Louis-François. The Maison Cartier started out selling and repairing jewelry, but also dealt in *objets d'art*; it appointed its own designers in the early twentieth century and, with the growing success of Cartier creations, the sale of *objets d'art* and antique jewelry began to take second place. However, the company

PREVIOUS PAGE

Montage from a detail
of a vanity case
1925
(see p. 129)

continued to deal in antiques until the 1920s, decreasing this activity somewhat after World War I. The large volume of transactions is evidenced by the invoices of clients and collectors who purchased not only antique or modern jewelry from Cartier, but also Sèvres and Mennecy porcelain and various other items, such as small paintings, frames, Indian jewelry, and Islamic artifacts and manuscripts.[2]

This antique-dealing activity sheds an interesting light on Louis's formative experiences. From his earliest childhood, he was immersed in the world of art and antique dealers and collectors, and developed a thorough familiarity with the Parisian networks of buyers and sellers.[3] The family business brought him into close contact with an international clientele, fostering an acute awareness of this world. His family history may hold another key to his initial interest in Islamic art: his grandfather began to study Eastern languages in later life, and owned a library to which Louis constantly added, including the latest specialist publications in the field.[4]

Louis was twenty-eight in 1903 when the major *Exposition des arts musulmans* opened at the Musée des Arts Décoratifs. Although it is extremely likely that he visited the exhibition, we have no proof of this—but we know he owned the exhibition catalogue compiled by Gaston Migeon.[5] In the early twentieth century, the small circle of Islamic art enthusiasts comprised collectors, dealers, and curators, all of whom kept in close touch and were seen as pioneers. Brought together by the Union Centrale des Arts Décoratifs (UCAD) at a time when Islamic artworks were reaching Paris in large numbers, they participated in the same exhibitions, frequented the same sales outlets, and exchanged works of art with one another.

These enthusiasts had several things in common. Their interest in Islamic art followed on from their admiration for East Asian and, particularly, Japanese art. Louis Cartier was no exception to this rule, as can be seen from the sales catalogue of his estate sold by his son in 1962.[6] Many Islamic art enthusiasts also took an interest in contemporary art.[7] As a designer, Louis Cartier was interested in the artistic productions of his time, and his personal approach demonstrates that he saw Eastern art as a potential source of inspiration for contemporary artists. Louis was not the only jeweler in this group of devotees: his neighbor, the jeweler Henri Vever, was a great collector, while the well-known dealer in Islamic art, Georges Demotte, was a jeweler before devoting himself exclusively to the art business.[8]

Portrait of Louis Cartier
Nadar's studio, 1898

Médiathèque de l'Architecture
et du Patrimoine, Paris
Inv. ND082936F

RECONSTRUCTING THE COLLECTION THROUGH THE ARCHIVES

THE STOCK BOOKS

As mentioned above, the Maison Cartier dealt in *objets d'art* and antique jewelry for many years. The purchase of antique pieces also served to furnish the stock of what were known as *apprêts*.[9] For this reason, the Cartier Archives include stock books that record the history of these pieces—elements of jewelry or objects sometimes reused in contemporary creations, altered, rearranged, or resold as they were—with those that remained unsold featuring in the stock books for several years in a row. These registers provide a brief description of the objects, usually the seller's name, the price, and the purchase and resale dates. Louis Cartier apparently often dealt with the purchase of *apprêts* in person as his name appears frequently in the registers,[10] one of which is called *"apprêts* Louis Cartier."[11] He sometimes bought some of these objects himself, in which case a note specifies that the objects in question were being transferred from the stock to his personal collection. Nineteen such transfers are recorded in the registers we consulted.[12]

Judging by their purchase prices, these pieces tended to be unassuming items, almost certainly intended for everyday or decorative use; such examples include an ashtray made of copper from one of the "Arab" lands and a "Persian" silver cigarette box.[13] Other pieces were probably items destined for his art collection, such as a "rock crystal perfume bottle with a gold stopper surmounted by a diamond" (whose stone Louis had

changed for a "Persian" sapphire cabochon),[14] a "Persian jade dagger with its scabbard set with colored gemstones in gold [LEFT],"[15] and two Indian bowls, one of "rock crystal inlaid with gold and small flowers of colored gemstone cabochons,"[16] the other of "jade with five motifs of flowers and birds inlaid with rubies, emeralds and sapphires [P. 65]."[17] Two jewelry pieces are also mentioned: a "circular green jade bangle" and a "barrel-shaped pendant inscribed in gold, a turquoise cap, five drop beads and a beaded necklace of ivory and engraved gold between two beads."[18]

The other items Louis purchased were textiles, sometimes of considerable value. These included fragmentary pieces,[19] accessories (a "bag made of Persian cloth,"[20] an "eighteenth-century Caucasian belt with a small silver dagger"[21]), and several apparently complete

Dagger and sheath
Jaipur, India, 19th century
Jade, gold, steel, rubies, emeralds, textile
Dagger length: 38 cm
Sheath length: 28 cm
Mengdiexuan Collection, Hong Kong
LC no. 56

items of clothing: an "Oriental jacket,"[22] an "Indian robe with gold stripes,"[23] "a shot silk maharajah's robe with embroidery over violet iridescence,"[24] and three Persian robes—a costly seventeenth-century one of "navy blue satin, brocaded with bouquets of flowers,"[25] another that was "embroidered and slit at the sides with a lining,"[26] and a third of "an eighteenth-century Chinese design"[27]. Interestingly, Pierre Cartier also bought a Persian robe with a Chinese design the same day.[28] The reason for the acquisition of these items is unknown: were they intended to be used as decorative items for Louis's residences (as was customary at the time)?[29] Had Louis yielded to the fashion for dressing up in an Eastern style at costume parties? Or were some of them collection pieces, as their prices might suggest?

In view of the small number of very valuable pieces that passed through Cartier's stock, the main items in Louis's collection were probably purchased directly from art dealers.[30]

THE INVOICES

Very few personal invoices have been preserved in the Cartier Archives, and only fifteen relating to Islamic pieces have been identified, ranging from the years 1911 to 1938. Some are addressed to M. Louis Cartier or the Maison Cartier. Among the sellers are well-known names, located near the Cartier boutique on rue de la Paix and well established in the Islamic art market, but not exclusively, as in addition to Dikran Kelekian, the Kalebdjian Frères, and Imre Schwaiger,[31] whose names appear in the stock books on a regular basis, another invoice relating to an Islamic piece was issued by Seligmann and Company.[32] Some of the pieces can be linked to stock-book references and/or images on negatives in the archives.

In chronological order, an invoice from 1912 mentions a "jade amphora inlaid with gemstones, an Indian artifact from the Viscomte de Vogüe"—an important piece also known from a negative and a contemporary print from the era.[33] In 1919, a collection of "32 fragments of thirteenth-century Persian faience from Rhages [Ray, Iran]" and a "coral necklace from Morocco" were purchased,[34] and a "Persian manuscript" was bought from M. A. Sidy.[35] The following year saw the purchase of a "pair of Arab doors inlaid with ivory," "six mosque panels with glass elements,"[36] and an "oriental rug."[37] In 1922 and 1923, a "Moroccan enameled silver belt buckle set with gemstones representing two birds,"[38]

Persian jacket
Negative, 1921
Cartier Paris Archives
Inv. DOC68/010203040

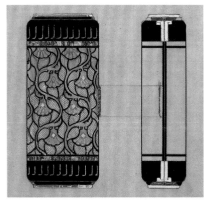

a "small mother-of-pearl tray from Damascus"[39] and a "Persian bag"[40] are listed. In 1931, we see an "Indian miniature with figures," an "Indian dagger with a jade hilt in the shape of a horse's head with gemstone inlays,"[41] and an "Oriental wall tile in old faience partly glazed in green and blue, forming a rosette on a solid background" (a penciled note mentions a brown, wood frame and refers to the library).[42]

It is difficult to be sure whether all of these pieces were intended for Louis or whether some were added to the Maison's stock, which seems likely for the jewelry, belts, and bags.[43] Many items, such as the doors, the mosque panels with glass (probably windows), the rug, and perhaps the ceramic tile, may have been acquired as interior decorations, probably to furnished his various residences.[44] The manuscript, miniature painting, dagger, "amphora," and hardstone objects stand out from this list. Other sources confirm Louis's interest in Islamic book arts (the field in which his collection is mainly known), while these invoices and the other sources used testify to his taste for inlaid objects of hardstone or precious materials, an interest doubtless related to his profession.

THE GLASS PLATE NEGATIVES

The Cartier Archives include a collection of over 40,000 photographic negatives on glass plates,[45] which served various purposes. They were primarily used to document the firm's creations, but for business purposes—grouped into albums, the prints were a means of presenting items for sale to potential clients. They also served administrative, personal, and documentary purposes, the last being of the greatest interest to us. We were able to use, after their digitization, a collection of negatives—unsorted for many years—corresponding to these different uses. Photographs taken from pictures in magazines or scientific books seem to have provided sources of inspiration for the Maison's designers. There are also many photographs of works of art, some from the stock of *apprêts*, but many others formally identified as having been part of Louis Cartier's collection. Contemporary prints made from this

Variations on
Indian textiles:

Indian textile (Banaras?)
Negative, 1925
Cartier Paris Archives
Inv. DOC122/022492430

Design for a vanity case (detail)
Cartier Paris, 1925
Graphite, India ink, and gouache
on buff tracing paper
11.3 × 11.5 cm
Cartier Paris Archives
Inv. ST25/60B

Handbag
Cartier Paris, 1925
Fabric, gold thread, jade,
enamel, diamonds
14 × 22 × 5 cm
Private collection,
London/Monaco

collection of negatives are not held in the Cartier Archives,[46] but some were found in an archive of drawings owned by Charles Jacqueau, one of the company's designers.[47] Their presence among the drawings clearly indicates that they had served as a source of inspiration to Cartier's designers, who obviously had access to these photographic prints and doubtless to the original works themselves, as we know from imprints made on pieces found in the Jacqueau archives.[48]

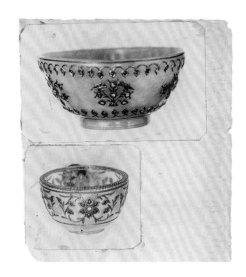

Archival notebooks listing the photographs in this documentary collection and the dates of photographs sometimes shed light on the origins of the pieces.[49] Louis Cartier's personal requests for photos are marked with a red pencil line. The works shown in some of the plates—including several objects and a few manuscripts—have not been formally identified by other sources as being part of his collection. So did they belong to Louis, as seems likely, or did they belong to clients or collector friends? Only a few of the objects in his collection are known, overshadowed by the exceptional quality of the paintings and manuscripts, most of which have been published. The negative images shed new light on the Islamic objects he owned.

These negatives include numerous images of fabrics, garments, bags, belts, and rugs, confirming Louis's personal interest in textiles, known from stock-book entries relating to his purchases. As for the objects, some were purchased by Louis from the Cartier stock; these include the two Indian bowls[50] [ABOVE] mentioned above and a dagger. The negative of the latter is lost, but it appears, together with a second dagger, in a photographic print in the Jacqueau archive[51]. Finally, pieces that only appear in the negatives include a turquoise-inlaid flintlock musket,[52] an element from a Qajar mirror case or box decorated with *khatamkari* marquetry [P. 66, FIG. 1],[53] a seventeenth-century, mother-of-pearl dish from Gujarat [P. 67, FIG. 4],[54] what appears to be a Mughal screen [P. 67, FIG. 1],[55] and several Iranian metal pieces: two thirteenth- or fourteenth-century bowls from Fars[56] and a late, sixteenth-century Safavid torch stand.[57] These pieces have not been located.

Several paintings and manuscripts only known from the negatives include a Near Eastern Qur'an copied on parchment, dating to the ninth or tenth centuries [P. 68, FIGS. 1 AND 2].[58] One negative shows the frontispiece of a sixteenth-century Persian Qur'an attributable to Shiraz [P. 66, FIG. 5];[59] unfortunately, however, the notebook reference is incorrect and does not indicate whether the manuscript belonged to Louis.

Two bowls
India, 19th century
Jade inlaid with precious stones,
gold *kundan* work
Rock crystal inlaid with precious
stones, gold *kundan* work
Print on albumen paper laid on paper
19.1 × 13.4 cm
Petit Palais, Paris,
gift of the Jacqueau family, 1998
Inv. PPJACPH99-30, LC nos 54 and 55

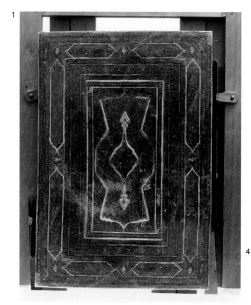

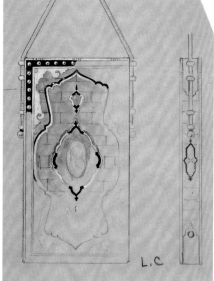

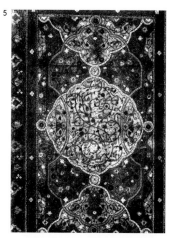

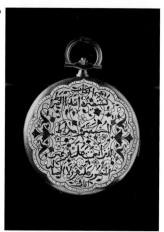

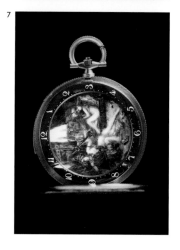

FIG. 1
Fragment of a box or mirror case
Iran, 19th century
Wood and marquetry
of colored wood, ivory,
and metal (*khatamkari*)
Negative, 1922

Cartier Paris Archives
Inv. DOC439/015201318, LC no. 43

FIG. 2
Imprint of the box fragment
Charles Jacqueau
Blue crayon on squared paper,
laid on albumen print
23.7 × 6.9 cm

Petit Palais, Paris,
gift of the Jacqueau family, 1998
Inv. PPJAC02871

FIG. 3
Study for a vanity case
inspired by the box fragment
Charles Jacqueau
Graphite and ink on paper
laid on lined paper
8.2 × 13.4 cm

Petit Palais, Paris,
gift of the Jacqueau family, 1998
Inv. PPJAC01098

FIG. 4
Design for a vanity case
inspired by thr box
Cartier Paris, 1923
Graphite, India ink, and gouache
on buff tracing paper
22.8 × 12 cm

Cartier Paris Archives
Inv. ST23/104

FIG. 5
Frontispiece of a Qur'an
Shiraz, Iran, 16th century
Ink, opaque watercolor,
and gold on paper
30 × 19.4 cm
Negative, 1921

Cartier Paris Archives
Inv. DOC460/005901318, LC no. 5

FIG. 6
Watch inspired by
the frontispice of the Qu'ran
Negative, 1917 (detail)

Cartier Paris Archives
Inv. 048451824

FIG. 7
Watch dial (interior): harem scene
Negative, 1917

Cartier Paris Archives
Inv. 048441318

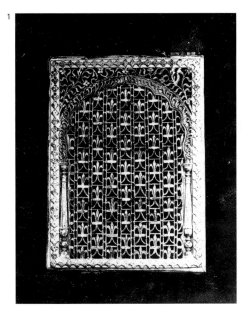

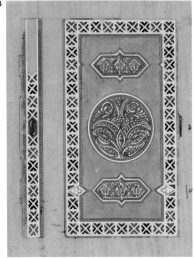

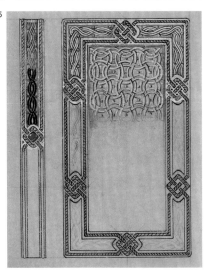

FIGS. 1 AND 2

Two pages from a Qur'an
Middle East, 9th-10th century
12.8 × 20.2 cm

Chester Beatty Library, Dublin
Inv. MS 1411

FIGS. 3 TO 6

Projects for vanity cases
inspired by the illuminated pages
of the Qur'an
Charles Jacqueau
Graphite, black ink, gouache, and blue
crayon on vellum tracing paper
12.7 × 9.8 cm,
12.2 × 9.3 cm
6.6 × 9 cm,
19.3 × 15.8 cm

Petit Palais, Paris,
gift of the Jacqueau family, 1998
Inv. PPJAC00447, PPJCA00448, PPJAC01102,
PPJAC02676

Part of the frontispiece was used as the model for the decoration of a pocket watch, several preparatory drawings of which were photographed [P. 66, FIGS. 6 AND 7].[60] Several Indian paintings, some of which have not been located, were also photographed: a falconer on horseback (late sixteenth century),[61] Joseph and his brothers in a landscape setting (Allahabad, c. 1600),[62] a portrait of Ibrahim Khan ibn 'Alim Dan Khan (seventeenth century),[63] and two unfinished portraits, one of the elderly Shah Jahan without margins and the other an unidentified figure in a margin (possibly seventeenth century).[64] The negatives also feature five book bindings, but it is uncertain whether they were associated with manuscripts in the collection.[65] Finally, a Persian book binding from the early seventeenth century is known to us from two contemporary photographic prints preserved in the Jacqueau archive, but is missing from the negatives. The presence of this book binding in Louis's collection is confirmed by two publications by Sakisian from 1935 and 1937.[66] We know from the archive that numerous negatives are missing, having doubtless been broken and discarded.[67]

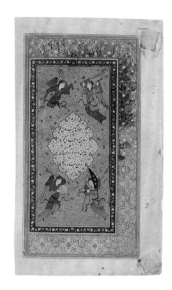

LOUIS CARTIER AS A LENDER TO EXHIBITIONS

Exhibition catalogues and historical art publications also provide information on the masterpieces in Louis Cartier's collection. Louis participated in many of the great international exhibitions of Islamic art in the twentieth century, and the works he loaned were featured in various publications, which he sometimes supported financially; this was the case with Arthur Upham Pope's *A Survey of Persian Art*, first published in 1939.[68]

Louis Cartier's name does not appear among the lenders to the Paris exhibition of 1903 nor the Munich exhibition of 1910; after the latter event, however, several of the works exhibited there came into his possession. These include a Safavid painting of a seated princess[69] [P. 86], which was part of the Ducoté collection in 1910 and featured in Louis's collection two years later[70]—indeed, he lent it to the exhibition of 1912 at the Musée des Arts Décoratifs (the first time he appeared as a lender). He also exhibited a *Bustan* by Sa'di, made for 'Abd al-'Aziz Khan, the sultan of Bukhara (1540–1550), which, according to autograph notes in folio 2, had belonged to the library of the Mughal emperor Akbar, his son, Jahangir, and grandson, Shah

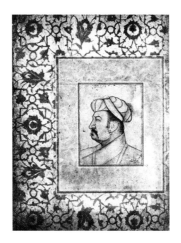

Jahan.[71] He also lent a Timurid-era copy of the *Khamsa* of Nizami, made around 1420–1425, which came from the library of Prince Shah Rukh (1404–1447), the son of Timur, whose seal it bears [PP. 84-85].[72] The catalogue also mentions a manuscript of the *Guy u-Chawgan* of 'Arifi, made in Herat in 1523, folio 2 of which bears the seals of many former owners, including those of Akbar, Jahangir, and Shah Jahan[73] [P. 69]. The catalogue also mentions three separate single-folio paintings: a depiction of a falconer on horseback (late sixteenth century),[74] a portrait known as that of Emperor Akbar painted around 1625[75] [LEFT], and the *darbar* of Emperor Aurangzeb, by the artist Bichitr, painted around 1660–1685[76] [BELOW].

The 1912 exhibition catalogue mentions only the essential paintings and manuscripts, but we know from the archives of the Musée des Arts Décoratifs that objects were also exhibited. A note written by Louis Cartier on June 10, 1912, tells us that he was late in sending his miniatures and that he was adding "some Jaipur enamels that would be in good company with those of M. Gouloubew."[77] The lists relating to the lenders' insurance values make no mention of Louis Cartier, probably due to the abovementioned delay. A receipt issued by the Union Centrale des Arts Décoratifs when the exhibition ended on October 26, 1912, attests to the fact that four Persian manuscripts, five Persian miniatures, a dagger, a child's bracelet, and an arm bracelet exhibited by Louis Cartier were given to Georges Demotte, who evidently acted as an intermediary for Louis.[78] Interestingly, only four miniatures and three manuscripts were published in the catalogue, and the objects exhibited by Louis were weapons and jewelry.

Louis Cartier also participated in the 1931 *International Exhibition of Persian Art* at the Royal Academy of Arts in London. The catalogue mentions several new pieces, attesting to the considerable expansion of his collection. He exhibited two book bindings: one of embossed leather decorated with gold arabesques and medallions with figures in lacquer, dating from the early sixteenth century;[79] the second of stamped leather decorated with openwork panels on a blue and green background, dating from the sixteenth century [P. 73].[80] The manuscripts he lent include a *Diwan* of Hafiz, made in Tabriz around 1530, with miniatures by Shaykh Zada and Sultan Muhammad, and a lacquered

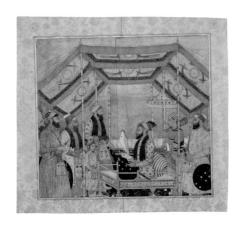

Portrait of Akbar
India, c. 1625
Negative, 1921
Cartier Paris Archives
Inv. DOC182/009472430, LC no. 14

The *darbar* of Emperor Aurangzeb
Attributed to Bichitr
India, c. 1660-1685
Ink, opaque watercolor,
and gold on paper
19.1 × 21.4 cm
Museum of Islamic Art, Doha
Inv. MS.54.2007, LC no. 15

cover with figures of angels[81] [BELOW], and a work that was exhibited in Munich in 1910—an unfinished portrait of the sultan Husayn Mirza Bayqara and made in Herat around 1480–1510.[82] Interestingly, Louis owned another object linked to this ruler: an agate bowl bearing his name.[83] The reunion of these two works attests to Louis's interest in the historical value of the pieces in his collection while,

as an informed collector and genuine bibliophile, he was also attentive to their pedigree. This attitude is illustrated by an ivory pen box inlaid with gold, turquoise, and black paste, thought to have been made for Mirza Muhammad, vizier of the Safavid ruler, Shah Tahmasp, and dating from the late sixteenth century,[84] part of a set from which Louis acquired several pieces.

Other works lent by Louis include a "Timurid era copper basin inlaid with gold and silver and decorated with medallions and figures" from the fourteenth or fifteenth centuries;[85] a man's belt in mother-of-pearl, with emeralds from the eighteenth century, consisting of a "buckle in the form of a duck's head in gold and emerald, and a sword holder with medallions," whose appearance is known from two negatives[86] [ABOVE]; a "gold pendant decorated with antique diamonds, rubies and pearls, two pieces with a hinge and clasp";[87] and lastly, two seventeenth-century rugs.[88]

In 1933, Louis generously lent a large number of works,[89] some of them for the first time, to an exhibition of painting and book arts at the Metropolitan Museum in New York: an anthology of poetry by the calligrapher Mir 'Ali Haravi (Bukhara, c. 1550),[90] a standing princess reading (c. 1540)[91] [P. 72, TOP], four paintings from a manuscript of *Layla va Majnun* by Jami (Tabriz, c. 1540),[92] a horseman and his page (c. 1560)[93], and a page with a bowl and bottle (Isfahan, c. 1620)[94] [P. 72, BOTTOM].

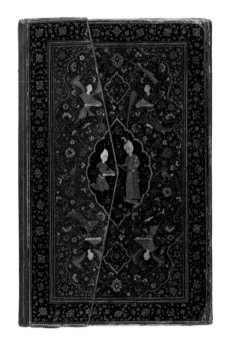

Except for the loan of the ivory pencil box,[95] Louis Cartier did not participate in later exhibitions held in New York in 1935, San Francisco in 1937, and at the Bibliothèque Nationale de France in 1938.

Sword belt and duck-shaped buckle
Iran or India, 18th-19th century
Copper alloy, mother-of-pearl, gold,
and emeralds
Negatives, 1922
Cartier Paris Archives
Inv. DOC89/013792430,
DOC96/015922430, LC no. 46

Drawing of the belt buckle
Charles Jacqueau
Graphite on vellum tracing paper
12.4 × 6.6 cm
Petit Palais, Paris,
gift of the Jacqueau family, 1998
Inv. PPJAC02949

Binding of the *Diwan* of Hafiz
Attributed to Sultan Muhammad
Iran, Tabriz, c. 1530
Lacquer on paper with leather
29.2 × 19.1 × 3.5 cm
Harvard Art Museums/
Arthur M. Sackler Museum
Gift of Mr. and Mrs. Stuart Cary Welch, Jr.
Inv. 1964.149, LC no. 4a

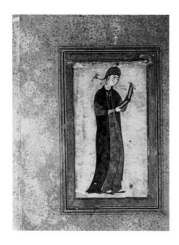

Once again, we know of other pieces in his collection from specialized publications: Arthur Upham Pope's compendium features reproductions of an unpublished painting, *Chasseurs à un ruisseau*, signed Riza-e 'Abbassi (Isfahan, c. 1625),[96] and a book binding, perhaps the one presented at the exhibitions of 1931 and 1933[97] [P. 73, TOP], as well as a Fars basin dating to between 1350 and 1375[98] [P. 73, BOTTOM].

There are doubtless other sources yet to be discovered and researched in order to continue this reconstruction of Louis Cartier's Islamic art collection, and many other works of art have yet to be located.

THE DISPERSAL OF THE COLLECTION

Louis was in the United States when he died in 1942, during the war. His will, drawn up on February 2, 1939, in Budapest, stipulated that his collections should be divided between his two children, Anne-Marie and Claude.[99] With a few exceptions,[100] the works themselves are not detailed in this document, although Louis insisted on the importance of a division by category so as "not to break the unity of the groups of pieces," and was not opposed to the sale of his works, if both heirs were in agreement.

We have little information about what happened to Louis's works of art during the war. It seems that in 1939, in order to protect his collection, he secretly sent some of his works (his library, his collection of prints and drawings, silver and porcelain objects, etc.) from

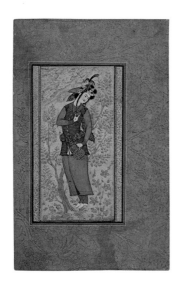

France to England, to a garage requisitioned by the army and under close surveillance, at Ingmire Hall, Sedburgh, Yorkshire. Another part of his collection— the precious inlaid objects in particular—appears to have been kept at his London boutique. It seems that after the war, Louis having died in the meantime, Ingmire Hall was no longer subject to special surveillance and the works were rediscovered there by chance, packed in half a dozen tea crates and eight smaller boxes. When the executors of Louis's will visited the site in November 1945, many of the chests had been opened and some of the works, stolen.[101] However, between 1945 and 1946 they compiled a list of the works at Ingmire Hall and those in the boutique at 175

Standing princess
Iran, c. 1540
Ink, opaque watercolor,
and gold on paper
Negative, 1926
Cartier Paris Archives
Inv. DOC509/027261318, LC no. 21

Standing page with cup and bottle
Iran, Isfahan, c. 1620
Ink, opaque watercolor,
and gold on paper
20.64 × 10.16 cm
Harvard Art Museums/
Arthur M. Sackler Museum
Gift of John Goelet, 1958.77, LC no. 18

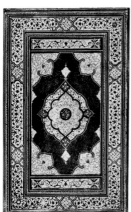

New Bond Street, London. The list includes a number of Islamic pieces. Unfortunately, the extremely succinct descriptions make it impossible to identify the manuscripts, paintings, or book bindings, but do at least give an idea of their number.[102] The list contains some of the aforementioned objects,[103] while other pieces include an agate Indian mirror decorated with inlaid garlands of flowers, and a Qajar mirror in a lacquer case decorated with flowers and nightingales.

In 1956, Claude Cartier was approached by his old Harvard friend Stuart Cary Welch, who was looking for quality Indian and Iranian paintings and offered to buy the prestigious pieces in Louis's collection. In the difficult post-war period, jewelers were struggling to recover their pre-war level of sales; moreover, Claude was about to get married and needed money quickly.[104] Private archives have made it possible to reconstruct the history of how Harvard acquired the paintings in Louis Cartier's collection.[105] Stuart Cary Welch, honorary curatorial assistant at Harvard's Fogg Museum at the time, discussed the matter with the museum's director, John Coolidge.[106] Basil Robinson, a specialist in Persian miniatures, curator at the Victoria and Albert Museum, and a friend of Welch, was sent to Claude Cartier's Paris home to put together a description of the remarkable pieces in the collection, and to assess their quality.[107] Their exchanges show that this was a complex business. Claude seems to have changed his mind several times and the Fogg Museum did not have the necessary funds. Stuart Cary Welch negotiated with Claude and eventually had to purchase the collection himself before ceding part of it to the Fogg Museum, which was able to buy it from him thanks to a donation from John Goelet, a former Harvard student.[108] Robinson's specialization in Persian painting and Welch's interest in Indian paintings may explain why most of the Indian paintings do not figure among the pieces acquired by the Fogg Museum.[109] The deal was finally concluded in May 1957.

There are fifty-six works on the list, most of which were Indian. The Persian pieces are of very high quality, with some described by Robinson as "quite first class" and well-known from publications.[110] Remarkable pieces were indicated by an asterisk, exceptional pieces by two.[111] A number of other pieces can be distinguished within the list: a kneeling youth with a cup and bottle (Mashhad, c. 1560),[112] the remains of an album of paintings and calligraphy including

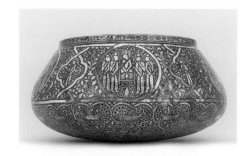

Binding
Iran, 16th century
Cut-out leather on a blue
and green paper background
25 × 15.5 cm
Cartier Paris Archives
Inv. BibCart/397, LC no. 37

Bowl
Iran, Fars, 2nd half of the 14th century
Copper alloy, gold, and silver inlays
5.5 × 11 cm
Museum of Islamic Art, Doha
Inv. MW.481.2007, LC no. 52

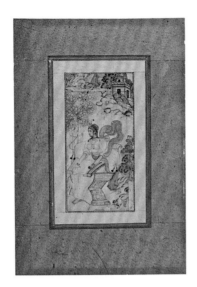

a depiction of a youth with bow and arrows, a double title page, a painting of Majnun, a youth with a bouquet of flowers and calligraphy by Mir 'Ali, 'Ali Reza, and Mohammad Hussayn Tabrizi,[113] a woman playing a zither (India, c. 1610)[114] [LEFT], two pages from the Late Shah Jahan Album (India, c. 1650)—the first representing the elderly Shah Jahan,[115] the second, Akbar[116]—a portrait of an elderly courtier (described by Claude as a picture of a prince holding a falcon) that could be identified as a portrait of Jahangir,[117] an erotic scene (Iran, c. 1700),[118] and an illuminated Qur'an in Maghribi script. The list also includes numerous pages (twenty-four paintings and two manuscripts) for which no images exist, and which are still difficult to identify due to the brevity of the descriptions.

Once the twenty-three Persian pieces had entered the Fogg Museum, the references to Louis's collection were not systematically retained in the museum's records and do not always feature in publications. Moreover, some pieces remained with Cary Welch, who donated several pages to Harvard years later, and sold others at auction or through brokers. These pieces remain very difficult to identify and locate, especially as the Cartier provenance of the items is not systematically mentioned in Welch's publications, making it practically impossible to find all of those he purchased from Claude.

Finally, in 1962, Louis's descendants organized a sale of some of their father's East Asian books and artifacts.[119] Due to the previous sale, the catalogue included only three Islamic pieces: the *Bustan*[120] and two previously unknown collections of Persian poetry, one copied by Sultan 'Ali al-Mashhadi in Herat in 1476,[121] the other with a splendid binding decorated with birds and trees dating from the sixteenth century.[122] After Claude Cartier's death, his children sold the few Islamic pieces from Louis's collection still in his possession at auctions or to art dealers. Such was the case with the bowl from Fars[123] and the sixteenth-century Safavid torch stand, which went on sale in 1979,[124] and a jade hookah stand inlaid with rubies and emeralds from Jaipur dating from the twelfth century, of which no image is known.[125]

Louis Cartier's Islamic collection focused primarily on sixteenth- and seventeenth-century Persian and Indian book arts[126] and inlaid precious objects. The importance he apparently attached to the inscriptions on the pieces, the coherence sometimes demonstrated by his purchases, and the large number of manuscripts in his collection all suggest that

he was a well-informed connoisseur who, in addition to the beauty and quality of a work, was interested in its history and must have derived a certain satisfaction from owning masterpieces that had passed through the hands of such great sovereigns as the Mughal emperors. His interest in history and art history is reflected by the books in his library, which he expanded over the years and which contained all the publications in his field of interest. As a true bibliophile, he was interested in books as objects, as shown by the complete manuscripts in his collection, at a time when books were often taken apart to remove the paintings.[127]

Photographs of Louis's pieces found in the possession of Cartier's designers, sketches and drawings made by Jacqueau, and, in particular, tracings of the works themselves indicate that the objects in Louis's collection were made available to the Maison's designers. Like the organizers of the great Islamic art exhibitions, Louis Cartier was doubtless convinced that these wonderfully delicate, if unfamiliar forms gave a new lease on life to art and suggested a path to modernity—an idea confirmed by the Maison's successful new designs. His generosity as a lender also testifies to this belief; the important objects that remained in his collection until his death show that, unlike some collectors, he did not take advantage of exhibitions to increase the value of his pieces but may instead have been determined to present such works of art to as wide an audience as possible; unfortunately, however, due to the lack of correspondence relating to his collections, we can only make assumptions.

Finally, it is worth noting the relative absence—to our knowledge—of Islamic works in Louis's interior decoration, with the exception of a few rugs, doors, stained-glass windows, and perhaps display windows for his inlaid objects,[128] whereas his East Asian objects seem to have found their place among his eighteenth-century furniture. Louis's Islamic pieces, like the precious masterpieces in his library, suggest a highly personal collection, probably also kept in the privacy of his library, showing the jeweler Louis Cartier to have been a man of taste, as well as an intellectual and a visionary.

1. As we know from the sales of his estate and the inventories compiled after his death.

2. New York, the Morgan Library Archives, ARC 1310. The invoices of J. P. Morgan attest to the large number of antique pieces purchased.

3. The stock books show that, from the late nineteenth century, the Maison Cartier purchased Eastern jewelry from suppliers: in 1872, "oriental matte gold filigree earrings" (register 1, f. 20).

4. Chaille et al., 2018, p. 130.

5. An invoice from Kelekian dated October 24, 1911, records the purchase of the exhibition catalogue, but it may have been the exhibition brochure held in his library: BibCart/304.

6. *Succession de Mr Louis Cartier. Estampes et laques d'Extrême-Orient*, M. Étienne Ader, MM. A. and G. Portier, Paris, March 15 and 16, 1962. This catalogue shows that the collection comprised a large number of Japanese lacquers and prints from the seventeenth and eighteenth centuries, as well as eighteenth-century Chinese prints.

7. Labrusse, 1997, pp. 280–282.

8. Georges Demotte made his name by inventing a technique for reconstructing rubies. He became an art dealer between 1905 and 1907 and soon specialized in Islamic and medieval art. See Vivet-Peclet, 2019, p. 46. He was one of the art dealers from whom Louis purchased Eastern jewelry and *apprêts* or pieces for his private collection.

9. *Apprêts* included materials that had already been crafted, carved, or engraved, for example, and reused.

10. These registers list genuine *apprêts* but also items destined for resale without modification.

11. Many items are recorded as being kept in his office.

12. Several registers were consulted; the ones that concern these transfers are the "*apprêts* Louis Cartier" and the register of textiles (in which some records apparently came from the Louis Cartier register).

13. Purchased by Louis on March 3, 1923. Stock book, *Apprêts* LC (2 AH 587).

14. Ibid., purchased by Louis on December 1, 1922.

15. LC no. 56. Register 2 AH 587. Added to the stock on March 7, 1922; purchased by Louis on January 6, 1925.

16. LC no. 55. Register 2 AH 589. Added to the stock on September 19, 1919; given by Jeanne Toussaint to Louis Cartier on July 1, 1935.

17. LC no. 54. Register 2 AH 589. Purchased from Kraft in November 1920; given to Louis Cartier by Mlle Toussaint on July 1, 1935. There are negatives of the last three pieces. The purpose of the last two is unclear and we are not sure if they were added to Louis's collection.

18. These two pieces are noted in the Oriental stock book (see Violette Petit, pp. 33-34). The bracelet was added to the stock on February 26, 1912, and purchased by Louis on February 7, 1914; the other piece, which may have been one or several elements, was added to the stock on November 14, 1913 (purchased from Kandjimull) and purchased by Louis on February 5, 1914.

19. "A band of Persian silver-plated embroidery, black edge, 160 long, in two pieces," register 2 AH 587, purchased from Melkoniantz, added to the stock on September 25, 1919, sold to Louis Cartier on October 8, 1919; "a small bag in 5 pieces, Eastern fabrics, dimensions: 14 × 18," register 2 AH 587, sold to Louis Cartier on December 16, 1919.

20. Register 2 AH 587, purchased from Kalebdjian, added to the stock on March 12, 1923, sold to Louis Cartier on October 30, 1925.

21. Ibid., sold to Louis Cartier in 1919. A penciled note underneath says "*repris et reporté*," meaning that Louis returned the piece to the stock.

22. Described as follows: "colored flowers on a blue ground, two long slit sleeves with metal weights." Ibid., sold to Louis Cartier on September 26, 1919, it had belonged to Jeanne Toussaint.

23. Ibid., sent to Budapest in May 1922.

24. Sold to Louis in 1921.

25. Register 2 AH 587, added to the stock on March 6, 1923, taken to Budapest by Louis on March 17, 1923.

26. Ibid., no. 241, purchased from Melkoniantz, added to the stock on October 4, 1919, sold to Louis Cartier on October 4, 1919, and perhaps given to Jeanne Toussaint.

27. Ibid., purchased from Melkoniantz, added to the stock on September 27, 1919, and sold to Louis Cartier on the same day.

28. Ibid., purchased from Melkoniantz and sold to Pierre Cartier on the same day.

29. As upholstery for a chair or fire screen, or as tablecloths, drapes, etc.

30. Travel was another supply source for Louis, as indicated by Jacques's letter from India dated November 25, 1911 (see notes 127 and 128). However, apart from this letter, we have no other information about objects brought back in this context.

31. Turkish-born Dikran Kelekian arrived in the United States in 1893. He owned a store in Cairo and another on Fifth Avenue in New York; he settled in Paris in 1907 at 2, Place Vendôme. Hagop and Garbis Kalebdjian set up a boutique at 32, rue Peletier, then at 12, rue de la Paix and 21, rue Balzac in Paris; they also owned a boutique in Cairo. Imre Schwaiger, an art dealer of Hungarian origin based in India and London, served as an intermediary for the Maison Cartier.

32. An art dealer specializing in European art, who settled from 1900 at 23, Place Vendôme and also owned a branch in New York. He was entrusted by J. P. Morgan with the repatriation of his art collection to the United States before his death.

33. LC no. 53. Invoice from Seligmann, June 22, 1912. The print is held in the Jacqueau archive and the negative in the Cartier Archives, no. 1346, photographed on May 10, 1922. See pp. 90-91.

34. Invoice from Kalebdjian, September 17, 1919; however, an invoice dated January 19, 1920, from the same Kalebdjian specifies that these two pieces were returned.

35. Invoice of December 8, 1919, with a letterhead stating "M. A. Sidy, Persian rug and *objets d'art*." This is the only invoice in the Cartier Archives from this dealer, whose boutique was at 17, rue Cadet in the 9th arrondissement of Paris (LC7_016R).

36. Invoice from Kalebdjian, October 7, 1920.

37. Ibid., November 6, 1920.

38. Ibid., December 7, 1922.

39. Ibid., March 13, 1923.

40. Ibid., October 8, 1923.

41. Ibid., May 11, 1931. LC no. 58. It was most probably the dagger with a horse's head featured in the catalogue *Importante argenterie européenne: succession de Monsieur Claude Cartier provenant de la collection de ses parents Monsieur et Madame Louis Cartier*, Monaco, Sotheby Parke Bernet Monaco, November 27, 1979, lot. 802 (ill.).

42. Invoice from Kalebdjian, May 11, 1931.

43. An invoice includes the reference of the stock of *apprêts* to which it was added.

44. This hypothesis is confirmed by a letter from the Kalebdjian Frères dated December 23, 1924, containing a list of all the objects in their stock, including some of the pieces listed in the invoices (twelve stained-glass windows, a fragment of rug, a copper ceiling light, two pairs of Arabic doors inlaid with ivory, a large rug). Kalebdjian asks Louis to specify which objects should be marked "Spain" and "Budapest" (where he owned properties).

45. A photographic reproduction process commonly used from the early twentieth century to the 1930s.

46. Apart from prints featuring clients' jewelry.

47. This archive, comprising photographic prints and numerous drawings, was donated by Jacqueau's descendants to the Musée du Petit Palais de la Ville de Paris.

48. Several rubbings were made directly from the objects themselves, notably bindings and a mirror case or box; see pp. 66-67.

49. Seven notebooks (up to the year 1970) have been preserved. The first is undated but appears to begin in 1910; Islamic items are featured in the notebooks up to 1954.

50. LC nos. 54 and 55. Plates nos. 1348 and 1349, made on May 10, 1922.

51. LC nos. 56 and 59. The notebook records that "two daggers with inlaid hilts" were photographed on May 10, 1922, and adds that they were "returned to stock, page 357, book 3." The daggers also feature in the inventory of items held at Ingmire Hall (see note 103) and are illustrated in the 1979 succession sale catalogue, suggesting that they remained in Louis's possession until his death. One of the daggers recently reappeared on the art market and is currently in a private collection in Hong Kong.

52. This musket, as well as a bow, are not in the catalogue of the Louis Cartier collection.

53. LC no. 43. This object served as a model for the creation of a Persian-inspired case (inv. VC 34 A24); see pp. 66 and 92.

54. LC no. 44.

55. LC no. 45. We only know about this object from a print in the Jacqueau archive. It is still difficult to evaluate its size and identify it more precisely; it could also be a small fragment of a box.

56. LC nos. 48 and 49.

57. LC no. 47.

58. Negatives inv. 263 to 273. This object was used in several drawings by Jacqueau. In 1912, it belonged to the collector Frederick Robert Martin (see Martin, 1912, vol. II, pls 235 and 236). It was located in the Chester Beatty Library, MS 1411, which purchased it from F. R. Martin on May 4, 1923 (my thanks to Moya Carey for this information). Was the manuscript temporarily part of Louis's collection, or did he borrow it from Martin to take photos around 1913. Martin may also have offered it for sale to Louis, who then took several photos of the manuscript.

59. LC no. 5. Negative inv. 945, but which corresponds to a portrait in the notebook. This piece was put up for auction at Christie's (*Art of the Islamic and Indian Worlds*, London, Christie's, October 20, 2016, lot 22) and has not been located.

60. Negatives inv. 548, 570, 590, 616, 622. The project was a special order. Surprisingly, it combined part of the first surah of the Qur'an on the watch case and an Oriental-style harem scene on the dial.

61. LC no. 16. The first reference in the notebook mentions "Mr. Louis equestrian miniature" and the second, "drawing, order from Mr. LC."

62. LC no. 17.

63. LC no. 19.

64. LC no. 20.

65. LC nos. 31-35.

66. LC no. 39. inv. 1958.82.

67. The list includes thirty-three "Persian miniatures," five bindings, an unidentified manuscript, a "Moroccan carved wooden crow," a "Persian torch stand," a "bowl with an Arabian design," three sabers (one in the name of Husayn Mirza Qadjar), a "Persian belt" and a "set of Eastern jewelry and garments." However, it is impossible to know whether certain negatives correspond to the same pieces, as the photographs were sometimes taken several years apart.

68. Louis's library included all the editions of this work.

69. LC no. 12.

70. This painting was also presented at the 1931 exhibition in London.

71. LC no. 3.

72. LC no. 1. Also presented at the 1931 exhibition in London (p. 257, no. 539) and at the Metropolitan Museum in New York in 1933.

73. LC no. 2. My thanks to Monique Buresi for her reading. This manuscript was also presented at the 1931 exhibition in London (p. 259, no. 541 C).

74. LC no. 13. My thanks to Heather Ecker for locating this painting.

75. LC no. 14.

76. LC no. 15.

77. Victor Goloubew was a wealthy Russian aristocrat, a member of the second generation of great Islamic art collectors (c. 1910), and a specialist in Persian miniatures.

78. Musée des Arts Décoratifs, Archives, D1/74.

79. Exh. cat., London, 1931, p. 82, no. 126 H, dims: H. 30 cm; W. 17.5 cm. This piece may correspond to the binding held in the Harvard Museum, inv. 1960.673, donated to the museum later by Stuart Cary Welch (LC no. 36).

80. LC no. 37.

81. LC no. 4. Presented at the exhibition of 1912 (no. 89), when it was part of the Sambon collection. Purchased by Louis from the Galerie Georges Petit in 1914.

82. LC no. 24. In 1910, it was in the possession of F. R. Martin, and is noted likewise in 1912.

83. LC no. 57. Louis probably purchased this piece from Armenag Bey Sakisian between 1925 and 1931. The latter had found it at the Istanbul bazaar c. 1925 (see Sakisian, 1929). It remained in Louis's collection until his death (see note 103).

84. LC no. 41. This work was also loaned to the 1938 exhibition in Paris (no. 246); see pp. 94-99.

85. Ibid., p. 143, no. 226 F, dims: H. 11.5 cm; diam. 18 cm. It could be piece LC no. 49 or the one held in Doha, LC no. 52.

86. LC no. 46.

87. Ibid., p. 212, no. 351 C, dim. H. 16.5 cm. It could be the pendant Louis purchased from the stock of *apprêts*; see note 18.

88. Ibid., p. 189, no. 300, dims: W. 420 cm; L. 190 cm, which could correspond to LC no. 62; and the second, p. 195, no. 312, dims: W. 488 cm; L. 192 cm, with large palmettes and buds on a pale red ground. The latter certainly corresponds to LC no. 61.

89. The pieces already exhibited include the *Khamsa* (LC no. 1), the portrait of Sultan Husayn Mirza (LC no. 24), the *Guy u-Chawgan* (LC no. 2), the painting of the seated princess (LC no. 12), and two bindings, one of which (LC no. 37) might correspond to no. 127 D at the 1931 exhibition (not illustrated in the catalogue).

90. LC no. 7. The pages exhibited are certainly the following: Harvard Museum, inv. 1958.67, 68, 69, and 74, and two other unidentifiable pages from the album. See New York, 1933, pp. 39-40.

91. LC no. 21.

92. Negatives inv. 111 to 114, corresponding to an early addition to the collection c. 1912. These four paintings were later joined together to form two pages (LC nos. 10-11).

93. LC no. 25.

94. Is it the LC no. 18, which corresponds to negative inv. 950, photographed with a set of Japanese drawings on Louis Cartier's request?

95. LC no. 41.

96. LC no. 26. This work may have been exhibited at the 1933 exhibition in New York (rather than the page with the bottle, see note 94).

97. Pope, 1939, vol. X, pl. 967.

98. LC no. 52.

99. His will is reproduced in the negatives in the Archives (inv. 8182 to 8200).

100. A Spanish painting, candle holder, and armchair for his daughter.

101. *The Ashburton Guardian*, July 9, 1946, p. 3. Articles in the local press describing this discovery allowed us to make the connection between the inventory in the Maison Cartier Archives and this hoard.

102. Fifteen manuscripts, nine leather bindings, two lacquer bindings and seventy-one isolated paintings and drawings—a small number in comparison with the Western objects listed.

103. The objects described are the three daggers, the man's belt in mother-of-pearl, and the famous "jade amphora," the agate cup in the name of Husayn Mirza, one of the ivory pen boxes (perhaps the larger one, featuring ebony restoration according to the description), and panels with glass elements, probably the mosque panels (see note 36).

104. Welch and Masteller, 2004, pp. 98–100, no. 25 and p. 5.

105. Private archive, Welch family. My warmest thanks to Thomas Welch, Mary McWilliams, and Heather Ecker for allowing me access to the archive, which provided precious help in the reconstruction of this history and Louis's collection.

106. In a summary of the dossier dated October 15, 1956, Welch mentions that Claude wanted the pieces to go to Harvard, having attended the university himself, and liked the idea that they would be part of a museum.

107. Letter of March 14, 1956: "[...] such a collection is of course a great temptation even to as indigent a museum as the Fogg."

108. These points are summarized in a memorandum addressed to Welch on May 8, 1957. The items selected for Harvard correspond to the Persian objects marked with one or two asterisks on Robinson's list (inv. 1958.59 to 1958.80 and 1958.82); the others were to remain in Welch's possession, with all the Indian pages.

109. Robinson advised the Fogg not to buy the whole collection, but to focus on the pages dating from the time of Shah Tahmasp (1524–1576); these were already very rare at the time, and he emphasized that there might never be another opportunity to purchase them (preamble to the list of June 16, 1956).

110. The visit took place on May 30, 1956, at 17, rue Barbet de Jouy. At that time, the *Khamsa* was no longer part of the collection, having perhaps been sold or donated by Louis before his death. Several pieces were not in Paris: the *Diwan* of Hafiz was in New York, two bindings (probably those of the 1931 London exhibition, nos. 126 H and 127 D) and a nineteenth-century page were missing.

111. Robinson also explained his lack of interest in Indian painting, which is perhaps why he found most of the pages "mediocre."

112. LC no. 27.

113. LC no. 8.

114. LC no. 29. One of the Indian works kept by Welch, donated by Edith I. Welch in his memory in 2011.

115. LC no. 23. Donated by S. C. Welch in 1999.

116. LC no. 22. Louis may have purchased these two pages from Georges Demotte, according to an account by Gaston Migeon in 1927: "[...] Mr Demotte allowed several connoisseurs to share a very large collection of 104 folios, almost all by Hindu schools, with full-length precisely-crafted portraits in fine, soft gouache colors; with wide margins decorated with animals and florets; very naturalistic in terms of observation; 19 folios were dated from 1522 to 1605 and bore various signatures. The last one bore the name and seal of Shah Bahman Mirza; son of Abbas Mirza Shah, son of Fathali Shah [Collections of Behague,

Henri Vever, Georges Marteau (Louvre), Cartier, Pozzi, etc.]." Quoted by Vivet-Peclet, p. 155.

117. LC no. 28. Donated by S. C. Welch in 1999.

118. LC no. 30.

119. The precious manuscripts were sold on March 1 and 2, 1962, and the East Asian collections on March 15 and 16, the same year.

120. LC no. 3. Lot 38.

121. Lot 37; we have photographs (taken in 1922) of LC no. 6. This manuscript was in the possession of F. R. Martin in 1912.

122. LC no. 9. Lot 39 (of which we have no photographs).

123. LC no. 52.

124. LC no. 51. My thanks to Alain Cartier for this precious information.

125. LC no. 60.

126. Most of the manuscripts and paintings date from the sixteenth and seventeenth centuries; one manuscript

and one painting date from the fifteenth century, and several paintings date from the eighteenth century.

127. A letter from India, written by Jacques on November 25, 1911, mentions the purchase of a manuscript with detached folios. He explains: "The scoundrels did that while I was bargaining; the manuscript would have been worth twice as much if I had seen it complete first."

128. The surviving photos of Louis's interiors and the inventories of furniture and objects in his Budapest residence do not show any Islamic pieces, except for rugs. We know he had a pair of Arabic doors and stained-glass windows (see note 44) sent to his house in Spain. In a letter dated November 25, 1911, during a trip to India, Jacques refers to his search for objects for the "display windows in Louis's new room"; the room in question may have been in his house or in the boutique on rue de la Paix. A recently discovered photo shows six framed paintings on a wall of the boutique—one of which was in Louis's private collection (LC no. 23)—and a Persian textile, known from the negatives, used to cover a desk.

Portrait of the elderly Akbar (r. 1556-1605)
Page from the Late Shah Jahan Album
India, c. 1650
Ink, opaque watercolor, and gold on paper
36.8 × 25 cm
Aga Khan Museum, Toronto
Inv. AKM149, LC no. 22

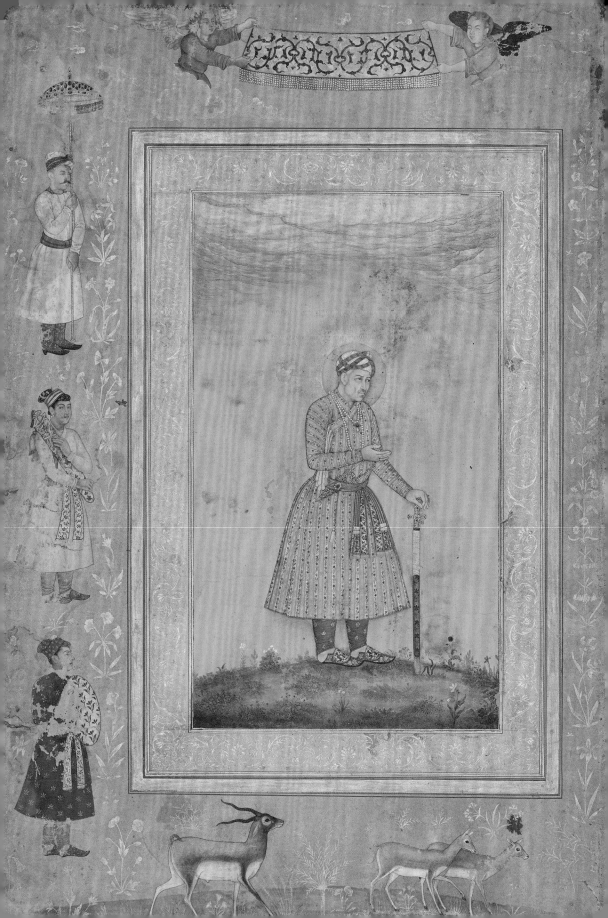

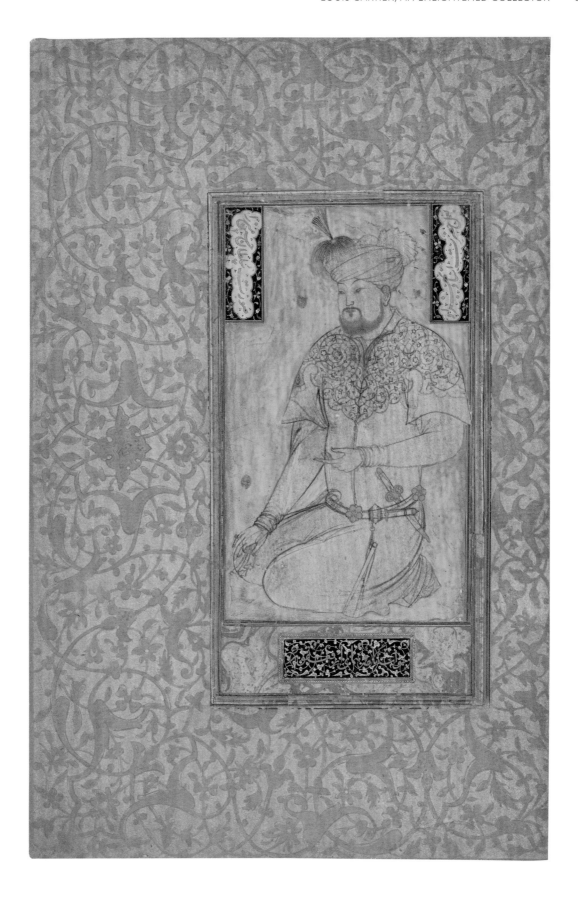

Portrait of Sultan
Husayn Mirza Bayqara

Afghanistan, Herat, c. 1480-1510
Ink, color, and gold on paper
34.3 × 32.7 cm

Harvard Art Museums/
Arthur M. Sackler Museum
Gift of John Goelet
Inv. 1958.59, LC no 24.

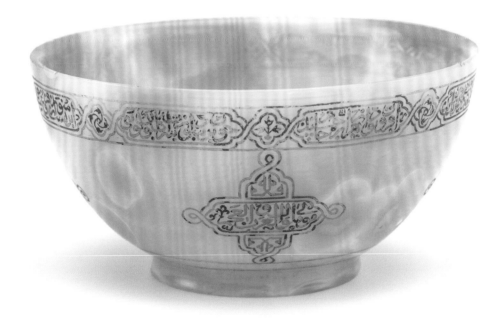

Cup in the name of Sultan
Husayn Mirza Bayqara

Signed Bihbud
Herat, Afghanistan, 1470
Agate, engraved decoration
5.5 × 11 cm

Arthur M. Sackler Gallery,
Smithsonian Institution, Washington (DC):
The Art and History Collection
Inv. LTS1995.2.27, LC no. 57

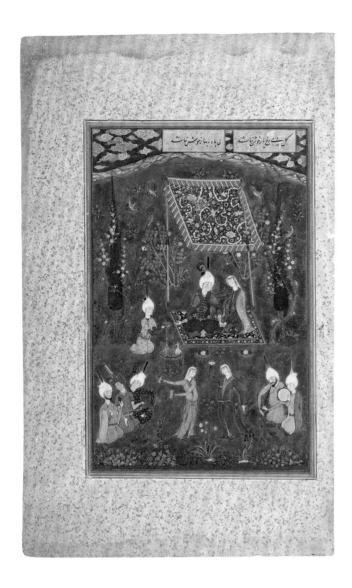

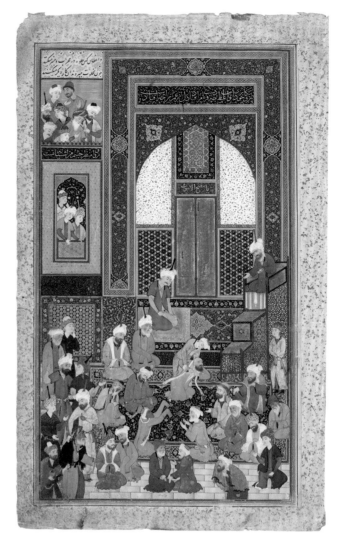

Detached paintings
of the *Divan* of Hafiz

Iran, Tabriz, c. 1530
Ink, opaque watercolor,
and gold on paper
LC no. 4

Lovers' picnic

Folio 67r.
Attributed to Sultan Muhammad
19 × 12.4 cm

Harvard Art Museums/
Arthur M. Sackler Museum,
Gift of Stuart Cary Welch, in honor
of Edith Iselin Gilbert Welch
Inv. 2007.183.2

Incident in a Mosque

Folio 77r.
Signed by Shaykh Zada
29 × 18.2 cm

Harvard Art Museums/Arthur M. Sackler Museum
Gift of Stuart Cary Welch, Jr.
Inv. 1999.300.2

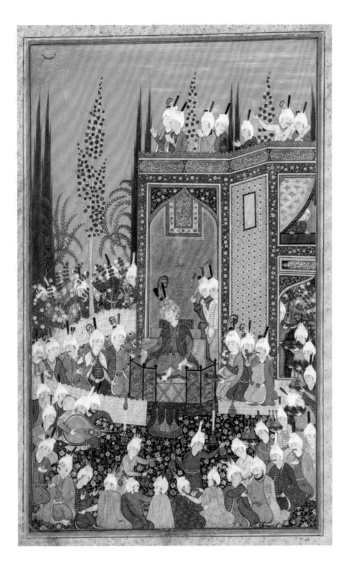

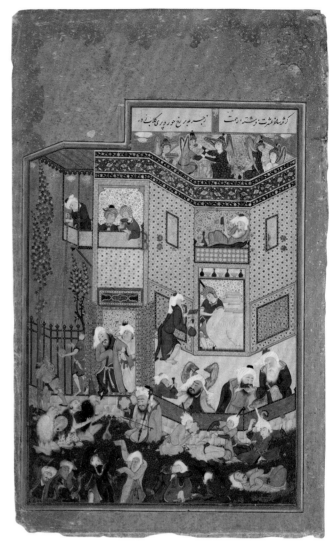

Feast of 'Id

Folio 86 r.
Signed Sultan Muhammad
29 × 18.2 cm

Arthur M. Sackler Gallery,
Smithsonian Institution, Washington (DC):
The Art and History Collection
Inv. LTS 1995.2.42

Earthly drunkenness

Folio 135 r.
Signed Sultan Muhammad
28.7 × 35.5 cm

Harvard Art Museums/Arthur M. Sackler Museum
The Stuart Cary Welch Collection
Gift of Mr. and Mrs. Stuart Cary Welch in honor
of the students of Harvard University and Radcliffe College
Jointly owned by the Harvard Art Museums
and the Metropolitan Museum of Art
Inv. 1988.460.2 and 1988.430 (Met)

Detached folio from
a *Khamsa* of Nizami

Afghanistan, Hérat, c. 1415-1417
From the library of the Sultan Shah Rukh
Ink, watercolor, silver, and gold on paper
26.3 × 16.4 cm

Khosrow slays a lion
with a blow from his bare fist

Inv. R:462-2015.4

The battle of the clans

Inv. TR:462-2015.6

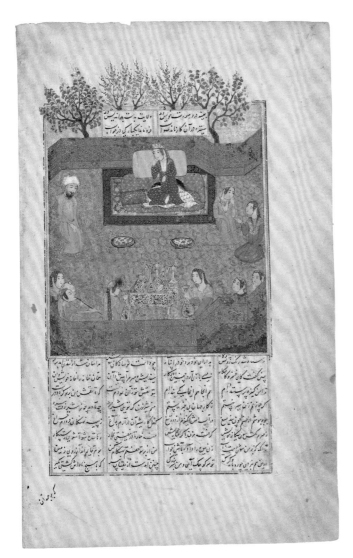

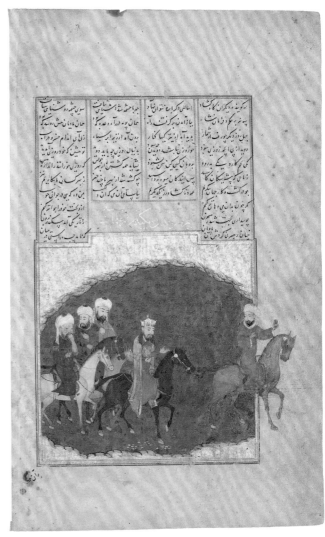

Nushabeh recognizes Iskandar
Inv. TR:462-2015.11

Iskandar leaving the land
of the water of life
Inv. TR:462-2015.13

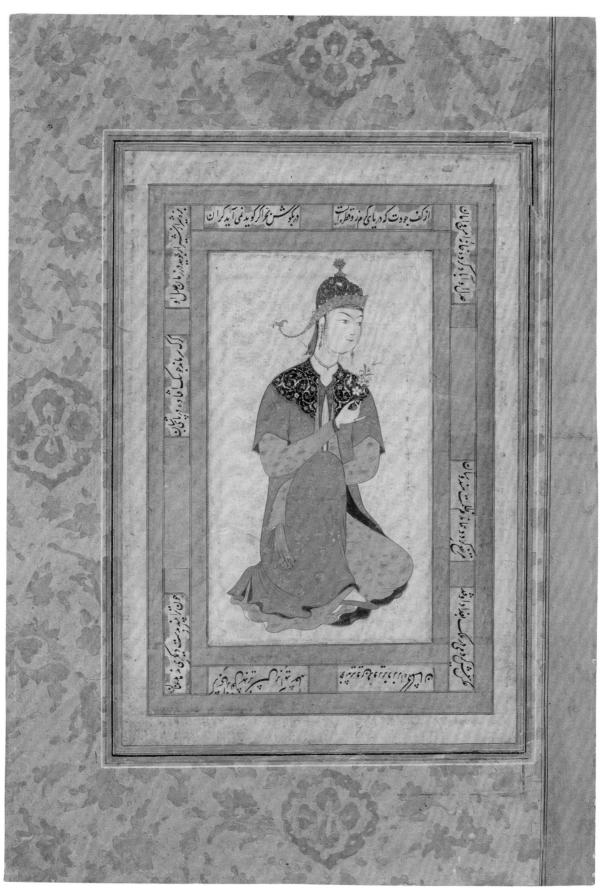

Seated princess

Attributed to Mirza 'Ali
Iran, Tabriz, c. 1540
Ink, opaque watercolor, gold,
and silver on paper
39.7 × 28 cm

Harvard Art Museums/Arthur M. Sackler Museum
Gift of John Goelet, inv. 1958.60, LC no.12

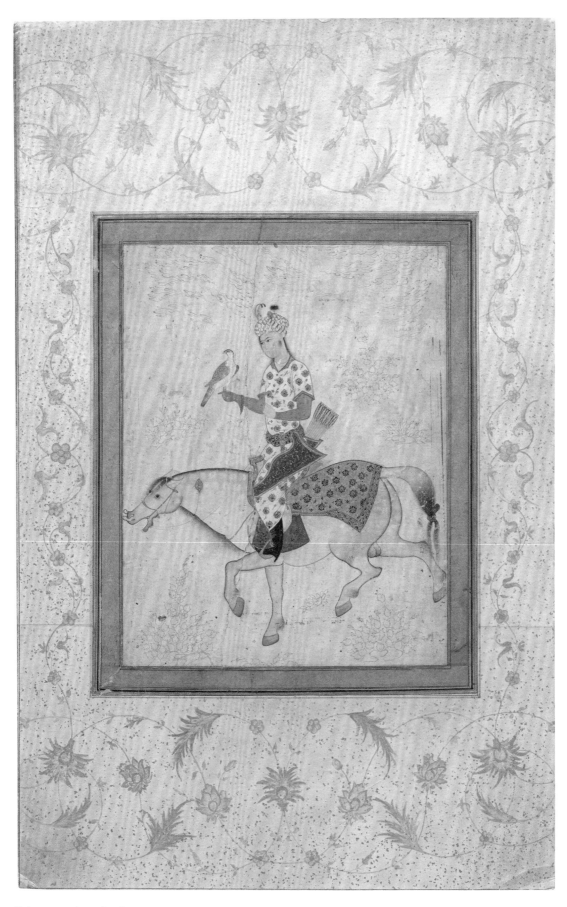

Falconer on horseback

Deccan, India, late 16th century
Ink, opaque watercolor, gold,
and silver on paper
39.3 × 25.1 cm

Fondation Custodia, Paris
Inv. 1973-T.3, LC no.13

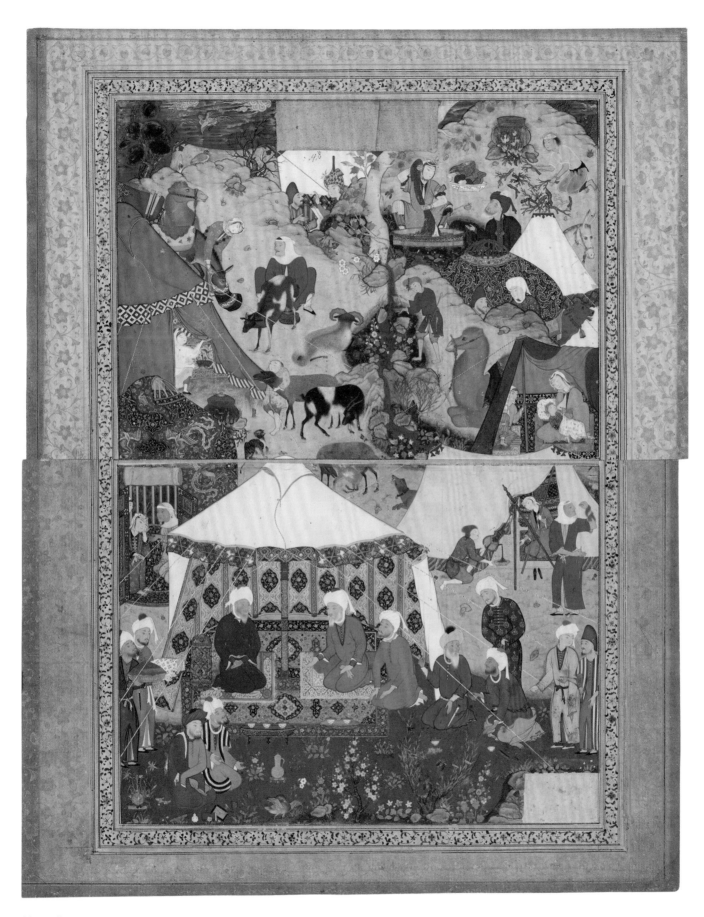

Nomadic encampment

Iran, Tabriz, c. 1540
Opaque watercolor, gold,
and silver on paper
33.4 × 26.5 cm

Harvard Art Museums/Arthur M. Sackler Museum
Gift of John Goelet, inv. 1958.75, LC no. 10

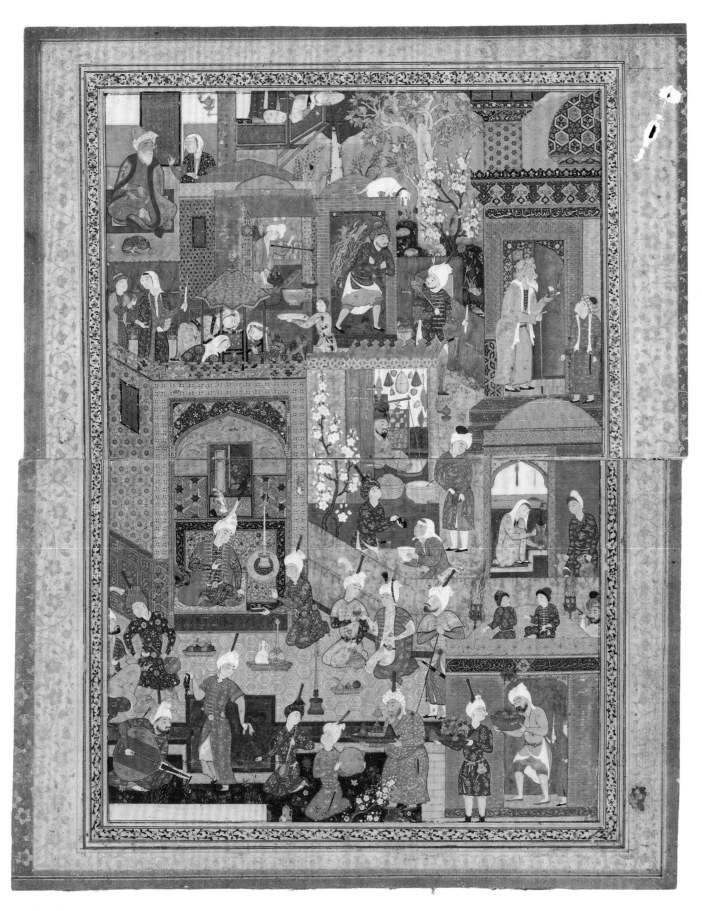

Nighttime in a city

Attributed to Mir Sayyid 'Ali
Iran, Tabriz, c. 1540
Opaque watercolor, gold, and silver on paper
33.9 × 26.9 cm

Harvard Art Museums/Arthur M. Sackler Museum
Gift of John Goelet, inv. 1958.76, LC no. 11

A PRECIOUS MUGHAL SPRINKLER

This jade, pear-shaped sprinkler is decorated with floral-vegetal motifs inlaid with rubies and emeralds according to the Indian *kundan* technique. It was produced in Mughal India in the seventeenth century and passed through the hands of some renowned collectors during the nineteenth and twentieth centuries. It is easily identifiable due to its quality and the unique shape of its neck, making it possible to trace its provenance from the late nineteenth century to the present day.[1]

To our knowledge, it first appeared in 1860 at the auction of the estate of the great Parisian art collector Louis Fould,[2] where it was purchased by the Duc de Morny, a famous French statesman then nearing the end of his career.[3] At the latter's death in 1865, his collection was put up for sale[4] and, curiously, the sprinkler was bought by Louis Fould's son Édouard, who may have had an emotional attachment to a work of art he had known in childhood. Édouard Fould sold it, with a large part of his collection, in 1869.[5] The piece then reappeared at a public auction in 1877, but the identities of both owner and buyer are unknown.[6]

It next appears on an invoice dated June 22, 1912, addressed to Louis Cartier by Seligmann, where it is described as a "jade amphora inlaid with gemstones, an Indian artifact." It is recorded as coming from the collection of the "Vicomte de Vogüe,"[7] who had died two years earlier. However, it is not mentioned in the catalogue of the Vicomte's

collection sale; Seligmann may have purchased it directly from the heirs. Two negatives in the Cartier Archives show the sprinkler, photographed in 1922, confirming that it is indeed the same piece.[8] Louis kept this outstanding work of art in his collections until his death, testifying to his taste for inlaid objects of hard stone.[9] Most probably sold by his heirs, the piece went to auction in 2002 and was purchased by the Museum of Islamic Art in Doha.[10] J.H.

1. My thanks to Marie-José Castor who traced this piece in historical auction records.

2. Auction organized by Pillet (experts: Roussel and Laneuville) in Paris on June 4, 1860, and the following days, lot 3000. Louis Fould also owned the cameo depicting Shah Jahan, held in the Cabinet des Médailles at the Bibliothèque Nationale de France (inv. Camée.366); it was published in 1861 with his collections (Chabouillet, 1861, p. 182, no. 2496).

3. Half-brother of Napoleon III, he was notably a deputy

in the French parliament and Minister of the Interior during the Second Empire.

4. Collection of Charles Auguste Louis Joseph, Duc de Morny (1811–1865), sold on May 31, 1865, in Paris, lot 52, p. 86.

5. Édouard Fould sale, April 5–9, 1869, in Paris, by Pillet and Mannheim, lot 45.

6. Auction, May 18–19, 1877, in Paris, by Pillet and Mannheim, lot 22. The sale notice specifies its provenance from the Fould and Morny collections.

7. Renowned French author, diplomat, and statesman.

8. Negative nos. 1346 and 1347, photographed on May 10, 1922.

9. The piece appeared in the inventory of objects held at Ingmire Hall in 1945–46. See pp. 72-73

10. Sotheby's sale, London, April 25, 2002, lot 106. My thanks to Jean-Baptiste Clais for this information, and to Mounia Chekhab-Abudaya and Tara Desjardins for further details regarding the acquisition of the bottle.

"Eastern objects from the collection of the Duc de Morny"
Gazette des beaux-arts, 1864, p. 35

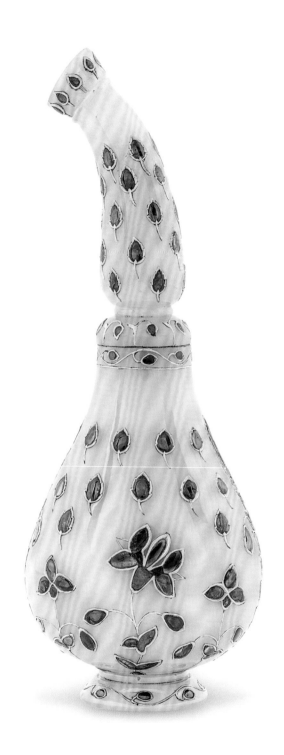

Sprinkler

India, 1st half of the 17th century
Jade inlaid with gold, rubies,
and emerald *kundan* work
Height: 17.5 cm

Museum of Islamic Art, Doha
Inv. JE.169.2003, LC no. 53

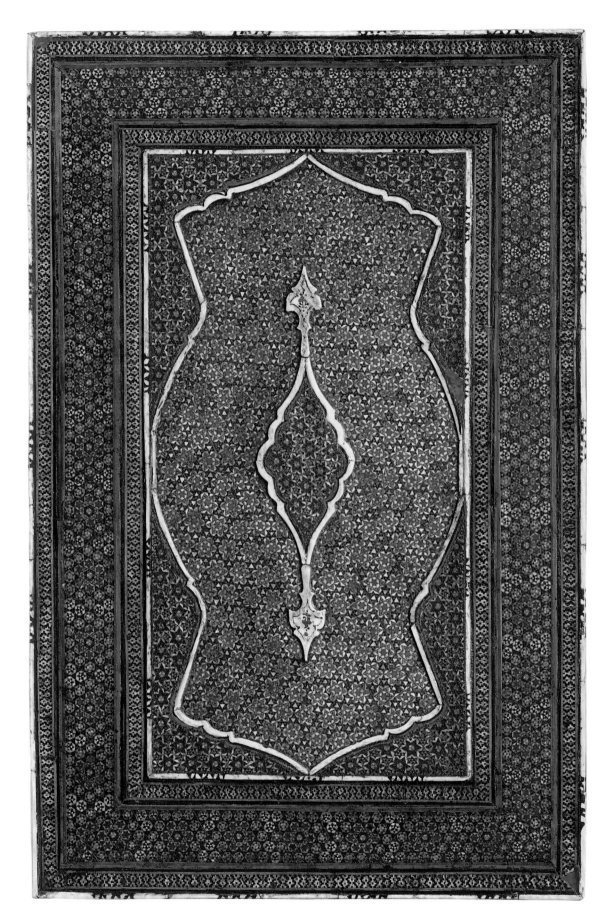

Casket

Iran, 19th century
Wood and marquetry of colored wood,
ivory, and metal (*khatamkari*)
24.5 × 36.5 × 24.2 cm

Musée du Louvre, Paris, département des Arts de l'Islam
On loan from the Musée des Arts Décoratifs
Inv. AD 29247

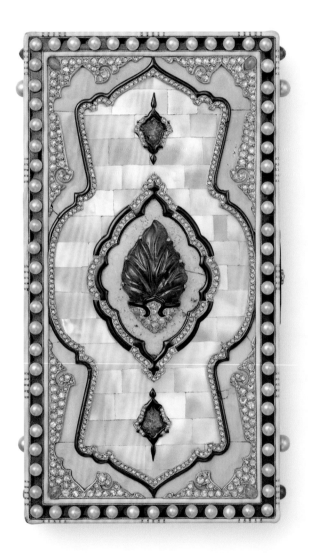

Vanity case

Cartier Paris, 1924
Gold, platinum, mother-of-pearl, turquoise,
emeralds, pearls, diamonds, enamel
10.9 × 5.9 × 2 cm
Cartier Collection, inv. VC 34 A24

THE SHAH'S PEN BOXES

These two pen boxes [FIGS. 1 AND 2], acquired by the Louvre in 2018, were originally part of a larger set of similar pen boxes of different sizes. The larger of the two was presented at the *International Exhibition of Persian Art* in London in 1931 and still bears the exhibition label; it was also shown in Paris at the 1938 exhibition.[1] In both cases, Louis Cartier was the lender. A sketch on a stock index card,[2] and images found among the glass plate negatives stored in the Cartier Archive, attest to the presence of these two items in his personal collection from 1912, along with several other pieces from the set.

The notebooks, in which photographic images were listed in the Cartier Archive,[3] include various references to the pen boxes, which are among the first Islamic pieces mentioned. "M. Louis, photograph of an ivory box" was annotated alongside photograph numbers 100 to 103.[4] These first photographs, probably dating from 1912, correspond to a pen-box lid [FIG. 3]

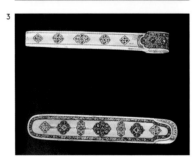

and to the small pen box now at the Louvre [FIG. 4]. Another annotation dating from 1921, "An Eastern-style pen box; order of Mr. Louis," accompanies numbers 906 and 907, corresponding to the photographs of the large pen box now at the Louvre [FIG. 5].[5] The most intriguing note,[6] added on June 30, 1922, cites "5 Persian writing cases," a photograph ordered by Louis Cartier (number 1412). The corresponding glass plate is unfortunately lost, as are the negatives relating to the last entries in the notebooks from October 1930: "two Persian writing cases" (number 4576), "1 Persian writing case belonging to Mirza Muhammad Gr Viz Munshi" (number 4577, corresponding again to the large pen box at the Louvre), and "from four viewpoints," "Mr. LC collection" (number 4578).[7]

We know that the two pen boxes at the Louvre were present in Louis's collection in 1912, together with the lid of a pen box of similar craftsmanship. The latter, featured in two photographs, was found in the collection of the Metropolitan Museum of Art, New York [FIG. 6], where it arrived as part of the collection of financier and art collector J. Pierpoint Morgan, donated by his son in 1917. An invoice found in the archives of the Morgan Library[8] attests to the fact that Louis Cartier sold the pen-box lid to Morgan on May 18, 1912:

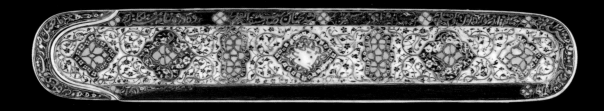
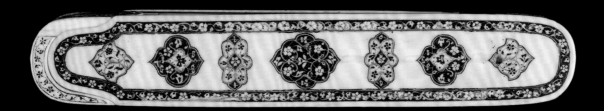
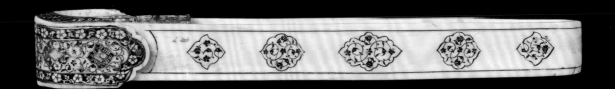
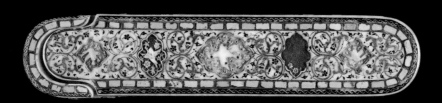
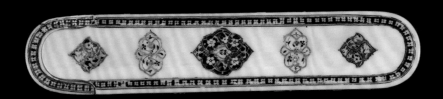
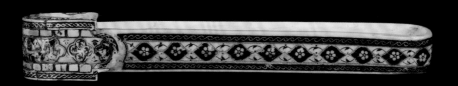

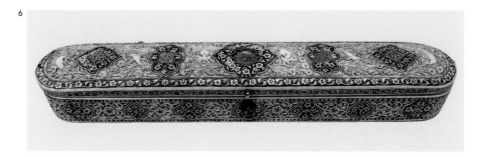

"1 Top of an antique Persian engraved ivory box, 7,000 francs."[9] A second ivory pen box from Morgan's collections was donated, together with the lid, to the Metropolitan Museum in 1917 [FIG. 7],[10] but no trace of it has been found in the Cartier or Morgan Library archives.[11]

By the time the photograph of the "5 Persian writing cases" was taken in 1922, the pen-box lid was no longer part of Louis's collection and the second pen box in the Metropolitan Museum was not part of it either, though it may previously have been. This remarkable set, therefore, included another three pen boxes that have yet to be found.

The pen boxes of the Louvre and the lid are made of finely carved walrus ivory inlaid with gold and turquoise (one well-known turquoise mine is in the region of Nishapur in Iran).[12] Both boxes comprise a base with a sliding compartment; the larger pen box also has a copper ink-well covered in gold leaf and inlaid with turquoise. All the outer surfaces of the box and of the compartment itself are decorated with carvings of outstanding quality. Two different techniques were used to create the medallions: some were carved directly into the material of the lid, making the decoration integral to the object. Other isolated medallions, comprising a design within an openwork frame, were positioned inside hollowed-out cavities. The latter technique made it possible to inlay the bottom of the medallion with a red silk fabric onto which (partially pre-served) gold leaf was added, giving the carving greater dynamism [FIG. 8].

The inscriptions, in fine Persian *nasta'liq* script, follow in the tra-

dition of poems composed for precious objects, prais-ing the qualities of the work in question and ending with good wishes for its owners. The inscription on the smaller pen box in the Louvre links it with the Safavid ruler, Shah Abbas I (r. 1587–1629), while that on the larger one with a figure identified by the curators of the 1931 exhibition as the Shah's grand vizier, Mirza Muhammad Munshi (the inscription refers to the "master of the sword and the pen," a double title he bore from 1586 to 1588).[13]

FIG. 6
Pen box with flowers, birds,
and animals
India, 17th century
Ivory, gold, black lacquer, textile
2.5 × 3.5 × 20.3 cm
The Metropolitan Museum of Art, New York
Gift of J. Pierpont Morgan, 1917
Inv. 17.190.819

FIG. 7
Detail of the pen box with flowers,
birds, and animals

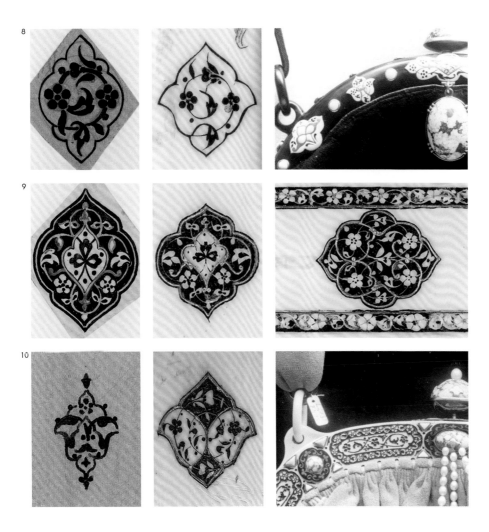

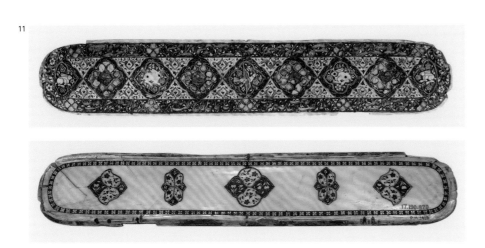

FIGS. 8 AND 9

Details and studies
of the medallions of the large
pen box of the Louvre
Charles Jacqueau
Graphite, black ink, and gouache
on white vellum paper
3.9 × 2.8 cm, 4.6 × 3.6 cm

Petit Palais, Paris
Gift of the Jacqueau family, 1998
Inv. PPJAC02863 and PPJAC02864

FIGS. 10

Details of the design
for a vanity case (fig. 16)
and of the large pen box
of the Louvre

FIG. 11

Cover of a pen box
Top and bottom views
India, Deccan, 17th century
Walrus ivory, gold, turquoise,
black paste
21 × 3.8 cm

The Metropolitan Museum of Art, New York
Gift of J. Pierpont Morgan, 1917
Inv. 17.190.820

FIGS. 12 AND 13

Handbags inspired
by the pen boxes
Cartier Paris, 1919 and 1920
Antelope leather; clasp: gold,
tortoiseshell, and turquoise
Antelope leather; clasp: gold,
ivory, onyx, pearls, and turquoise
Photographs, 1919 and 1920

Cartier Paris Archives
Inv. 059383040 and 068763040

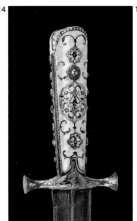
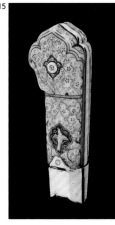

Ivory artifacts from this period are rare, and these pen boxes have only a few known counterparts. The first is a sword hilt bearing the date 1634–1635, now in the al-Sabah collection, Kuwait [FIG. 9]. The second is a dagger bearing an inscription referring to the Mughal ruler Jahangir (r. 1605–1627), now in the Freer Gallery of Art, Arthur M. Sackler Gallery, Smithsonian Institution, Washington [FIG. 10]. On the basis of style, quality of carving, and engraved gold wire inlays and inscriptions, these pen boxes and weapons can be attributed to the same workshop in Deccan.

The two pen boxes in the Louvre remained in Louis's collection until his death.[14] They provided a rich source of inspiration for the Maison Cartier, as can be appreciated in several drawings by Charles Jacqueau, one of Cartier's principal designers, featuring floral branch motifs [FIGS. 8 AND 9], and in a project for a vanity case [FIGS. 10 AND 16]. A vanity case [FIG. 17], a cigarette case [FIG. 18], and two bags [FIGS. 12 AND 13] reflect the direct inspiration these pen boxes provided to designers at the Maison Cartier. J. H.

1. The exhibition, entitled *Les arts de l'Iran, l'ancienne Perse et Bagdad*, was held at the Bibliothèque Nationale de France.

2. Register 2 AH 588.

3. The notebooks are part of the "Documents" archive; they record the photograph number, the nature of the item, the format, and sometimes the date the photograph was taken.

4. Negative no. 103 is missing.

5. For no. 481 (probably from 1921), the photo of the inkwell from the large pen box appears under the heading "various jewelry pieces."

6. Another note indicates a link with photograph nos. 906 and 907.

7. These additional photographs may have been taken with a view to the Burlington House exhibition of 1931.

8. ARC 1310.

9. On May 10 of the same year, Morgan also bought from the Maison Cartier "1 Persian manuscript from the sixteenth century decorated with 2 miniatures with explanatory notices, parchment leaf various colors, 27,500 francs." It seems that Morgan did not take his purchases away with him immediately but had them delivered to his hotel around June 10. A document (ARC 1310) records that the pen-box lid was given by Morgan himself to M. Rey on June 10, 1912, at the Hôtel Bristol, so that it could be taken to the Metropolitan Museum with part of the financier's collections.

10. Morgan had a long-standing relationship with the Cartier brothers, having been a client of the Maison Cartier since 1898.

11. A letter dated December 12, 1912, and addressed to Morgan by Seligmann (in charge of taking Morgan's collections to the United States) lists the pieces sent. The list includes the pen-box lid collected in Paris, but also mentions an "oblong box ivory, encrusted with arabesques and small flowers. Oriental, 16th century." In view of the ivory pieces donated by Morgan to the Metropolitan Museum, only the second pen box could correspond to this description. This second pen box was picked up in Paris, but sent from London.

12. Only the large pen box in the Louvre and the one in the Metropolitan Museum still retain some gold wire inlay, showing that the wire was engraved with fine detail. The pen boxes in the Louvre and the lid in the Met were restored with brass powder. The base of the large pen box in the Louvre is fragmentary and partially restored with ebony; the break was already visible in the archival photographs and in the drawing at Cartier.

13. In the Islamic world, the pen box was an attribute of rulers and high dignitaries.

14. They appear in the post-mortem inventory of the London boutique where, during the war, Louis kept part of his collections of gemstones and inlaid ivory pieces.

FIG. 14
Hilt of a sword
Bijapur, India, 1634-1635
Walrus ivory inlaid with engraved gold, iron covered with gold and silver
10.9 × 3.9 × 2.5 cm
Al-Sabah Collection,
Dar al-Athar al-Islamiyyah, Kuwait
Inv. LNS 37 I

FIG. 15
Dagger
Iran, 2nd quarter of the 17th century
Steel, wood, ivory inlaid with gold, silver, black paste, and jewels
29.6 × 5.9 × 3.6 cm
Freer Gallery of Art,
Smithsonian Institution, Washington (DC):
Purchase—Charles Lang Freer Endowment
Inv. F1958.15a-b

16

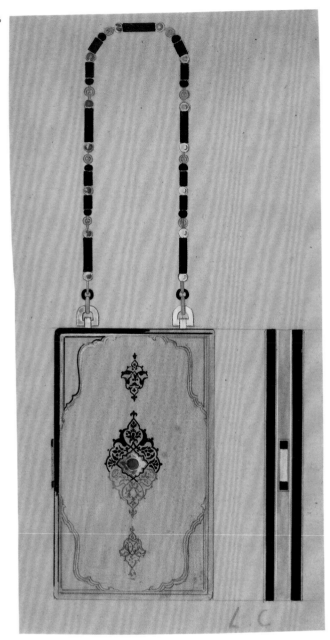

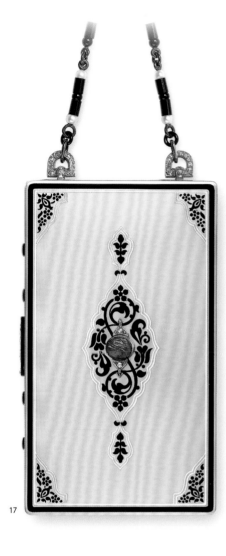

17

18

FIG. 16
Design for a vanity case
Cartier Paris, 1922
Graphite, India ink, and gouache
on buff tracing paper
20.5 × 10.4 cm
Cartier Paris Archives
Inv. ST22/89

FIG. 17
Vanity case
Cartier Paris, 1923
Gold, platinum, one ruby, diamonds,
pearls, onyx, enamel
Case: 9 × 5 × 1 cm
Cartier Collection
Inv. VC 52 A23

FIG. 18
Envelope cigarette case
Cartier Paris, c. 1925
Yellow gold, enamel, sapphires
8.1 × 5.4 × 1.3 cm
Formerly in the collection of Prince
and Princess Sadruddin Aga Khan
LA Private Collection

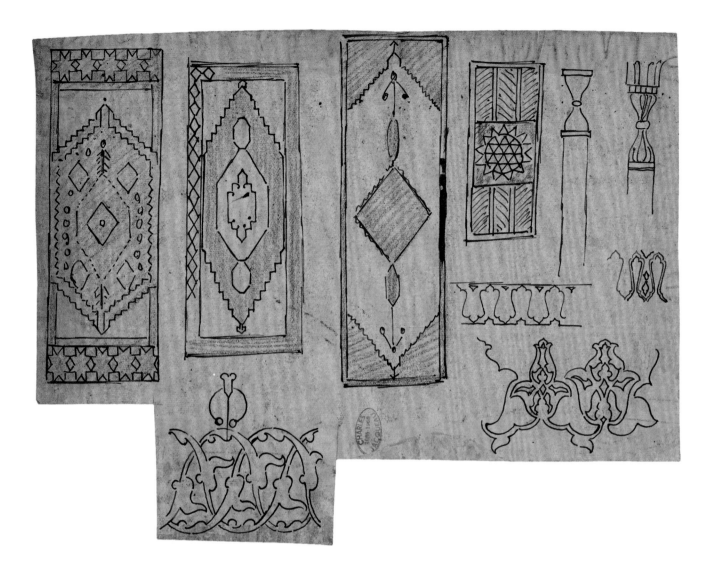

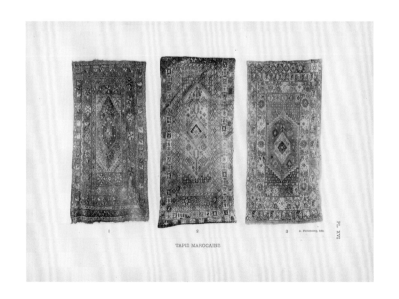

Study of rug patterns

After the exhibition catalogue
L'Exposition d'art musulman d'Alger
Charles Jacqueau
Black ink, blue crayon
on vellum tracing paper
13.8 × 20.9 cm

Petit Palais, Paris,
gift of the Jacqueau family, 1998
Inv. PPJAC02851

"Tapis marocains"

Georges Marçais
L'Exposition d'art musulman d'Alger, pl. XVI
Albert Fontemoing, Paris, 1906

Cartier Paris Archives
Inv. BibCart/349

Inspiration board
after Prisse d'Avennes

Charles Jacqueau
Graphite, black ink on vellum tracing paper
16.5 × 13.9 cm

Petit Palais, Paris, gift of the Jacqueau family, 1998
Inv. PPJAC02857

Émile Prisse d'Avennes

*L'Art arabe d'après les monuments du Kaire
depuis le viie siècle jusqu'à la fin du xviiie siècle*
P. 87, pl. V; p. 77, chap. VI; p. 127, pl. VIII
J. Savoy & Cie, Paris, 1877

Cartier Paris Archives, inv. BibCart/095

Studies of Arabic decorative patterns
after Prisse d'Avennes

Cartier Paris, c. 1910
India ink on tracing paper
24.2 × 18.6 cm
Cartier Paris Archives, inv. E26

Studies of decorative patterns
after Marie de Launay

Cartier Paris, c. 1910
Ink on tracing paper
18 × 26 cm
Cartier Paris Archives, inv. E90

"La décoration arabe,
xive siècle", pl. XI

Prisse d'Avennes
La décoration arabe
André Daly fils & Cie, Paris, n. d.
Cartier Paris Archives, inv. BibCart/076

"Marbres sculptés", pl. V

Marie de Launay
L'Architecture ottomane
Central printing and engraving company,
Constantinople, 1873
Cartier Paris Archives, inv. BibCart/305

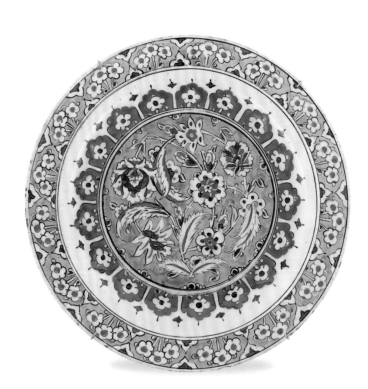

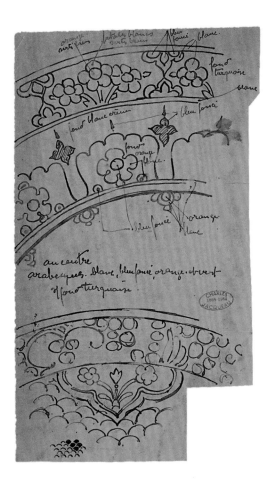

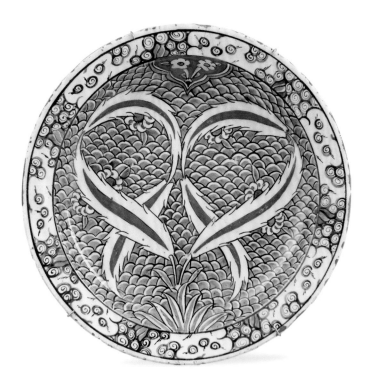

Study based on two Iznik plates

Charles Jacqueau
Ink on paper
18.8 × 10.5 cm

Petit Palais, Paris,
gift of the Jacqueau family, 1998
Inv. PPJAC02875

Plates

Iznik, late 16th century
Ceramic, slip decoration
under transparent glaze
Diam. 31.2 cm

Musée national de la Renaissance, Écouen
Inv. E.Cl. 8504 and E.Cl. 8508

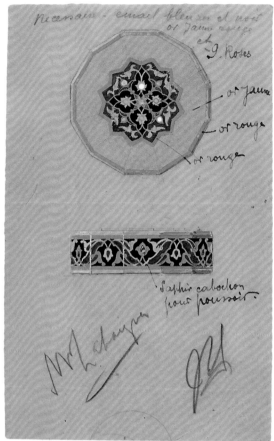

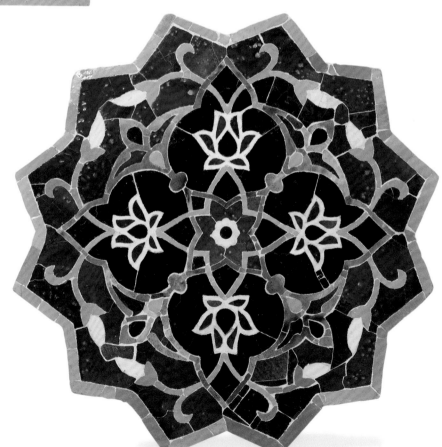

Project for a powder box

Cartier Paris, c. 1920
Graphite, India ink, and gouache
on buff tracing paper
18 × 11.3 cm
Cartier Paris Archives, inv. RB53

Fragment of architectural decoration

Iran, Khargid, late 14th to15th century
Ceramic mosaic
59.5 × 3.6 cm

Musée du Louvre, Paris, département des Arts de l'Islam
Purchase 1895, formerly in Sorlin-Dorigny collection
On loan from the Musée des Arts Décoratifs,
gift Filippo, F.C., 1908, inv. AD 15116

CARTIER

AND

INDIA

A SOURCE
OF FORMAL
AND
TECHNICAL RENEWAL

ÉVELYNE POSSÉMÉ

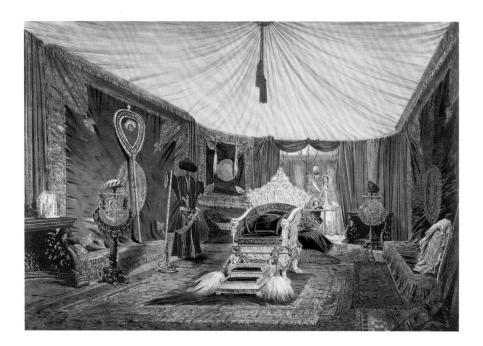

The idea for this research arose from a comparison of the titles for a series of Cartier exhibitions of "Oriental"[1] jewelry, held between 1912 and 1913. It is easy to see, at the very least, a semantic shift in the verb forms used: "collected" in London, "adapted" in Paris, and finally, "created" in Boston and New York. Did these verbs express mere linguistic differences, or did they reflect a shift in the approach of Cartier and its workshops to these Oriental jewels? This initial investigation was expanded with the archival discovery of advertisements from the 1930s and 1940s, in which jewelry, reproduced under the Cartier name, seemed to have been directly inspired by the jewelry traditions of India. These two findings illustrate Cartier's initial interest in Indian jewelry and its persistence throughout the 1950s and even beyond.

The early exhibition catalogues from the 1910s list Persian, Hindu, Tibetan, Arab, and even Russian and Chinese jewels, in concordance with Cartier's "Oriental" stock books that indicate these same origins, with the addition of Indian and Egyptian jewelry and *objets d'art*. It is noteworthy, however, that the historic and cultural links between Iran and Mughal India make it impossible to easily note the differences between jewelry, motifs, and techniques that are specific to these two countries, all of which—links, motifs, and techniques—were inherited by Victorian India. An analysis of the designs produced by the Maison Cartier, according to types of jewelry, motifs, materials, and techniques, demonstrates that Indian influence was of primordial importance throughout nearly the whole of the twentieth century.

CARTIER AND LONDON

Indian jewelry started to become popular in Europe during the second half of the nineteenth century, concurrent with British rule in India. India was showcased at the Great Exhibition of 1851 in London, where fabrics and inlaid metals were admired, although the critics appear to have ignored the jewelry [P. 108].[2] Thomas Holbein Hendley's book, *Indian Jewellery*, published in 1909, extracted articles that appeared in *The Journal of Indian Art* from 1906 to 1909; it included reproductions of jewelry from the Indian department of London's Victoria and Albert Museum in South Kensington and from the Maharaja Sawai Man Singh II Museum in Jaipur. This publication was consulted and amply annotated by Louis Cartier and the Maison's designers.[3] It was not until the beginning of the twentieth century that the Victoria and Albert Museum began to research and acquire Mughal jewelry, notably with a bias toward the collections of Indian Maharajahs.

Cartier's first contacts with India were initiated by events in England, in response to the two royal coronations that took place in London in 1902 and 1911. These celebrations presented British nobility throughout the Empire the occasion to adorn themselves with sumptuous jewels and, at the same time, to offer their sovereigns elaborate gifts, and had generated an intense period of creation and production for European jewelers. Pierre Cartier, Alfred Cartier's second son, was sent to London in preparation for the coronation of King Edward VII and Queen Alexandra in 1902. In 1901, Alexandra had ordered a necklace[4] from Cartier, made in part from Indian jewels which were already held among the collection of the Crown Jewels. It is possible that this necklace was worn by Queen Alexandra in 1903 during the Delhi Durbar, the coronation of the English sovereigns as Emperor and Empress of India, and visible on an Indian miniature from the time portraying the imperial couple [RIGHT].[5] In any case, in the wake of this order, Cartier was appointed as official supplier to the British Crown in 1904.

While the 1901 commission was one of the first Indian-style designs made by Cartier, it was not the Cartier family's first encounter with Indian jewelry. As part of their antiquarian

King Edward VII and Queen Alexandra
India, Punjab, c. 1902
Gouache on paper
25 × 19.5 cm
National Gallery of Modern Art, New Delhi
Inv. 2336

activity, Cartier started adding Indian jewelry to its stock in 1872.[6] Cartier sold an Indian bracelet to the American magnate J. Pierpont Morgan in 1903, followed by a necklace in 1908.[7] At the time, the Cartier family worked as antique dealers and jewelers; indeed, they also sold Renaissance-era jewelry and Sèvres porcelain to Morgan.

The coronation celebrations introduced the Cartier family to a wealthy clientele in London, as well as in India. The youngest of the Cartier brothers, Jacques, was sent to England in 1906 to supervise the London activities of the company, which at this time maintained a concession in the shop of the English fashion house of Worth. He was also tasked with prospecting locations for a new store, which would open in 1909 at 175–176 New Bond Street. Jacques then became well acquainted with Cartier's English clients, as well as with Indians traveling to the British capital. These relationships and his personal interest in gemstones destined him for a singular mission on behalf of the family company.

JACQUES CARTIER AND INDIA

Following the death of King Edward VII, the coronation of King George V and Queen Mary in London in June 1911 was followed by a durbar in Delhi in December 1911 [ABOVE]. Jacques Cartier left Marseille in October 1911 aboard the ship *Le Polynésien*, en route to India via the Suez Canal. He took advantage of the occasion of the coronation not only to meet with Maharajas but also with merchants of gemstones and pearls, a trade that was dominated by Indian merchants in Bombay. He reached India in November, traveling through the subcontinent and then the Persian Gulf for over four months before returning to France on April 12, 1912. It was unusual for companies at that time to undertake this type of journey, but certain adventurous traders had traveled along this route some years earlier. A new 1882 edition of Jean-Baptiste Tavernier's travelogue, first published in 1676, had revived the interest in India of French jewelers, a principal source of precious stones since antiquity.[8] Competition with India, long the only global purveyor of gemstones, began to develop from the sixteenth century onward, with the discovery and

King George V and Queen Mary
at the Durbar, New Delhi
Photographic print, 1911-1912
Jacques Cartier's travel album
Cartier Paris Archives
Inv. ALB/JC/14V

exploitation of mines in Brazil in the New World. The legendary diamonds of Golconda were no longer unique, as such, and the fame of Colombian emeralds grew to be so great that the trade routes shifted from west to east. Mughal emperors and their courts loved these gems and had been adding them to their treasuries for more than three centuries. It was this accumulation of stones, engraved with flowers or with phrases from the Qur'an, which European jewelers discovered in the early twentieth century in the chests of the Maharajas and in Mughal jewelry, especially when Indian clients began to commission Cartier to reset their stones in modern, platinum settings.

Jacques Cartier discovered this for himself on his travels, during which he visited the Indian princes, as well as merchants dealing in gemstones, pearls, and jewelry [BELOW]. In each city he visited he headed to the bazaar, where he sought out gems and antique objects not only for himself, but also for his brother Louis, and his father, Alfred. In a letter to Louis dated November 25, 1911, from the Taj Mahal Palace Hotel in Bombay, he wrote: "Even in Hyderabad, which has the most interesting bazaars I have ever seen, I could not find works for the vitrines of the new salon. I purchased quite a few objects for myself, in which you will probably find drawings ... The lovely miniatures and manuscripts are extremely rare. The objects I purchased are for myself, but if you or father want anything, obviously, take what you'd like."[9] One Indian name appears among the merchants listed in the stock books[10] at the time, Kanjimull and Sons, established in Delhi, which Jacques visited during this trip. The letterheaded paper lists their specialties: "merchants in gemstones, Indian jewelry, Persian and Indian textiles, shawls, carpets, Rampur veils, embroidery, *objets d'art* and curiosities, etc."[11]

For these transactions, Jacques Cartier could count on the help of Imre Schwaiger, a Hungarian antiquarian based in Delhi, whom he had met in Europe the previous summer. This contact permitted Jacques the opportunity to display Cartier's creations in Schwaiger's Delhi shop, which attracted visits by the viceroy of India and several other well-known figures.[12] Schwaiger, who also supplied works of art to European museums, would continue to add to Cartier's stock of Indian jewels for many years to come.[13]

Yet Jacques's most important mission lay elsewhere, as he described it himself in a letter written to his brother Louis from Patiala on October 24, 1911: "If I have correctly

Jacques Cartier
with Indian merchants in India
Photographic print, 1911-1912
Jacques Cartier's travel album
Cartier Paris Archives
Inv. ALB/JC/27V

understood my mission, the most important task during my trip to India is to investigate the pearl market and to determine the best way for us to source them."[14] In the second half of the nineteenth century, with the discovery of diamond mines in South Africa, diamonds had become more "commonplace" and connoisseurs had turned to natural pearls, which at that time, and throughout the first half of the twentieth century, became highly prized, with a great deal of speculation around their trade. The most beautiful pearls have always come from the Persian Gulf, while lesser-quality pearls are found around Sri Lanka and in the Red Sea region. The Gulf region was then under British rule and London was the world's pearl capital. After spending several weeks in India, Jacques, along with the trader Maurice Richard, ended his trip with a stay in the Persian Gulf to meet the leading tribal chiefs who held the rights to the pearl-bearing oyster beds along the gulf coast, notably around Bahrein [BELOW].[15] By the 1910s, Paris had taken over as the pearl capital—in 1912, more than a hundred pearl traders were in business around the streets of Lafayette, Châteaudun, and Le Peletier. By the late 1920s, the sale of natural pearls represented sixty percent of Cartier's sales and each boutique had its own pearl salon. By 1930, however, with the intensive harvesting of the Persian Gulf oyster beds and the arrival on the market of cultured pearls from Japan, the market for natural pearls collapsed.

After arriving in Europe in April of 1912, Jacques organized an exhibition of "Oriental jewels and *objets d'art* recently collected in India," held at the Cartier boutique in London on May 28.[16] It appears that the same pieces were then shown in Paris on June 2, 1913. The invitation to the London exhibition has not been preserved but the catalogue offers this indication on the title page:[17] "Exhibition of a selection of Persian, Hindu and Tibetan Jewels adapted to new styles. June 2, 1913 at Mssrs. Cartier, rue de la Paris 13."[P. 244] The word "collected" from the London invitation became "adapted to new styles" in Paris, indicating some interventions made by the Cartier ateliers. A text at the end of the catalogue seems to confirm this: "To conserve the character and authenticity of these Jewels, Mssrs. Cartier did not consider it necessary to change the low-carat gold, nor the glass beads that imitate turquoise, or other Oriental *trompe-l'oeil*, but have indicated them, as much as possible, in this catalogue."[18] Furthermore, there is no mention of the provenance of these works—in this case, India—but instead, a few indications mentioned in the

Pearl merchants
in the Persian Gulf, 1912
Photographic print, 1912
Jacques Cartier's travel album
Published in *La Renaissance de l'art
français et des industries du luxe*,
June 1923, p. 324
Cartier Paris Archives
Inv. ALB/JC/73V

descriptions of the jewels: "Tibetan work," "Hindu work," "Persian work," and finally, "from the period of the Mughal emperors." With no extant catalogue and therefore no descriptions or reproductions from the exhibition in London, it is impossible to compare the jewels exhibited in the two cities.

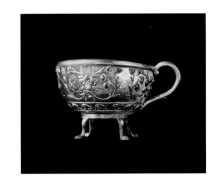

Nevertheless, research conducted in the Cartier Archives has revealed twenty-four photographs, taken in 1913, that reproduce most of the eighty-two jewels exhibited in Paris.[19] Among them, only the pearl necklace and rock crystal pendant in the shape of a crescent (no. 12) could be identified in the collection of the Musée des Arts Décoratifs in Paris.[20] Many of the jewels can be linked to entries in Cartier's "Oriental" stock book, thus revealing their provenance; some were purchases from the gem expert Charles Schutz (nos. 30, 32, 33), some from Imre Schwaiger (nos. 35 to 58, 61, 64, 66 to 70, 74, 78 to 81), others from the Paris dealer Demotte (nos. 62, 63, 65, 73, 75, 77), while a pearl and seed pearl necklace was purchased from J. P. Worth (no. 59). Apparently, only two of the pieces came from Jacques Cartier's trip to India: a necklace purchased on February 20, 1912, from Jugalkisore Narandas in Bombay (no. 34), and a smoky topaz bowl with gold inlay set with gemstones, purchased from Ganeshi Sall in Agra on February 22, 1912 (no. 82 [ABOVE]). Six of these jewels include notes indicating that work had been carried out on them in the Picq or Lavabre ateliers, but only small interventions.[21] Oddly enough, no trace remains of the first jewels (nos. 1 to 29), except for the photographs in the Cartier Archives. Perhaps they correspond to the jewels that Jacques Cartier acquired during his trip to India? The jewels in the images look similar to traditional Indian jewelry and therefore had probably not undergone any major transformations, except for restringing and the fitting of cliquet clasps for necklaces or clips on the backs of brooches.

Were the jewels that did not sell in Paris exhibited once again in Boston and New York? A comparison of the catalogue descriptions indicates that the jewels were completely different in those two exhibitions. No photographs of the jewels exhibited in the United States have been found, however. The catalogues for the exhibitions held on November 4, 1913, at the Copley Plaza Hotel in Boston, and on November 11, in New York, have the same cover as the Paris catalogue: the title page features an illuminated frame, in the style of Persian books; the only difference between them is the indication of the location.[22] The catalogue is more methodical, however, and includes fifty-six jewels organized by country of origin: twenty Indian pieces, ten Persian pieces, five Arab pieces,

Cup
India, 19th century
Smoky topaz, gold, gemstones
Displayed at the exhibition held
in the Cartier boutique
in Paris in 1913, cat. 82
Photograph, 1913
Cartier Paris Archives
Inv. 34281318

four Russian pieces, ten Chinese pieces, and finally, seven antique pieces. The name of the two exhibitions was somewhat contradictory, indicating that these jewels were created by Cartier but came from different, faraway countries. Based on the notice "adapted to new styles" in the Paris catalogue, it seems that the jewelry house took an additional step by adapting and restyling these Eastern jewels. They were made using Oriental raw materials—*apprêts*, gemstones, and pearls—in an Oriental style, but produced by Western workshops [ABOVE]. The only piece of jewelry that could be identified confirms this: a pendant brooch consisting of a triangular emerald vase surmounted by emerald cabochons, hanging from a double chain of pearls and onyx with four emerald drop pendants.[23] Surprisingly, it corresponds to no. 50 in the catalogue, the first jewel in the chapter titled "From the Antique," where it is shown along with an Egyptian jewel and three antique jewels, either from Greece or Rome. Based on this only identifiable piece, it appears that the jewels exhibited in the United States were more elaborate than those in the Paris exhibition—new, Indian-style jewelry had replaced the adapted Indian jewels.[24]

Group of emeralds and sapphires
Photograph, 1929
Cartier London Archives
Inv. C815

The groups of *apprêts* presented
to Cartier for purchase were highly
diverse and included uncut stones,
carved or engraved Chinese stones,
and Indian stones carved into
leaves or flowers.

CARTIER AND INDIA
IN THE 1920S

The 1913 vase pendant ushered in the Indian-style designs of the 1920s, which were dominated by commissions from maharajas who wanted to have their traditional jewelry reset and, especially, their stones to be placed in new, platinum settings. While some opted for European designs, many maintained a certain continuity with the jewelry style of their ancestors and commissioned the Cartier ateliers to make pieces more in keeping with Indian tastes.[25] After a hiatus in orders during World War I, the relationships that had developed with the Indian princes picked up again with large commissions in the 1920s, notably from the maharajas of Patiala and Kapurthala [BELOW]. These clients brought their stones to Paris, while the ateliers learned about different Indian cuts and systems for drilling holes for stringing, as well as new types of jewels, such as turban ornaments, the use of talisman stones, and the fashion for wearing multiple necklaces.

 One of the most interesting aspects was Cartier's widespread use at the time of Eastern *apprêts*, fragments of jewels and objects created in the Middle East or in India, which the ateliers incorporated into modern jewelry and objects. This is how enameled Indian plaques, Persian miniatures, and even pieces of ceramic were added to cigarette and vanity cases. The enameled plaques were decorated with various motifs—trees and birds, peacocks, flowers—produced at the time by Indian enamelists in cities such as Jaipur, Hyderabad, and Lucknow. These elements, the so-called *apprêts*, do not always appear in the "Oriental" stock books, but instead were included in the many lots of diverse stones that were sent from Bombay to London and Paris by Cartier's agents in India. The Cartier Archives in London have photographs of rows of stones, as well as miniatures of various sizes, in their original settings.[26] This creative approach, using Eastern *apprêts*, would continue throughout the early 1930s.

Two fabulous Hindu necklaces
Lady Mendl brought back
from India. First a blaze
of diamonds, fringed with
pearls and emeralds.
Below, a lacy collar of
rubies, pearls, and emeralds.

Chanel's
ruby and emerald
necklace which she
wears with everything –
even sweaters

Once it was an Indian pendant
of pearl and emerald tassels –
now it's Mlle. Toussaint's clip

Another magnificent necklace
of Lady Mendl's – a rigid tube
paved with pearls and diamonds

A Hindu chessman that is now
Lady Mendl's prized bibelot –
all gold, enamel, and diamonds

38 E. Lindner

"Bijoux des Indes"
Illustration by Ernest Lindner
Vogue Paris, June 1938, p. 34
Vogue, July 15, 1938, p. 38
Condé Nast Archives

CARTIER AND INDIAN JEWELRY FROM THE 1930S

In 1933, Jeanne Toussaint was named Creative Director at Cartier in Paris and breathed new life into the company, notably by reviving contacts with India. Indian jewelry was then in high style, as illustrated by the many articles in women's magazines. For example, the February 1934 issue of *Harper's Bazaar* reproduced an Indian necklace belonging to Daisy Fellowes with the caption, "She is wearing a beautiful antique necklace of rubies and emeralds, imported from India by Cartier,"[27] while the December 1934 English edition of *Vogue* titled an article, "The jewels of India come West."[28] This long, well-documented article describes the multiple contributions of Indian jewelry to Occidental jewelry—gems, cuts, special drilling methods for stones—but also the relationships between the jewelers and their Indian and European clientele, citing the Maharani of Cooch Behar, Indira Devi, and Princess Karam of Kapurthala, who are portrayed twice wearing jewelry "reset by Cartier."

Other European clients and collectors of Indian jewels were also featured in the press: Madame Muñoz, Madame Robert Lazard, Lady Mendl, Coco Chanel, and Jeanne Toussaint. The last three appeared in an article written by the jeweler Robert Linzeler, "Bijoux des Indes," which included color reproductions of a few of their jewels [LEFT]. He noted that Lady Mendl purchased her own jewels in India, in Bombay and Jaipur, and provided details of her transactions with Indian gemstone merchants.[29] These Indian-style jewels may therefore have been imported, reset, or created from original Indian elements, as was the case for a long clip formed of three tassels with pearls and emeralds, owned by Jeanne Toussaint. The necklace worn by Madame Muñoz appears to be very similar to an Indian necklace bought by Jeanne Toussaint on January 10, 1935, an "enameled gold necklace with pearls and rubies."[30]

In the 1930s, it appears that the ateliers were no longer using *apprêts* but entire Indian pieces of jewelry, which they disassembled, remounting the various elements of the piece differently. The most extraordinary example is a set of jewelry—a necklace, pair of bracelets, and earrings—purchased by the fashion designer Elsa Schiaparelli on April 11, 1935, that was created from a Hindu belt acquired in 1929 from the Aga Khan. The belt was disassembled in 1933; the stock notes indicate that the forty-eight elements were then divided up into different jewels, including the Schiaparelli set and a tiara sold on June 22, 1936, to the opera singer Ganna Walska [PP. 138-139].[31] Photographs of another set of jewelry for Ganna Walska were found in the Cartier Archives in London. The round flowers

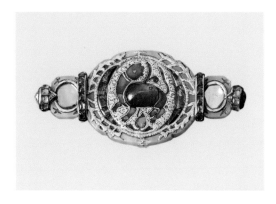

and leaves were reset in a tiara, and then into a necklace, before finally being sold as a bracelet in 1971 [PP. 136-137].[32]

These same stock books mention a brooch that was previously preserved in the Al Thani collection, with the description, "Era of the great Mughals, India, agate brooch with cabochon, ruby dog, inlaid with gold and two emerald crescents, two ruby links and two calibrated emeralds, in an Indian gold setting," purchased in 1924 from Gazdar and modified in 1935 by Lavabre [ABOVE].[33] Several jewels now held in public collections underwent this type of transformation, including a bracelet in the British Museum, an ornament in the Metropolitan Museum of Art [P. 128], and a few pieces in the Cartier Collection.[34]

JEANNE TOUSSAINT AND THE INDIAN INSPIRATION

After World War II, Cartier, still under the creative direction of Jeanne Toussaint [BELOW], began to develop other styles of jewels, which, while they were less inspired by Indian jewels, nevertheless had the same sensuality and polychromatism aspect, through the use of bold, new color harmonies and the generous use of gemstones. As early as the 1910s and 1920s, the company had already set itself apart with its decision to

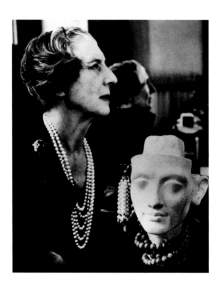

make use of unusual color combinations, like the pairing of blue sapphires with green emeralds, which had never been done before in Europe. Louis Cartier called this his "peacock decor." Turquoise blue was also popular combined with the flecked, deep blue of lapis lazuli, which reproduced the colors of the ceramic tiles used in Iranian architecture. Iranian turquoise, which was highly prized in the nineteenth century, was engraved and gilded and used in many Eastern-style jewels, including a pair of tortoise-shell bracelets from the 1930s and a set of jewelry made in recent years at Cartier.[35] Onyx, coral, and lapis lazuli have always been used in North African jewelry; these pieces were discovered and then copied in Europe from the nineteenth century onward.[36]

Lion brooch
India, 18th century
Cartier Paris, 1935
Gold, agate, rubies,
emeralds, diamonds
2.5 × 5.7 cm
Al Thani sale, Christie's, 19th June 2019, no. 166
Private collection

Jeanne Toussaint
Photograph by Cecil Beaton, 1962
The Cecil Beaton Studio Archives

More than merely associating colors, it was the multitude of hues in the combined materials that made the Indian-style jewels so successful. Alongside emeralds engraved with flowers or inscriptions from the Mughal era, carved into the hexagonal crystal structure of emeralds with a fairly thin, table cut, was an abundance of stones with different cuts and polishes: emeralds cut into smooth, fluted, or carved beads, polished as drops, or flat-cut into leaf and flower shapes and engraved. These cuts were also used for sapphires and rubies, which were bought in entire lots for the Cartier ateliers. Engraved leaves and flowers were inlaid into rock crystal or into jade applied to silver or gold objects and to Indian jewelry from the Mughal era. Cartier's brilliant invention from the mid-1920s was to use these varied, carved stones to make pieces of jewelry that were initially referred to as multicolored, before being baptized as "Tutti Frutti."[37] Inspired by hanging tassels and cluster ear-pendants, in 1938 the ateliers made an extraordinary Hindu necklace, featuring cluster pendants with carved stones in multiple colors [P. 151].[38] Cartier also borrowed from Indian jewelers the technique of setting a diamond in the center of gemstones cut into beads, creating even more sparkle and reflection. In the 1960s and 1970s, Jeanne Toussaint set many of these gemstones *en masse*, creating large necklaces with several rows of different types of gems; she also created three-dimensional effects, like movable ornaments on rings and in the center of necklaces [PP. 152-155]. In her later years, she built on the color harmonies introduced in the 1930s by adding the mauve of amethyst alongside turquoise or lapis lazuli. These gems from India had often already been set, and the drilled holes and fastening methods were different from those used in Western jewelry techniques. To set these gems, the Cartier ateliers had to adapt and draw on their accumulated expertise, notably to set the drop-shaped gems that they managed to mount on head ornaments.

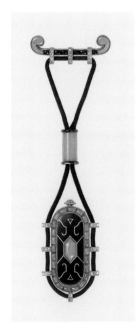

The imported Indian jewels and the flexibility of their settings also allowed Cartier jewelers to learn new techniques when older Indian pieces were repeatedly disassembled and reset; this also provided fresh inspiration for their own work. There were the aigrettes, of course, known as *sarpech*, tassels of pearls, open bracelets featuring heads of *makara*, and other jewels and motifs that had been well known since the seventeenth century, but the *bazuband*—a bracelet worn on the upper arm,

Bazuband
India, 1st half of the 19th century
Low title silver, silk, and cotton
3.3 × 14 cm
Musée des Arts Décoratifs, Paris
Purchased at the Castellani sale, 1884
Purchased by Castellani at the Centennial
International Exhibition, Philadelphia, 1876
Inv. 975.74

Watch brooch
Cartier Paris, 1923
LeCoultre movement
Gold, platinum, diamonds, coral,
onyx, enamel, silk
Case: 4 × 2.5 × 0.6 cm
Cartier Collection
Inv. WB 16 A23

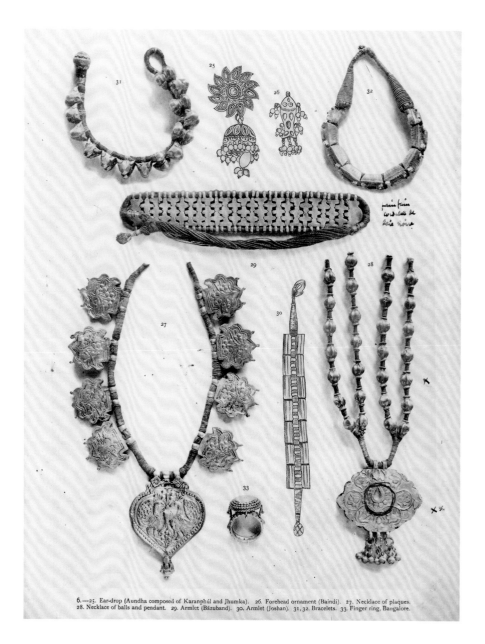

6.—25. Ear-drop (Aundha composed of Karanphúl and Jhumka). 26. Forehead ornament (Baindi). 27. Necklace of plaques. 28. Necklace of balls and pendant. 29. Armlet (Bázuband). 30. Armlet (Joshan). 31, 32. Bracelets. 33. Finger ring, Bangalore.

whose unique assembly method was also used for necklaces and hair ornaments—was something new [P. 119]. Many Indian bracelets and necklaces were decorated with geometric patterns of gold, in "Z" shapes, or in chevrons strung on interior strands or placed at the edges. The Cartier workshops did not replicate these types of settings, but sought to create the same flexibility and tried to make each element in the design mobile [P. 119].

In the 1950s, 1960s, and 1970s, Indian-inspired jewelry was still in fashion, but the designs moved away from the original, Indian models. These were mostly necklaces with almond-shaped pendants, with colored

Thomas Holbein Hendley
Indian Jewellery, pl. 6
W. Griggs, London, 1909
The *bazuband* is annotated
by Louis Cartier "faire faire/
cordelette de/soie noire"
Cartier Paris Archives
BibCart/102

gemstones at the center. Coral and mother-of-pearl pendants were hung on long, Berber-inspired *sautoir* necklaces [P. 118]. In 1959, *Vogue* reproduced a so-called "Oriental-style" necklace by Cartier decorated with bouquet motifs "whose design evokes Persian miniatures."[39] The five hexagonal-shaped pendants, adorned

with a bouquet of three ruby and emerald flowers, were no longer Indian jewelry but were made in the Maison's atelier in the Indian style. Thus, the jewels created in the Cartier workshops retained only a trace of the original Indian jewels. Later, the hippie movement coincided with the rediscovery of India and its jewelry and, once again, as in the 1930s, clients went directly to the source in search of jewels. Mexican actress María Félix (1914–2002), a major client of Cartier, shared a love for Indian jewelry with Jeanne Toussaint; she wore "hippie haute couture" outfits matched with a large necklace and a nineteenth-century Ottoman coat.[40]

The fashion for Oriental and, specifically, Indian jewelry was widespread among Parisian jewelers throughout the entire twentieth century. The Boucheron and Chaumet archives contain records of this trend as well, but none pursued it so consistently and with such a vast production as Cartier. The Maison's originality lay not only in adapting the Middle Eastern and Indian ornamental repertory, but also in combining it with other sources of inspiration. By adopting certain forms of jewelry, by selecting certain materials and colors, and by developing innovative techniques derived from the study of jewelry produced outside of Europe, Cartier designers developed the conceptual, formal, and technical foundation for the Maison's identity, which is clearly visible in contemporary collections today.

Design of a *bazuband*
Charles Jacqueau
Ink on vellum paper
17.8 × 6.3 cm

Petit Palais, Paris,
gift of the Jacqueau family, 1998
Inv. PPJAC02341

1. This is the word that appears on the invitation card for the 1912 Cartier exhibition in London (see note 16).

2. And yet it was during this first world's fair that the Victoria and Albert Museum in London purchased its first pieces of contemporary Indian jewelry.

3. Hendley, 1909. This book is in the Cartier library and was available to its designers (inv. BibCart 102). Some of the illustrations are annotated.

4. Nadelhoffer, [1984] 2007, p. 155; New York, London, and Chicago, 1997–2000, p. 158.

5. Punjab, c. 1902, *King Edward VII and Queen Alexandra as Emperor and Empress of India*, miniature, gouache on paper, New Delhi, National Gallery of Modern Art, inv. 2336, reproduced in Untracht, 1997, p. 373. The sovereigns did not, in fact, travel to Delhi; the king was represented at the ceremony by his brother, the Duke of Connaught. In the miniature, the queen is wearing a double necklace of diamonds and an Indian dress given to her by Mary Curzon, the wife of the viceroy of India, over which she wears a large necklace of ruby medallions surrounded by pearls and with two emerald pendants. Cartier provided the rubies, but because we could not find the necklace or a photograph in the company's archives, we do not know with any certainty what the Indian-style necklace ordered by Queen Alexandra looked like.

6. Two pairs of gold and turquoise earrings in 1872, one pearl necklace with enamel plaques in 1879, and one necklace of India coins in 1884 (Nadelhoffer, [1984] 2007, p. 156).

7. New York, Morgan Library, invoices from May 20, 1903, and May 15, 1908; see Henon-Raynaud in this volume, p. 96.

8. Tavernier, [1676] 1882; see also Lugand, 2018; Paris, 2018.

9. Cartier Archives, India correspondence; in this letter Jacques lists a series of antique objects he purchased, including a book and pieces of jewelry.

10. Cartier Archives, Oriental stock book begun in February 1912, just prior to Jacques's return to Paris; one of the first items, a tiara, came from Schwaiger on August 3, 1911. Two other items, a turquoise Ganesh and a crystal Buddha, were transfers of hardstones as the Oriental stock was being compiled in 1912. The decorators Clément Mère and Franz Waldraff added a screen and a leather base to the Buddha.

11. Cartier Archives, India correspondence, letter dated February 8, 1912, on letterheaded paper addressed to Maurice Richard in Bombay, concerning the acquisition of a privately owned necklace of emerald beads and an offer for a batch of cabochon sapphires and two batches of pink pearls. Letterhead translated from the French.

12. Cartier Brickell, 2019, p. 159.

13. In the Oriental stock book, dating from February 24, 1912, to June 7, 1919, his name is listed alongside those of Kanjimull, the Paris expert Charles Schutz, Paris dealers Langweil, Frances Vitali and Sons, P. Mallon, Kalebdjian, and the English and Indian merchants Tonsett and Ram Sarup.

14. Cartier Archives, India correspondence, typewritten letter.

15. Cartier Archives, Jacques Cartier travel journal; Dubai, 2019.

16. The invitation for the inauguration of this exhibition included the following text: "Messrs. Cartier respectfully invite their patrons to inspect an exhibition of Oriental Jewels and *Objets d'Art* recently collected in India. For one week from Tuesday the 28th of May. 175 New Bond St." This invitation was reproduced by Hans Nadelhoffer (Nadelhoffer, [1984] 2007, p. 153) and by Susan Stronge (Stronge, 2001, p. 69), but could not be located in the archives.

17. *Exposition d'un choix de Bijoux Persans, Hindous & Thibétains adaptés aux Modes nouvelles. Le 2 Juin 1913 chez Messieurs Cartier, rue de la Paix 13*, in Paris, 1913 (Cartier Archives). The cover has a simple layout, a copy of an Oriental binding: red mandorla and cusped arches between gilded borders, as opposed to the London invitation which features an Oriental-style motif, with the depiction of a maharaja, and an illuminated framework inspired by Persian manuscripts, with pseudo-script in the cartouches.

18. "Afin de conserver à ces Bijoux leur caractère et leur authenticité, MM. Cartier n'ont pas cru devoir changer les parties en or bas ni les boules de verre en imitation de turquoises et autres trompe-l'œil orientaux, mais les ont signalés, autant que se peut, dans le présent catalogue."

19. The following catalogue numbers were not reproduced or were not identified: nos. 71, 72, and 76. Number 74 was linked to another set of photographs. In November 1913, forty-eight of the eighty-two pieces of jewelry on display were sold in Paris.

20. Inv. 30587, bequest by Jean Jacques Reubell in 1933, in a green case marked "Cartier," sold for 600 francs by Cartier on June 10, 1913. We do not know how Jean Jacques Reubell acquired it, as his name does not appear as the first purchaser.

21. Paris, 1913, nos. 35, 68, 72, 73, 74, and 76, and stock books. Thanks to Violette Petit, as well as to Aude Barry and Sophie Brahic, at the Cartier Archives for comparing these.

22. *Catalogue of a Collection of Jewels ... created by Messieurs Cartier ... from the Hindoo. Persian. Arab. Russian and Chinese* (Cartier Archives).

23. Cartier Collection, CL 183 A 13, pendant brooch designed by Charles Jacqueau and made by Picq atelier in 1913; New York, London, and Chicago, 1997–2000, cat. no. 30, pp. 96–97; Chaille et al., 2018, vol. 1, p. 145.

24. In the Oriental stock book from 1912 to 1917, the Parisian ateliers (Picq and Lavabre) are mentioned, but it is hard to determine whether they did a simple repair or entirely created an Indian-style jewel, as with a "cornucopia" bracelet and an "Indian palm" brooch.

25. The jewelry made by Cartier for the Indian maharajas will not be discussed here, as the subject was covered at length by Hans Nadelhoffer (Nadelhoffer, [1984] 2007), Judy Rudoe (New York, London, and Chicago, 1997–2000), and Susan Stronge (Stronge, 2001). See also Jaffer, 2007; London, 2009; Jaffer, 2013; Paris, 2017.

26. Primarily in the London photo archives. In Paris, the *apprêts* were often only indicated in the stock notes for each object or final piece of jewelry, which sometimes refers to a separate *apprêt* stock sheet, but not always. Furthermore, the *apprêts* were not photographed individually as they were in London, where they seem to have arrived in lots.

27. "In Comes the morning mail," *Harper's Bazaar*, February 1934, p. 69.

28. Two versions of this article were published: in the UK edition of *Vogue*, December 26, 1934, pp. 10–13, and in the American edition of *Vogue*, April 1, 1935, pp. 124–125. The photographs of Princess Karam of Kapurthala were printed in the UK edition.

29. Robert Linzeler, "Bijoux des Indes," *Vogue Paris*, June 1938, pp. 35–36, and 94. These reproductions were used to illustrate another article published in the American edition of *Vogue*, July 15, 1938, pp. 38–39. The article, by John McMullin, was titled "We went to India," and recounts the author's trip to India with Lady Mendl. I would like to thank César Imbert from Documentation Cartier for providing me with this further clarification.

30. General stock book, which is included in the "Oriental" stock book of 1912–1919, purchased on November 22, 1917, from Frances Vitali and adapted by Mental (Léon Mental, jeweler who worked from 1913 to 1924), transformed on April 16, 1930, by the Lavabre ateliers, which added fifteen rubies and restrung the necklace.

31. Notebook of "*apprêts orientaux*"; album of Indian jewelry and sets: pair of ear-clips, pair of bracelets, necklace; bandeau with 21 motifs, whose item numbers come from the Muslim stock (number preceded by the letter "M" for Muslim).

32. Sales catalogue, New York, 1971, no. 104. The Parisian stock books indicate the sale to the opera singer, on July 27, 1936, of a clip brooch with the same décor, indicated as a Hindu motif, modified by Lavabre and bought back by Jacques Cartier on September 21, 1938.

33. "Époque des grands Moghols, Inde, Broche en agate avec chien rubis cabochon retournés Incrustés d'or et de deux croissants émeraudes, deux liens rubis et deux liens émeraudes calibrés, monture à l'indienne or"; stock book, modified in May 1935 by Lavabre: 28 stones recut, supplied 2 rubies, 10 rubies, 16 emeralds, 2 roses, and a case, sold on July 13, 1935. In fact, the animal depicted more closely resembles a lion than a dog.

34. See p. 128.

35. Two bracelets in the collection of the Musée des Arts Décoratifs (inv. 28313 and 28314); a pair of Cartier bracelets, 1938, BT 38 A 38, Cartier Collection; and set of jewelry (necklace and ring), 2014.

36. See Album Louis-Eugène Crouzet, Paris, Bibliothèque Forney. Pendant jewels by Alphonse Fouquet, Eugène Fontenay, among others.

37. Name registered as a trademark in 1989, when older pieces reappeared at auction.

38. See p. 151. This necklace was worn by Madame Robert Lazard in 1938, and credited to Cartier (*L'Officiel de la couture et de la mode*, December 1938, p. 56). Madame Lazard was photographed again with the necklace the following year (ibid., July 1939, p. 70). These photographs of the Seeberger brothers were published in the society pages.

39. "Bijourama de Vogue," *Vogue Paris*, no. 393, October 1959, p. 153.

40. "Collier Chapelet Musulman," similar model in the Cartier Collection, inv. NE 45 A70. María Félix also owned a Hermès Oriental-style coat (sales cat., Paris, 2007, lot 494).

Court sash (detail)
Iran, 17th century
Silk, silver threads
465 × 66 cm
Musée du Louvre, Paris,
département des Arts de l'Islam
Inv. MAO 616

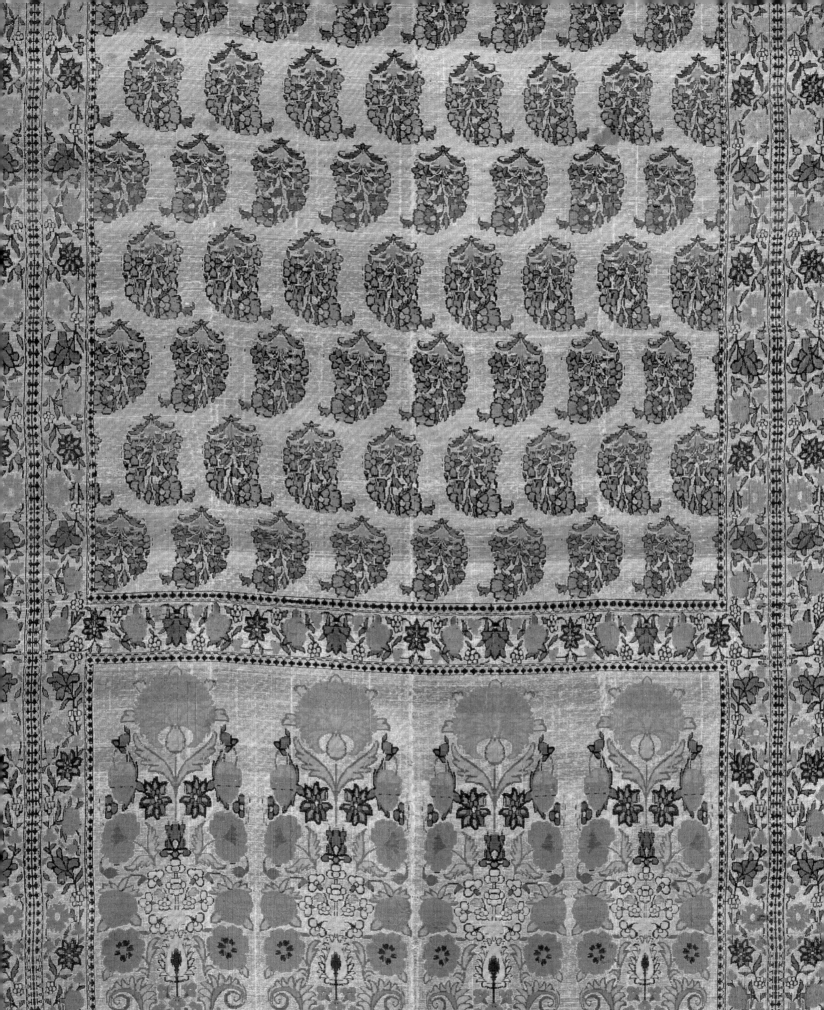

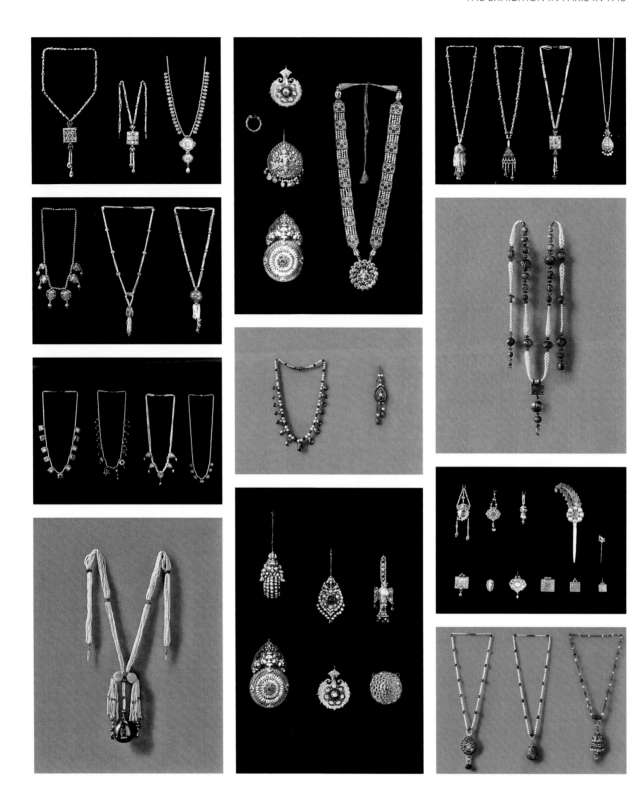

Photographs of the 82 Indian
jewels and objects presented at
the *Exposition d'un choix de Bijoux
Persans, Hindous & Thibétains
adaptés aux Modes nouvelles*

Paris, Cartier boutique, 1913

Cartier Paris Archives
Inv. 34281318 à 34513040

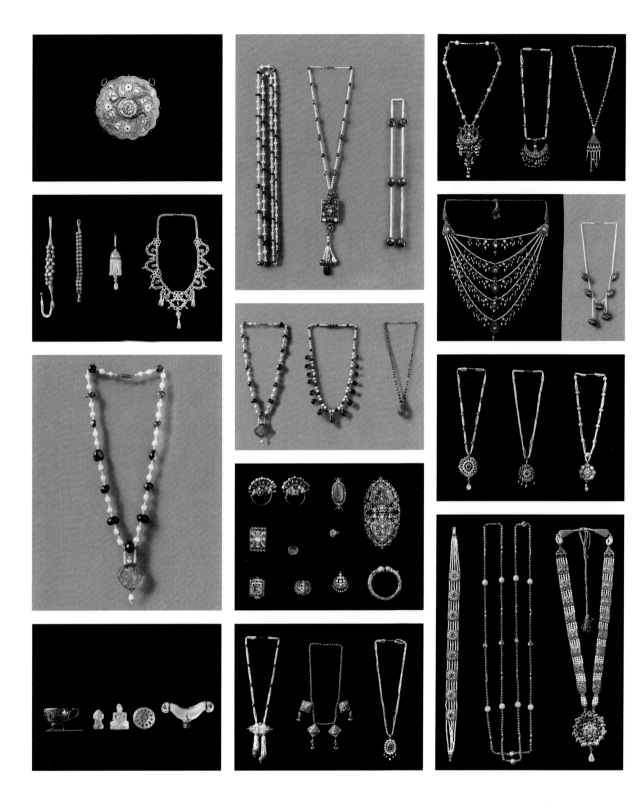

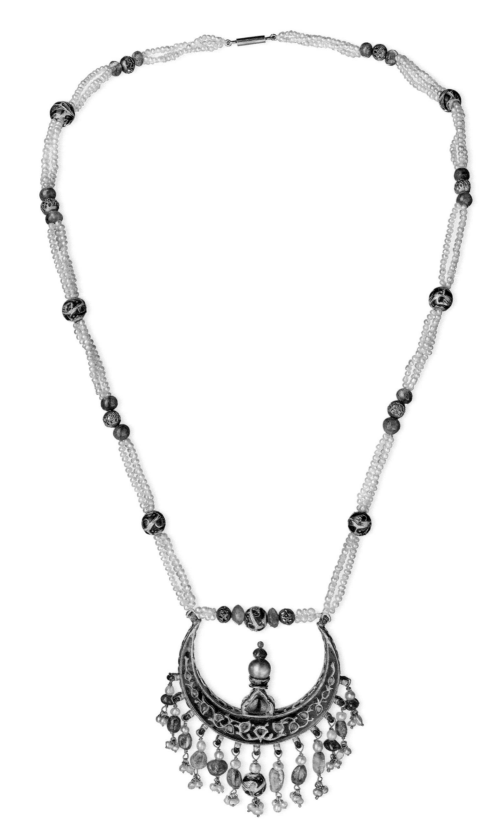

Necklace

India, 17th-18th century
Cartier Paris, 1913
Gold, smoky quartz, emeralds,
rubies, jade, pearls, enamel
Pendant: 6 × 5 cm
Necklace: length 55 cm

Presented at the Cartier boutique in 1913, cat. 12
Musée des Arts Décoratifs, Paris
Jean-Jacques Reubell bequest, 1934
Inv. 30587

Indian-style necklace with pendant

India, 18th–19th century
Cartier Paris, special order, 1928
Gold, diamonds, rubies, emeralds,
pearls, jade, enamel, silk
Necklace without the back cord: length 52 cm
Pendant: diam. 4.2 cm

Cartier Collection
Inv. NE 34 A28

The pendant, from Louis Cartier's stock of
apprêts, was originally placed on a necklace
of emerald beads. In 1928, at the request
of a client, this white jade pendant, carved
on one side and set with carved rubies and
emeralds on the other, was attached to this
necklace composed of "18 ruby and diamond
plaques strung on 360 pearls in 5 strands,"
which was typical of the Mughal period.

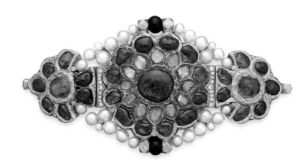

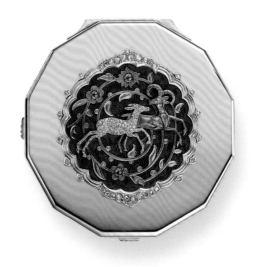

Necklace with pendant (detail)

Pendant: Iran, 19th century
Cartier London, 1926
Platinum, gold, onyx, emeralds, rubies,
diamonds, pearls, enamel, cotton
Pendant: 11.4 cm

Private collection, New York

Brooch

Central motif of an armband
North India, 18th-19th century
Cartier Paris, c. 1920
Gold, rubies, sapphires, emeralds,
diamonds, pearls, onyx
5 × 9.5 cm

The Metropolitan Museum of Art, New York
Gift of George Blumenthal, 1941
Inv. 41.100.118

Music box

Central motif: Iran,
19th-20th century
Cartier London, 1926
Gold, platinum, diamonds, emeralds,
rubies, enamel
6 × 2.3 cm

Cartier Collection
Inv. BS 12 A26

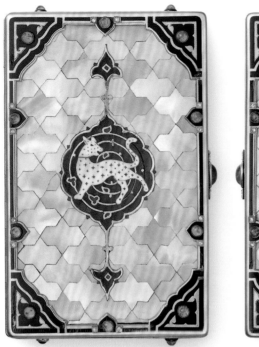

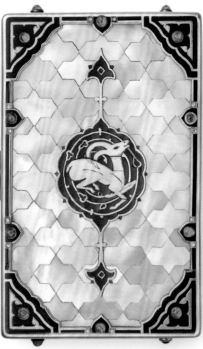

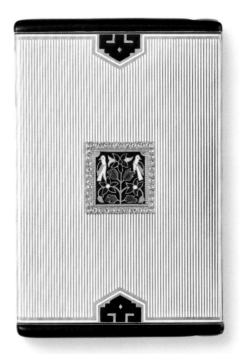

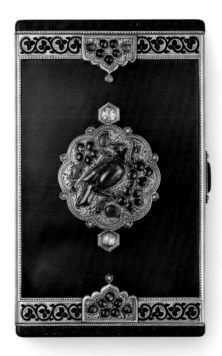

Vanity case (front and back)

Two plaques: Iran, 19th-20th century
Cartier Paris, 1925
Gold, platinum, mother-of-pearl, galalith,
ivory, emeralds, diamonds, enamel
9.5 × 6.1 × 1.8 cm

Cartier Collection
Inv. VC 53 A25

Vanity case

Plaque: Iran, 20th century
Cartier Paris, 1932
Gold, platinum, diamonds, enamel
8.7 × 5.8 × 1.6 cm

Cartier Collection
Inv. VC 29 A32
Not exhibited

"Persian" cigarette case

Medallion: India, 18th-19th century
Cartier Paris for London, 1926
Gold, agate, lapis lazuli, sapphires,
rubies, emeralds, diamonds, enamel
8.7 × 5.6 × 1.8 cm

Cartier Collection
CC 87 A26

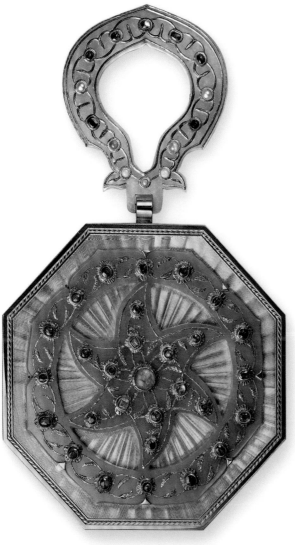

Vanity case

Jade plaques: Iran, 19th-20th century
Cartier Paris, special order, 1936
Gold, silver-gilt, gray jade, diamonds,
rubies, emeralds, colored stones, pearls
20.8 × 12 × 3 cm
Formerly in Daisy Fellowes collection
Cartier Collection
Inv. VC 05 A36

Semi-spherical clock

Ceramic: Iran, 12th-13th century
Cartier Paris, 1943
Gold, silver-gilt, hard stone, ceramic
with overglaze decoration, coral, diamonds
13 × 15 cm
Cartier Collection
Inv. CS 17 A43

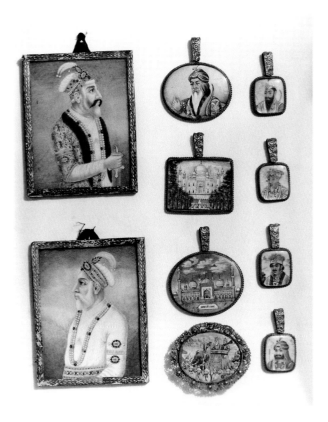

Portraits and views
of monuments

India, 19th century
Painting on ivory
Photograph, 1930
26.9 × 34.2 cm
Cartier London Archives
Inv. C1176

Table cigarette box

Mughal portrait: India, 19th century
Cartier New York, 1930
Gold, miniature, enamel
5.2 × 14.5 × 8.8 cm
Cartier Collection
TB 02 A30

123.—848. Amulet; carved black stone with white beads; Kandahar. I.M. 76. 849. Armlet, gypsum; worn as an amulet; Kandahar. I.M. 77. 850. Necklace of human bone and ivory, carved; worn by Nagpa sorcerers; 19th century. I.M. 404.

Thomas Holbein Hendley

Indian Jewellery, pl. 123
W. Griggs, London, 1909
Annotated by Louis Cartier

Bracelet

Amulets engraved with religious inscriptions:
Iran, 19th to early 20th century
(provided by the client)
Cartier Paris, 1923
Gold, hardstones, diamonds, enamel
5 × 23 cm

Formerly in the Sir Alfred Chester Beatty Collection
Fabrice Gros, Antwerp

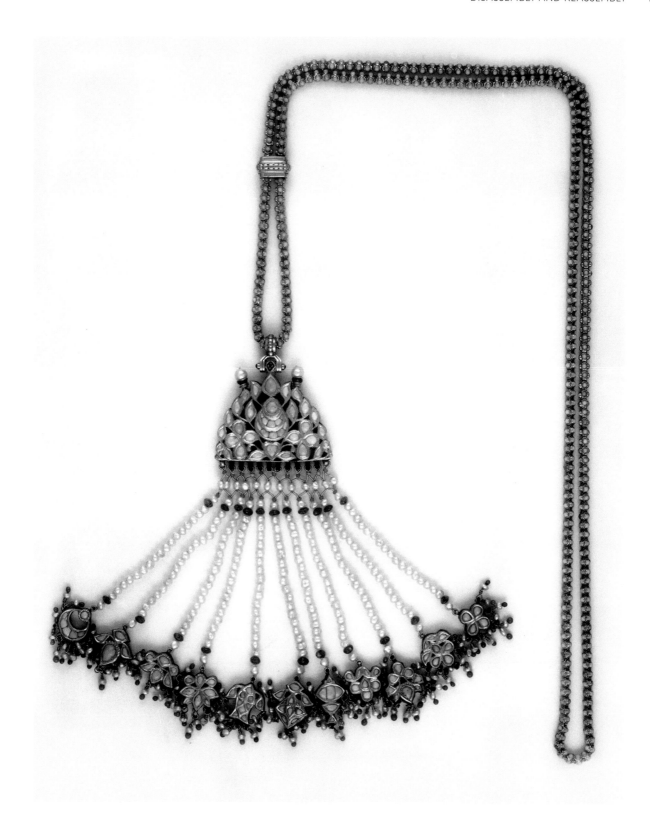

Hindu necklace

Indian elements, 19th century
Cartier Paris, 1932 and 1937
Gold, turquoise, pearls,
colored stones, diamonds
Photograph, 1937

Cartier Paris Archives
Inv. 320552430

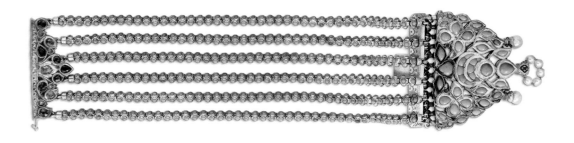

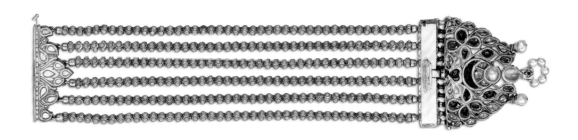

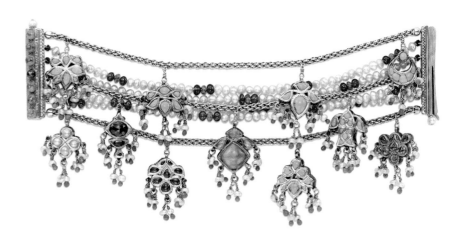

Bracelet (front and back)

Elements of the *Hindu* necklace:
India, 19th century
Cartier Paris, special order, 1938
Gold, platinum, turquoise, colored stones,
rubies, emeralds, sapphires, diamonds,
natural pearls, enamel
4.5 × 21 cm

Private collection

Bracelet

Elements of the *Hindu* necklace:
India, 19th century
Cartier Paris, special order, 1938
Gold, natural pearls, emeralds, rubies,
colored stones, turquoise
6 × 16 cm

Private collection

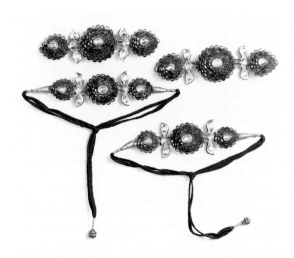

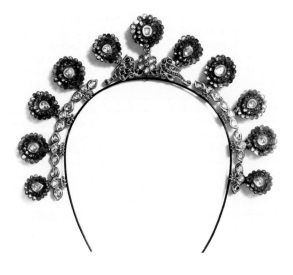

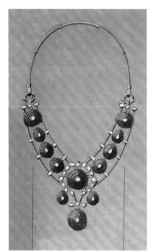

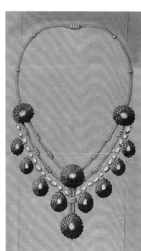

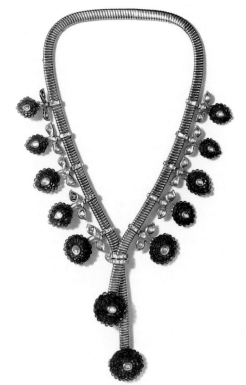

Four armbands

India, Jaïpur, 19th century
Photograph, 1938
Photograph album of oriental objects

Cartier London Archives
C2242_C

Two designs of a necklace

Cartier London, c. 1938
Gouache on paper
27.9 × 13.9 cm
25.4 × 15.5 cm

Ganna Walska Lotusland Archive, California
Ganna Walska Archives, scrapbook

Head ornament and necklace

Cartier London, 1935 and 1938
Gold, rubies, diamonds
Photographs, 1935 and 1938

Cartier London Archives
A9883_A et A11181

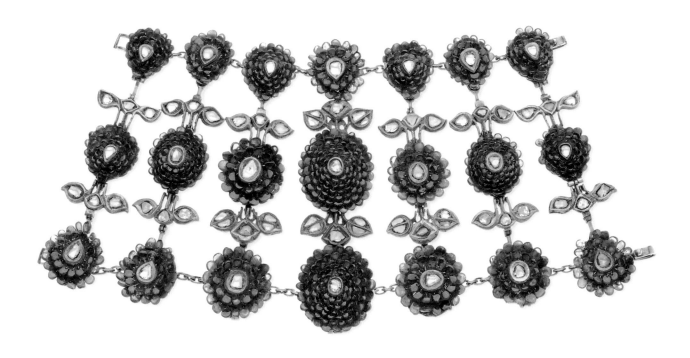

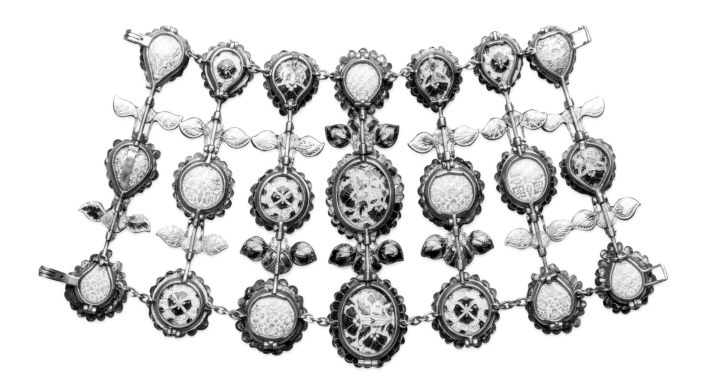

Bracelet (front and back)

India, Jaïpur, 19th century
Cartier London?
Gold, rubies, diamonds, enamel
11.4 × 22.9 cm

Formerly in the Ganna Walska Collection,
purchased by Doris Duke, 1971
Shangri La, Museum of Islamic Art,
Culture & Design, Honolulu, inv. 57.74
Not exhibited

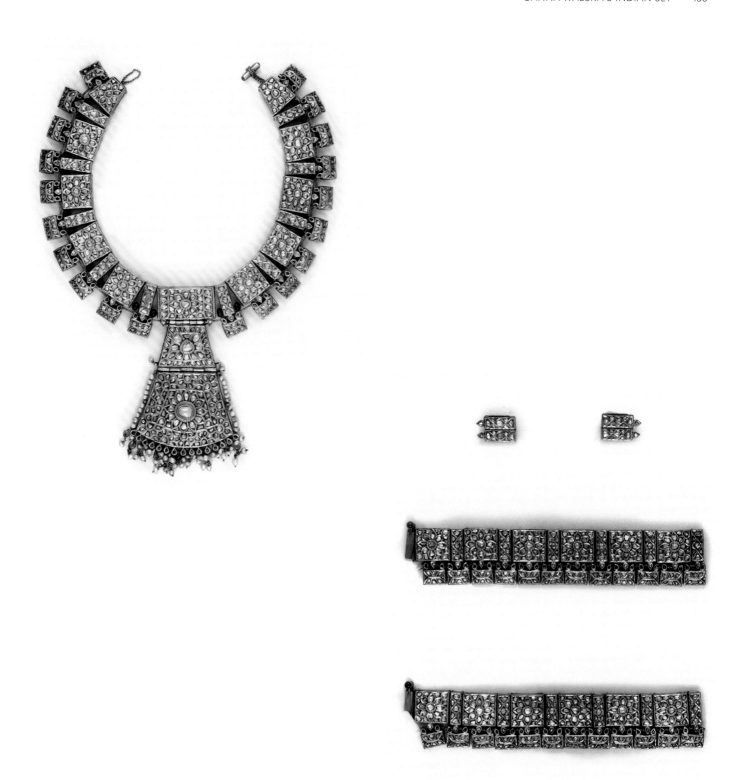

Indian set

A necklace, two bracelets,
and a pair of earrings
Made from an Indian belt
purchased from the Aga Khan in 1929
Cartier Paris, 1935
Photograph, 1935
Photograph album of oriental objects

Cartier Paris Archives
Inv. 297752430 et 297762430

A headband, bought by Ganna Walska
and photographed by Man Ray, was made
in 1936 from the same Indian belt.

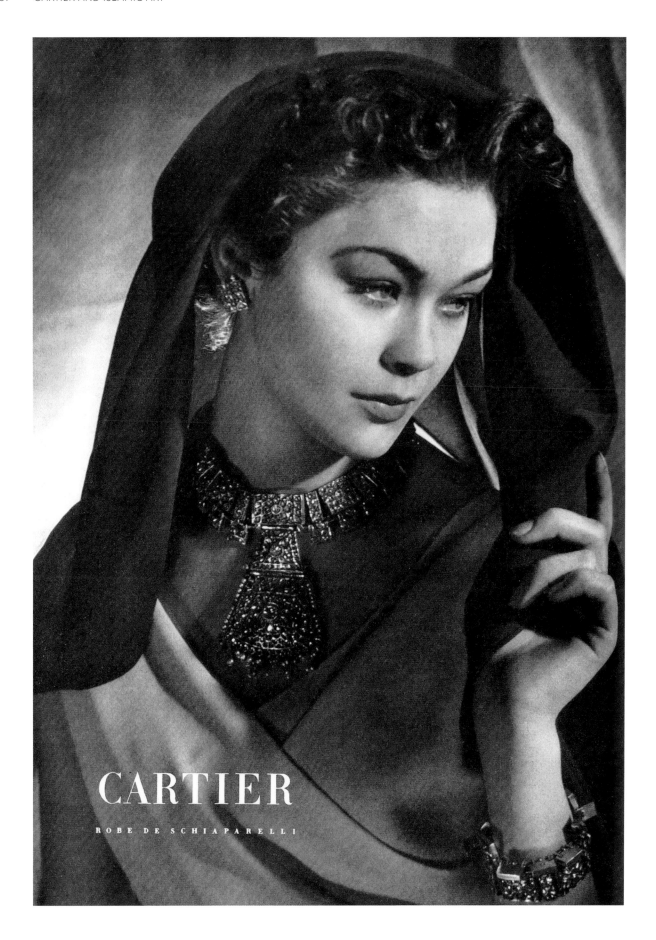

"Cartier, Schiaparelli dress"
Photograph by Horst P. Horst
Vogue Paris, May 1935, p. 22
Condé Nast Archives

Set purchased by Elsa Schiaparelli
and reproduced on a model wearing a sari
dress created in 1935 by the fashion designer.

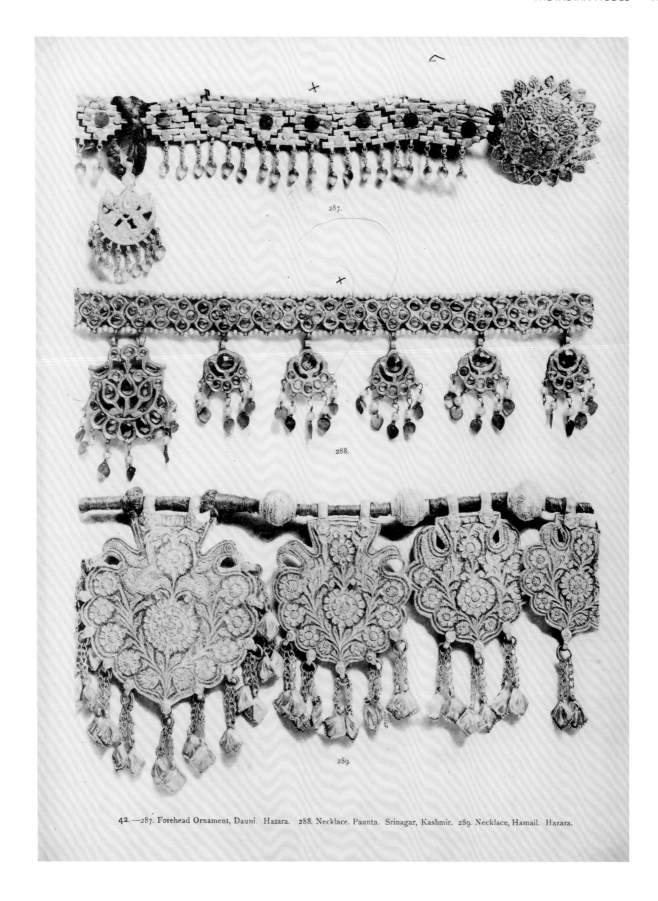

42.—287. Forehead Ornament, Dauni. Hazara. 288. Necklace. Paunta. Srinagar, Kashmir. 289. Necklace, Hamail. Hazara.

Thomas Holbein Hendley

Indian Jewellery, pl. 42
W. Griggs, London, 1909
Annotated by Louis Cartier

Cartier Paris Archives
Inv. BibCart/102

Bandeau

Cartier New York, special order, 1924
Platinum, diamonds, natural pearl
5.25 × 18 cm

Formerly in Nanaline Duke collection,
Doris Duke's mother
Cartier Collection
Inv. HO 28 A24

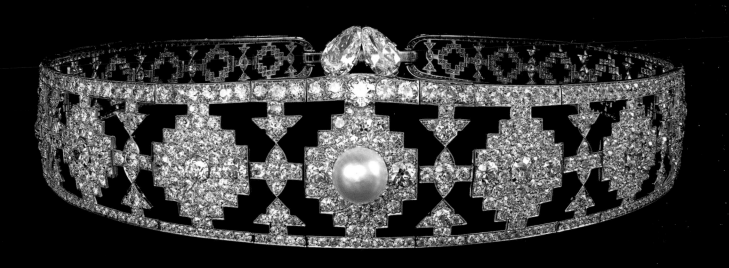

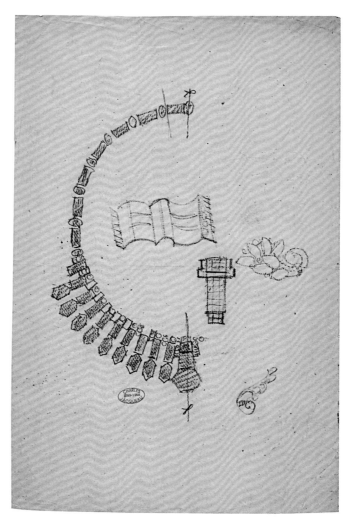

Designs for two necklaces
inspired by India

Charles Jacqueau
Graphite and gouache
on transparent vellum paper
Graphite and blue pencil
on transparent vellum paper
19.7 × 27.3 cm, 27.3 × 18.6 cm

Petit Palais, Paris,
gift of the Jacqueau family, 1998
Inv. PPJAC02000 and PPJAC02001

Necklace

Cartier Paris, 1948
Platinum, gold, diamonds
7 × 37 cm
Cartier Collection

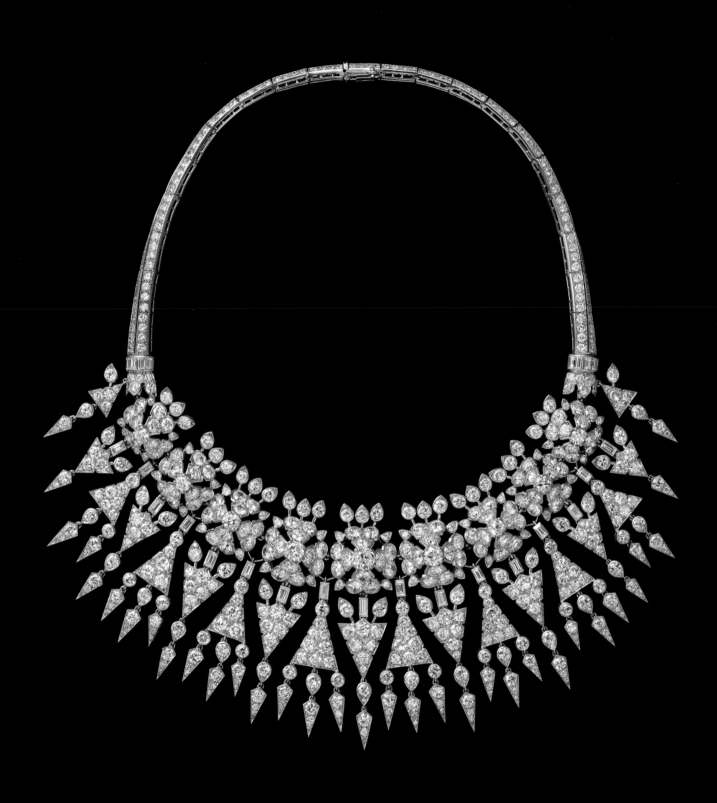

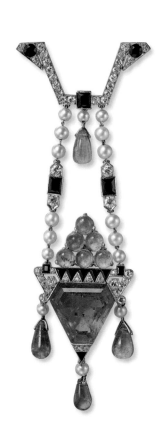

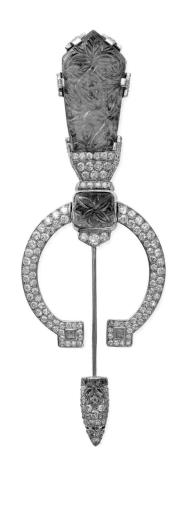

Necklace (detail)

Cartier Paris, 1923
Platinum, gold, enamel, emeralds,
coral, onyx, diamonds
24.5 cm
Private collection, Florida

Brooch

Cartier Paris, 1913
Platinum, diamonds, emeralds,
natural pearls, onyx
9.7 × 3.6 cm
Exhibited in New York in 1913, no. 50
Cartier Collection
Inv. CL 183 A13

Cliquet brooch

Cartier London, 1924
Platinum, gold, diamonds, emeralds
Small emerald: old Indian cut
11 × 3.9 × 0.9 cm
Cartier Collection
Inv. CL 03 A24

Ring

Cartier London, 1928
Platinum, emerald, rubies, sapphires,
onyx, diamonds, enamel
3.3 × 2.1 cm
Private collection, New York

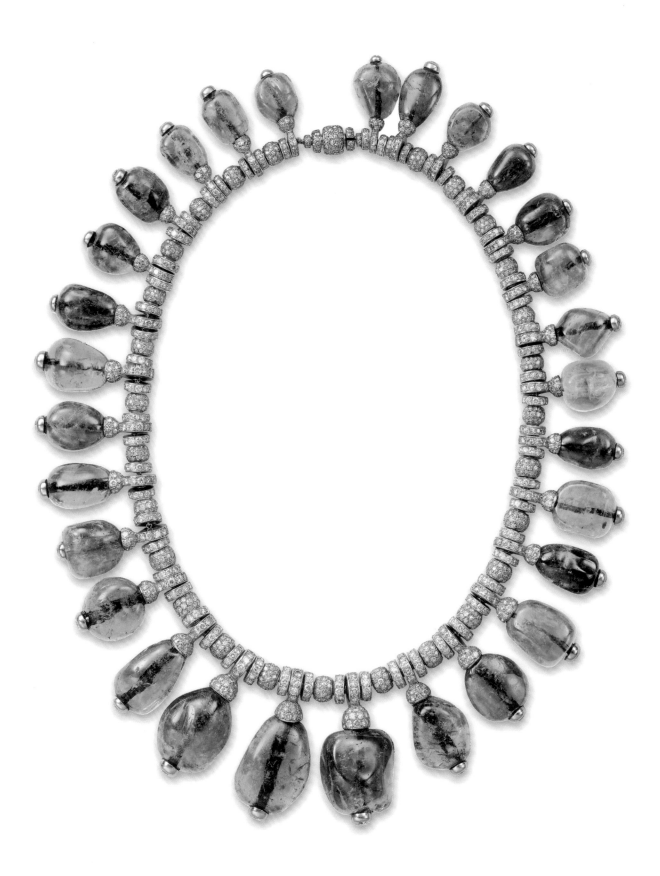

Necklace

Cartier London, 1938
Lengthened by Cartier Paris, 1963
Platinum, diamonds, emeralds
44 cm (open length)

Formerly in Merle Oberon collection
Private collection

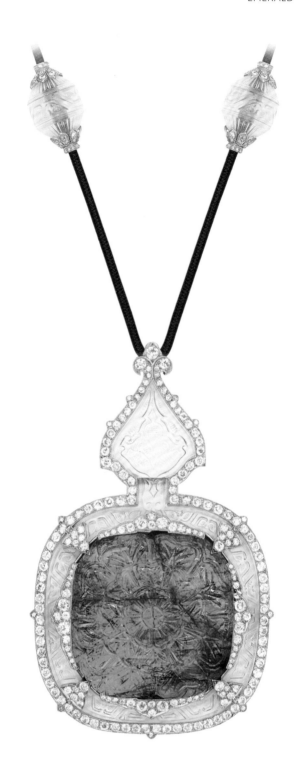

Necklace (detail)

Cartier Paris, 1912
Platinum, emerald, rock crystal, diamonds
Emerald engraved with
an Indian floral decoration
49.5 × 6.3 cm

Formerly in the collection of Victoria, Lady Sackville
of Knole, and her daughter Victoria Vita Sackville-West
Private collection, London/Monaco

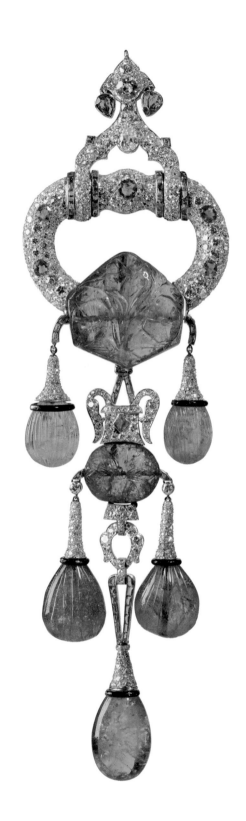

Pendant

Carved emeralds, India, 17th century
Cartier London, 1923
Cartier New York, 1928
Platinum, diamonds, emeralds, enamel
Persian inscription:
"The servant of Shah Abbas"
Length: 20.3 cm

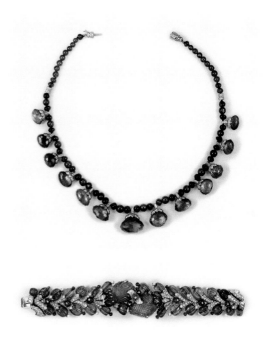

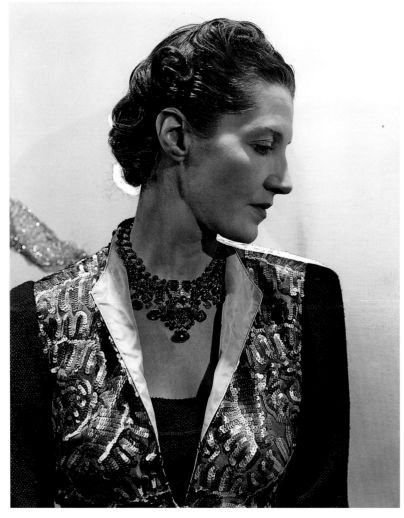

Necklace

Cartier Paris, 1928
Platinum, diamonds, sapphires,
and emeralds
Photograph, 1928
Formerly in Daisy Fellowes collection
Cartier Paris Archives
Inv. 197032430

Bracelet

Cartier Paris, 1929
Platinum, diamonds, sapphires,
emeralds, and rubies
Photograph, 1929
Formerly in Daisy Fellowes collection
Cartier Paris Archives
Inv. 226502430

Daisy Fellowes

Photograph by Cecil Beaton, 1937
The Cecil Beaton Studio Archive
Daisy Fellowes wears the *Hindu* necklace
of 1936 and a jacket by Elsa Schiaparelli.
The Cecil Beaton Studio Archives

Hindu necklace

Cartier Paris, 1936
Platinum, diamonds, sapphires,
emeralds, rubies, silk
Special order realized with the stones
of the previous necklace and bracelet
for Daisy Fellowes
Photograph, 1936
Cartier Paris Archives
Inv. 312352430

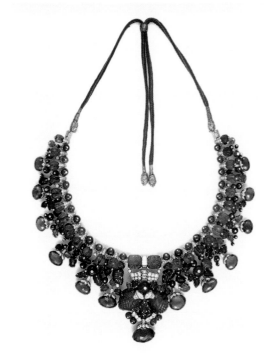

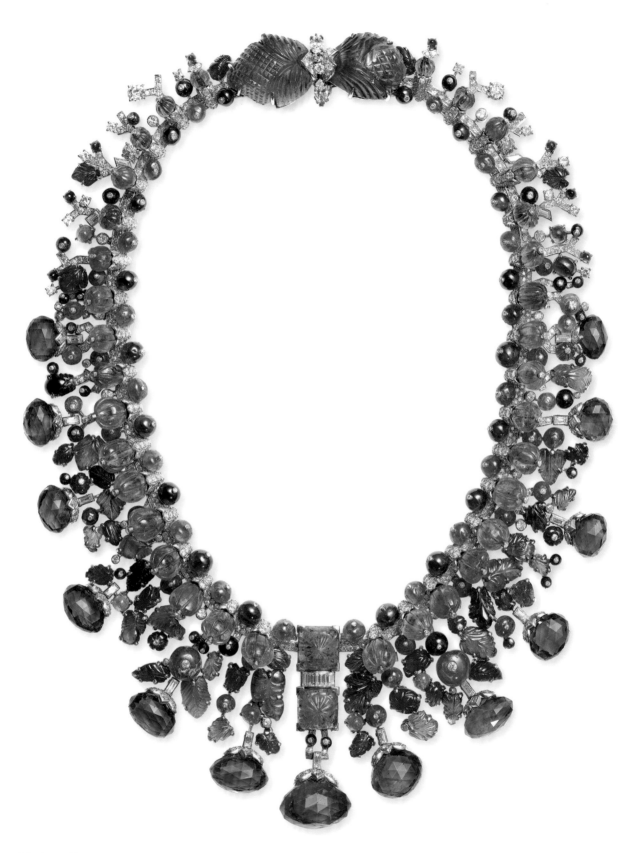

Hindu necklace

Cartier Paris, 1963
Platinum, gold, diamonds, sapphires,
emeralds, rubies
5.5 × 19 × 43 cm (open)
Made as a special order for Daisy Fellowes
in 1936, altered at the request of her daughter,
the Countess of Castéja, in 1963

Cartier Collection
NE 28 A36

Button

India, 18th century
Jade, gold, rubies, emeralds
set in *kundan*
Diam: 3.5 cm

Musée des Arts Décoratifs, Paris
Gift of the Marquise Arconati Visconti, 1916
Inv. 20351

Brooch,

Cartier London, c. 1935
Platinum, emeralds, diamonds,
sapphires, rubies
3 × 3.8 cm

Private collection/Courtesy of Albion
Art Jewellery Institute, Japan

Tutti Frutti brooch

Cartier London, 1929
Platinum, gold, emeralds, rubies,
sapphires, onyx, diamonds
8.7 × 3.45 cm

LA Private Collection

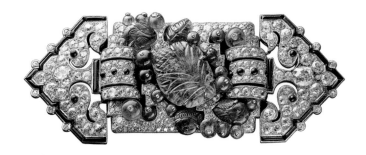

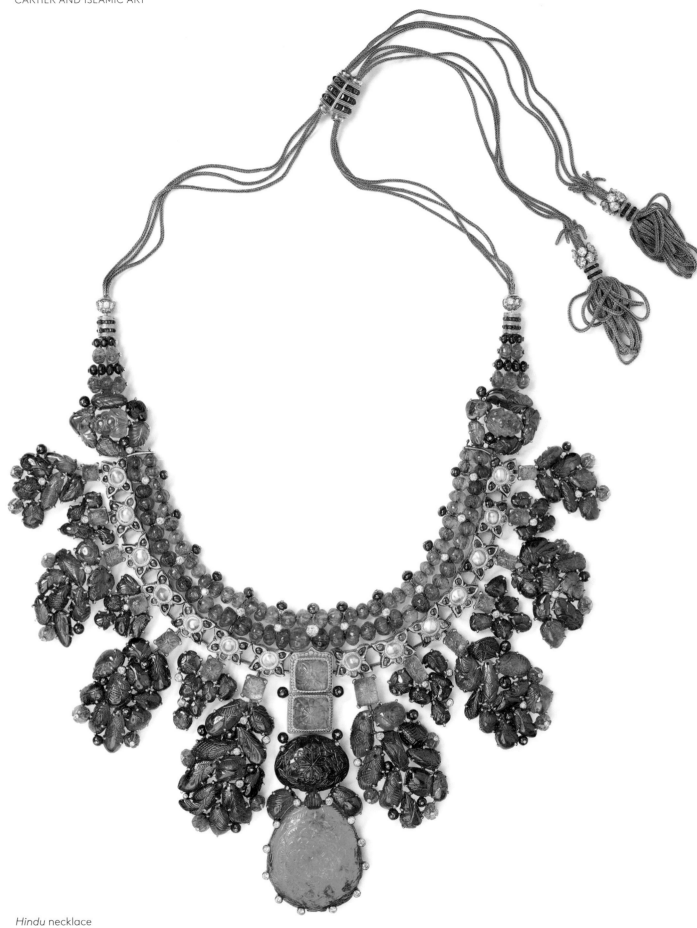

Hindu necklace

Stones and mounting: India, 19th century?
Cartier Paris, special order, 1938
Gold, platinum, diamonds, emeralds,
rubies, sapphires, pearls, enamel
Height at center: 11 cm

Formerly in Madame Robert Lazare collection
Private collection

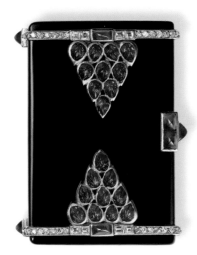

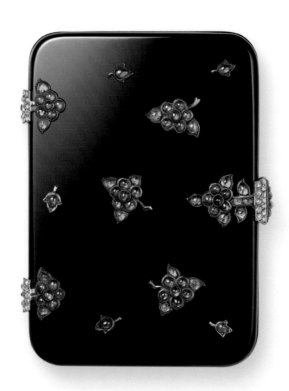

Miniature powder compact

Cartier Paris, 1931
Gold, platinum, enamel, rubies, diamonds
Gold setting of rubies imitating
the Indian technique of *kundan*
4.7 × 3.7 × 1.5 cm

Cartier Collection
Inv. PB 27 A31

Cigarette case

Cartier Paris, 1927
Gold, platinum, onyx, rubies, emeralds,
sapphires, diamonds
8.9 × 6.7 × 1.75 cm

Cartier Collection
Inv. CC 57 A27

Brooch

Cartier Paris, special order, 1931
Platinum, gold, diamonds, rubies
5.1 × 5 × 1.2 cm
Made as a special order for
Sir Bhupindra Singh, Maharajah of Patiala
Cartier Collection
Inv. CL 324 A31

Boule ring

Cartier Paris, 1948
Gold, rubies
3.2 × 2.9 cm
Formerly in Daisy Fellowes collection
Cartier Collection
Inv. RG 39 A48

Fruit bowl brooch

Cartier Paris, 1914
Design of 1913
Gold, rubies, emeralds, onyx
2.6 × 3.7 cm
Cartier Collection
Inv. CL 255 A14

Bracelet

Cartier Paris, 1956
Gold, rubies
1.4 × 19.5 cm
Cartier Collection
Inv. BT 102 A56

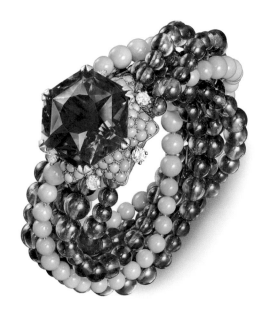

Bracelet

Cartier Paris, 1954
The star motif of the clasp comes
from a brooch made in 1951.
Gold, platinum, amethysts,
turquoise, diamonds
21 cm
Formerly in the Duchess of Windsor Collection
Cartier Collection
Inv. BT 151 A54

Necklace

Cartier Paris, 1953
Gold, amethysts, turquoise
34.6 × 32.5 cm
Formerly in Daisy Fellowes collection
Cartier Collection
Inv. NE 37 A53

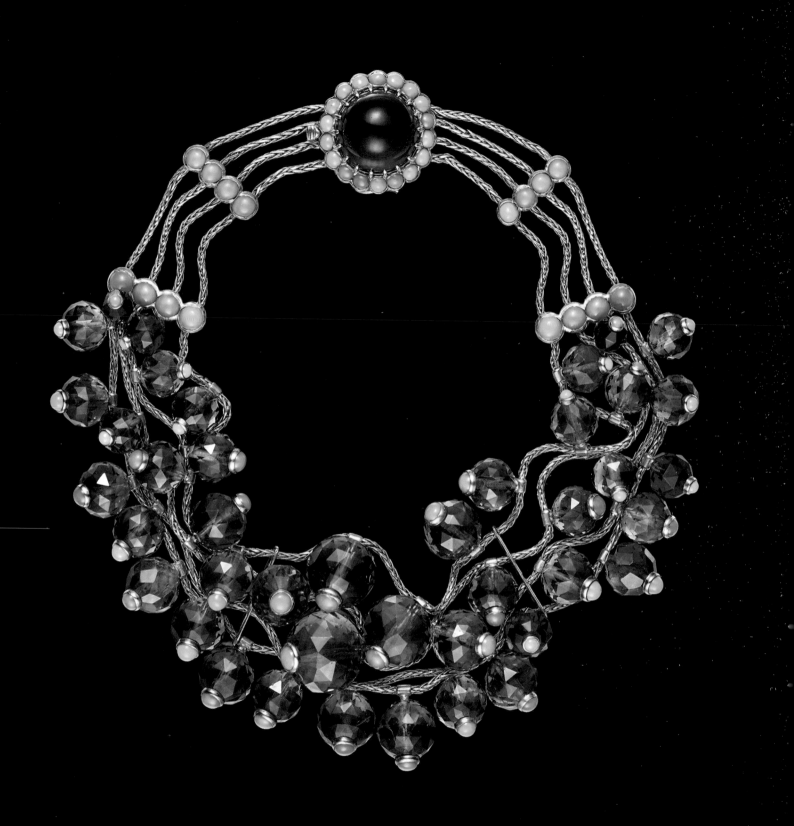

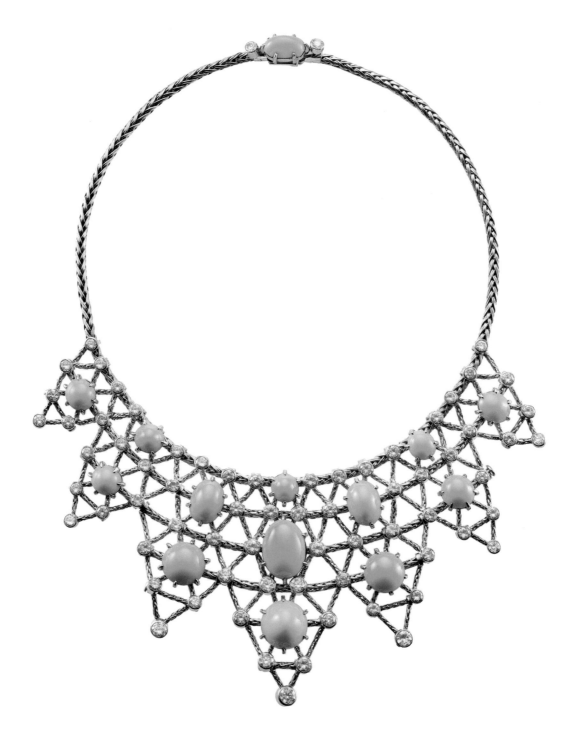

Necklace

Cartier Paris, 1950
Gold, turquoise, diamonds
6 × 34.5 cm
Formerly in Daisy Fellowes collection
Private collection, Florida

Bib necklace

Cartier Paris, special order, 1947
Gold, platinum, diamonds,
amethysts, turquoise
20 × 19.5 cm
Formerly in the Duchess of Windsor collection
Cartier Collection
Inv. NE 09 A47

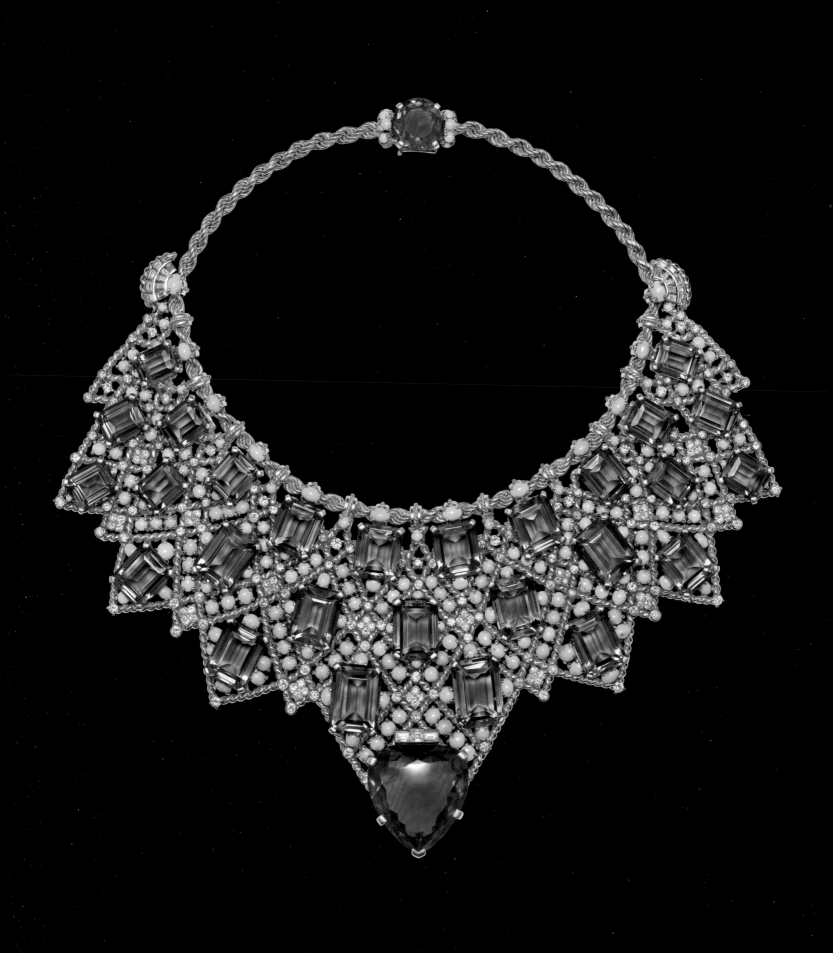

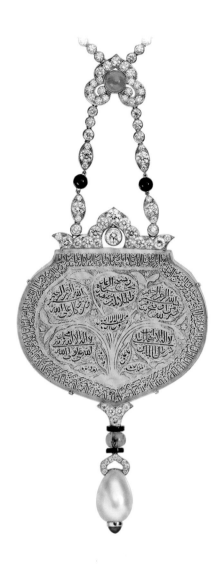

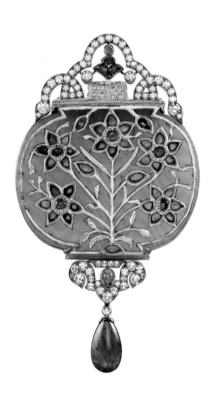

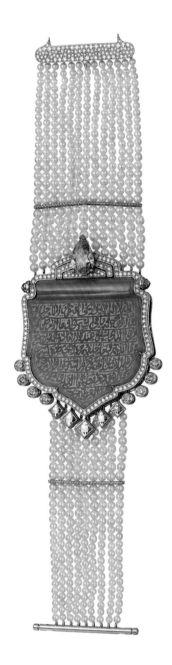

Necklace (detail)

Amulet engraved with
surahs from the Qur'an:
Iran, 19th century
Cartier, 2015
Platinum, gold, agate, emeralds,
onyx, natural pearls, diamonds
Pendant: 14.3 × 5.9 cm
Necklace: length 42.5 cm

Private collection
Not exhibited

Brooch

Jade set in kundan: India, 18th century
Cartier, 2015
Platinum, gold, nephrite jade, emeralds,
spinels, garnets, beryls, diamonds
10 × 5.7 cm

Private collection

Bracelet

Amulet engraved with a surah
from the Qur'an: Iran, 18th-19th century
Cartier, 2017
Platinum, nephrite jade,
natural pearls, diamonds
Center: 6.05 × 4.55 cm
Bracelet size: 15 cm

Adel Ali Bin Ali Collection

Necklace

Cartier, 2019
Platinum, emeralds, rubies,
sapphires, diamonds
Approx: height at center: 6,3 cm;
width: 20 cm

Private collection

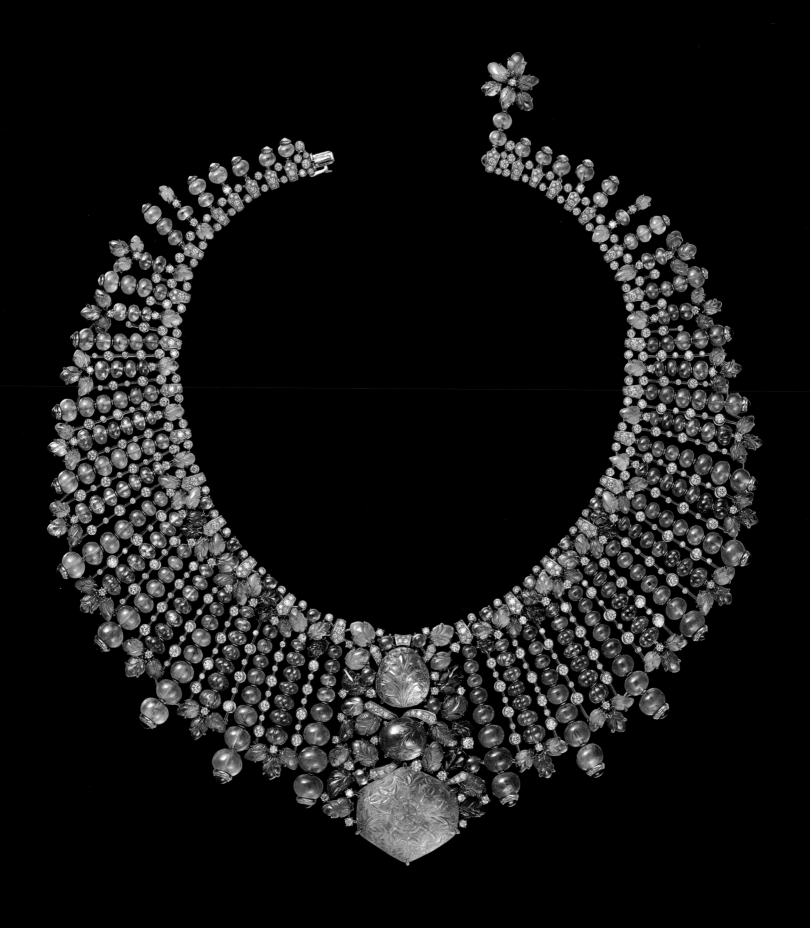

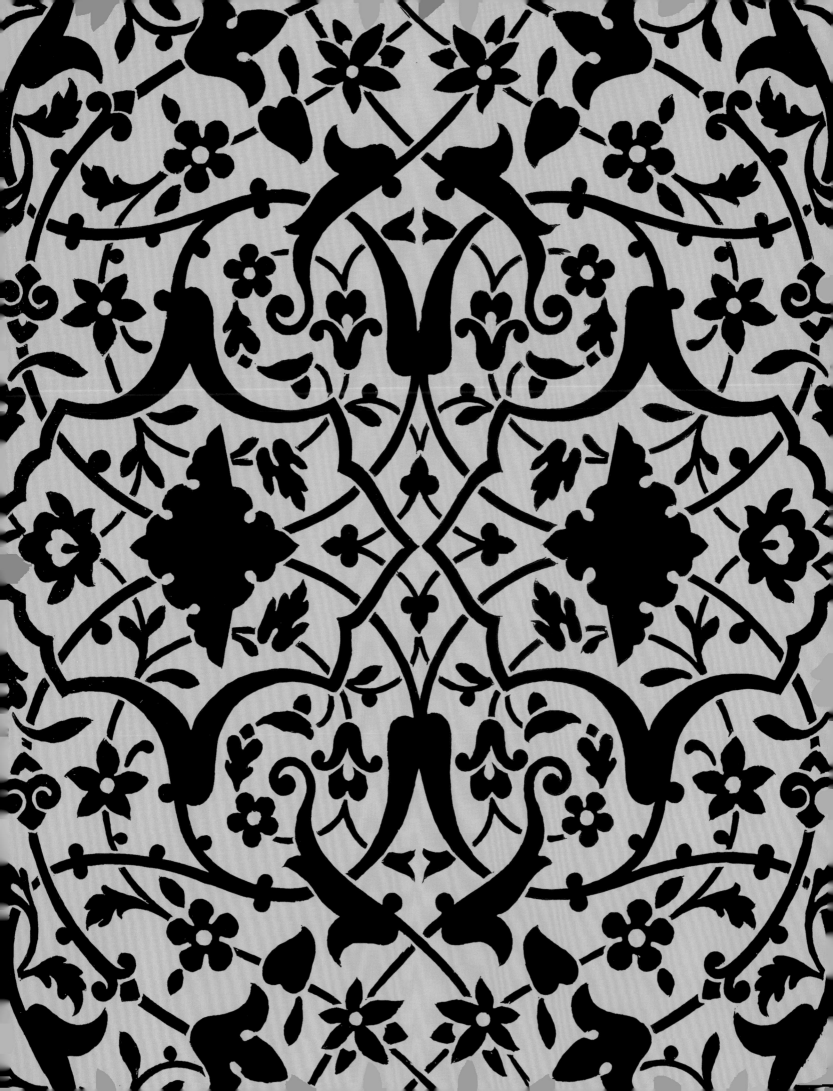

CARTIER'S LEXICON OF FORMS

ADAPTED
FROM ISLAMIC ART
AND
ARCHITECTURE

HEATHER ECKER

In the first decade of the twentieth century, the French jewelry house of Cartier began to experiment with novel design ideas that moved away from its prevailing classicizing style toward abstract ornamental forms that reflected contact with Islamic design sources, among others. The sources were, at first, indirect, drawn from an in-house library of published English and French compendiums of ornament, particularly Owen Jones's *Grammar of Ornament* in its French translation (1865), as well as works on Arab art that documented, principally, Mamluk ornamental stonework. A British publication on Indian jewelry from 1909 by Colonel Thomas Holbein Hendley was also particularly influential. After 1910, other references became available to Cartier's designers including Persian and Indian book paintings, bindings, and objects that Louis Cartier collected; contemporary and antique Indian jewelry; and vintage gemstones, pearls, jeweled and enameled plaques, and other elements such as engraved stones and amulets from India and Iran that were incorporated into new creations. Theatre with a Persian intonation, especially the Ballets Russes, was also instrumental. Public exhibitions of Islamic art in Paris in 1903 and 1912, and elsewhere, also provided source material, if not directly, then through published catalogues. From these collective sources, Louis Cartier, his designers, and their successors developed a distinctive lexicon of Islamic-inflected forms. These included simple and interlocking geometric shapes, palmette finials as singular or reciprocal forms, medallions and corner pieces, cartouches, the cloud collar, vine-scrolls, amulet shapes, the stepped merlon, different types of arcades, cypress trees, lotus blossoms, and *çintamani* patterns.[1]

A "lexicon" is used here to describe this catalogue of forms because it was selective, repetitive, and consolidated over time. It consciously echoes the project of a universal grammar of ornament proposed, among others, by Owen Jones in 1856 and Jules Bourgoin in 1880, whereby design elements were divided or generated into corresponding groups of similar patterns. Owen Jones created categories along ethno-national lines so that his "grammar" would reflect contemporary practices in the field of linguistics, which established, in the nineteenth century, language families and their genealogies. Jules Bourgoin, in contrast, considered ornament to provide its own internal logic and stripped ornamental forms down into alphabetic components that could be conjugated and regenerated. Owen Jones mattered to Cartier's designers—the use of his *Grammar* for source material is clear in both drawings and jewelry production. Jules Bourgoin's more theoretical and linear proposals filtered through, too, although his works are not present today in Cartier's design library.[2]

PREVIOUS PAGE
Detail of a cigarette case
1924
(see p. 215)

A lexicon is not a grammar, however, but a collection of words. In the design process at Cartier, there were no rules, conjugations, nor syntax to provide structure. Rather, forms were selected subjectively, often by Louis Cartier himself in the early decades of the twentieth century. If they were pleasing or successful, they accumulated as a kind of vocabulary. No theory was imposed upon or extracted from them—no exercise of all possible variations, as in Bourgoin's *Elements*.[3] Instead, forms were called upon and recombined, serving as a well from which to draw inspiration into the present moment. Cartier was not the only jewelry house to introduce designs that adapted forms found in Islamic art—in the 1920s, especially, the practice was widespread. But Cartier was an innovator in this field and its designers drew upon a disciplined and select group of forms to produce work that was not merely extravagant or exotic, but rather well digested into a recognizable and particular modern style.[4]

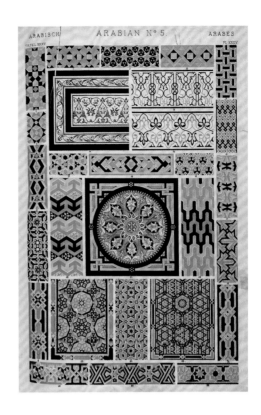

Chronologically, from about 1900 until 1930, these design developments can be roughly divided into three stages: abstractions, the "Arab" style, and the "Persian" style. Neither the Arab style nor the Persian style correspond to categories that are genuine or accurate from present perspectives on the study of material culture. Rather, they signify the reductive classifications offered by the authors of pattern books and the earliest exhibitions of Islamic art, undertakings largely justified by commercial and educational purposes: that they might inspire modern industrial design.[5] Cartier's designers used "Arab," "Persian," and similar terms to annotate their sketches, while Cartier's stock clerks noted them in reference to particular styles or motifs in the stock books. Their intentions were likely casual and internally directed, but the use of these terms offers one of the few documentary perspectives at Cartier on perceptions of these designs.

Arabian no. 5
Owen Jones
Grammaire de l'ornement, pl. 35
Day and Son, London, Ltd., 1865
Cartier Paris Archives
BibCart/126

ABSTRACTIONS

A group of five jewels illustrate some early, abstract thinking at Cartier. The most dramatic is an articulated head ornament in platinum and diamonds from 1902 that takes the form of a lock of hair, a sine curve, or the sinuous watering of a *moiré* silk. Its symmetrical curves terminates in two volutes [P. 193]. Even if its inspiration was figurative, the head ornament represents a significant step toward non-representation, away from the bows and cravats produced since the late 1890s.[6] The concept of interlocking waveforms was developed further in a neck plaque in platinum and diamonds from 1903: a dense block of alternating curves threaded onto a wide, black, silk ribbon [P. 192].

A more timid gesture is expressed in a tiny brooch from 1904 in gold and platinum. The brooch takes a single geometrical element—a rhomb or dart shape—subdivided four times with contrasting rubies and diamonds.[7] The joins between each of the darts are awkward, with round, old-cut diamonds inserted as spacers. But the intention toward geometry is clear.

Like the waveforms, the inspiration for the early dart-shaped brooch is unknown. The simplicity of the design—a larger unit composed atomically of identical smaller ones—suggests a conceptual source. Jones offered a theory of multiplication of repeated units in his ninth proposition on ornamental principles.[8] Bourgoin included a line drawing of the dart shape as a type of "polygone assemblé" in his *Théorie de l'Ornement* (1873) and again as a practical exercise in his *Études architectoniques et graphiques* (1901).[9]

Two brooches produced in 1907 also reflect geometric concepts. The first, fabricated in three colorways (sapphires, rubies, emeralds) [P. 165], takes the form of a five-by-five grid of calibrated gemstones with small diamonds as spacers between the stones.[10] Rather than additive, the design follows the opposite principle of decomposition. Both Jones and Bourgoin

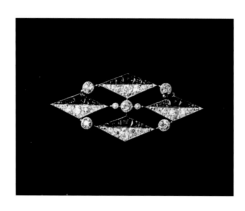

address this postulate, Bourgoin most succinctly: "Parallelograms, lozenges, rectangles and triangles can be broken down into small elements of the same shape. This break-down is infinite and established by the subdivision of sides within a same ratio." He provided a drawing of a similar grid of twenty-five small squares among his examples.[11]

The second conceptual brooch, also produced in three colorways (emeralds, rubies, and pearls), takes the form of a hexagon in strapwork (here with emeralds, and P. 172, FIG. 2, with pearls).[12]

Brooch
Cartier Paris, 1904
Platinum, rubies, diamonds
Photograph, 1907 (detail)
Cartier Paris Archives
Inv. 006972430
See Cartier Collection CL 288 A04

The straps, set with small, rose-cut diamonds, terminate beyond the hexagon, punctuated by a colored gemstone. It is a form of great subtlety, not merely a polygon but not yet a star. The underlying design work is not preserved, but it is not hard to imagine that it may have taken inspiration from Bourgoin's linear proposals—he designed grids or networks of hexagons and triangles, explored the interior possibilities of the hexagon, and illustrated the interweaving of hexagonal strapwork.[13] Alternatively, it may also have been inspired by a photographic source. A copy of Gaston Migeon's *Manuel d'art musulman*, published the same year, still resides in Cartier's design studio, bearing Louis Cartier's distinctive crossed marks of interest on the plates with suggestions for transformations of motifs into brooches or diadems.[14]

Fig. 54.

THE ARAB STYLE

Between 1902 and 1910, there appears to have been an adoption of overlapping ideas at Cartier rather than a linear progression towards an incorporation of Islamic design modes. Printed books were the principal vehicles for these explorations. Cartier's design library also preserves Friedrich Maximilian Hessemer's *Arabische und alt-italienische Bau-Verzierungen* (1853),[15] Jones's *Grammar of Ornament* in its French translation (1865), Prisse d'Avennes's *L'Art arabe* (1877), Eugène Collinot and Adalbert de Beaumont's *Ornements arabes* (1883) and *Ornements turcs* from the same year, the third edition of Albert Racinet's *L'Ornement polychrome* (1887), Prisse d'Avennes's abridged *La décoration arabe* (1887), and Gaston Migeon's catalogue for the *Exposition des arts musulmans* at the Musée des Arts Décoratifs in 1903.[16] Unusually, the library also includes *Les Mosquées de Samarcande*, vol. 1, by Nikolai Ivanovich Veselovskii et al. (St. Petersburg, 1905), with its extraordinary, folio-size color plates.[17]

"Les polygones assemblés"
Jules Bourgoin
Théorie de l'ornement, p. 158, fig. 54
A. Lévy, Paris, 1873

Brooch
Cartier Paris, 1907
Platinum, sapphires, diamonds
Photograph, 1907 (detail)
Cartier Paris Archives
Inv. 007841824

Brooch
Cartier Paris, 1908
Platinum, emeralds, diamonds
Photograph, 1908 (detail)
Cartier Paris Archives
Inv. 013281318
See Cartier Collection CL 314 A08

It is not surprising that published plates of Arab art or Arab ornament, principally documenting Mamluk architecture and objects, served as a basis for adaptation as they had done for a previous generation of French craftsmen. One thinks of ceramist Théodore Deck (1823–1891), who made meticulous copies of Ottoman Iznik ceramics and Mamluk glass and metalwork in glazed earthenware.[18] Exact copying was rare at Cartier, but in keeping with the nineteenth-century nomenclature, orientalizing jewels were labeled in Cartier's stock books until about 1910 as having "Arab motifs" or as being in the "Arab style," when they were described at all. It was a classification of convenience for a body of work perceived to share common design ideas that would come to form recognizable elements of Cartier's lexicon.

Textual evidence for Cartier's orientalist turn is inconspicuous. Apart from the stock books, almost no in-house writing survives that encourages a substantial Islamic design initiative in the first decade of the twentieth century. Rather, the interest may have been personal. Louis Cartier clearly enjoyed studying art for resonant ideas.[19] A vivid recollection of his tastes and methods, if anachronistic, is found in a posthumous elegy by Louis Devaux, then Chairman of Cartier Paris: "Louis Cartier's inner life was characterized by his creative imagination ... Everything for Louis Cartier had significance for the art of jewelry. Whether it was the monastic sobriety of early art in Japan, or the dazzling richness of flamboyant Gothic art or Muslim art, the cathedral of Chartres or the *azulejos* of the Alhambra in Granada, the severity of a Franz Hals or the dignity of a Velazquez, the elegance of a piece of furniture by Boulle or the majestic weight of a medieval crown, whether Hindu, Coptic, or Egyptian art or sculpture from the apogee of ancient Greece, Louis Cartier tasted, judged and interpreted everything he saw: This volute will form the setting of a brooch, that foliage will break the uniformity of this box, and by means of the emerald and the sapphire, it will be restored with all the brilliance that the stones bring, with the harmony of certain greens and blues found in Moroccan ceramics. The collector within him had a profound sensibility, not of an aesthetic egoism, but of a commendable concern to have constantly before him the authentic sources of art that were his very life."[20]

For the artifactual, there are surviving works of jewelry as well as archival materials, including photographs, period glass negatives, scrapbooks, execution drawings used by the workshop, and plaster casts of finished works. Some additional evidence can be gleaned from the personal studies and sketches of Charles Jacqueau, one of Cartier's designers from 1909 to 1930, now preserved in the collections at the Petit

Palais.[21] Jacqueau's studies indicate that, on the whole, he, too, sketched from books, as he sometimes noted authors and page numbers. He also appears to have worked directly from some objects in Louis Cartier's private collection of Islamic art and from direct sketching of works encountered outside of the studio.[22] Given that most historical works of jewelry produced by Cartier are no longer extant or of unknown location, these archival materials provide the principal indicationsof design directions.

Research into Arab forms at Cartier proceeded alongside the continued production of the "garland style" that had brought success to Cartier since the 1890s.[23] A tracing from about 1910 illustrates a striking contrast between the two modes [P. 196]. Drawn in ink and blue-green wash (a jewelry convention indicating platinum set with diamonds), the drawing compiles eclectic motifs from the Italianate walls of the royal chambers at the Chateau de Blois (marked *Arabesques Renaissance*). On the right side of the page is a larger, stellate ornament enclosed within a circle, comprising two interlaced equilateral triangles bound by six arcs. Its book source is unknown, but the form is found across the Islamic world on eleventh- and twelfth-century objects and was particularly favored in the Islamic West.[24] Whatever its origin, its precise abstraction is meticulous and economical.

Several contemporary drawing studies, probably by the same hand, provide more insight into these explorations. One, labeled *Décoration Arabe* and *Art Arabe*, bears twenty-three renderings of motifs from Owen Jones's *Grammar* [P. 202].[25] Another, labeled *Décoration arabe* and *Musulman*, bears fifteen designs that can all be located in photographs in Migeon's *Manuel* [P. 200].[26] What the designer called "Arab" was a hybrid gathering of material.

Although the drawing studies are not execution drawings, it is not difficult to find the pathway from nineteenth-century pattern books to the fabrication of jewels. For example, a third sheet of studies by the same hand, also labeled *Art Arabe* and *Décoration Arabe*, records a lattice design from Jones's *Grammar*, perhaps taken originally from an Indian textile [P. 168, FIG. 1].[27] The same lattice was elongated and reinterpreted as a design for a flat, round pendant. That rendering was pasted into one of Louis Cartier's "idea notebooks" (*cahiers d'idées*) from c. 1908–1911, alongside other finished designs derived from Jones's *Grammar* [P. 168, FIG. 2].[28] Evidence that the design was realized is provided by an archival photograph, a plaster cast made to record the piece in three dimensions [P. 168, FIGS. 3-4], and a stock book entry. The stock book records that the jewel was executed in platinum, diamonds, and pearls, and described it as a "round pendant containing Arab motifs".[29]

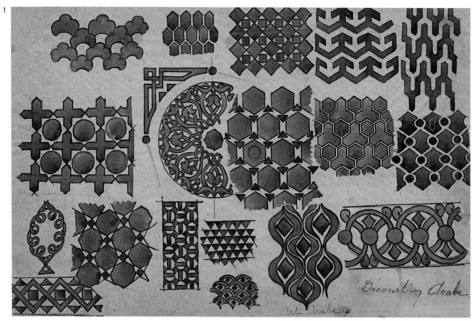

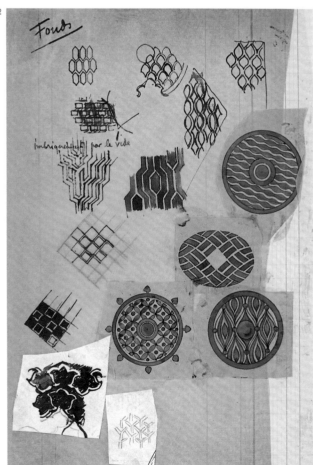

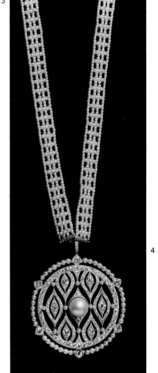

FIG. 1
Studies for Arab-style
decorative patterns
Cartier Paris, c. 1910
Graphite and gouache
on tracing paper
18 × 26.1 cm
Cartier Paris Archives
Inv. E41

FIG. 2
Louis Cartier's idea notebooks
Cartier Paris, 1908-1909
Handwritten notes and sketches
in pen, pencil, and gouache,
some pasted on tracing paper
30 × 19.5 cm
Cartier Paris Archives
Inv. CH04_103-104

FIG. 3
"Arab motifs" pendant
Cartier Paris, 1910
Platinum, pearls, diamonds
Photograph, 1910 (detail)
Cartier Paris Archives
Inv. 019051824

FIG. 4
Plaster cast of the same pendant
Cartier Paris, 1910
6.5 × 6.4 × 1.7 cm
Cartier Paris Archives
Inv. BRO375

Three styles of jewelry in the Arab mode were produced at Cartier concurrently during this period:

1. A hybrid, or transitional mode, in which the jewels are conceived as geometrical forms, but incorporate classicizing elements such as wreathes, bows, and floral motifs [P. 171, FIGS. 1–10, AND P. 195].

2. A more conventional Islamic style that includes jewels with six-, eight-, and twelve-pointed stars, as well as rounded or hexagonal medallion shapes with internal designs that can often be traced to Owen Jones [P. 172, FIGS. 1–11, AND P. 197].

3. A flexible, escutcheon style based upon the shapes of Indian or Persian amulets, often adorned with a small finial and with an internal design of repeated small elements, sometimes copied from pattern books, and adorned with a central gemstone that appears to float on the surface [P. 173, FIGS. 1–13, AND PP. 198–199].

A brooch produced in 1906 is a good example of the hybrid mode [P. 195].[30] Fabricated in platinum and diamonds, the jewel is based upon an underlying structure of a hexagon divided into six equilateral triangles.[31] Each angle of the triangles is accentuated with a round, old-cut diamond, with a larger one at the center. The central field is filled with a stellate figure formed of twelve large tines, in the manner of a baroque monstrance. The outer hexagon is adorned with a covering of laurel leaves. The same design concept was evolved by 1909 to make several pendants that did not conceal the underlying structure, aligning with the second Arab style [P. 172, FIGS. 2–3].

A group of triangular brooches and pendants in the hybrid mode may have had a more contemporary design source. Thomas Holbein Hendley's *Indian Jewellery* (1909) is one of the few books preserved in Louis Cartier's library that bears his annotations.[32] On a photograph of women's caps from Kashmir decorated with silver amulets, Louis noted the triangular form of one, and the "magnifique motif 2 palmes" (the Persian *boteh*) of another [P. 171, FIG. 5].[33] Both forms appear as sketches in an idea notebook worked over several pages.[34] The triangle form would evolve into execution drawings, fabricated multiple times as jewels, while the "bonnes pampilles" of an earring, marked on an earlier page in Hendley, would be adapted as the platinum and diamond elements that adorned them [P. 171, FIGS. 6–8].[35] It is unclear if the double-palm form was developed further. By 1910, the hybrid triangular designs evolved into brooches made in the flexible escutcheon style (the third Arab style), surmounted by a finial, and an upper stirrup (*étrier*), a characteristic of many Cartier pieces in this period [P. 173, FIG. 8].[36]

The second style of Arab jewels favored more conventional, Islamic, geometric ornaments, predominantly single star forms extracted from complex compositions of interlocking shapes. Sometimes the star forms were enclosed in a circular mount reminiscent of the hybrid-style jewels [P. 172, FIGS. 7-8, 10-11]. These pendants and brooches were produced in unusual color combinations. For example, a brooch from 1907 in the form of a hexagonal star was set with a large amethyst on a green, enamel ground.[37] A brooch from 1909 in the form of a twelve-pointed star in a hexagonal surround circumscribed with pearls was set with emeralds, sapphires, and amethysts [P. 172, FIG. 4], while another pendant from 1909 in the form of a hexagonal star was set with diamonds and eight turquoise cabochons of varying size [P. 172, FIG. 9].[38] The combinations of colored stones appear to be original compositions, not copied from printed sources.

The third, escutcheon style of Arab jewels takes its outline principally from Indian or Persian amulets, like those that Louis Cartier sketched from Hendley in one of his idea notebooks. In the stock books, their shape is often described as *forme écusson*. Each of the amulet shapes was space-filled with smaller forms, sometimes a pattern of small hexagonal *chatons*, a chevron pattern, or internal volutes with a gemstone or pearl set as if floating on the surface.[39] These shapes were deployed facing up or down, as in a brooch from 1910 that represents an inverted finial terminating in a smaller finial with a stirrup flourish added above [P. 173, FIG. 10].[40] A related, inverted brooch design from 1910 was later righted and transformed into a head ornament, adorned with a dramatic white aigrette [P. 173, FIGS. 12-13].[41] Described in the stock book as "Arab", the jewel is filled with a floral repeat taken from Owen Jones's Byzantine pattern no. 2 or no. 3, each petal a small, *navette*-shaped diamond. A dramatic Arab-style necklace, also from 1910, employs five almond-shaped pendants, each set with a magnificent marquise diamond, while the multiple-row diamond chain includes nine almond-shaped spacers turned horizontally, like *nazar* talismans to ward off the evil eye [P. 173, FIG. 5].

An interesting series of head ornaments that adapt Islamic architectural forms also evolved in the escutcheon style.[42] The earliest, from 1910, 1911, and 1914, were made in the form of the Russian head-dress, the *kokoshnik*, during a moment of public interest in Russian arts. The first two have a bold zigzag enclosing large diamonds that recalls the façade of the eighth-century Mshatta Palace, housed at the Kaiser Friedrich Museum in Berlin in 1903 [P. 174 AND PP. 204-205].[43] The third takes the form of a series of wide horseshoe arches enclosing a chequerboard ground and large pear-shaped diamonds [P. 175]. In 1922, a different type of head ornament, described in the stock books as having a *dessin*

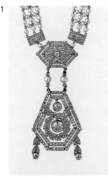

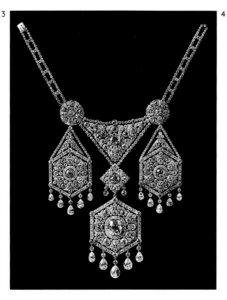

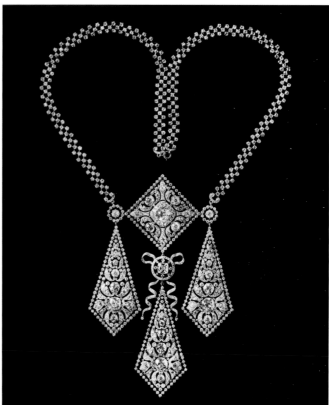

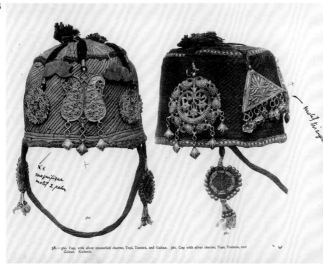

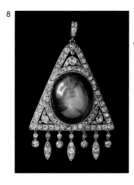

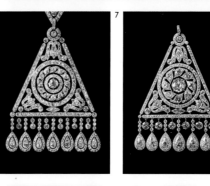

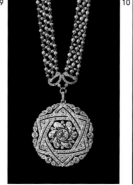

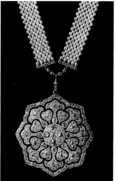

FIG. 1
Long necklace(*sautoir*) (detail)
Cartier Paris, 1907
Platinum, pearls, diamonds
Cartier Collection
Inv. NE 33 A07

FOR FIGS. 2 TO 4, 6 TO 10
Cartier Paris creations
Details from photographs
Cartier Paris Archives

FIG. 2
Brooch, 1908, platinum, pearls,
diamonds, inv. 013281318

FIG. 3
Necklace, 1909, special order,
Mrs. Cornelius Vanderbilt, platinum,
diamonds, inv. 017282430

FIG. 4
Necklace, 1908, platinum,
diamonds, inv. 010102430

FIG. 5
Caps with silver charms
Annotated by Louis Cartier
Thomas Holbein Hendley
Indian Jewellery, pl. 58
London, 1909
Cartier Paris Archives
Inv. BibCart/102

FIG. 6
Pendant, 1909, platinum, pearls,
diamonds, inv. 017533040

FIG. 7
Pendant, 1909, platinum,
diamonds, inv. 015431824

FIG. 8
Pendant, 1912, platinum, sapphire,
diamonds, inv. 027871824

FIG. 9
Pendant, 1907, platinum,
diamonds, inv. 008532430

FIG. 10
Pendant, 1909, platinum, pearls,
diamonds, inv. 016821824

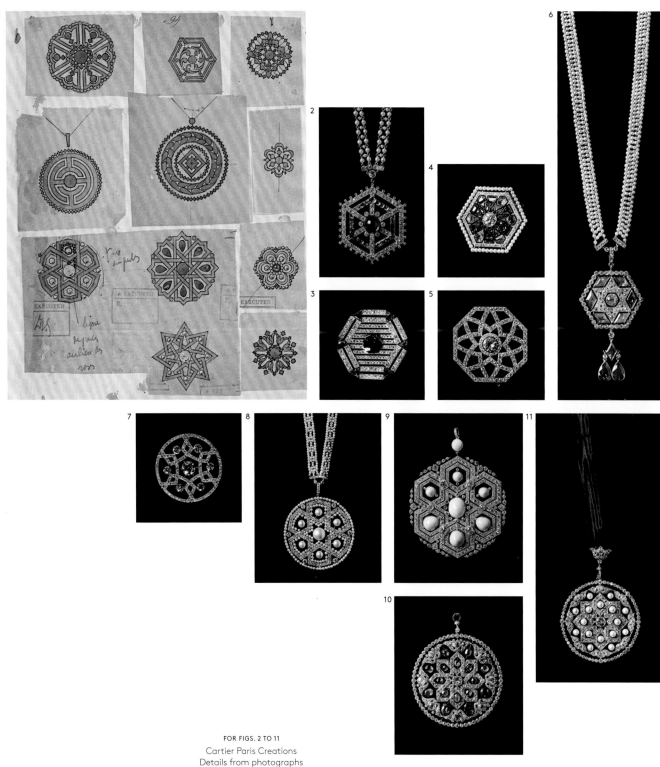

FOR FIGS. 2 TO 11
Cartier Paris Creations
Details from photographs
Cartier Paris Archives

FIG. 2
Pendant, 1909, platinum, pearls,
sapphires, diamonds, inv. 014792430

FIG. 3
Brooch, 1909, platinum, sapphires,
diamonds, inv. 015402430

FIG. 4
Brooch, 1909, platinum, sapphires,
emeralds, amethysts, pearls,
diamonds, inv. 018513040

FIG. 5
Brooch, 1908, platinum, diamonds,
inv. 014482430

FIG. 6
Pendant, 1909, platinum, sapphires,
pearls, diamonds,
inv. 016222430

FIG. 7
Brooch, 1909, platinum, diamonds,
inv. 015811318

FIG. 8
Pendant, 1909, platinum, pearls,
diamonds, inv. 015402430

FIG. 9
Pendant, 1908 special order,
Grand Duke Paul Alexandrovich
of Russia, platinum, turquoise,
diamonds, inv. 015192430

FIG. 10
Pendant, 1909, platinum, sapphires,
diamonds, inv. 016301318

FIG. 11
Pendant, 1909, platinum, pearls,
diamonds, inv. 016362430

FIG. 1
Garland-style sketchbook
Cartier Paris, c. 1910
Graphite, India ink, and gouache
27.5 × 22.5 cm
Cartier Paris Archives
Inv. CHGIV_094-095

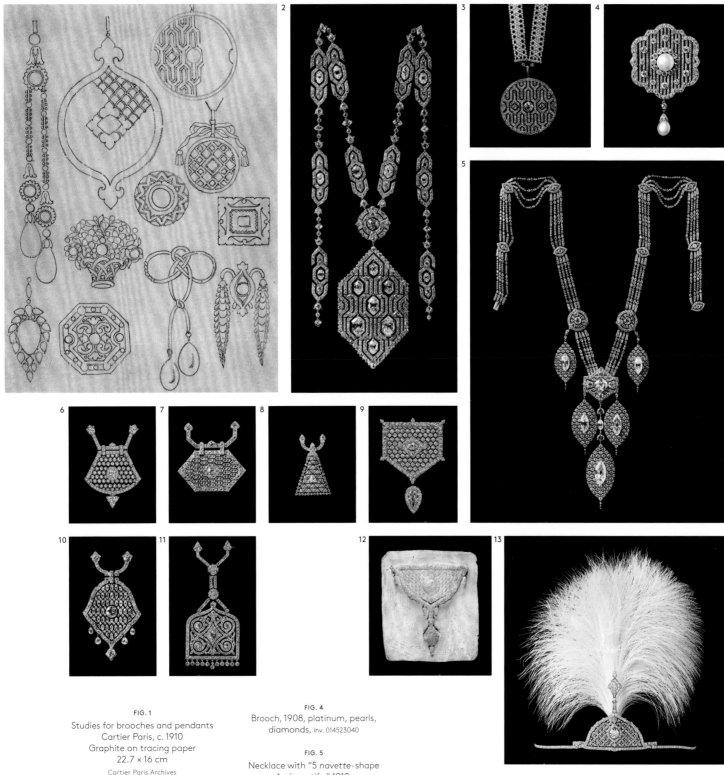

FIG. 1
Studies for brooches and pendants
Cartier Paris, c. 1910
Graphite on tracing paper
22.7 × 16 cm
Cartier Paris Archives
Inv. E255

FIGS. 2 TO 8, 10-11, AND 13
Cartier Paris Creations
Details from photographs
Cartier Paris Archives

FIG. 2
Necklace with "10 Arab-style
motifs, Arab-style ground," 1910,
platinum, diamonds,
inv. 019862430

FIG. 3
"Arab style" pendant, 1909,
platinum, pearls, diamonds,
inv. 018652430

FIG. 4
Brooch, 1908, platinum, pearls,
diamonds, inv. 014523040

FIG. 5
Necklace with "5 navette-shape
Arab motifs," 1910,
platinum, diamonds,
inv. 024413040

FIG. 6
"Arab-style, flexible, escutcheon
form" brooch, 1910, platinum,
diamonds, inv. 020573040

FIG. 7
"Arab-style background" brooch,
1910, platinum, diamonds,
inv. 020573040

FIG. 8
Brooch, 1910, platinum, diamonds,
inv. 020621824

FIG. 10
"Escutcheon" brooch, 1910,
platinum, diamonds, inv. 020892430

FIG. 11
"Arab style, escutcheon form"
brooch, 1910, platinum,
diamonds, inv. 020962430

FIG. 12
Plaster cast of an "arched
Arab style" brooch
Cartier Paris, 1910
9.8 × 8.9 × 3 cm
Cartier Paris Archives
Inv. BRO183

FIG. 13
Brooch mounted with
an aigrette as a head ornament
(see fig. 12), 1910, platinum,
diamonds,
inv. 032453040

FIG. 9
Brooch
Cartier Paris, 1910
Platinum, gold, diamonds
7 × 4.95 cm
Private collection of S.Y.S.

mauresque, was produced around a broad, tortoise-shell comb [P. 207]. It was densely adorned with an arcade in red coral outlined in small diamonds, intercalated with black onyx columns, and may recall the arcades with red and white voussoirs at the Great Mosque of Córdoba.[44] The structure of the arcade is not inspired by Córdoba, but rather appears to have been devised by Charles Jacqueau as a pastiche of a number of Syrian and Egyptian forms recorded in photographs published by Henri Saladin in 1907 in the first volume of the *Manuel d'art musulman* [P. 206].[45]

 The jewels in the Arab style made by Cartier from 1900 to 1910 may owe a formal debt to Islamic designs filtered through flattened renderings in European publications, but their technique of construction and conceptual re-materialization are inventive, including the use of platinum, providing lightness. Techniques such as granulation and hollow, box constructions, inheritances from the Classical past and characteristic of medieval and early modern jewelry made in the Islamic lands, were never employed by Cartier, while filigree was used only rarely.[46] Instead, the transparent, hinged, planar structures of the jewels are light and flexible, almost like paper silhouettes, also reflecting, perhaps, the mediation of printed books.

 Cartier's early interest in these Islamic forms was an *antropofagia*, a selection that bore little cultural encumberment, once digested. Among Charles Jacqueau's studies is a drawing labeled "caractéristiques arabes" that records various designs including a pierced-work finial, perhaps from an *'alam* (a processional standard) that bears an inscription of the *shahada* (the Islamic credo), surely Iranian, and sketches of split palmettes that document his reckoning with a complicated pattern of interwoven leaves. The drawing is annotated with Jacqueau's observations of the three

Bandeau
Cartier Paris, 1910
Platinum, diamonds
Photograph, 1910 (detail)
Cartier Paris Archives
Inv. 019821824

dimensionality of the leaf form as it interpenetrates and combines with itself: an arabesque [P. 176]. All of these motifs, with their variants drawn in dotted lines, were surely copied from a book.

But beyond the essentialization, what was truly Arab about the arabesque?[47] Already denatured and deeply naturalized in European culture since the term appeared in Italy in the sixteenth century, borrowing from Ottoman designs, the so-called arabesque was absorbed as a sprawling, spiraling contour into art, music, and poetry, evolving by the nineteenth century into a kind of classicism that yielded to indicate anything desired.[48] It could be sublime—the poet Charles Baudelaire considered the arabesque "the most spiritualist of designs" and "the most ideal of all"—or dainty— Robert Schumann composed his Arabesk in C Major, perceived as a pure and innocent key, a work he considered "delicate enough for ladies."[49] Likewise, in classical ballet, it transformed from a picaresque posture of Neapolitan dancers in the eighteenth century to an infinite grammar of extended leg and arm positions in the nineteenth.[50] Like the arabesque, in Cartier jewels the Arab style was a recognizable mode of modern design with an echo of Islamic forms of no singular or objective origin.

THE PERSIAN STYLE

A brief remark in a letter Louis wrote to his father, Alfred, from Russia in 1911 provides some evidence for a shift in focus: "We have to offer choices of new objects for sale, which I cannot imagine except in the Russian or even the Persian genre."[51] Louis was impressed by both the jewels and the clientele that he encountered in Russia between 1910 and 1914.[52] He must have encountered Persian art, if not in Russia, then in Paris

Tiara
Cartier Paris, 1914
Platinum, diamonds
Photograph, 1914
Cartier Paris Archives
Inv. 041591824

or at the 1910 exhibition in Munich, *Meisterwerke Muhammedanischer Kunst*.[53] He acquired two Persian paintings that had been exhibited there, marking a new phase as a collector of Islamic art.[54] Importantly, Louis lent various paintings and drawings to the exhibition organized at the Musée des Arts Décoratifs in 1912, *Miniatures Persanes*, organized by Georges Marteau and Henri Vever, seven of which were published in the exhibition catalogue. These included the well-known portrait of the Timurid ruler, Sultan Husayn Bayqara Mirza (1438–1506), that had been exhibited in Munich [P. 80].[55] This generous display solidified his public reputation as a collector of this material, especially alongside Vever, a fellow jeweler.

Judging by the works in his collection, Louis focused on Timurid-era, Safavid-era, and Mughal-era book paintings and manuscripts, as well as some Deccani works. He also collected other types of objects, both Persian and Indian, particularly in nephrite, as well as carpets and other architectural elements that he had sent to his homes in Budapest and Spain.[56] Interestingly, Louis also owned an exquisite wine cup in carved agate that had belonged to Sultan Husayn Bayqara Mirza [P. 81].[57] He collected no works of Arab art or literature, apart from a Qur'an said to be Maghribi and some items of jewelry, such as Moroccan belt buckles.[58] Among the Persian and Indian manuscripts and single-folio paintings he owned are works that must be considered at the highest level of artistic quality.

If Louis Cartier collected Islamic art for prestige or to reinforce his image as a connoisseur, these works also served as a source of design inspiration and to support sales.[59] The portrait of Sultan Husayn Bayqara Mirza serves as a good example.[60] In this delicate, almost transparent drawing, the Sultan kneels in the posture of Timurid princes, wearing a jeweled belt from which hangs a geometer's compass. His shoulders are adorned with an embroidered garment, a cloud collar decorated with small leaves, scrolls, and split palmettes. The Chinese cloud collar (*yün chien*) was a celestial symbol that became naturalized as an artistic motif in Iran under the Ilkhans and Timurids, expressed in Iranian book illustration and illumination, carpet weaving, tiles, and other media, and as an element of prestige dress [P. 177].[61] As the motif traveled West through the Islamic world, it was also employed in jewelry, evinced by a Persian

"Caractéristiques arabes"
Charles Jacqueau, c. 1910
After E. Collinot and A. de Beaumont,
Ornements arabes, Paris 1883
Black ink on transparent vellum
18 × 12 cm
Petit Palais, Paris,
gift of the Jacqueau family, 1998
Inv. PPJAC02848

example formerly in the collections of the Museum of Fine Arts, Boston [P. 178, TOP]. Cartier adopted the form as an ornament in its design lexicon as early as 1912, when it appeared on a tiara [P. 203], and later in 1929 as the pendant of a *sautoir* [P. 178, BOTTOM].

Louis's early collecting of Islamic art coincided with the establishment in February 1912 of a separate stock at Cartier, the "collection d'objets orientaux." It comprised material acquired from art dealers, including Delhi-based Imre Schwaiger, and marked the start of a new period of work with a strong focus on Indian jewels and stones. In part, this was also dependent on Jacques Cartier's efforts in India and the Persian Gulf the previous year to acquire new clients and to establish new relationships to source pearls and precious stones. It was from the *objets orientaux* that Cartier made a selection of jewelry to sell in a series of exhibitions held in London in 1912 and in Paris, Boston, and New York in 1913, publicized by a series of invitations set within Persian or Indian manuscript framing devices. The London and Paris exhibitions included the resale of Indian jewels, in their original form, or lightly retouched, while the Boston and New York exhibitions also presented new jewels inspired by Indian, Persian, and Arab, as well as Russian, Chinese, and antique art.[62]

The exhibition in Paris opened on June 2, 1913, and was reviewed favorably in *Le Figaro* on its front page the next day: "A curious exhibition has just opened at Messieurs Cartier, the jewelers of rue de la Paix. It includes a selection of Persian, Hindu and Tibetan jewelry, with a completely original and rich character: superb pearl necklaces interspersed with emerald or ruby beads, flower and bird motifs, *bayadère* chokers, multicolored enamels, long necklaces, baroque pearls, [jewels] studded with pierced rubies, bracelets, medals, amulets, turban ornaments, earrings, rings, cups, statuettes of gods, etc./It is a new art that is revealed to us by this collection of authentic jewelry, unique in the world, that is adapted to new fashions, and which will certainly enjoy great success in Paris."[63]

The subtitle of the exhibition cited in the review, "adaptés aux Modes nouvelles," acknowledged that the shift toward Persian– and Indian– inspired jewelry at Cartier was an innovative response to a change in fashion. Whether Cartier's initiative followed a prevailing style or set a new trend was answered in part by an anonymous response that appeared in

Ornamental design
in the form of a cloud collar
Iran, 14th century
Diez Albums
Staatsbibliothek zu Berlin PK
Diez A, fol. 73, p. 41, nr. 2.

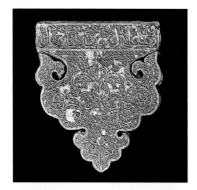

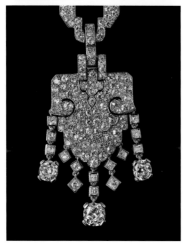

Le Figaro the following day, entitled "Le Goût Oriental" and signed simply "Delhi." It claimed: "At this precise moment and by a curious coincidence, the taste for Eastern art has established itself in Paris through Russian imports: ballets, music, decoration. Russian artists have been intermediaries between the East and us, and they have perhaps given us a taste for Eastern color more than that of their own art.[64] Is it necessary to enumerate in detail all the modifications which have resulted from it from the point of view of female dress? They have renewed fashion, and whatever opinion one has about the value of this renewal, it is indisputable. And not only fashion has been transformed, not only that concerning costume, but also concerning the extras, the framing of the woman, so to speak ..."[65]

The most popular Russian import to Paris was Serge Diaghilev's Ballets Russes with its Russian dancers, musicians, choreographer, set designer, and boldly conceived orientalist productions created between 1910 and 1912. A new ballet, *Schéhérazade* (which premiered on June 4, 1910), based upon Nikolai Rimsky-Korsakov's exoticizing score of 1888, was the most memorable of these despite its compact format of a single act of less than forty minutes. All of its action takes place in a fantastic, royal harem of concubines, female dancers, male slaves, and eunuchs. It is Diaghilev's only ballet that is still performed, although now as a period piece and not as an ecstatic presumption of Middle Eastern mores and tastes.

The "framing of the woman" mentioned in *Le Figaro* is presumably a reference to jewelry design. The text goes on to describe a switch to a new, lighter style of jewelry, presumably also due to changes in corsetry. The boning at the front of the late nineteenth-century bodice that would have supported the size and weight of a stomacher brooch had shifted by 1910 to longer undergarments that smoothed the hips and thighs.[66] Brooches became smaller and lighter and could be worn at the waist or shoulder, while pendants were supported by delicate, long chains. Head ornaments framed the face with bejeweled bands and light aigrettes, conceived outside of the sphere of royal, aristocratic, or military costume. Some of these liberations were inspired by the orientalist costumes of the Ballets Russes.[67]

Pendant in the form of a cloud collar
Iran, 13th century
Gold
6.5 × 7.9 cm
Archival photograph
Museum of Fine Arts, Boston
Museum purchase with funds donated
by the John Goelet Foundation
Inv. 65.248

Pendant of a sautoir (detail)
Cartier Paris, 1928 (pendant),
1929 (chain)
Platinum, diamonds
Pendant height: 8 cm
Cartier Collection
NE 14 A29

A bilingual pamphlet was produced at Cartier New York in the form of a Persian book—with a central medallion, corner ornaments, and doublure—probably to coincide with the New York exhibition of 1913. It comprises two texts: an English-language section that must date to 1912, as it references the exhibition of Indian jewels at the Cartier London branch, and a reprint of the 1913 "Delhi" response from *Le Figaro*. It was surely intended for Cartier's American clients interested to learn how the exhibitions had been received in London and Paris. Interestingly, the English-language text states that authentic works of Persian art that had been shown at the Musée des Arts Décoratifs, presumably paintings from Louis's collection, were exhibited with the jewels in London. It also claims that the jewels were not only inspired by the "design" of the paintings, but also by their colors.[68]

The idea that historical, Persian works of art might lend authenticity to new, French jewelry designs is also supported by the perspective offered in the catalogue to the Cartier Paris exhibition in 1913; it states that in the interest of authenticity, no changes were made to the "base gold nor the glass beads imitating turquoises and other Eastern trompe-l'oeil."[69] This sensibility of seeking fidelity or historicity was paralleled by Michel Fokine (1880–1942), choreographer of the Ballets Russes, who was said to have studied Persian paintings for inspiration, while painter Leon Bakst's (1866–1924) sets and costumes reflect recognizable motifs from Iranian and Turkish arts, particularly textiles [P. 44].[70] This was a movement away from the nineteenth-century pattern books, but not from reductive categories: many of the jewels exhibited in Paris are documented in glass plate negatives in the Cartier Archives, which show that they are of Indian origin, and not necessarily of the Persian or Tibetan origins as described in the pamphlet that accompanied the exhibition. There was a similar porosity of alleged provenances in the Boston and New York exhibitions later the same year.[71]

The shift in production at Cartier to works in a demonstrably different "Persian" style began around 1912, coinciding with the exhibitions of Indian jewelry, and continued throughout the 1920s. These jewels and luxury objects are often described in the stock books as "Persian" or bearing "Persian decoration" or "Persian motifs."[72] The earliest and most enduring form was a central medallion with finials, possibly inspired by Persian book bindings in Louis's collection. The Charles Jacqueau archives at the Petit Palais also preserve photographs of book bindings, as well

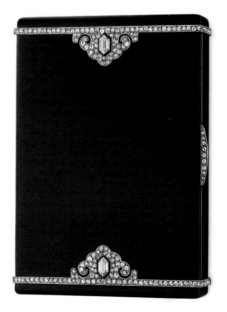

Cigarette case
Cartier Paris, c. 1929
Platinum, black enamel, yellow gold,
diamonds
7.6 × 5.7 × 2.2 cm
Formerly in the collection of Prince
and Princess Sadruddin Aga Khan
LA Private Collection

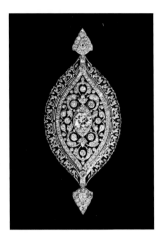
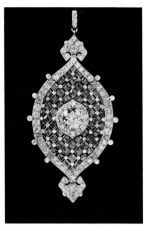

as rubbings made directly from the impressed leather of bindings [SEE, FOR EXAMPLE, P. 67, FIG. 2].

At first, these medallion designs were made into brooches and pendants in the Arab escutcheon style. Of two jewels created in 1912, one was still described as a *pendant arabe* in the stock book.[73] A more rigid design is exemplified by a brooch-pendant, also from 1912, in which a large, lozenge-shaped sapphire cabochon was treated as a central medallion framed by a rectangle of faceted and calibrated sapphires with diamond-set corner pieces [P. 212, LOWER RIGHT].

Medallions were also conceived as an ornament for vanity and cigarette cases, recalling Islamic-style book bindings. One of the earliest was produced in 1913, the design of which was described in the stock book as "Arab decoration" [P. 245].[74] The decorative technique was complex: it combined enameled borders in white with enclosing finials of split palmettes, with a central medallion in rock crystal that was engraved and painted on the reverse with split palmettes. The medallion, inlaid with a marquise-shape onyx outlined with diamonds, was itself surrounded by small diamonds. The painted and enameled designs of split palmettes, conceived like a silhouette, may have been inspired by the intricately cut paper inlays that formed part of the interior of Iranian book bindings, some found in Louis's collection [P. 213].

This decorative strategy was simplified for the production of future rectangular cases by the application of enameled plaques or by enameling directly into the gold. In some examples from the 1920s, the center of the enameled medallion was set with a stone, creating the effect of an encrusted, Byzantine book cover [PP. 99 AND 181].[75] There were other variations, such as a vanity case in black enamel from 1923 adorned with a jade plaque retouched with diamonds as the central medallion. The gold arcades at top and bottom are described in the stock book as "dessin mauresque," recalling the design of the architectural head ornament from 1922.

Some of the enameled plaques applied to the vanity cases were square variants of the *gul-u-bulbul* (rose and nightingale) motif of Qajar-era arts [SEE, FOR EXAMPLE, P.129, LOWER LEFT].[76] These were invariably referred to as "plaque persane" in the stock books. They may have been acquired in Iran and reused as *apprêts* at Cartier. The *apprêts* were generally antique pieces or fragments reemployed by Cartier for its new creations.[77]

Arab-style *navette*-shape pendant
Cartier Paris, 1912
Platinum, crystal, diamonds
Photograph, 1912
Cartier Paris Archives
Inv. 026781318

Brooch wearable as a pendant
Cartier Paris, 1912
Platinum, sapphires, diamonds
Photograph, 1912 (detail)
Cartier Paris Archives
Inv. 028691824

However, given the quantity of jeweled objects adorned with these square plaques, they may have also been made in France for Cartier rather than imported.

An unusual variant on the concept of the central medallion on vanity and cigarette cases was the central placement of an oval cut-out of a face from a manuscript painting under a glass cover. It appears that only a few examples of this type were produced at Cartier; most enclose cut-outs from the same manuscript, of commercial, though unknown, origin. One of the most elaborate, from 1920, was carved from nephrite and adorned with a cut-out with two male figures, described in the stock book as an "Indian plaque" [P. 183, LOWER RIGHT].[78] All of the others bear cut-outs of female figures, applied to cases made in 1923 and 1924 [P. 183].[79] A related design idea was executed as a table cigarette box in 1927: the lid was veneered with a section cut from a leather book binding bearing its central, embossed medallion [P. 182].[80]

One of the most elaborate objects with a medallion and corner pieces is a vanity case made in 1924 [P. 183]. Its general outline appears to have been inspired by the design of a Qajar-era box, although its elaborate adornment borrows from Gujarati mother-of-pearl inlay techniques and from the rows of pearls that encrust medieval, Byzantine book covers.[81] Its central medallion was an *apprêt*, a portrait miniature in enamel identified in the stock books as Bulgarian. The figure, wearing a bejeweled turban and holding a dove, may be an Eastern Orthodox image of the Christ child. It was later replaced with an emerald carved in the form of a leaf [P. 93].[82]

Between 1924 and 1930, enamel was used to create striking all-over (infinite) patterns and reciprocal patterns on gold vanity and cigarette cases. These, too, appear to have taken inspiration from the art of Persian paper cutting, used to decorate the interiors of book bindings. A set of cases with identical, bilaterally symmetrical designs of split palmettes was made in different

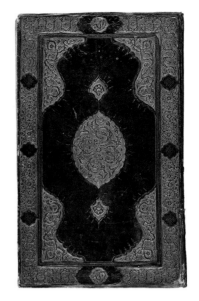

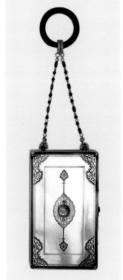

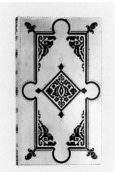

Outer cover of a manuscript
of the *Bustan* of Sa'di
Copied for Sultan 'Abd al-'Aziz
(1540–1550)
Bukhara, Uzbekistan, 1531–1532
Leather, gold, ink, gouache, paper
28.9 × 18.4 × 3.5 cm
Harvard Art Museums/Arthur M. Sackler Museum
Gift of Philip Hofer in memory of Frances L. Hofer
Formerly in the collection of Louis Cartier
Inv. 1979.20, LC no. 3a

FIG. 1
"Persian style" vanity case
Cartier Paris, 1923
Gold, enamel, emeralds,
onyx, diamonds
Photograph, 1923
Cartier Paris Archives
Inv. 106141824

FIG. 2
"Persian decorations" vanity case
Cartier Paris, 1923
Gold, enamel, onyx, diamonds
Photograph, 1923
Cartier Paris Archives
Inv. 098622430

FIG. 3
"Arabesque decoration" vanity case
Cartier Paris, 1927
Gold, enamel
Photograph, 1927
Cartier Paris Archives
Inv. 172382430

colorways with the principal design in enamel or in reserve—black on gold, white on gold, gold on black, and white and black on gold. The design was almost always described as "Persian decoration" [P. 215].[83] Vanity cases with other all-over patterns, drawn from Owen Jones and elsewhere, were enhanced with triangular ornamental devices with split palmettes and arabesques, also described as "Persian" [P. 184].[84] Enamel was also used to create interesting reciprocal patterns on two cylindrical vanity cases, while a pattern drawn from the border of an Anatolian rug, described as a "moresque frieze," was used to enhance the two ends of a vanity case in 1926 [P. 184].[85] Persian fabrics, probably taken from shawls, were used to make handbags during this period, such as a *pochette* with a reciprocal design made in the S Department under the direction of Jeanne Toussaint [P. 184].[86]

Another recognizably Iranian design element adapted at Cartier and transformed into a lexicon vocable was the cartouche form, derived from the borders of book bindings, illuminations, carpets, and tilework. The earliest examples of its use date to 1913. In these, the cartouche was conceived both vertically and horizontally in a somewhat rigid, geometric pendant in the escutcheon style (later refashioned as a brooch) and horizontally as a stomacher brooch with a large, pendant finial [FOR EXAMPLE, P. 185, FIG 1].[87] The same year, the cartouche shape was devised in a radically different manner as a flexible, *bazuband*-like form, slimmed down and executed in the "Arab" escutcheon style as a choker necklace [P. 185, FIG. 4]. It was also made as a pendant brooch set with colored stones: jade, turquoise, sapphires, and a pearl [P. 279, TOP RIGHT].[88] These colors may have taken inspiration from the stage sets of the Ballets Russes, and represent the new style of combining colors mentioned in the contemporary bilingual pamphlet (1913). Other pendants in the vertical cartouche shape were conceived with bold color combinations in mosaic-like designs in abstract or representational modes [P. 185, FIGS. 2-3, 5-6].[89]

While it is not possible to include or analyze here the entire lexicon inspired by Islamic designs that was employed at Cartier in the 1920s, it is worth mentioning a revival of sorts of the "Arab" escutcheon style applied to a series of strap bracelets— essentially an abstract frieze worn around the wrist. In the stock book descriptions, the internal designs on the bracelets were labeled "arabesques," "Persian frieze,"

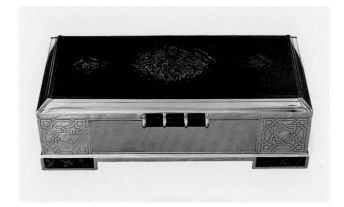

"Persian plaque" table cigarette box
Cartier Paris, S Department, 1927
Silver, portion of a Persian leather
book binding, gold, coral, wood
Photograph, 1927
Cartier Paris Archives
Inv. 181452430

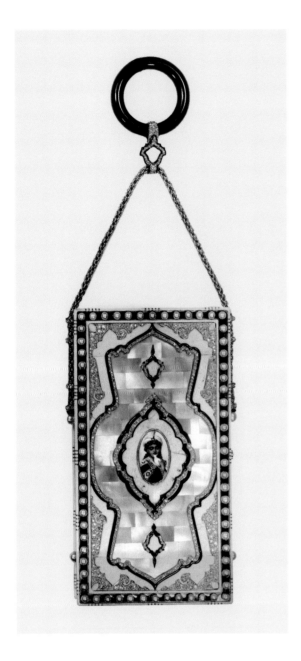

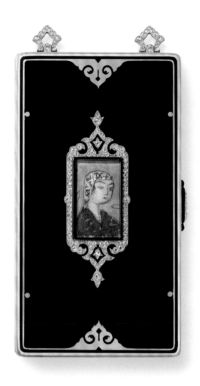

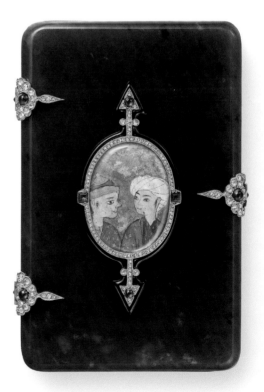

Vanity case
Cartier Paris, 1924
Mother of pearl, turquoise,
"Persian" miniature, enamel, pearls,
gold and onyx
Photograph, 1924
Cartier Paris Archives
Inv. 118962430
See Cartier Collection VC 34 A24

"Centre plaque Persian
miniature" vanity case
Cartier London, 1924
Gold, platinum, cut-out of a painting
from a Persian book, enamel,
glass, diamonds
8.7 × 4.5 × 1.1 cm

Cartier Collection
Inv. VC 91 A24

"Persian" cigarette case
Cartier Paris, 1920
Nephrite, cut-out of a painting from
a Persian book, platinum, sapphires,
enamel, glass, diamonds
9.32 × 6.05 × 1.83 cm

Cartier Collection
CC 09 A20

or "Persian interlace."[90] Some forms were already familiar: split palmettes, reciprocal scrolls, square plaques, and the cartouche. But, for the first time, complex interlaced star patterns were expressed, of the type that had been explored by Jules Bourgoin decades earlier [PP. 186 AND 239]. Charles Jacqueau's interest in these layered geometries is evinced by tracings in his personal archive that must date from this moment. In a sense, it was a return to the beginning. They were also a nod to the future—Cartier would use such strap bracelets as a repeated motif on an advertisement in the british edition of *Vogue* in 1935 as an ideogram of modernity [P. 251].[91]

In the post-war period, Cartier's designers produced iconographically diverse work drawing upon sturdy precisionism, flora and fauna, beads, carved coral, and gemstones that recalled earlier influences from India, symbols, and icons such as Moors' heads—no longer felt as modern—and the hand of Fatima. Of interest to this study are jewels that drew inspiration from a new source: France's territories in North Africa.[92] In 1946, Cartier produced an extraordinary, beaded necklace in gold with a drop bead inscribed in stylized Arabic script, and a long pendant bead. It was described in the stock records as a "sautoir arabe" [P. 187].[93] The *sautoir* is comprised of the eleven sections of nine beads that make up the ninety-nine counters of the *misbaha*, a devotional rosary, although transformed by the addition of knotted loops to larger, melon-shaped beads. The style continued to be developed throughout the mid-1970s, with versions described in the records as "chapelet musulman" or "chapelet arabe." The Cartier collection preserves an example from 1970 [P. 219] where the drop bead is inscribed with the word *Allah* in Arabic and the pendant is a stepped cage-work bead resembling the form of a thirteenth-century, Spanish, bronze lamp published decades earlier by Gaston Migeon and admired by Louis Cartier [P. 200].[94] Considerations of propriety aside, it was a composition of great elegance generating other necklaces in gold with open-work beads and knots. In the spirit of a new eclecticism, joining these

"Moorish friezes" vanity case
Cartier Paris, 1925
Gold, enamel, diamonds
Photograph, 1925
Cartier Paris Archives
Inv. 142992430

"Persian triangles" cigarette case
Cartier Paris, 1925
Gold, enamel
Photograph, 1925
Cartier Paris Archives
Inv. 126662430

Vanity case
Cartier Paris, 1925
Gold, enamel, natural pearls, sapphires
2.4 × 10.2 × 4 cm
New York, private collection

Evening bag
Cartier Paris, S Department, 1928
Persian fabric, emerald, onyx,
coral, diamonds
24 × 30 cm
Photograph, 1928
Cartier Paris Archives
Inv. 187022430

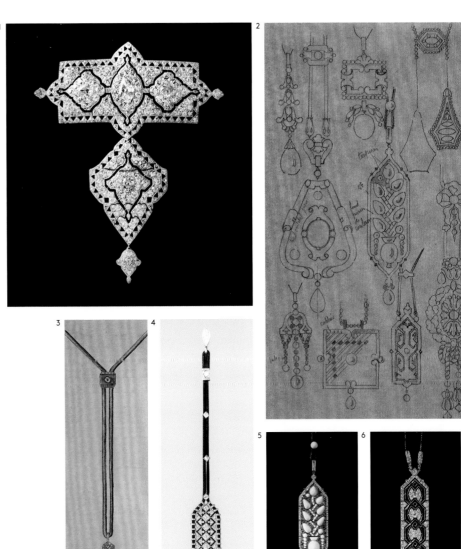

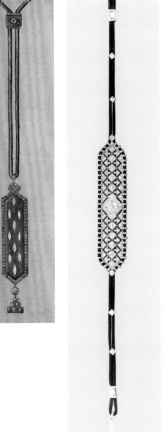

FIG. 3
Design for a pendant
Cartier Paris, 1913
18 × 4.5 cm
Graphite and gouache on tracing paper
Cartier Paris Archives
Inv. CN_030-031

FIG. 4
Choker necklace, 1913, platinum,
black-braided cord, diamonds,
Inv. 038383040

FIGS. 1, 4, 5, 6
Cartier Paris Creations
Details from photographs
Cartier Paris Archives

FIG. 2
Studies for pendants
Cartier Paris, 1912
Graphite on tracing paper
24 × 17.2 cm
Cartier Paris Archives
Inv. E254

FIG. 5
Pendant, 1913, platinum, turquoise,
sapphires, diamonds, inv. 033941318

FIG. 1
Stomacher brooch, 1913, platinum,
diamonds, inv. 033863030

FIG. 6
Pendant, 1916, platinum, onyx,
diamonds, inv. 044241318

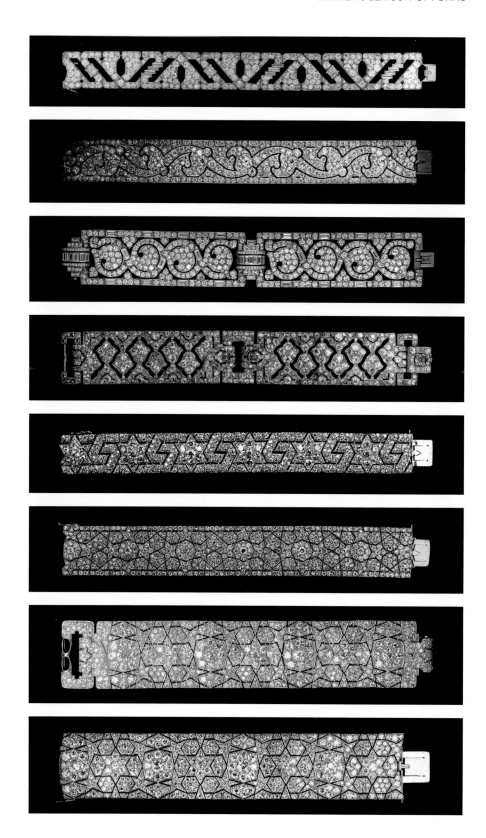

Bracelets
Platinum and diamonds
Cartier Paris
Details from archival photographs
Cartier Paris Archives

"Persian interlaces," 1930
Inv. 244692430

"Persian frieze," 1926
Inv. 147382430

"4 Arabesques," 1928
Inv. 193692430

1926
Inv. 150002430

"Geometric arabesques," 1923
Inv. 103722430

"Arabesques designs," 1923
Inv. 101642430

"Arabesques," 1923
Inv. 128962430

"Geometric arabesques," 1923
Inv. 098992430

pieces in the 1970s were others composed of triangular forms inspired by Berber fibulae from Kabylia, Algeria, although gemstones substituted the traditional coral and enamel [P. 218].[95] Celebrating the aesthetics of the Hippy Trail, these jewels brought a moment of relaxed informality into Cartier's lexicon.

According to Hans Nadelhoffer, Jeanne Toussaint, who served as creative director at Cartier from 1933–1970, recognized "the originality of Cartier's products from earlier periods, and in 1934 she advised a return to 'the sources of inspiration,' namely the ideas that had been formulated around 1906."[96] The cyclical habits of fashion excite different points of reference in every era—some remain mute while others are reactivated into the language of the style of the moment. There is no return, precisely, to the past. But Cartier's fidelity to its own historical practices and its profound archival and bibliographic resources allow for a long view toward the origins of its modalities and their inspirations. The lexicon of Islamic forms, first adapted in the early twentieth century, is by now well absorbed within its style profile, from which it continues to generate recognizable traits in colors, materials, shapes, and techniques.

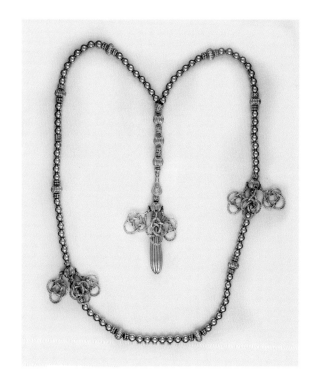

"Arab *sautoir*" necklace
Cartier Paris, 1946
Gold
Photograph, 1946
Cartier Paris Archives
Inv. 371382430

1. My sincere thanks are due to the magnificent archive team at Cartier, led by Violette Petit—Aude Barry, Sophie Brahic, Gaëlle Naegellen, Jenny Rourke, and Marina Wright—and to Pascale Lepeu, curator of the Cartier Collection, and her team, without whose dedicated research this project would not have been possible.

2. Jones, 1856; Bourgoin, 1880, a re-worked edition of his *Théorie de l'ornement* (Bourgoin, 1873). Significant recent work on this aspect of Bourgoin's work includes Thibault, 2012, espec. pp. 231–250; Labrusse, 2016; 2018; and Frank, 2017.

3. Bourgoin, 1879.

4. Cartier's lexicon was a kind of reverse cultural cannibalism, or *antropofagia* of forms, to use Oswald de Andrade's metaphor. The Anthropophagist movement, baptized by Andrade's *Manifesto Antropófago* in the avant-garde journal *Revista de Antropofagia* (1928), was a transcultural concept of consuming the enemy, promoted by Brazilian Modernists as a reaction to imported European products, arts, and literature. The idea was that Brazilian production, in turn, would create a new product for global consumption. The ambiguity of the tautology of colonizer vs. colonized in this post-colonial vision for a modernist path is complicated by European, and particularly French, modernism's interest in so-called Primitive or indigenous cultures. A parallel French admiration for borrowing from, or exploitation of, Islamic cultures and their cultural production, and vice-versa, is not the same as the Brazilian model, but the idea of *antropofagia* offers complexity to raw notions of appropriation through the process of digestion and transformation (slyly, cannibalism) in addition to the formal language of the lexicon. I thank Agustín Arteaga for bringing this movement to my attention.

5. See, for example, Necipoğlu, 1995.

6. These would continue to be designed and produced alongside experimental styles over the next decade—there is no sharp break, but rather a gradual transition toward a new style.

7. "Dart" was the term the mathematician Roger Penrose chose to describe this shape; in the Cartier stock book, it is described as a "losange."

8. Jones, 1856, p. 5, "... every assemblage of forms should be arranged on certain definite proportions; the whole and each particular member should be a multiple of some simple unit." A similar figure was composed by Jones at the center of his plate "Byzantine no. 3" comprising cells filled with four different patterns; see Jones, 1856, pl. 30. The idea of subdivision and form-filling was also defined by Jones in his seventh proposition: "The general forms being first cared for, these should be subdivided and ornamented by general lines; the interstices may then be filled in with ornament, which may again be subdivided and enriched for closed inspection." See Labrusse, 2016, p. 322.

9. Bourgoin, 1873, p. 158, fig. 54; Bourgoin, 1901, vol. 2, pl. 35; Bourgoin's works are noticeably absent from Louis Cartier's design library. This may not be surprising: Mercedes Volait has wondered if Bourgoin's work on Arab art was perceived as complementary to that of Émile Prisse d'Avennes, French artist and architect of the previous generation who documented Egyptian monuments, and if their works might be compatible in the same library. Volait, 2012a, p. 63. Indeed, the text volume of Prisse d'Avennes, 1877, survives in Louis Cartier's library, although without the color plates, their absence suggesting a removal to the design studio; however, they are apparently no longer stored there.

10. The sapphire brooch is described in the stock book as a "brooch in the form of a square checkerboard." The emerald brooch was not photographed.

11. Bourgoin, 1873, p. 148, fig. 46. "Les parallélogrammes, les losanges, les rectangles et les trigones se décomposent en petits éléments de même forme. Cette décomposition est infinie et établie par la subdivision des côtés dans un même rapport"; Bourgoin, 1901, pls. 22–23.

12. The brooch with emeralds, produced in 1908, forms part of the Cartier Collection (CL 314 A08). The present locations of the brooches with rubies and pearls are unknown. The stock book entry for the brooch with rubies records that it was fabricated for Cartier in 1907, and it is described in the stock book as a "hexagonal brooch of six sticks."

13. Bourgoin, 1873, pp. 253–254, fig. 197; Bourgoin, 1901, pls. 125, 128, 152–153, 168.

14. For example, the hexagonal forms in a photograph of the reverse side of the mihrab from the twelfth-century Mausoleum of Sayyida Ruqayya in the Museum of Islamic Art, Cairo; Migeon, 1907, p. 97, fig. 83.

15. Originally 1842.

16. On grammars and compendia, see Labrusse, 2016, pp. 320–322; Labrusse, 2018, pp. 28–33.

17. Beyond the notable absence of Bourgoin, other well-known volumes on Arab decorative design may once have formed part of the collection, for example, Girault de Pranguey, 1846 and Gayet, 1893. This literature has been well studied recently for its particular arguments in regard to serving as a source to revitalize European industrial arts. See Necipoğlu, 1995; Labrusse, 2016, espec. pp. 324–326; and, among other studies, Bouchon, 2007; and Rugiadi, 2019.

18. For Mamluk objects published by Eugène-Victor Collinot and Adalbert de Beaumont and copied in glazed earthenware by Théodore Deck and Collinot himself, both in 1863, see Paris, 2007, cat. nos. 251 and 252, pp. 254–255. Interestingly, Collinot and Beaumont identified the bottle as Persian, from the Sasanian period; Possémé, 2007.

19. Although no hard evidence connects Louis Cartier with Bourgoin's ideas, early twentieth-century creations produced at Cartier reflect a parallel interest in Ancient Greek, Japanese, and Arab art, which Bourgoin also felt were formally distinctive and exemplary. Bourgoin, 1880, p. 9; Thibault, 2012, pp. 232, 237.

20. Speech delivered on August 4, 1942 at 10.30am, rue de la Paix, in front of Madame J. Cartier, all the personnel of Cartier S.A. Direction, employees and workers, by M. Louis Devaux, Cartier Archives, Paris.

21. These drawings are the only ones assuredly attributable to Charles Jacqueau as the studies and execution drawings preserved in the Cartier Archives are typically unsigned.

22. For example, Jacqueau appears to have sketched Iznik ceramics in Alexandre du Sommerard's collections at the Hôtel de Cluny (today the Musée National du Moyen Âge), now housed at the Château d'Écouen (see p. 104). Thanks to Judith Henon-Raynaud for noting the links

between the Iznik works included in this exhibition and Jacqueau's sketches, particularly the Petit Palais, inv. nos. JAC02875 and JAC02893. He also made direct rubbings from Islamic bookbindings, some possibly in Louis Cartier's collection, for example, inv. nos. JAC02871, JAC02873, and JAC02874.

23. Nadelhoffer, 2007, pp. 31–57.

24. For example, the same genre of ornament in an octagonal format is painted on a twelfth-century, Spanish, ivory casket at the Instituto de Valencia de Don Juan, Madrid (ivory casket 51); see Silva Santa-Cruz, 2017.

25. Jones, 1856, from plates Arabian nos. 1 (XXXI), 2 (XXXII), and 3 (XXXIII), but also Byzantine no. 3 (XXX), Indian no. 1 (XLIX), Middle Ages no. 3 (LXVIII), and Renaissance no. 6 (LXXIX).

26. Migeon, 1907, figs. 190, 191, 195, 219, 240, 241, 246, 247, 248, 259, 275, 282, and two others not easily identified.

27. Jones, 1856: India no. 1 (11); India no. 3 (8); India no. 4 (5); or India no. 7 (4).

28. Cartier Paris Archives, *Cahier d'idées* CH04, p. 103.

29. Until 1929, Cartier supplied designs for fabrication to a select group of jewelry workshops; Cartier Paris Archives, 1910, negative inv. 019051824, plaster cast inv. no. 395, REGST19/130–131: *Pendant rond fond motifs arabes.*

30. Cartier Collection CL 100 A06. Cartier Paris Archives, 1906, plaster cast inv. no. BRO632, REGST32/104–105.

31. Geometrically quite basic, the form may have found its inspiration in Bourgoin's theories of decomposition—he illustrated it among other forms described as *polygonaux dérivés*; Bourgoin, 1873, p. 148, fig. 46.

32. Hendley, 1909.

33. Ibid., pl. 58.

34. Another page in the notebook entitled *Formes de médaille pas rondes et souples* includes other amulet forms copied from Hendley; Cartier Paris Archives, *Cahier d'idées* CH04, p. 104, 1908–1909.

35. Hendley, 1909, pl. 7, no. 34.

36. The brooch existed in several colorways, all fabricated in 1910.

The emerald example is preserved in the Cartier Collection, CL 334 A10.

37. Cartier Paris Archives, plastercast inv. no. BRO122_R. The glass plate bearing the archival photograph of this piece is missing.

38. Cartier Paris Archives, 1909 brooch, negative inv. 018513040 /REGST33/076–077; Cartier Paris Archives, 1909 pendant, commissioned by Grand Duke Paul of Russia, negative inv. 015192430.

39. Cartier Paris Archives, 1910 brooch, negative inv. 020962430 /REGST33/140–141. It was described in the stock book as *broche, style arabe*. The scroll work was surely inspired by a published model, for example, a drawing of a fifteenth-century, Mamluk colored glass window; see Gayet, 1893, p. 179, fig. 84. This squared-off, half-medallion amulet shape would endure at Cartier well into the 1920s. For example, a jewel formerly in the Cartier Collection (CL 213 A13) produced in 1913, as well as Cartier Tradition inv. CRHSA40515, produced in Paris in 1921.

40. Cartier Paris Archives, 1910 brooch, negative inv. 020892430/ REGST33/136–137.

41. Cartier Paris Archives, plaster cast inv. BRO183/REGST33/132–133.

42. Here, I refer to the third Arab style described above.

43. Today, the Museum für islamiche Kunst; thanks to Judith Henon-Raynaud for this observation.

44. It was described in the stock book as *motif architecture mauresque*.

45. Saladin, 1907 (Cartier Archives Paris, BibCart 383) and Charles Jacqueau's sketches thereof held in the collections of the Petit Palais, acc. num. PPJAC 3239. The drawing is marked "page 84," corresponding with an image of windows with ornamental stone grills at the Mosque of Ibn Tulun, Cairo. Other mosque arcades sketched by Jacqueau from Saladin's photographs include the exterior window arcades of the Dome of the Rock, Jerusalem (p. 61), those of the distinctive entrance and courtyard of the Azhar (pp. 86-87), and windows of the Qala'un complex (p. 112), Cairo. On the right of Jacqueau's drawing is a rendering of a watch face that appears to have derived its contours from the chevron-patterned archway of the Bab al-Futuh gate, Cairo (p. 98).

46. Various jewels and objects at Cartier between the 1930s and the 1950s were set with stones using a *kundan* setting, a traditional Indian technique of embedding a gemstone within a soft, gold bezel with a reflective foil beneath. In the stock registers, this was referred to as an Indian setting. These include a matching powder compact and lipstick holder set made by Cartier in 1931 and 1933 (Cartier Collection PB27 A31–33), as well as other pieces in the Cartier Collection: CL 58 A38, NE 18 A49, and NE 31 A55.

47. For recent thinking on Alois Riegl and the possible functions and meanings of the "arabesque" in Islamic art and architecture, see Flood, 2016.

48. If Picolpasso's recording of a *Rabeschi* design for maiolica popular in Venice and Genoa in the *Tre Libri dell'Art del Vasaio* (1556–1559) is a reliable marker; Piccolpasso, 1879, table 25; Fontana, 2007, pp. 286–287. Other nearly contemporary style books were published with examples of "Moorish" and "Damascene" designs of curling stem and leaf patterns intended to serve as inspiration for other arts, such as Geminus, 1548.

49. Baudelaire, 1920, *Fusées* V–VI, p. 10; for the key of C, see Schubart, 1806; Daverio, 1997, p. 177.

50. Falcone, 1999, pp. 71–72, 90–91 and espec. Hammond, 1995. Léopold Adice's unpublished manuscript volume on the arabesque, *Sur l'arabesque*, illustrating the multiplicity of arm and leg positions, followed his monumental *Théorie de la gymnastique de la danse théâtrale* (Paris, 1859), part of a larger work, mainly unpublished, of which the work on the arabesque represents the third volume, held at the Bibliothèque-musée de l'Opéra, Paris.

51. "On doit offrir en vente des choix d'objets nouveaux que je ne vois guère possible que dans le genre russe ou même persan." Bachet and Cartier, 2019, p. 249.

52. Nadelhoffer, 2007, espec. pp. 111–113.

53. On the history of the display of Islamic art at the Louvre, see Makariou, 2012, espec. pp. 11–15 and Henon-Raynaud, 2018. By 1860, some works of Islamic art were displayed at the Louvre, blended with European art. By 1876, Islamic ceramics could be seen at the Musée de la

Manufacture de Sèvres, and by 1878 at the Hôtel de Cluny. By 1893, the Département des Objets d'Art at the Louvre collected and displayed "art musulman" and established a dedicated gallery to the subject in 1905; in 1903, the great exhibition of Muslim art was presented at the Union Centrale des Arts Décoratifs. A general volume of the Munich exhibition catalogue is present in Louis Cartier's design library; Sarre and Martin, 1912.

54. Louis must have acquired the portrait of Sultan Husayn Mirza shortly after Munich as he exhibited it in Paris in 1912 under his own name; Sarre and Martin, 1912, vol. 1 (*Miniaturen und Buchkunst; die Teppiche*): miniature lent by M. Ducoté, Paris, table 24, cat. no. 669 (Harvard Art Museums, 1958.60); sketch of a miniature, lent by F. R. Martin, Stockholm, table 26, cat. no. 677 (Harvard Art Museums, 1958.59).

55. Marteau and Vever, 1913: cat. 20, *L'Empereur Aureng Zeb* (Museum of Islamic Art, Doha, acc. no. MS.54.2007); cat. 63, *Scène dans le pavillon noir (pavillon du samedi)*, detached folio from a *Khamsa* of Nizami (Hussein Afshar Collection on loan to the Museum of Fine Arts, Houston, acc. no. TR: 462-2015); cat. 86, *Deux premières pages d'un manuscrit, Gouy va Tchougan* (Harvard Art Museums, acc. no. 1958.79); cat. 93, *Page d'un Boustan de Saadi* (Harvard Art Museums, acc. no. 1979.20); cat. 144, *Jeune femme agenouillée* (Harvard Art Museums, 1958.60); cat. 172, *Jeune cavalier chassant au faucon* (Fundation Custodia, Paris, acc. num. 1973-T.3); cat. 249, *Portrait d'Akbar* (current location unknown).

56. Cartier Paris Archives, Louis Cartier correspondence 1909-1939, inv. CORR/LC11: a receipt from art dealers Kalebdjian Frères dated October 7, 1920, details several objects including two pairs of Arab doors inlaid with ivory (*paire de portes arabes incrustées ivoire*), as well as six "mosque panels with colored glass" (*6 panneaux de mosquée avec verroteries*), presumably inlaid, stucco or carved stone windows. These items reappear in a receipt from the Kalebdjian Frères, dated December 23, 1924, in regard to objects, furniture, and carpets purchased and in the possession of Louis Cartier. The list is annotated in pencil, referencing the locations to which the works should be sent, including a large

carpet marked "Budapest," two "pairs of Arab doors inlaid with ivory" marked "Spain" and *12 panneaux vitraux*, also marked "Spain." The pairs of doors and the panels of glass, perhaps colored glass windows, may have been of Arab origin, perhaps of the late Mamluk or Ottoman eras and from Egypt or Syria. They may also have been from Turkey or Iran—it is impossible to verify. Cartier Paris Archives, Louis Cartier correspondence 1923–1935, inv. CORR/LC13 also contains an inventory of furniture in the house in Budapest that includes Turkish and Persian rugs.

57. The wine cup is now in the Freer Gallery of Art and Arthur M. Sackler Gallery, Smithsonian Institution, Washington, DC: Art and History Collection, LTS1995.2.27.

58. The Qur'an in Maghribi script was mentioned in an appraisal made by Basil Robinson of Louis Cartier's collection in 1956— Cartier had passed away in 1942; the document is held in a private archive. Interestingly, Louis Cartier donated the pommel of a French crusader sword with the Arms of Pierre de Dreux (c. 1187–1250), Duke of Brittany and Earl of Richmond, acquired in Damascus, to the Metropolitan Museum of Art in 1938 (acc. no. 38.60).

59. For the milieu of French collectors of Islamic art, see Roxburgh, 2000 and Paris, 2019. Susan Stronge thought Louis Cartier might have been inspired to collect by a visit to the library of John Pierpont Morgan in New York in 1908; Stronge, 2001, p. 68. Reviews of the 1933 exhibition of Islamic art at the Metropolitan Museum of Art mention Louis Cartier, a lender to the exhibition, as a renowned "connoisseur in the field of Islamic painting" on a par with Arthur Chester Beatty; see, for example, "Museum puts Islamic art on view Tuesday," *New York Herald Tribune*, October 7, 1933. In his obituary in *The New York Times*, July 4, 1942, it states: "Mr. Cartier was known almost as well for his collection of miniature Islamic paintings, chiefly Iranian. He was regarded as an expert in Islamic art and possessed a large collection of masterpieces in this field."

60. Martin, 1912, vol. II, pl. 81; Harvard Art Museums, inv. no. 1958.59. For recent thoughts on the painting and its exhibition in 1910 see Troelenberg, 2010.

61. The Armory of the Moscow Kremlin preserves a rare, fifteenth-century, Iranian cloud

collar adorned with embroidered, winged *peris*; inv. no. TK-3117; see Levykin, 2009, pp. 28–29. Fifteenth-century design drawings for various cloud collars are preserved in the Diez Albums at the Staatsbibliothek zu Berlin-Preußischer Kulturbesitz, for example, Diez A, fol. 73, p. 41, no. 2 (a cloud collar with a pointed finial containing a crane standing in water with aquatic flowers) and Diez A, fol. 73, p. 54, no. 1 (a cloud collar with a *peri*, two *qilin*, and a swan).

62. Cartier New York Archives, 1913, Boston exhibition (CNYA21-22) and Cartier Paris Archives, 1913, New York exhibition (PF14/COM/P08); see the essays by Évelyne Possémé and Sarah Schleuning in this volume.

63. "À travers Paris," *Le Figaro*, June 3, 1913, 1.

64. This rather guileless positioning of Russia as the intermediary between Iran and Europe echoes the more humorous, nearly contemporary analysis of G. I. Gurdjieff, who, from the European point of view, likened the Europeans to peacocks, the Persians to crows, and the Russians to the intermediate bird, turkeys; Gurdjieff, 1950, pp. 597–599.

65. "La vie de Paris. Le goût oriental," *Le Figaro*, June 4, 1913, 1. The author of the response in *Le Figaro*, clearly a Cartier ally writing in support of the exhibition, may have been Imre Schwaiger himself, who had formed a partnership with Cartier in India and was especially close to Jacques Cartier, director of the Cartier London branch. Thanks to Jenny Rourke, Cartier London Archives, for this suggestion, and see Nadelhoffer, 2007, p. 159.

66. For examples of the newer style of undergarments see "The plastic art of the corsetiere," *Vanity Fair*, January 1914, 72; Jacques Cartier, somewhat later, described the shift to a lighter style of jewelry, "Le client aujourd'hui ne veut plus de lourdes montures … le massif est banni. La monture n'est plus qu'un soutien, une agrafe, rien de plus." Merlet, 1929, p. 27.

67. "The Oriental phase through which we are passing reaches a culmination in the stage pictures of Leon Bakst [costume and set designer for the Ballets Russes]. His costume drawings for opera and ballet have had their influence on modern dress. But to appreciate Bakst one must see his ensemble. One must share his joy in the height and depth of the stage, the mystery of his

lights, the arabesque of his forms, the sensuous dissonance of his colors." In "Snapshots for the Hall of Fame," *Vanity Fair*, January 1914, 23; see also Paul Cornu, "Coiffures persanes et parisiennes," *Jardin des modes nouvelles*, no. 1 (October, 1912), 8, cited in Zaras, 2019.

68. "*The oldest, the newest* is not an aphorism, as demonstrated by the selection that Messrs. Cartier have chosen for a short exhibition in their London House. Together with a few of those rare and antique specimens of Persian Art—which created a far-reaching movement when exhibited lately in Paris—will be shown a representative collection of their newest models. Very different and yet very much akin to the former, they derive their character not only from the design, but mostly from a scheme of colour. The result is not necessarily a loud effect— very far from it. Blue, green and purple hues with a touch of black and white dominate in most of their combinations—and are not rubies and emeralds seen next to each other in perfect harmony on Dame Nature's own jewels? Those creations are stamped by the *goût oriental*, otherwise *The Art of Blending Colours* through which the XXth Century Style now is in his powerful youth will gain its classic laurels." *XXth Century Style*, Cartier New York Archives.

69. "Afin de conserver à ces Bijoux leur caractère et leur authenticité, MM. CARTIER n'ont pas cru devoir changer les parties en or bas ni les boules de verre en imitation de turquoises et autres trompe-l'œil orientaux, mais les ont signalés autant que faire se peut dans le présent Catalogue." Cartier Paris Archives, PF14 COM 07.

70. Nadelhoffer, 2007, p. 136; see also the comment on Vaslav Nijinsky's performance in "*Le Dieu Bleu*," for the Ballets Russes, in May 1912, also choreographed by Fokine with sets by Bakst; Lugano, 2017, pp. 210–215.

71. For example, Cartier Paris Archives, negatives inv. 034423040, 034433040, 034443040, and 034373040; see Évelyne Possémé in this volume, pp. 112–115, 124-125.

72. *Persan*, *décor persan*, or *motifs persans*.

73. Cartier Paris Archives, 1912 pendant, negative inv. 026781318, REGST 19/186–187. Cartier Paris Archives, 1912 brooch, negative inv. 028691824, REGST 33/348–349. The brooch has a loop to allow it to be worn as a pendant as well.

74. *Décor arabe.*

75. See Cartier Paris Archives, negatives inv. 10681, 9665, and 10012 (all from 1923). Enameled cases without jewels include negatives inv. 7054 (clock, 1920), 8457 (vanity case, 1922), 9862 (vanity case, 1923), and 17238 (vanity case, 1927, *décor arabesque*). For the Byzantine technique, see, for example, a tenth- or eleventh-century Constantinopolitan book cover from the Biblioteca Nazionale Marciana, Venice, in New York, 1997, p. 88.

76. For the enameled medallion forms see Cartier Paris Archives, negatives inv. 9238 (vanity case, 1922) and 10576 (vanity case, 1923), and for an example of the square type see negative inv. 24944 (vanity case, 1930).

77. The idea for reemploying antique elements from Egypt, Iran, or India into new creations at Cartier may represent a continuation of the practice of reuse of ancient cameos and seals. However, it may have also found its inspiration in the practice of incorporating architectural *spolia*, for example, the reemploying of Mamluk and Ottoman-era tiles and woodwork in new domestic settings, such as at the hôtel particulier Saint-Maurice in Cairo (1872–1879) or at Leighton House in London (1866–1895). See Volait, 2012b; 2020.

78. Cartier Paris Archives, negative inv. 6601; *centre plaque indienne*.

79. Ibid., negatives inv. 10681, 10614 (both 1923), and Cartier Collection VC 91 A24 (1924).

80. Ibid., negative inv. 18145 (1927). The sides of the box are engraved with a somewhat discordant interlace copied from a source in the Islamic West.

81. On the Qajar-era box, see Judith Henon-Raynaud's essay in this volume, p. 66 and 92.

82. Cartier Paris Archives, negative inv. 11896 (1924) and drawing inv. ST23-104; eighteenth-century Qajar box, Musée des Arts Décoratifs, Paris, inv. AD 29247. For the original miniature, see Apprêt LC dating from 1923.

83. *Décor persan*; Cartier Paris Archives, negatives inv. 18580 (vanity case, 1928) and 24108 (vanity case, 1930).

84. Cartier Paris Archives, negatives inv. 12942 (vanity case, 1925) and 12666 (cigarette case, 1925).

85. *Frise mauresque.*

86. Cartier Paris Archives, negatives inv. 13031 (vanity case, 1925), 14299 (vanity case, 1926), 18702 (pochette 1928). For the S Department, see Pascale Lepeu's essay, note 2; a photographed detail of the textile before it was transformed is held in the collection of the Petit Palais, Charles Jacqueau archives, acc.num. PHGG-16.

87. Cartier Paris Archives, negative inv. 033863040, REGST34_026–027 (brooch, 1913).

88. Ibid., negative inv. 3838 (choker necklace, 1913).

89. Ibid., negative inv. 033941318, REGST19_210–211 (pendant, 1913), negative inv. 044241318, REGST19_232–233 (pendant, 1915–1916), and *Cahier de dessin* CN_030_031, 1913.

90. *Arabesques*, *frise persanne*, or *entrelacs persan*.

91. See Schleuning in this volume.

92. Along these lines, one might also consider the gold *Coffee Bean* necklace, bracelet, and earrings (1954–1955) that recall the *coffea robusta* produced in French Indochina, Cartier Collection NE 57 A55, BT 150 A54, and EG 36 A55.

93. Cartier Archives, photographs inv. 37138 (1946) and inv. 2490 (1969). Interestingly, two *masabih* of standard format were recorded in Cartier's "stock musulman" in 1922. Many thanks to Cartier's archivists for their research into this form.

94. Cartier Collection, NE 45 A70, made in Paris; Migeon, 1907, p. 229. In the example in Louis Cartier's library, the plate is marked with his characteristic "+" and the words "forme générale."

95. A set of earrings and a necklace were made in New York in 1971, (see p. 218).

96. Nadelhoffer, 2007, p. 9.

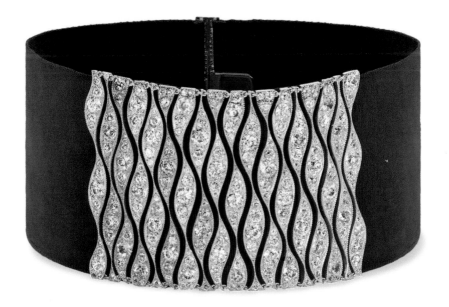

Choker

Cartier Paris, 1903
Platinum, diamonds
Height: 5.05 cm

Cartier Collection
Inv. NE 58 A03

Head ornament

Cartier Paris, 1902
Platinum, diamonds
Height: 7 cm

Cartier Collection
Inv. HO 25 A02

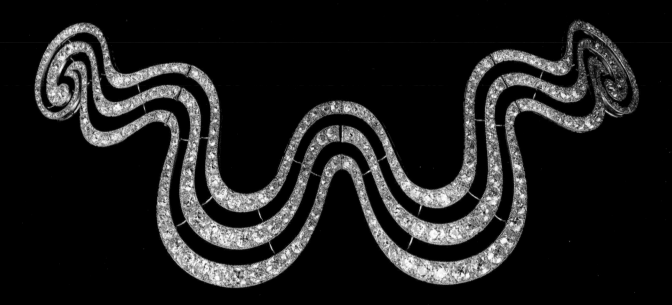

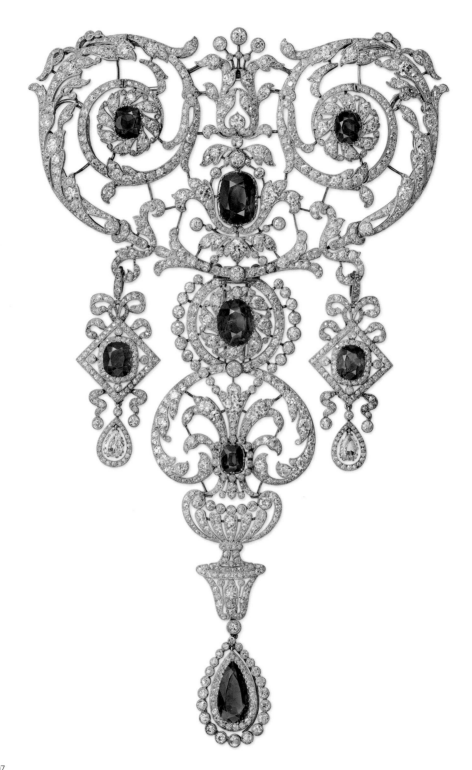

Stomacher brooch

Cartier Paris, special order, 1907
Platinum, diamonds, sapphires
21.0 × 12.9 cm

Cartier Collection
CL 292 A07

Stomacher brooch

Cartier Paris, special order, 1909
Platinum, diamonds
12 × 9.62 cm

Cartier Collection
Inv. CL 208 A09

"Sunray" brooch

Cartier Paris, 1906
Platinum, diamonds
4.2 × 4.7 cm

Cartier Collection
Inv. CL 100 A06

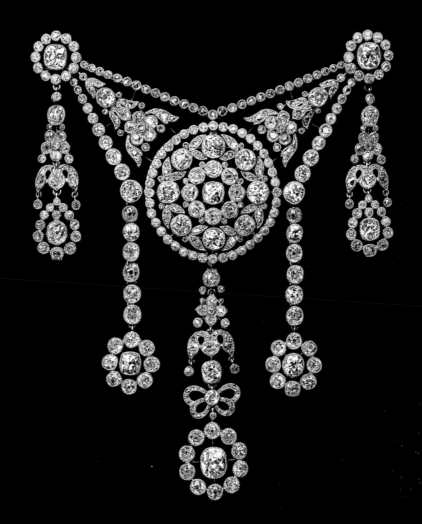
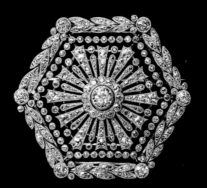

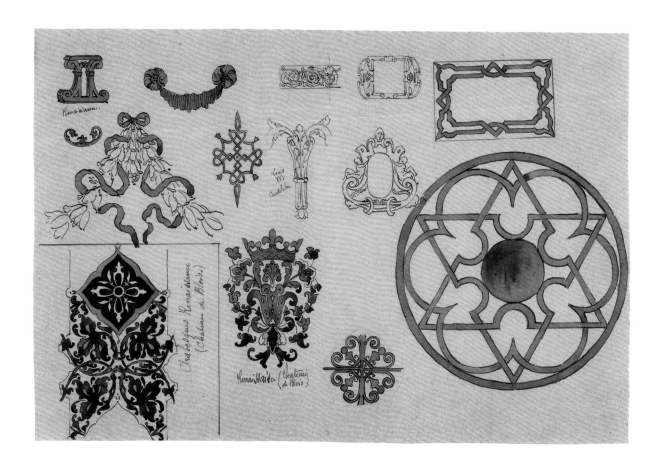

Studies for Arab- and
Renaissance-style ornaments

Cartier Paris, c. 1910
Ink on tracing paper
17.9 × 26.8 cm

Cartier Paris Archives
Inv. E11

Sautoir

Cartier Paris, 1907 (necklace), 1908 (pendant)
Platinum, pearls, diamonds
Pendant: 5.70 × 4.90 cm

Cartier Collection

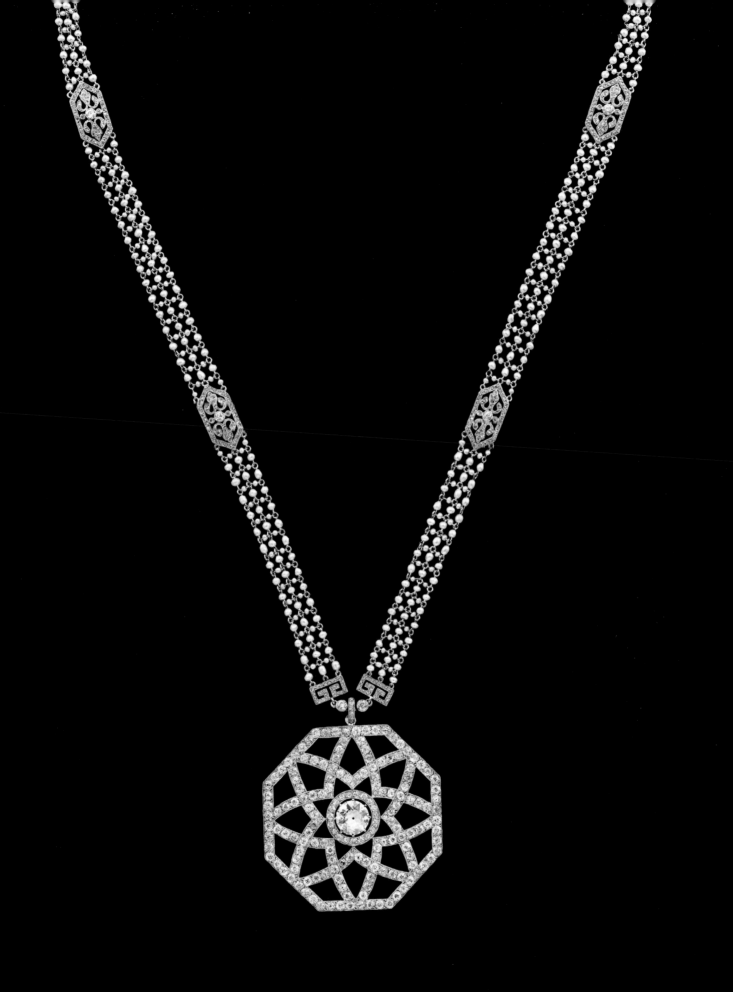

Plaster cast of a pendant

Cartier Paris, 1909
8.8 × 6.6 × 1.3 cm
Cartier Paris Archives
Inv. PE91

Plaster cast of a brooch

Cartier Paris, 1909
6.4 × 5.1 × 1.7 cm
Cartier Paris Archives
Inv. BRO271

Plaster cast of a brooch

Cartier Paris, 1909
9.1 × 8.6 × 2.0 cm
Cartier Paris Archives
Inv. BRO274

Pendant

Cartier Paris, 1910
Platinum, diamonds
Height: 4.8 cm
Formerly in Mohammed
Shah Aga Khan collection
Private collection

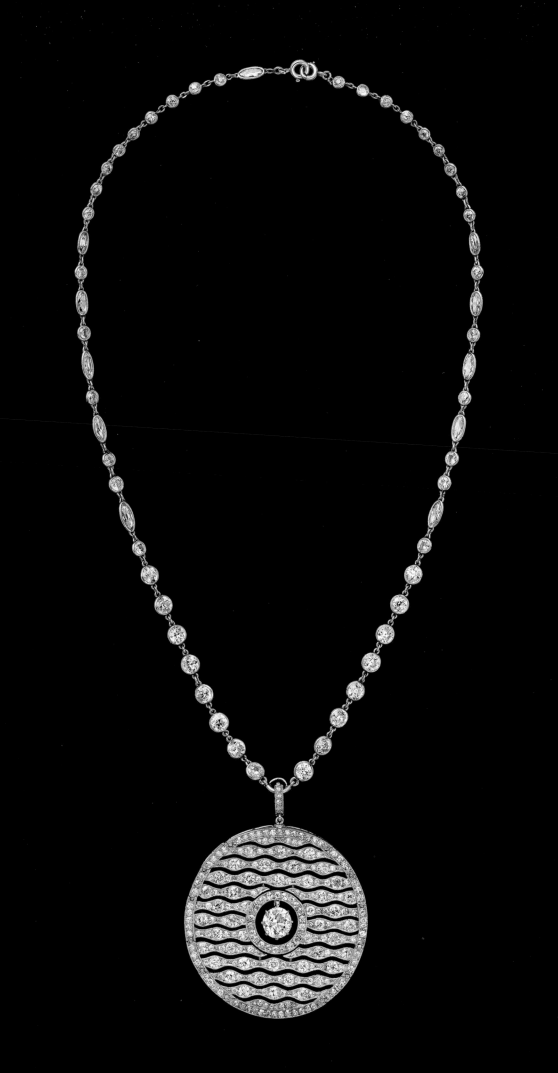

Gaston Migeon

Manuel d'art musulman, vol. II, pp. 228-229
Alphonse Picard et Fils, Paris, 1907

Cartier Paris Archives
Inv. BibCart/120_319

Louis Cartier's idea notebook

Cartier Paris, 1915-1925
India ink on buff tracing paper
pasted on paper
19.5 × 29.9 cm

Cartier Paris Archives
Inv. CH25_033-034-B

Studies of Arab-style patterns

After Migeon, *Manuel d'art musulman*
Cartier Paris, c. 1910
Ink on tracing paper
16.7 × 26.7 cm

Cartier Paris Archives
Inv. E10

Acorn- or lamp-shaped
pendant watch

Cartier Paris, c. 1925
Gold, platinum, enamel,
diamonds, silk cord necklace
Pendant: 4 × 2 × 2.1 cm

Formerly in the collection
of Prince and Princess Sadruddin Aga Khan
LA Private Collection

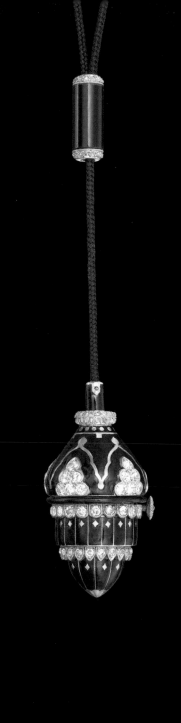

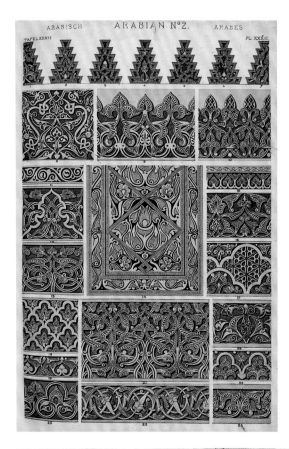

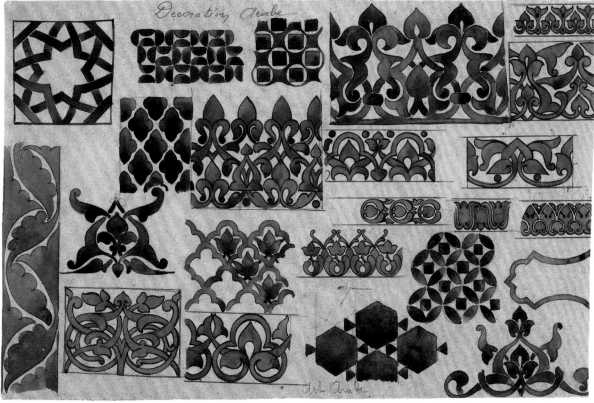

"Décoration arabe"
Studies of Arab art
and Arab-style patterns

Arabian no. 2

Owen Jones
Grammaire de l'ornement, pl. 32
Day and Son, Ltd., London, 1865

Cartier Paris Archives
Bibcart/126

After Jones, *Grammaire de l'ornement*
Cartier Paris, c. 1910
Graphite and India ink
on tracing paper
17.5 × 26.7 cm

Cartier Paris Archives
Inv. E13

Tiara

Cartier Paris, special order, 1912
Platinum, rock crystal, diamonds
Height: 3.75 cm

Cartier Collection
Inv. HO 31 A12

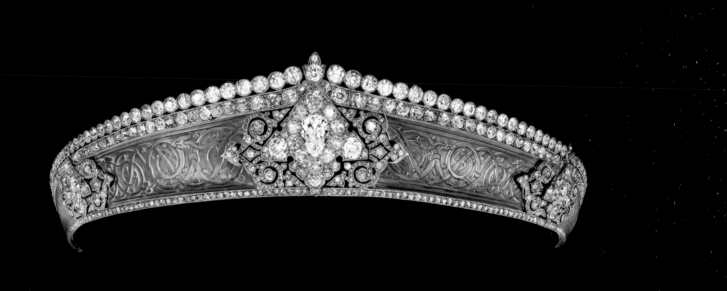

Façade of the Mshatta Palace

(Jordan, c. 743-744)
At the Museum of Islamic Art, Berlin
Archival photograph, 1904

Zentralarchiv, Staatliche Museen zu Berlin

Bandeau, "Oriental"

Cartier Paris, special order, 1911
Platinum, diamonds
Height: 5.1 cm

Cartier Collection
Inv. HO 33 A11

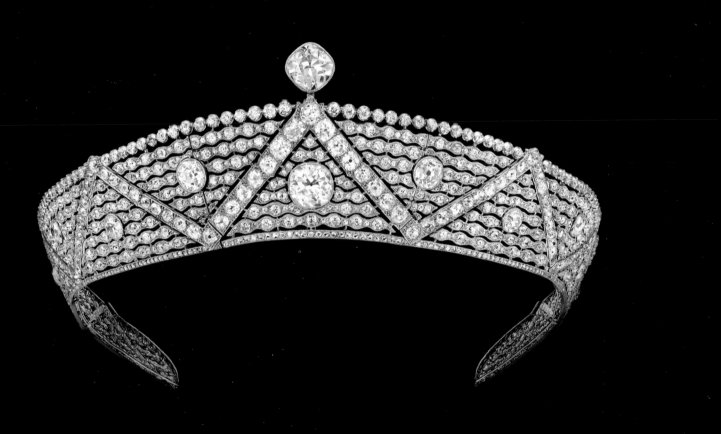

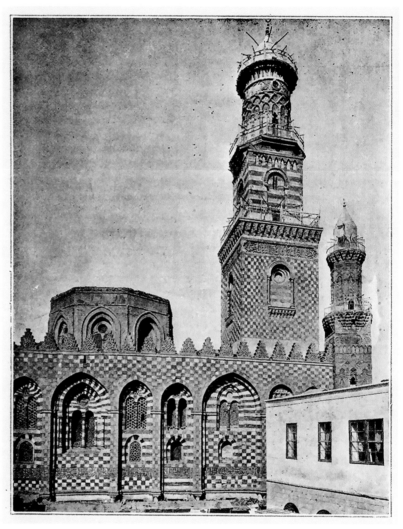

Sketches of arcades

Charles Jacqueau
After Saladin, *Manuel d'art musulman*
Circa 1910
Graphite on white paper
24.1 × 16.3 cm

Petit Palais, Paris,
gift of the Jacqueau family, 1998
Inv. PPJAC03239

"Extérieur et minaret du tombeau
du sultan Kalaoun au Caire"

Henri Saladin, *Manuel d'art musulman*, vol. I,
p. 112, fig. 74
Alphonse Picard et Fils, Paris, 1907

Cartier Paris Archives
Inv. BibCart/383

Bandeau

Cartier Paris, 1922
Platinum, gold, coral, onyx, tortoiseshell,
enamel, diamonds
Height: 3 cm

Cartier Collection
Inv. HO 24 A22

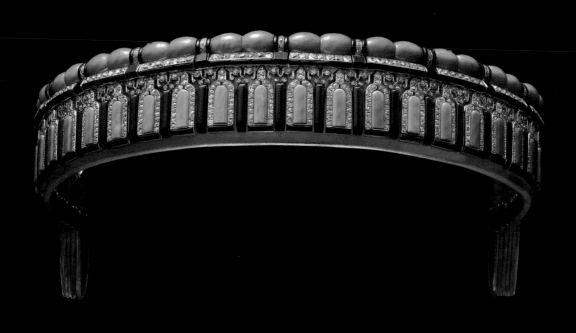

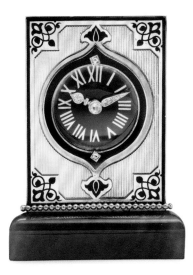

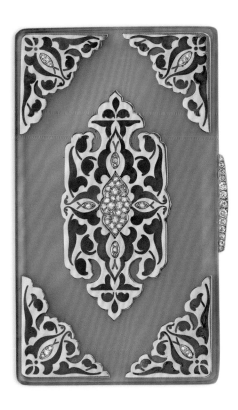

Cover from a book binding

Turkey, 16th-17th century
Leather, gold
25.7 × 14.2 × 0.2 cm

Musée du Louvre, Paris,
département des Arts de l'Islam
On loan from the Musée des Arts Décoratifs
Inv. AD UC150.B

"Mignonette" boudoir clock

Cartier, c. 1920
Yellow gold, platinum, enamel,
nephrite, diamonds
5 × 3.7 × 3.1 cm

LA Private Collection

Cigarette case

Cartier Paris for Cartier London
1929
Gold, agate, enamel,
platinum, diamonds
2 × 9.4 × 5.5 cm

New York, private collection

Vanity case

Cartier Paris, 1926
Gold, platinum, diamonds,
emeralds, onyx, enamel
10.9 × 4.4 × 2.7 cm

Cartier Collection
Inv. VC 46 A 26

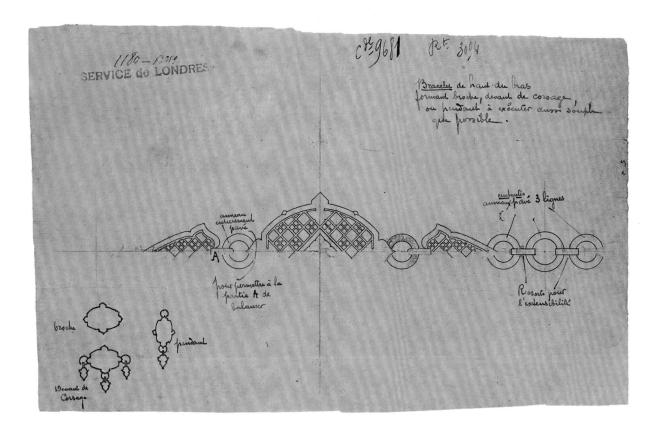

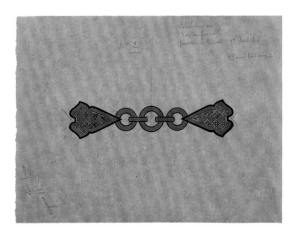

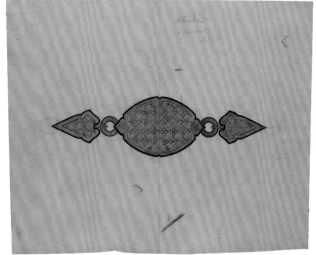

Design for an upper-arm bracelet

Cartier Paris, 1922
Executed in platinum and diamonds
Graphite and India ink on tracing paper
26.2 × 31 cm

Cartier Paris Archives
Inv. AT17/325B

Design for an upper-arm bracelet

Cartier Paris, 1922
Executed in platinum and diamonds
Graphite, India ink, and gouache
on tracing paper
19.2 × 25.7 cm

Cartier Paris Archives
Inv. AT17/325C

Design for an upper-arm bracelet

Cartier Paris, 1922
Executed in platinum and diamonds
Graphite, India ink, and gouache
on tracing paper
23 × 37 cm

Cartier Paris Archives
Inv. AT17/325A

Bazuband upper-arm bracelet

Bracelet that can be worn
as a stomacher jewel or as a brooch
Cartier Paris for Cartier London,
special order, 1922
Platinum, diamonds
14 × 22.3 × 0.2 cm

Cartier Collection
Inv. BT 08 A22

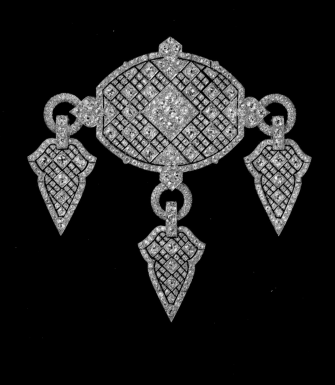

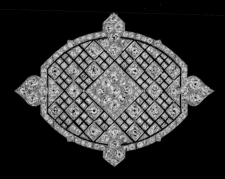

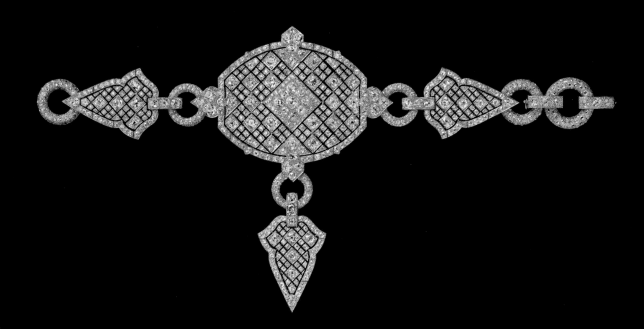

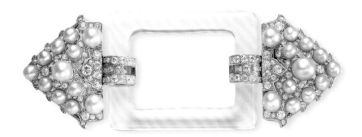

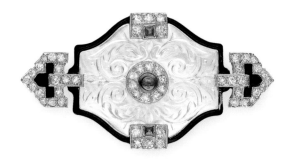

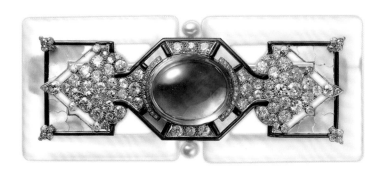

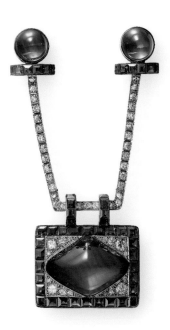

Brooch

Cartier Paris, 1925
Platinum, rock crystal,
pearls, diamonds
3.1 × 8.6 cm
Monaco Princely Palace Collection

Brooch

Cartier Paris
Circa 1915
Platinum, gold, black enamel,
rock crystal, onyx, sapphires, diamonds
2.37 × 4.51 cm
LA Private Collection

Brooch

Cartier Paris, 1924
Platinum, gold, sapphire, rock crystal,
mother-of-pearl, pearls,
enamel, diamonds
3.7 × 9.3 cm
Cartier Collection
Inv. CL 02 A24

Brooch pendant

Cartier Paris, 1912
Platinum, gold, sapphires, diamonds
7.35 × 3.96 cm
Cartier Collection
Inv. CL 197 A12

**Front interior cover of a manuscript
of the *Bustan* of Sa'di**

Copied for Sultan 'Abd al-'Aziz (1540-1550)
Bukhara, Uzbekistan, 1531-1532
Leather, gold, ink, opaque watercolor, paper
28.9 × 18.4 × 3.5 cm

Harvard Art Museums/Arthur M. Sackler Museum
Gift of Philip Hofer in memory of Frances L. Hofer
Formerly in the collection of Louis Cartier
Inv. 1979.20, LC no.3a

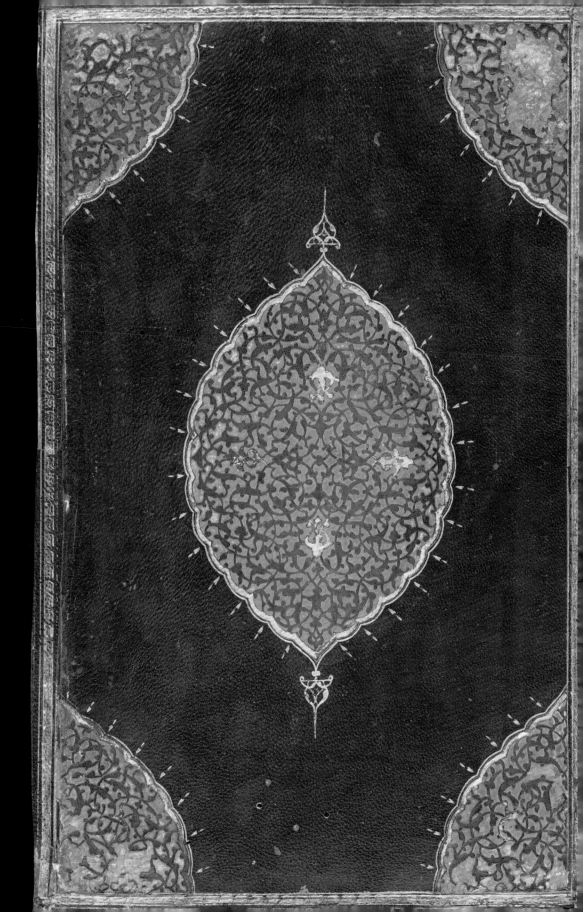

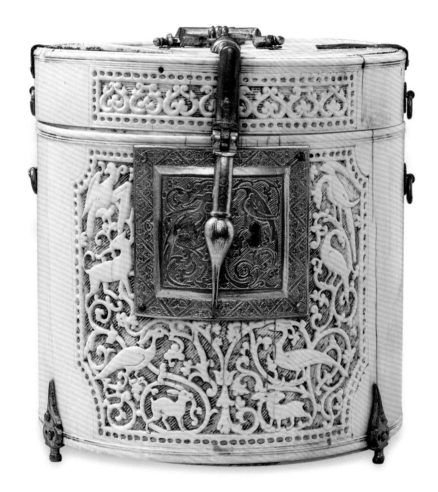

Pyxis

Sicily, 15th century
Elephant ivory, copper alloy
14.9 × 15.8 cm

Presented at the *Exposition des arts musulmans*,
Musée des Arts Décoratifs, Paris, 1903
Musée du Louvre, Paris, département des Arts de l'Islam
Gifted in 1916, formerly in the Arconati-Visconti collection
Inv. OA 6934

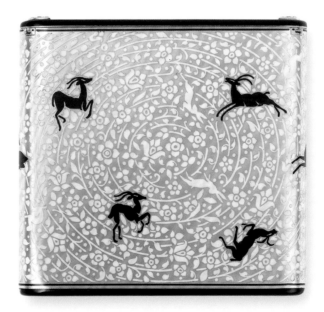

"Persian" vanity case

Cartier Paris, 1929
Gold, platinum, enamel, diamonds
6.1 × 7.7 × 1.4 cm
Cartier Collection
Inv. VC 31 A29

Lilliput lighter

Cartier Paris, 1931
Gold, enamel
3.0 × 3.0 × 1.0 cm
Cartier Collection
Inv. LR 53 A31

"Persian" cigarette case

Cartier Paris, 1924
Gold, enamel, onyx
7.7 × 8.7 × 1. cm
Cartier Collection
Inv. CC 64 A24

"Persian" cigarette case

Cartier Paris, special order, 1932
Gold, platinum, enamel, diamonds
8.5 × 9.0 × 1.7 cm
Cartier Collection
Inv. CC 88 A32

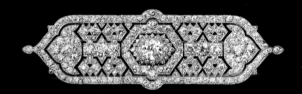

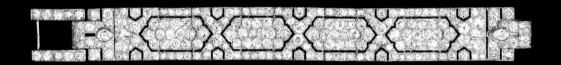

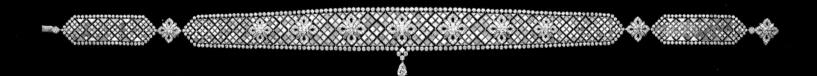

Bandeau

Cartier Paris, special order, 1920
Platinum, diamonds
2.3 × 39.8 cm

Cartier Collection
Inv. HO 16 A20

Brooch

Cartier Paris, 1913
Platinum, diamonds
2.91 × 9.77 cm

Cartier Collection
Inv. CL 277 A13

Strap bracelet

Cartier Paris, special order, 1926
Platinum, gold, diamonds
1.92 × 18.3 × 0.35 cm

Cartier Collection
Inv. BT 10 A26

Bandeau

Cartier, 2010
Platinum, gold,
mother-of-pearl, diamonds

Private collection

Illuminated folio
of a *Khamsa* by Nizami

from the library of Sultan Shah Rukh
Herat, Afghanistan, c. 1415-1417
Ink, gouache, gold, and silver on paper
26.3 × 16.4 cm

Hossein Afshar Collection
at the Museum of Fine Arts, Houston
Formerly in the Collection of Louis Cartier
Inv. 462.2015.1, LC no.1

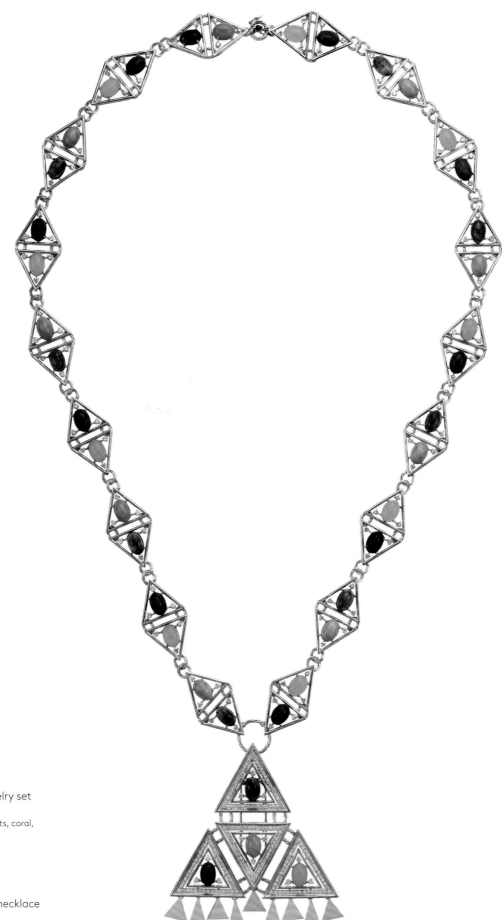

Necklace from a jewelry set

Cartier New York, 1971
Gold, diamonds, amethysts, coral,
chrysoprase, lapis lazuli
Length: 76 cm
Pendant: 7.8 × 7.4 cm

Cartier Collection

Muslim prayer-bead necklace

Cartier Paris, 1970
Gold
Pendant height: 16 cm
Chain length: 59 cm

Cartier Collection
Inv. NE 45 A70

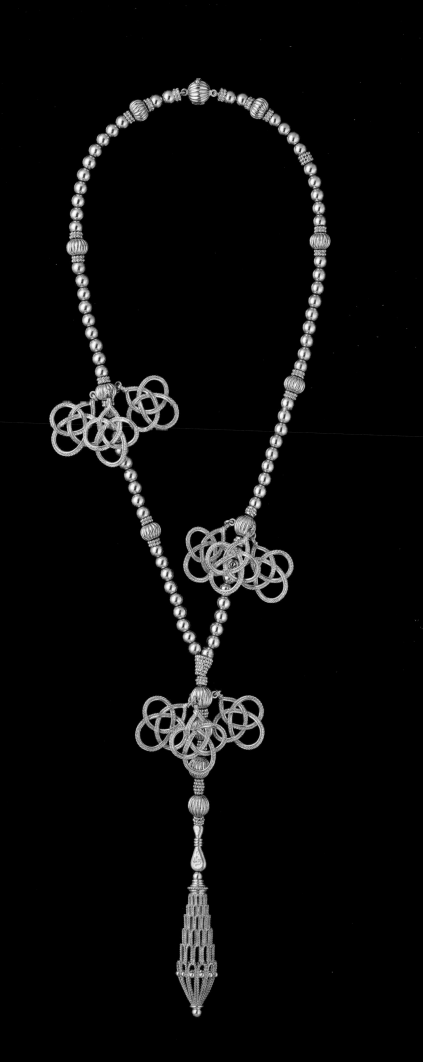

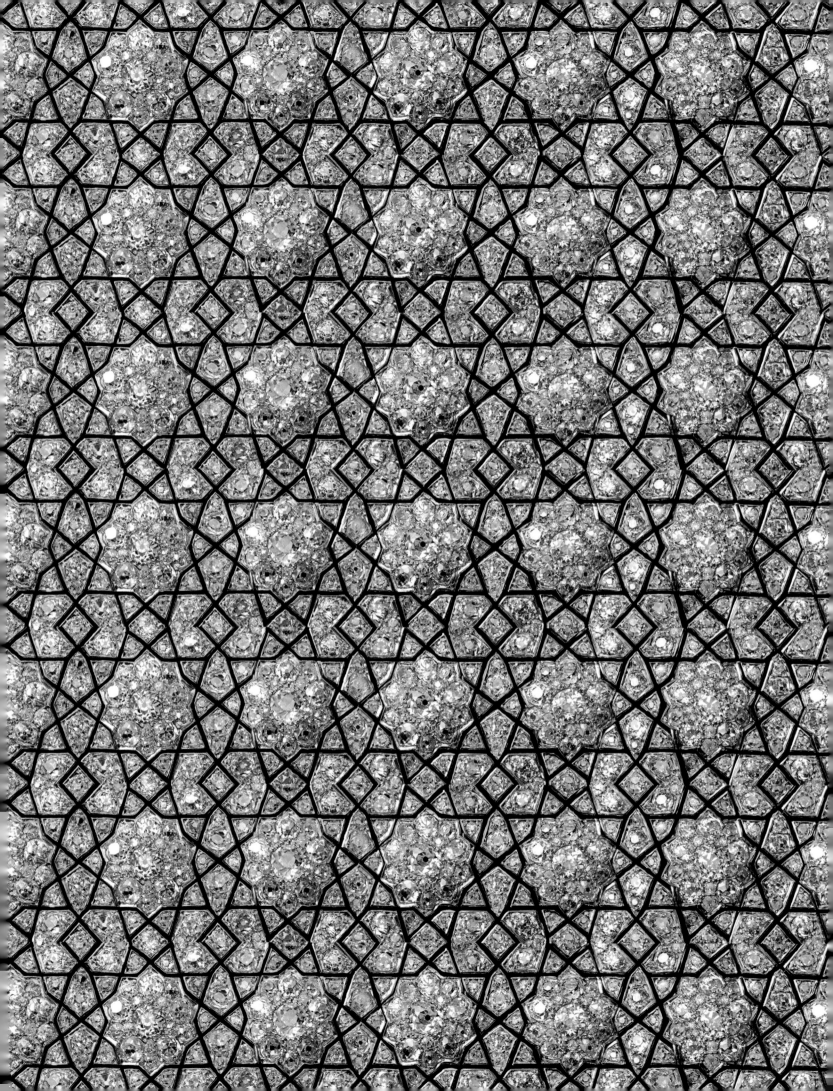

AN
AESTHETIC
EXPLORATION
OF THE
ISLAMIC
INFLUENCE
ON
CARTIER'S
GRAPHICS
1909–1940

SARAH SCHLEUNING

Inspiration sourced from Islamic designs is strongly evident in the aesthetic of Cartier's promotional printed material from the early twentieth century. An examination of Cartier's surviving graphic art from 1909 to 1940 reveals a pervasive thread of Islamic visual elements in many of the materials, as well as a progression of the ways in which these motifs were integrated into the graphics. The presence of these visuals in the print material transitions over time, from literal replication, to inspired interpretation and re-combination, to seamless assimilation. The Islamic influence evident in these graphics correlates with the aesthetics of the jewelry produced by Cartier concurrently, much of which also incorporated Islamic motifs, thus underscoring the deep connection and absorption of these visual forms into the design lexicon of the Maison Cartier.

Interest in and representation of Islamic culture, ornament, and motifs was more than merely a flirtation with exoticism. Instead, it was an aesthetic that was deeply absorbed into the visual identity of Cartier. The expression of these themes can be traced visually in the printed materials. There is an ongoing and evolving dialogue between these divergent forms of artistic expression: the physical jewelry and the graphics used to represent and market it. Because of the differences between types of media production, as well as intended audiences for the marketing ephemera and works of art, the relationship of graphics to the source material often varied from how these Islamic sources are aesthetically manifested in the jewelry itself. The Maison communicated its identity to the public through printed material, including magazine and newspaper advertisements; store, product, and exhibition catalogues and brochures; and invitation cards for the retail locations and specific events. Cartier's advertisements were broadcasters of style and disseminators of taste. They functioned to attract clients: from new ones drawn to the prestige of the Maison and its creativity, to existing clients reminded of the mystique and allure of the Cartier world. Through these advertisements, the marketing effort focused on a range of jewelry and *objets d'art*, from stock items to special-order custom pieces.

The Maison Cartier was hardly novel in its creative assimilation and repurposing of global design motifs for inspiration or in its application of these elements across different forms of expression. Artistic output as a rule finds inspiration from many sources and often moves fluidly among various endeavors and creative forms. The presence of Islamic motifs in the graphics reveals that Cartier thought holistically about the way the business presented itself. During this period, Cartier consisted of three branches, each headed by a different brother: Louis in Paris, Jacques in London (opened by Pierre in 1902; Jacques took over in 1906), and Pierre in New York (opened in 1909).

PREVIOUS PAGE

Montage from a detail
of a bracelet
1923
(see p. 239)

How the branches chose to distill their messages about their jewelry into campaigns that were meant to entice, excite, and engage, and then how they disseminated those messages—although quite consistent in certain respects—varied according to the personality of each brother and the culture and taste of the client base in each locale. While the graphics were not created in our contemporary sense of the word, with a strong consistency or "brand identity"—as we would say today— across multiple platforms, and are not immediately recognizable as Cartier-created materials with respect to the more unified marketing campaigns of today, they reveal that the brothers certainly focused on creating a unified message and had an established identity. This is evident in the presentation of singular, spectacular jewelry showpieces exhibited at international exhibitions; in jewels that adorned society's elite and prestigious world figures; and in more commercialized output, such as advertisements and catalogues, that were distributed to Cartier's most prized clientele.

This essay focuses on graphic works generated by the Maison Cartier in its entirety, across all three branches. The materials reviewed are drawn from the three Cartier archives, as well as other sources. While the discussion that follows identifies the producer of the materials, it does not delve into the differences between the three brothers or their unique markets. It also does not consider editorialized pieces produced about the Maison that address how Cartier was perceived, described, or incorporated into broad stories about advertisements and fashions. The focus is on the image Cartier projected of itself through its graphics, its positioning of itself as a global signifier of taste, and the ways in which it absorbed and incorporated Islamic motifs to communicate its various messages.

DRAWING INSPIRATION

The earliest instances of Cartier's use of Islamic motifs in printed material were fairly literal. Designers at Cartier studied forms from Islamic source materials, often found within publications or in the exhibitions and cultural events of the time. The works they drew upon included textiles, paintings, architecture, metalwork, ceramics, jewelry, and illustrated manuscripts, which they then translated and transformed to create a structure for their graphic designs. In some cases, these visual elements—concentrated on borders, bandings, and domes—formed a structural frame where the calligraphic texts in the original sources were replaced by modern blocks of promotional text about Cartier.

An analogy can be made between this usage of design elements and Cartier's singular work with what are referred to as *apprêts*. This term refers to the Maison's practice of using historic decorative items and fragments of jewels that have been previously worked, such as carved or engraved jade or amulets. These pieces were (and continue to be) acquired by Cartier and then are incorporated, reimagined, or simply reset. The newly realized piece, whether modernized or merely revitalized, depends on the creativity and techniques of its designers [P. 130]. References in this essay to graphic designs that replicated or repurposed Islamic motifs are not focused on what today might be called "cultural appropriation," which was widely practiced during these decades and merits a deeper investigation. What is presented here is simply an exploration of these graphic forms, and how they stylistically evolved, through an analysis of several examples.

Most of the source material for Cartier's Islamic-inspired graphics can be traced directly to holdings in Louis Cartier's private collection and his library. The wide range of materials containing these design elements were available to its designers. This is suggestive not only of Louis's fascination with Islamic aesthetics but also of the appreciation of, and desire to disseminate, these aesthetics on a more global and collectable scale. Louis Cartier was an avid collector. His carefully built and curated collection of Islamic art included artworks, manuscripts, and paintings. His library includes design portfolios, books of ornamental patterns, costumes, set designs, and photography of foreign locales. His collection greatly influenced his taste and, by extension, the Maison's creative output. Many of the items he collected were clearly with an eye for Cartier production; recent research has shown that he routinely shared these materials with the designers within the Maison Cartier. His collection was also shared with the public through loans to various exhibitions.[1]

At this time, Paris was the epicenter of style and the arbiter, incubator, and cultivator of international taste. Louis and his brothers were finely attuned to the cultural *zeitgeist*, which included a particularly strong interest in Eastern culture and aesthetics. Additionally, Louis was not only aware of, but also had connections to many of the prominent fashion designers as well as fashion illustrators in Paris at the time, for example, George Barbier, whose illustrations he also acquired [P. 225].[2]

In his collecting, and in his interests and influences, Louis was more of an omnivore than a devotee to a singular style or source of inspiration. Advertisements for Cartier's wares in the early twentieth century reveal a range of cultural influences. A case in point is the classical style of a 1911 invitation card [P. 226], in which the Maison's name and address

appear chiseled in architectural stone-work adorned with pediment and gar-lands. A similar promotional piece from a 1918 invitation card [P. 227] also draws on a variant of ornamentation rooted in a more European context with a similar garland motif, corner blocks, beading, and other elements. Within the latter's ornamental frame, there is a more flowing script with the company's logo and addresses. These examples are, of course, representative of how Cartier promoted its identity through the media of print. They also suggest the flexibility inherent in graphics as a print medium. The content and format in both examples remain fairly constant, while the ornamentation and treatment of typeface vary, responsive to current tastes and trends.

These advertisements reveal a great deal both about how the Maison Cartier perceived itself and how it wished, in turn, to be viewed by others. Interestingly, the advertisements had a much broader reach than the jewelry, which was owned and seen by relatively few; it was the printed advertisements that were a primary link to a mass audience. They reflect a balancing act between, on the one hand, formulaic repetition to create ongoing brand familiarity (audience loyalty) and, on the other, a desire to create engaging, fresh content in the cultivation of new clients. The varying stylistic tropes we observe in the materials may have been based on the market, current taste, or even the different aesthetics of individual graphic designers. What these advertisements show, most of all, is Cartier's willingness to experiment with various typologies, albeit through a fairly narrow lens, as none of these graphic designs are highly avant-garde or experimental in a way that could potentially alienate their client base.

Sources of inspiration for these advertisements and others like them, along with other printed materials such as invitations and sales catalogues, are evident when one explores Louis Cartier's library and art collection, particularly his illuminated manuscripts and Persian book paintings. The framing devices and organization of motifs apparent

Vaslav Nijinksy and Ida Rubenstein
in Schéhérazade
George Barbier
Pochoir print for *Designs*
on the Dances of Vaslav Nijinsky
C. W. Beaumont & Co., London, 1913
Mary Martin Fund, The Metropolitan
Museum of Art, New York
Inv. 1978.567

in a sixteenth-century album of paintings and calligraphy from Bukhara is an excellent example. The illuminated folios [P. 240], particularly their ornamentation and structural layout, illustrate the foundational elements that were adopted in a modern context, including the division of the interior rectangular panels of the folio into thirds, the cartouche patterns, and opposing lobed half medallions. All this intricate patterning frames and focuses the central, scripted text. A modern usage for these elements is evident in the invitation for a 1912 exhibition held at Cartier in London [P. 241].[3] The formal structure of the tripartite rectangular panels and lobed halves of a medallion form, modernized with a lacier, vegetal, open pattern, punctuate the central text. Inside these outlines, palmettes and scrollwork further draw the eye into the key text pane which reads: "Messrs. Cartier respectfully invite their patrons to inspect an exhibition of Oriental jewels and *objets d'art* recently collected in India." The graphic elements appear to be delineations from source material, and the design reinforces the subject matter the invitation is promoting, which is that of works acquired from Jacques Cartier's recent travels.[4]

REPLICATING A STYLE, ADAPTING MOTIFS

The practice of adaptation from original sources and usage is evident in Cartier's printed materials from all of its branches during these years. Both the design practices and the specific treatment of Islamic designs were very much in vogue. In the late nineteenth and early twentieth centuries, there was a tremendous wave of interest in Indo-Persian motifs in Europe and the United States. Examples include the 1885 Union Centrale des Arts Décoratifs exhibition with a room dedicated to Asian and Islamic art in the Palais de l'Industrie, the 1903 exhibition of Islamic works at the Musée des Arts Décoratifs, and the 1910 performance of *Schéhérazade* by the Ballets Russes, based on *The Thousand and One Nights*. Within Cartier's ephemera, and consistent with the language of the period, the words used to describe what in this catalogue is referred to as "Islamic"

Invitation card for an exhibtion
held at Hôtel de l'Europe
in St. Petersburg, 1911
Cartier Paris Archives
Inv. PF14 COM P03-B-2

include "Indian," "Persian," "Arab," and "Hindoo". This language repeatedly appears in Cartier's catalogue for the 1913 exhibition in Boston [P. 229], held at the Copley Plaza on November 4, and in the identical catalogue for a New York exhibition on the eleventh of that same month at the Cartier boutique at 712 Fifth Avenue. With only the date and location different and the events themselves seven days apart, the catalogues were potentially produced in the same print run, as both have Cosmus & Washburn Co., a New York City printer, listed.

There are similarities between the structure and layout of the first and last pages of these catalogues and the invitation card for the 1912 London exhibition. They have similar implementations of borders and cusped arches, and the text block set within the ornamental patterns draws inspiration from Persian book painting. These two examples of print material also display direct connections between the types of works for sale or viewing, and the motifs used for visual references. The various panels of text are separated either by blocks of design elements or by the cusped arch form that creates an architectural or graphic structure. Interestingly, the last page of the catalogue has the same structure and ornamentation, but the structure is inverted, creating a larger space for the final text block and harmoniously concluding the publication [P. 229, UPPER RIGHT]. The uncredited designer uses the negative space to create contrast between the text and the illustrated segments. Ornamentation here consists of stylized palmettes, vegetal forms, and interlaced scrollwork, all of which create a dynamic pattern that resembles those found on porcelain, textiles, or carpets. In these graphics, the stylized, Islamic ornamentation appears to be somewhat more flattened and generic than the more intricate forms found in source materials or in the Cartier objects themselves. Perhaps this is because of the limitations inherent in the printing techniques, or a simplification of the pattern due to the scale of the piece itself.

Owen Jones and other theorists of patterns helped to distill, disseminate, and inspire the aesthetics of this time. So too did photographers. Whether amateur or professional, a photographer's skill in framing, cropping, and developing the photograph shaped and defined what viewers saw, thereby structuring and focusing their perceptions. The cusped arches that create the outline forming the top (or bottom) third of the abovementioned catalogue pages also drew on, and were inspired by, photography of the architecture of the Islamic world,

Invitation card
1918
Cartier Paris Archives
Inv. PF14 COM P02-B

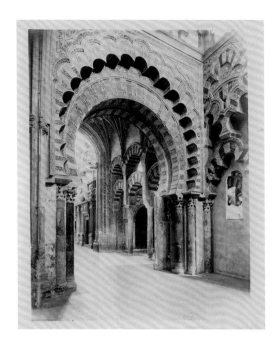

examples of which are found in the Cartier Archives and design library, such as an image of the Great Mosque of Córdoba [AT LEFT]. These photographs served as source materials; like Owen Jones's 1856 *Grammar of Ornament*,[5] they acted as intermediaries, visual transcribers, of Islamic designs—from motifs to architecture. For example, they were references for translating the ornamental architectural elements of the horseshoe archways into strong graphic elements. Creating a frame, the doorways and vistas in these architectural marvels focus the eye on key elements in the photographs and graphic materials. The colonnade or series of archways as a framing device continually emerges as a popular motif, both in the graphics and in jewelry and precious objects made by Cartier at this time. Examples include the Cartiers using it deftly on their charming 1931 playing cards [P. 229], whose production is specific to the New York branch.

The covers for the 1913 Boston and New York exhibition catalogues reveal another primary source for Islamic motifs and aesthetic composition in Cartier's graphics, that of sixteenth-century, Persian book bindings. Similar compositions and elements in these modern covers are evident in Louis Cartier's private collection [P. 71] and in photo documentation at various Cartier archives [P. 244, TOP], and they are also closely aligned with some direct rubbings from source bindings made as a design reference by Cartier's designer Charles Jacqueau [P. 66, FIG. 2]. In these catalogue covers, as with the 1913 Paris catalogue titled *Exposition d'un choix de bijoux persans, hindous & thibétains adaptés aux modes nouvelles* [P. 244, BOTTOM], which uses an identical cover (the interior content differs), the graphic formula of corner motifs with the central medallion and the elegant use of negative space reference these book bindings. Rather than gilded, embossed leather, the covers are printed in gold and red ink on heavy cream paper stock [P. 67, FIG. 2]. The catalogue covers display a simplified design when compared to the book bindings, partially because of the difference in scale, which would make the detailed patterning of the book bindings reproduced on the smaller footprint of the Cartier catalogue appear as dense and too detailed. Incorporating the rich composition and forms of the bindings, with their corner motifs and central medallion, elevated the prestige of these ephemera.

Great Mosque of Córdoba
Photograph, n. d.
Cartier Paris Archives
Inv. GF_Insp_23

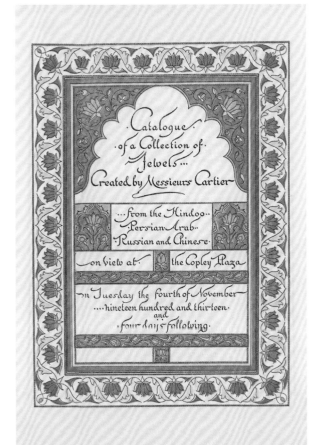

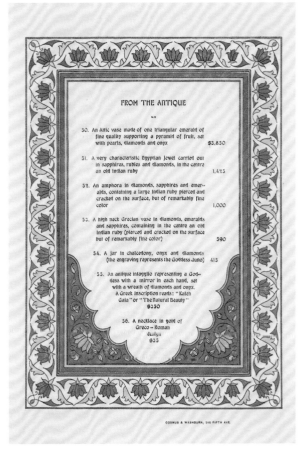

Catalogue of a Collection of Jewels
Created by Messieurs Cartier
from the Hindoo, Persian, Arab,
Russian, and Chinese
Copley Plaza, Boston, 1913, pp. 1 and 12

Playing cards
Cartier New York, c. 1931
Paper and gold leaf
(card edges)

Even the flap, in thick paper rather than leather, offers the clientele a sense of luxury, refined taste, and historical gravitas.

The use of borders, corners, and central medallions as ornamentation can also be found in many Islamic textiles, particularly carpets, several of which were documented in publications in Louis Cartier's library, as well as displayed at many exhibitions and fairs that Cartier and his cadre of designers would have been exposed to and inspired by [AT LEFT]. The incorporation of textile-inspired corners, borders, and central forms was interpreted over and over again in the *objets d'art* presented by Cartier. One example is a 1913 cigarette case [P. 245]. Here, the gold surface becomes the negative space, and the embellishments form the ornamental elements. However, more than simply being the products of a straightforward adaptation and abstraction, these works suggest a modernization and harmonization, pairing exoticism with contemporaneity. The designers were creating a style that was evolving, retaining the elegance of the Maison Cartier while staying in the moment, thus modernizing and adapting the Islamic aesthetic into the Cartier ethos.

INTEGRATION OF FORMS

In tandem with the increasing sophistication of graphic design, which included the codification of the field of modern graphic design (the term was first used in 1922), the rise in importance of marketing across different media, and the increasing practice of creating strategies for international companies, Cartier's use of Islamic motifs evolved during the interwar period. At this time, Islamic references became more integrated into their graphic medium. Rather than mere copying or replication of the sources, the graphics produced during these years reveal a greater synthesis of ideas and motifs formed in the style and sense of the Cartier lexicon— the variant influences were harmonizing. During this period, the Maison Cartier drew on Islamic visuals for inspiration, often using the jewelry itself as the framing graphic device.

In 1925, a special issue of *La Gazette du bon ton* highlighted the Pavillon de l'Élégance at the *Exposition internationale des arts décoratifs et industriels modernes*. Cartier's displays, including a variety

Turkish carpet in the collection
of the Museum of Decorative Arts,
Cologne
Wilhelm von Bode
Anciens Tapis d'Orient, fig. 87
Paris, Bulin, n. d.
Cartier Paris Archives
Inv. BibCart/116

of carved emeralds set into jewelry, were featured in the *Gazette*. These were unique, rarified exhibition pieces meant to showcase the sophisticated craftsmanship of Cartier's designers. The article discussed the history of Cartier and its current Indian connections. It also included a discussion on how Louis, in particular, had modernized the art of jewelry, proclaiming: "In the service of his creative invention, steeped in tradition and exoticism, he lavishes the resources of an incomparable technical virtuosity."[6] Accompanying the article is a full-page plate of an elegant modern woman wearing examples of finished work—diadem, necklace, and brooch—with the caption "Bérénice" [BELOW]. According to the company's stock books, the works were not "named," but merely referred to by their typology: *diadème*, *collier*, and *bijou d'épaule*. The name, however, has remained—sparked by this illustration, it became synonymous with this type of work and emblematic of the bold romanticism it evoked.

There are longer stories to tell about these exquisite pieces made for the 1925 exhibition and how the jewels were reused and recombined in works that followed. What is intriguing in this multispread feature in the *Gazette* is the integration of the text with the illustrations of the three pieces [P. 247]. The start, or head, of the article begins with the rendered diadem. The main body of the text, spread over two pages, utilizes the *collier* as a frame. With three large emeralds anchoring pearl tassels, it is designed without a connector or clasp, so the rendered *collier* gracefully drapes around these blocks of text as it would around a woman's shoulders. Though visually shortened to fit on the page, the rendered necklace becomes a graphic device, like the arches in the ephemera discussed previously. Here, the jewelry frames the text, drawing the eye to the printed words on the page that describe and discuss the object, but also foregrounding the beauty and craftsmanship that goes into the jewelry itself. The article culminates with an intricate brooch that would have been worn lower on the body, around the bust line or waist. At first glance, the brooch appears the most abstract of all the pieces. It could easily be an ornate flourish to punctuate the end of the text. This serves as a clever way to show not only the elegance and incredible design of the works themselves, but also the power of jewelry. There is a symbiotic relationship

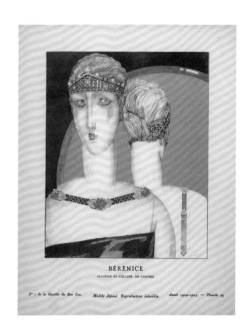

BÉRÉNICE
DIADÈME ET COLLIER, DE CARTIER

N° 7 de la Gazette du Bon Ton. Modèle déposé. Reproduction interdite. Année 1924-1925. — Planche 49

Bérénice, diadème et collier de Cartier
Special issue for the Pavillon
de l'Élégance at the *Exposition
internationale des arts décoratifs
et industriels modernes*, Paris, 1925
Gazette du bon ton, 1925, no. 7

Cartier Documentation, Paris

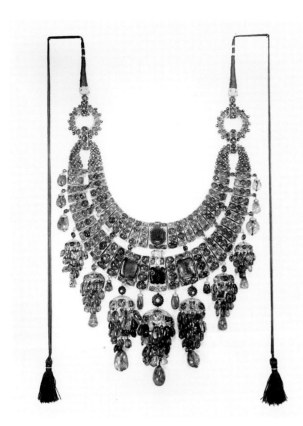

in the case of jewelry, or indeed anything, that enhances one's appearance. These adornments or embellishments should never eclipse the wearer, but should augment, elevate, and captivate, focusing the attention on the wearer without surrendering its strength and prowess as a form unto itself. These works reflect a modern femininity.

Another example of the use of jewelry as a graphic framing device is found in a Cartier advertisement published in the *New York Herald* in 1928 for "Crown jewels designed and Mounted for H. H. the Maharaja Dhiraj of Patiala by Cartier," featuring two custom necklaces [P. 233]. Both included long, silk cords with beautiful tassels in opulent shades of green. These two pieces are elegantly framed and laid out, and then redrawn onto a page with the key text in the center. The two most important parts of the graphic—the crown jewels and the Cartier name—are encircled and emphasized by these awe-inspiring jewels. The potential basis for the layout of the jewelry was found in the collection of glass plate negatives within the Cartier Archives [ABOVE]. It is unknown whether the purpose of the photograph was merely to document the production by Cartier, as seen with many similar examples of other large necklaces; however, it is probable that this was a source of inspiration from which the illustrator drew this rendering. Again, the cords and tassels have been shortened to fit the scale of the page, so accuracy of certain elements was not crucial for the graphics. There is no doubt that emphasis was placed on depicting the stones and design precisely, but the use of illustration versus the precision of a photograph suggests that the artistry of the hand created a more evocative way of depicting the dimensionality and seductiveness of this jewelry, as the black-and-white photograph often flattened the sparkle and brilliance of jewelry.

One part of the Cartier London Archives contains inventory logs noting all the photographs taken and at whose authorization. From the period 1930 to 1935, examples such as "2 sets of jewellery for reproduction in Litho" (1-3-34, no. C1778), or "advert page of jewelry Vogue advert" (2-1-35, C1868, Adverts), can be found interspersed with hundreds of other

Ceremonial necklace
Created for Sir Bhupinder Singh,
Maharaja of Patiala
Cartier Paris, 1928
Platinum, emeralds, diamonds
Photograph, 1928
Cartier Paris Archives
Inv. 208734050

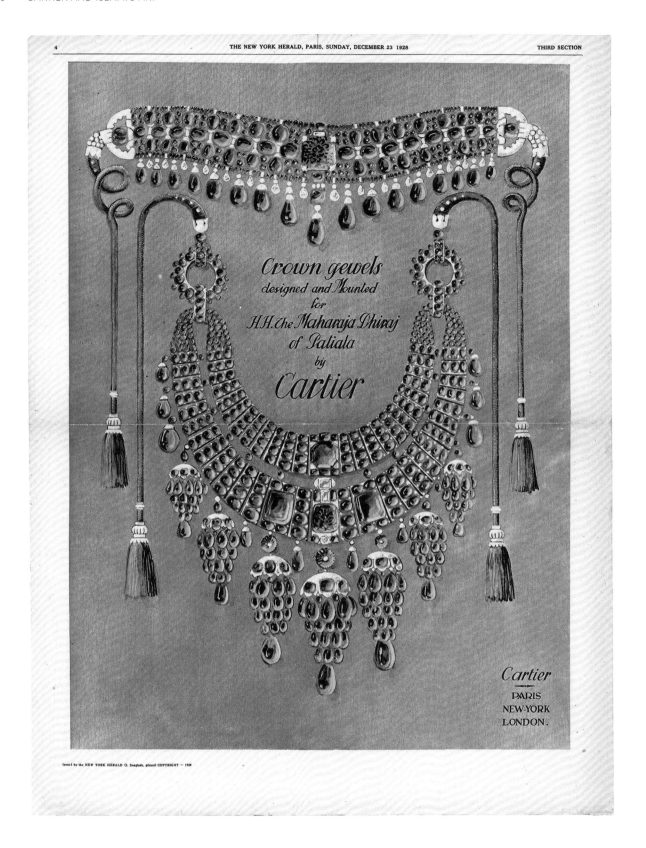

Advertisement for a necklace
and a head ornament created for
"H.H. the Maharaja Dhiraj of Patiala"
New York Herald, Paris, December 1928

Cartier Paris Archives
Inv. NY Herald/1928

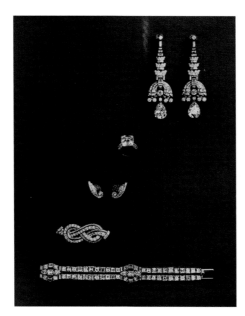 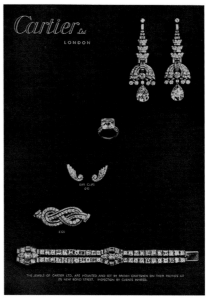

photographic requests. Most intriguing are the entries initialed by Jacques Cartier requesting "layout for advert." The corresponding images were untouched photographs probably meant to be used as experimentation for the layout of jewels on neutral fabric backgrounds [ABOVE]. The final selection would serve as the graphic framework in which the typographer would place the texts, similar to the function the ornamental and architectural elements had served previously. Now the photographic images of the jewelry provided the framework, the diagonals, bands, or borders, to guide the composition of the advertisements, working in tandem with the text. This represents the next step in the evolution of graphics at Cartier and reflects both advances in technology and also growth in the creative confidence of the Maison to create an elegant, refined structure in its graphic design. As always, in this period, the actual object serves as the primary focus with the typography being secondary—more informational, confirming that the maker was Cartier and advising as to where the work could be acquired. This is particularly evident in the London Archives, where the material that remains suggests a profound interest in the layout and hierarchy of how the jewels were placed, whether in the form of diagonals or C-shapes—evoking the "C" in Cartier. Similar examples were also found in the New York Archives. What is unknown is how much dialogue or creative license the graphic designer had in the creation of the graphics, and what level of oversight there was in the various locations in terms of creating a unified, versus a localized, visual identity.

Layout of jewels on a neutral fabric
background for an advertisement
Photograph, 1934
Cartier London Archives
Inv. C1852

Advertisement for Cartier
1934
Cartier London Archives
Inv. AD01-34

Using jewelry to frame text and help define the structure of the graphic layout continues in numerous Cartier catalogues and advertisements. In particular, this evolution of style can be observed in catalogues that utilized photography with a highly refined "paste-up" aesthetic reinforced by bold lines to create strong geometric patterns, especially diagonals [AT RIGHT AND P. 237].

THE POWER OF A LOGO AND THE ROLE OF TYPOGRAPHY

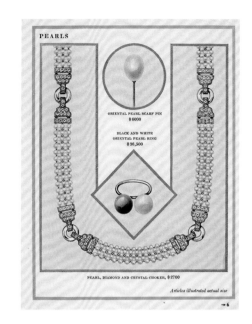

While the evolution of the typography of the Cartier logo does not seem to be drawn from Islamic visual inspiration, there are elements of such in some of the variations, with a curvy, arabesque quality to the "C" [P. 227]. In the graphics surveyed here, a set font or typographic consistency was not a guiding force in creating uniformity. In opposition to these more looping forms is the 1925 advertisement [P. 236, TOP] in which Cartier is spelled out in blue calibrated "sapphires," creating a modern sans-serif typeface, an adaptation of a jewelry technique (stone setting), and a visual reference to geometric motifs found in many of the pattern books and photographic sources documenting the aesthetics of Islamic designs. In this case, it is a break from the traditional Cartier logo and can be viewed in contrast to some of the advertisements done later, where jewels are laid out in a pattern to form a "C," which matches the scrolling arch or arabesque form of the first letter of Cartier [P. 236, BOTTOM]. Of course, the work carried out around the 1925 exhibition was intended to celebrate and promote modernity and new ideas.

In line with the hypothesis that has been explored throughout this essay, the stylistic legacy of the Maison Cartier is not about one source or font of inspiration, but in fact many, and shows us how those ideas were recombined, fusing to become something that is uniquely Cartier. If this is part of the DNA inherent in its design process, it is logical that this approach is also reflected in its printed materials.

Catalogue for Cartier
Interior page, 1929
Cartier New York Archives
Inv. CNYA19

BECOMING
THE GRAMMAR
OF CARTIER

The shift from combining elements culled from Islamic sources, as well as others, to full absorption into the Cartier style with the ephemera of this period is best seen in a British *Vogue* Cartier advertisement, from October 30, 1935, designed by Abel Imblot. This double-page spread has prime placement on the interior cover and the first page of the magazine [P. 238]. On the right, silhouetted figures shown in profile wear a variety of jeweled accessories. Each of these is depicted with the same gridded pattern that does not correspond to any specific piece of jewelry. Instead, the accessories seem to be stylistic variants, a single piece worn several ways, whether as a headband, a bracelet, or an armband. These female forms evoke ancient designs, perhaps inspired by the rise in Egyptomania at the time, and interest in events such as the 1929 Cartier exhibition in Cairo that Jacques Cartier oversaw. They were also possibly inspired by his travels to Egypt, as well as several significant exhibitions in London—for example, in 1931, the exhibition at the Wellcome Historical Medical Museum featuring a "remarkable collection of ancient, rare, and precious jewels and ornaments from Egypt,"[7] and the 1931 blockbuster *International Exhibition of Persian Art* at the Royal Academy at Burlington House, with over 259,000 people attending.[8] The diversity of cultural offerings

a few years prior foregrounds the *zeitgeist* of the early 1930s. The double-page spread incorporates many patterns that have been synthesized and reduced to a pure geometry.

On the left-hand page, bracelet forms are shown on the bias, creating a diagonal pattern, over which the company name is superimposed [P. 251]. The rendered, diagonal bands seem not to be based on real, known designs for bandeaus, belts, or bracelets [P. 239].[9] Instead, they appear to be bands representing modernized Islamic patterns that are overtly simplified and stylized. Many of them appear to reference patterns from Owen Jones's *Grammar of Ornament*, including "Nineveh and Persia," "Arabian," "Turkish," "Persian," and "Indian," or from the other pattern

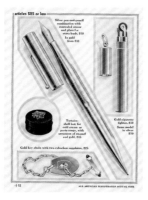
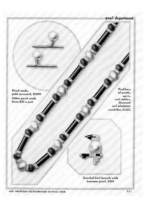
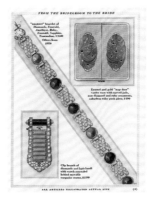
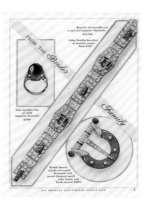

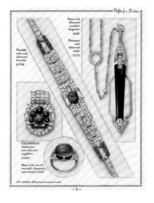
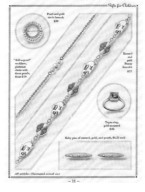
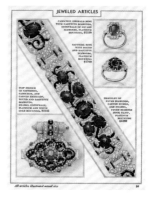
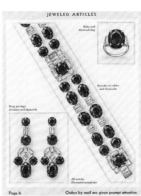
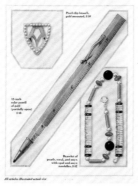
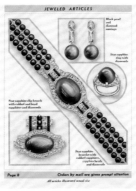
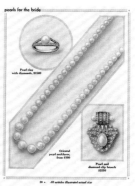
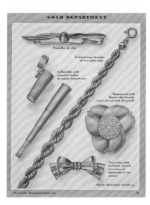
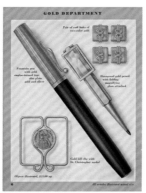
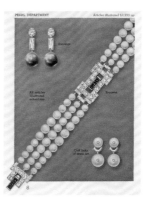
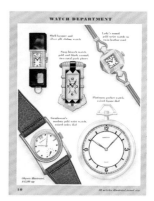

Catalogues for Cartier
Various pages, 1930 to 1937

books found in the Louis Cartier library.[10] The desire, perceived and cultivated by Cartier, for such geometric motifs is what the advertisement promotes, showing variants of both form and function for the clientele. It also imaginatively constructs the Maison's identity and underscores Cartier's prowess with modern forms—a fluidity with abstraction rooted in non-Western, and specifically Islamic, motifs—rather than being focused on trying to sell a specific piece of jewelry.

The diagonal or bias layout also suggests strong similarities to images of minbars, found in the Cartier London Archives, from a 1932 photo album of Cairo.[11] The annotated black-and-white images, including the Mosque of the Ibn Tulun and the Mosque of as-Salih Tala'i [P. 250], are taken from the vantage point of the side of the minbars emphasizing the raking diagonal of the stairs leading to the raised pulpit. This dramatic diagonal, formed from a triangulated structure, is enhanced further by carved and inlaid patterns of interlocking stars and other elements, and possibly could have served as one of the inspirations for Abel Imblot in this composition. This advertisement is signed by Imblot, which is unusual (both today and for Cartier advertisements from this period), and signifies his status as a designer of note; there are other examples of Cartier advertisements signed by him during this period.[12] Based on Imblot's skill at rendering, evident from this and other works, plus the highly visible advert placement on the front interior cover of *Vogue*, it seems that Imblot was greatly valued and had enough influence to sign his own work.

———

The genesis of the idea for this essay was to look at the influence of Islamic motifs on Cartier graphics. Their original meaning and the context of the motifs have been altered, and what remain are the aesthetic elements. From the framing techniques, graphic structure, and specific patterns, the designs have been absorbed and integrated into the language of Cartier as signifiers of sophistication, romance, glamour, and modernity. There was a clear desire evidenced by the Cartier brothers to delve into both the source material—Persian miniatures, textiles—and the various media used to disseminate these Islamic motifs—pattern books, travel

Advertisement for Cartier
Abel Imblot
British *Vogue*, October 1935
Cartier Documentation, Paris

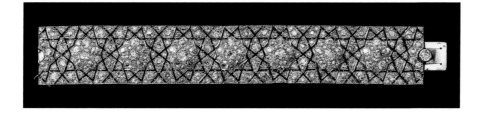

photography, exhibitions—as sources of creative inspiration. That approach helped germinate ideas of a modern language of form, thereby creating a lexicon that eventually encompassed the entire corpus of Cartier.

　　　　Conceptualizing the narrative drawn from these source materials is a bit like following a constellation of stars, in this case fabricated from brilliant stones, and examining the residue that remains. The path begins with the source material, appreciated and consumed by Louis Cartier, his brothers, and the Maison's various designers. Over time, the palette is refined, and the elements become less clearly connected to their origins, evolving until they are abstracted, stylized, and ultimately absorbed into the great body of motifs identifiable as Cartier. What starts as strands of Islamic designs—Arab, Persian, etc.—becomes ingrained, as did many global aesthetics. The language of Cartier as articulated to the public is more a singular body with elements that continue to populate and animate new works as the house itself continues to mine new impulses and create new arcs and inspirations from the past, both from its own creations and from original source materials.

1. Further discussion of these topics can be explored in the essays of Henon-Raynaud (pp. 59-78), Ecker (pp.161-191), and Petit (pp. 30-37).

2. Albert Flament, "Un créateur d'élégances, George Barbier, de Nantes," in *La Renaissance de l'art francais et des industries de luxe*, July 1918, p. 162. The reference accompanying the image is "Collection Louis Cartier."

3. The original of this, however, has now been lost and is only able to be seen in reproduction.

4. See the essay by Possémé for further discussion (pp. 107–122).

5. This book was published in English in 1856 and in French in 1865. The copy in the Cartier Archives is the 1865 French version.

6. "Il y prodigue, au service de son invention créatrice, toute pétrie de tradition et d'exotisme, les ressources d'une virtuosité technique incomparable." "Le pavillon de l'élégance. L'Exposition internationale des arts décoratifs et industriels modernes, Paris 1925." *La Gazette du bon ton*, special issue, no. 7, 1925, 3.

7. "Egyptian Exhibition at Wellcome Museum," *The Times*, October 10, 1931.

8. Wood, 2000, pp. 119–120.

9. Working with all the branches of the Cartier Archives, we were unable to document any direct correlation to any known stock or special order pieces, although there were some elements of similarity.

10. Further discussion of these topics can be explored in the essays of Ecker (pp. 161–191) and Petit (pp. 30–37).

11. Collections of these images also exist in the inventory ledger of ephemera.

12. Another example is Georges Barbier, whose signature can also be found on illustrations and invitations designed for Cartier Paris.

Bracelet
Cartier Paris, 1923
Platinum and diamonds
Length: 18 cm
Cartier Collection
Inv. JS 10 A23

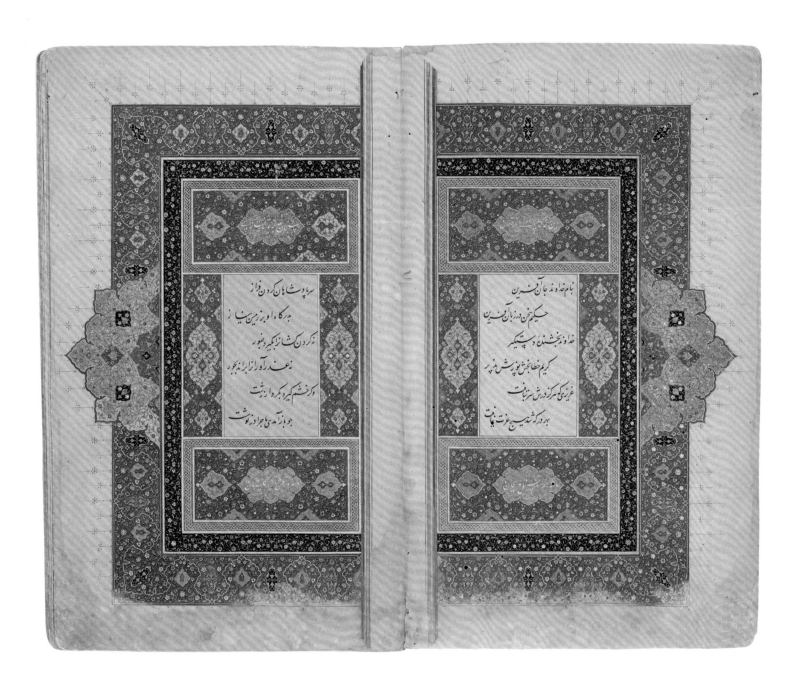

Illustrated manuscript
of a *Diwan* of Hafiz

Iran, Tabriz, c. 1530
Ink, opaque watercolor
and gold on paper
29,2 × 19,1 cm

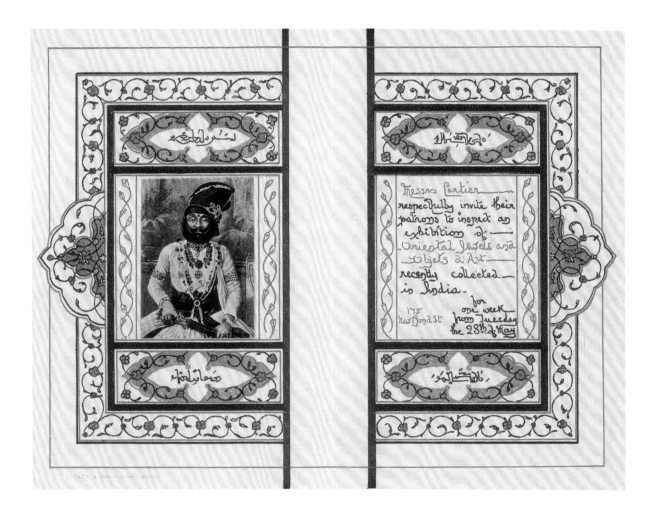

Invitation card to the *Oriental jewels*
and objets d'art exhibition

Cartier London, 1912
From Hans Nadelhoffer, *Cartier*, p. 153
London, Chronicle Books, 2007

Garden scene

Folio 78
Bustan by Sa'di
Painting attributed to Shaykh Zada
Written for Sultan 'Abd al-'Aziz (1540-1550)
Reworked for Emperor Jahangir (1605-1627)
Bukhara, c. 1531-1532
Ink, opaque watercolor, and gold on paper
23 × 13.2 cm

Harvard Art Museums/Arthur M. Sackler Museum
Gift of Philip Hofer in memory of Frances L. Hofer
Formerly in the collection of Louis Cartier
Inv. 1979.20.78, LC no. 3c

Catalogue for Cartier

Cover (top)
and interior page (bottom), 1931

Cartier New York Archives
Inv. CNYA01 and CNYA02

ENGAGEMENT RINGS

Down through the ages from ancient days, there has been cherished the beautiful custom of presenting a ring in token of betrothal.

Modern imagination in accepting this lovely, age-old sentiment has charmingly interpreted it with new and refreshing themes in settings and gems.

No longer does the diamond exclusively symbolize betrothal. Emeralds, rubies, and sapphires are enjoying a decided vogue.

At Cartier's you may choose an engagement ring from an array so plentiful that you may gratify every whim and fancy in both settings and gems.

Here, you will find the mode interpreted with that sparkling originality of design and fine craftsmanship traditionally associated with the name Cartier.

Cartier Inc.
5th Avenue and 52nd Street, New York, N.Y.
PARIS · LONDON

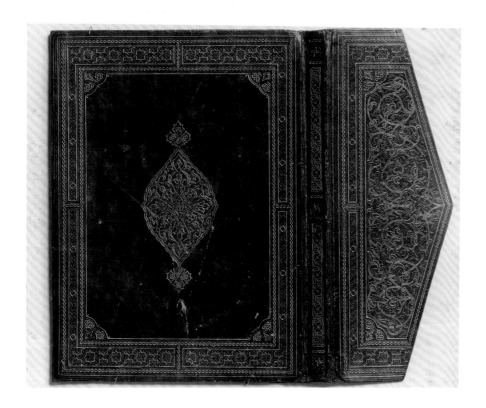

Catalogue for a jewelry exhibition

Exposition d'un choix de Bijoux Persans, Hindous & Thibétains adaptés aux Modes nouvelles, Chez Messieurs Cartier, rue de la Paix 13
Cover and frontispiece
Paris, June 2, 1913
Cartier Paris Archives
Inv. PF14 COM P07-02

Book binding
Photograph, n.d.
Cartier London Archives

Cigarette case

Cartier Paris, 1913
Gold, platinum, rock crystal, onyx, diamonds, and enamel
9.2 × 4.4 × 1.8 cm
Cartier Collection
Inv. CC 80 A13

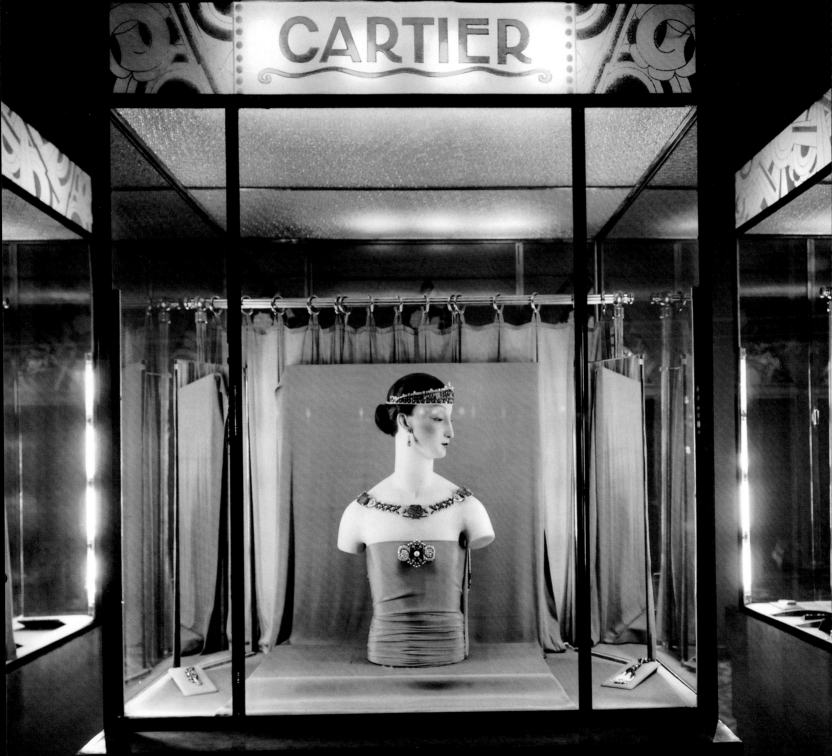

CARTIER

Ariane éblouie se penche, ramasse un diadème, une rivière, des poignées de splendeurs… et en pare, au hasard, ses cheveux, ses bras, sa gorge et ses mains.

Ainsi les femmes, ancestralement éprises de parure, viennent, chez Cartier, jouer avec des joyaux et se réjouir (l'étymologie, science perspicace, n'assigne-t-elle pas au mot joyau cette double filiation de jeu et de joie ?) chez Cartier, au Royaume de la Perle et au Jardin des Gemmes, où elles accourent, fébriles et passionnées, comme vers une Terre Promise, pour en revenir plus belles, plus heureuses, mieux aimées….

Glorieuses annales que celles de la maison Cartier ! Fondée en 1847, dans le vieux Paris de la rue Montorgueil, par M. Louis-François Cartier, elle monta, dès 1859, au boulevard des Italiens. Encouragé par l'exemple séculaire de la Communauté des Orfèvres qui s'était toujours approchée de la famille royale, son chef devint le fournisseur attitré de la Princesse Mathilde, la première de la rare lignée des clientes protectrices du grand joaillier, propagandiste zélée, enthousiaste et écoutée.

Alfred Cartier succéda à son père, et suivant le mouvement du commerce de luxe — installa sa maison au 13 de la rue de la Paix, la dernière année du dernier siècle, une maison dont l'activité est inlassable, mondiale et multiple, et qui ne néglige aucune des hautes attributions du joaillier.

En collaboration étroite avec son fils Louis, l'aîné, héritier du nom et des nobles traditions de la dynastie, il renouvela l'art du Bijou et fit retentir, à travers le vieux monde et le nouveau, une renommée sans pareille.

Dans ce domaine particulier, le goût pesant du Second Empire avait interrompu la suite de l'art : renouant avec les grandes époques du bijou, avec le XVIIIe siècle et avec la Renaissance, dont il vivifie les souvenirs et la technique au souffle puissant de son inspiration moderne, il supprima les lourdes montures d'or, prétentieuses et maladroites, semblables à des cadres trop riches et si éclatants qu'ils tuent le tableau au lieu de le faire valoir. Montées sur platine à la blancheur invisible, les gemmes ressortent "en une cascade d'étincelles, de rayons, de feux croisés, d'irisations; se rencontrent, s'éteignent, se rallument, déferlent, se multiplient, s'étalent et s'exaspèrent". Le bijou Cartier — diadèmes, bretelles, écharpes, devant de corsage, agrafes de drapé — conquiert la féminité tout entière, composé pour chaque cliente selon son profil altier ou mutin, selon l'éclat rosé ou l'ocre chaud de sa chair, l'ampleur ou la finesse de son buste et les reflets de ses cheveux…

Dès 1902, les deux plus jeunes fils d'Alfred Cartier, MM. Pierre et Jacques Cartier, ouvrant à Londres une succursale de la maison, obtiennent très vite le brevet de fournisseur de la Reine. Même faveur insigne auprès de l'Impératrice de Russie, et des souverains d'Espagne, de Belgique et de Portugal. Auprès de l'aristocratie du dollar aussi, dès qu'en 1908, fut créée une seconde succursale à New-York.

Invité aux fêtes du couronnement du roi d'Angleterre à Delhi, comme figuraient jadis, en bonne place, les orfèvres au sacre des rois de France, Jacques Cartier fonda aux Indes un comptoir pour l'achat des gemmes et des perles.

Cartier, c'est le temple de la perle rose, la plus émouvante et vivante, le

temple où s'élaborent pieusement, avec un art subtil et patient, les plus beaux colliers du monde, tel le collier célèbre de la Princesse Christophore de Grèce, chapelet harmonieux et rare de grains roses et parfaits, et où l'on vient adorer le collier de Mme Thiers.

On trouve encore chez Cartier, rapporté des Indes, une collection unique de bijoux anciens indo-persans, dont la délicatesse des ciselures ne le cède ni à la richesse des émaux ni à l'éclat des mosaïques de pierreries, et de beaux colliers en chute de boules d'émeraudes gravées, des XVIe et XVIIe siècles, qui s'harmonisent si bien avec la fine silhouette — inspirée de l'Orient millénaire — des Parisiennes d'aujourd'hui.

Dans l'art précieux du bibelot, Cartier s'était jadis exercé magistralement et, groupées en serres pour des boudoirs princiers, ses plantes lilliputiennes, aux feuilles de jade et aux fleurs de quartz, évoquent les perfections subtiles de la Chine et du Japon de la belle époque. A présent, il s'est voué aux bibelots utiles, à l'étui à cigarettes et aux boîtes à beauté, accessoires familiers de nos contemporaines. Il y prodigue, au service de son invention créatrice, toute pétrie de tradition et d'exotisme, les ressources d'une virtuosité technique incomparable. Et les matières les plus rares s'y allient harmonieusement. L'onyx et le cristal de roche, l'or et le platine, le jade et le corail, le quartz et le lapis-lazuli imbriqués, rehaussés de pierreries, toutes ces petites merveilles suspendues, cette année, au fin poignet des femmes, sont appelées à voisiner dans les Musées de l'avenir avec les tabatières et les boîtes à mouches du XVIIIe siècle.

En collaboration avec le maroquinier, Cartier enrichit d'un fermoir de brillants des sacs de daim à monture d'onyx, d'une exécution parfaite et d'une rare commodité, des ceintures aussi, pour le sport, en cuir et paille, assorties au petit chapeau cloche d'été et agrafées d'une boucle rare.

Horloger, Cartier a renouvelé la montre et la pendule. N'a-t-il pas transformé en montre, pour le caprice amoureux d'un milliardaire, une magnifique émeraude ? Et ne s'enorgueillit-il pas, à juste titre, de telle montre d'homme ultra-plate, faite dans un seul onyx et finement endiamantée sur tranches ?

Et, quoique les femmes ne subissent guère la loi de l'heure, elles se plaisent à la faire inscrire, par le joaillier, en aiguilles de diamants, sur des cadrans minuscules et féeriques, qu'un simple ruban maintient à leur bras par des attaches de pierreries…

Les horloges mystérieuses de Cartier, miracle de l'horlogerie, irréelles et précieuses, tissées dans un rêve avec des rayons de lune, découvrent le mystère du temps, minute par minute, à l'ombre d'une antique divinité de jade, entre deux colonnes de quartz rose émaillé de dragons noirs et rehaussé d'or, ou bien au pied d'une mosaïque égyptienne de nacre irisée…

Ces pièces uniques, qui témoignent d'un sens admirable de la décoration et du goût le plus raffiné, autant que d'un métier parfait, exhalent, dans quelques salons privilégiés, une saveur d'art digne des plus grandes époques de civilisation. La première qui soit sortie des ateliers de Cartier a été offerte par Lady Ripon à la reine Marie d'Angleterre…

Le grand joaillier a bien mérité de la France et de la Beauté !

Cartier display mannequin
wearing a bandeau, shoulder
necklace, and brooch

*Exposition internationale des arts décoratifs
et industriels modernes*
Paris, 1925

Cartier Documentation, Paris

Article for the special issue
for the Pavillon de l'Élégance
at the *Exposition internationale
des arts décoratifs et industriels
modernes*, Paris, 1925

Gazette du bon ton, 1925, no. 7

Cartier Documentation, Paris

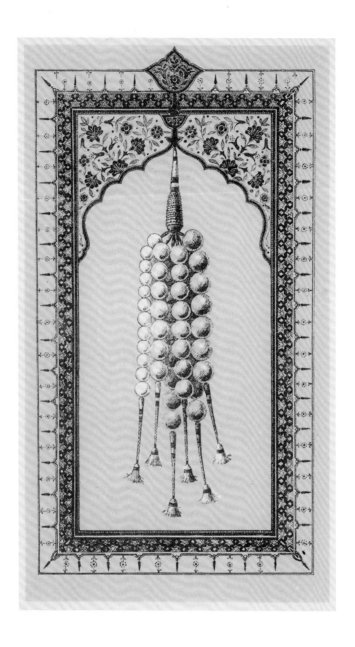

Catalogue describing
the pearls department
at the New York boutique

Interior page
1922
Cartier New York Archives
Inv. CNYA04

Necklace

Cartier Paris, 1910
Platinum, diamonds, sapphires,
and natural pearls
Pendant length: 13 cm
Cartier Collection
Inv. NE 16 A10

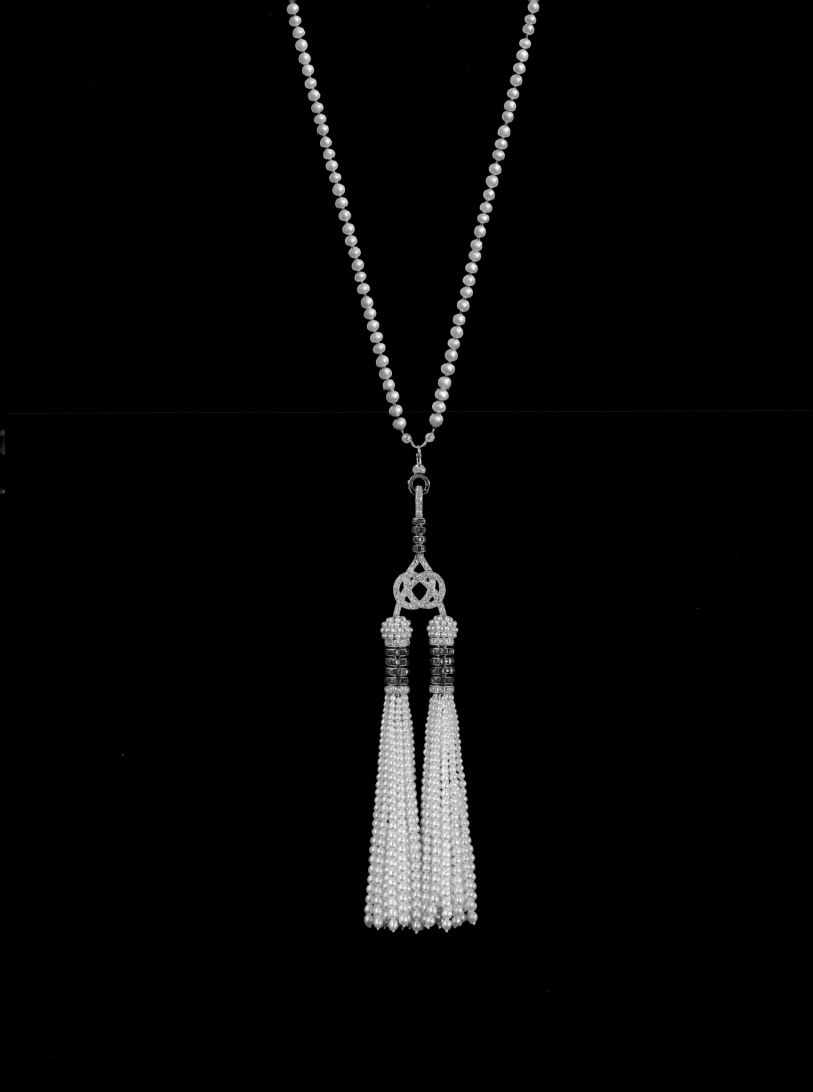

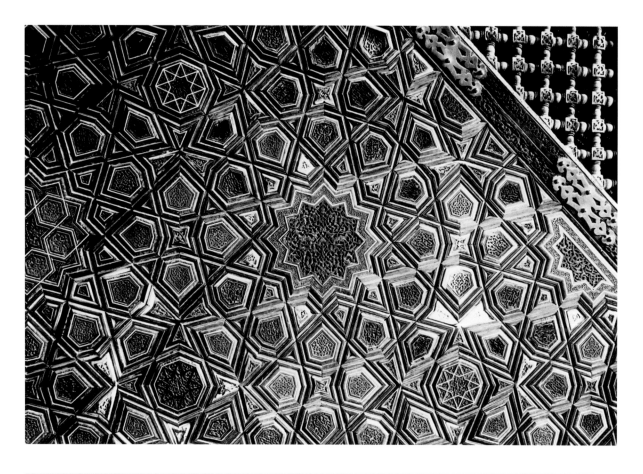

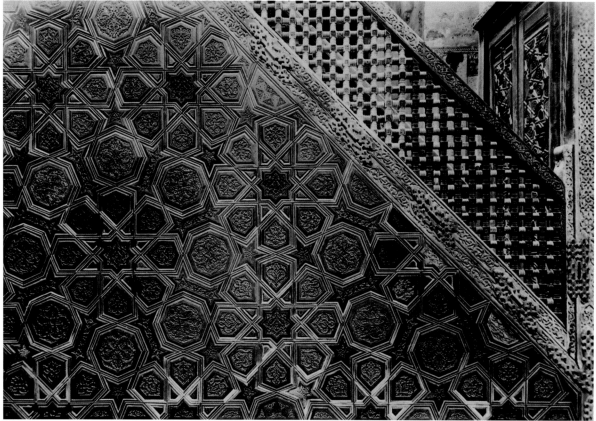

Details from photographs of the minbars
of the Mosques of al-Salih Tala'i and Ibu Tulun, Cairo

Photo album
1932

Cartier London Archives
Inv. C1612_023, C1612_019

Advertisement for Cartier (detail)

Abel Imblot
British *Vogue*, October 1935

Cartier Documentation, Paris

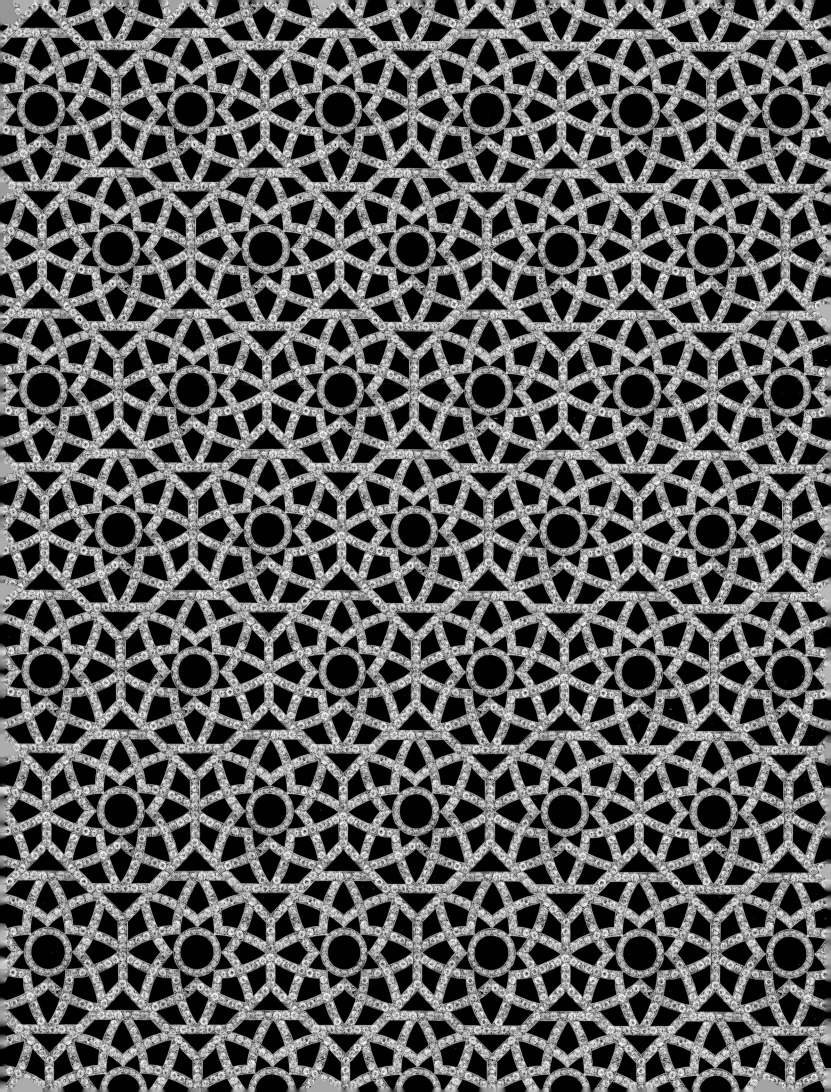

MOTIFS
AND
TYPES

Montage from a detail
of a *sautoir*
1908
(see p. 196)

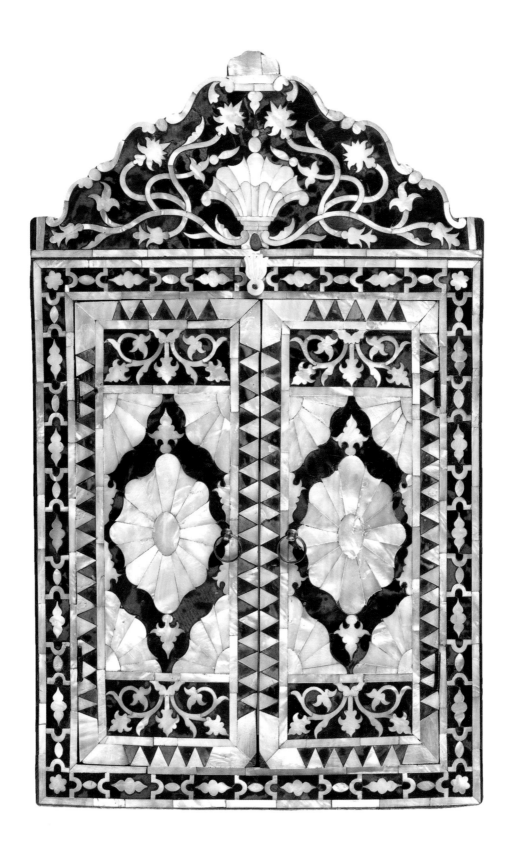

Mirror

Turkey, c. 1750-1800
Wood, mother-of-pearl, tortoiseshell,
ivory, paper, coral bead
45 × 43.3 × 4 cm

Musée du Louvre, Paris,
département des Arts de l'Islam
On loan from the Musée des Arts Décoratifs
Marguerite Arquembourg bequest, 1966
Inv. AD 39882

Bandeau

Cartier Paris, special order, 1923
Platinum, diamonds
Height: 7.5 cm

Cartier Collection
Inv. HO 05 A23

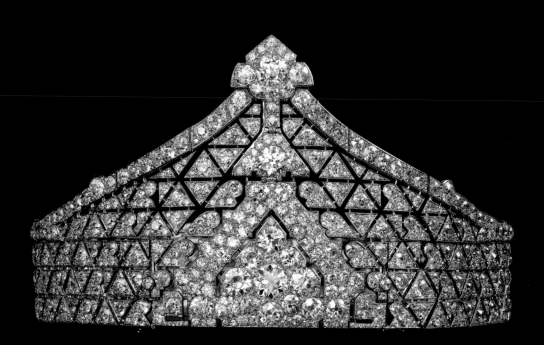

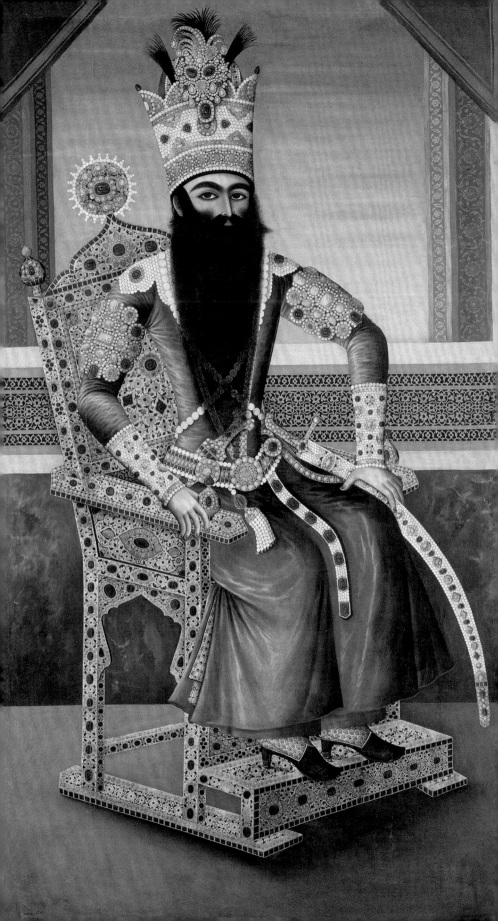

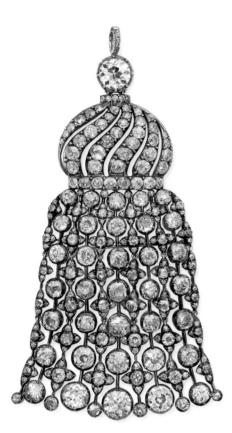

Portrait of Fath 'Ali Shah

Attributed to Mihr 'Ali
Iran, 1800-1806
Oil on canvas
227 × 134 cm

Musée du Louvre, Paris,
département des Arts de l'Islam
On loan from the Château-Domaine
national de Versailles
Inv. MV 6358

Pendant

Cartier Paris, special order, 1902
Gold, silver, diamonds
10.5 × 5.6 cm

Formerly in Jane Hading collection
Cartier Collection
Inv. PE 20 A02

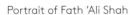

Sautoir (detail)

Cartier Paris, 1911
Platinum, gold, diamonds
Neck size: 58 cm
Height of pendant below
barrette at longest: 16.5 cm

Private collection

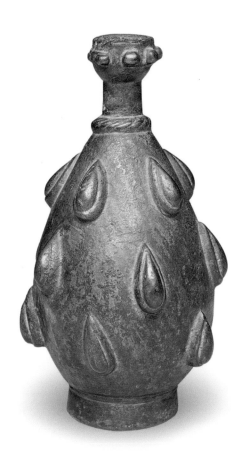

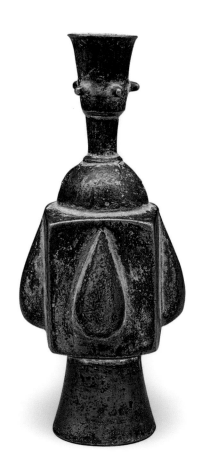

Two small "bejeweled" bottles

Iran, 9th-10th century
Bronze
13.1 × 7.6 × 8 cm
15.9 × 6.7 × 6.7 cm

Keir Collection of Islamic Art
On loan to the Dallas Museum of Art
Inv. K.1.2014.523, K.1.2014.522

Tiara

Cartier Paris, special order, 1914
Platinum, blackened steel,
diamonds, rubies
4.1 × 17.4 cm

Cartier Collection
Inv. HO 11 A14

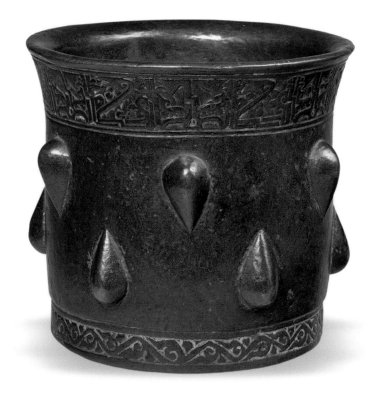

Mortar
Iran, 11th-12th century
Bronze
13 × 15 × 0.5 cm
Musée du Louvre, Paris,
département des Arts de l'Islam
On loan from the Musée des Arts Décoratifs
Gift of Jules Maciet, 1904
Inv. AD 11287

Indian tiara
Cartier Paris, 1923,
transformed c. 1937
Platinum, sapphires, pearls,
diamonds
8.5 × 21.5 cm
The Duke and Duchess of Gloucester Collection

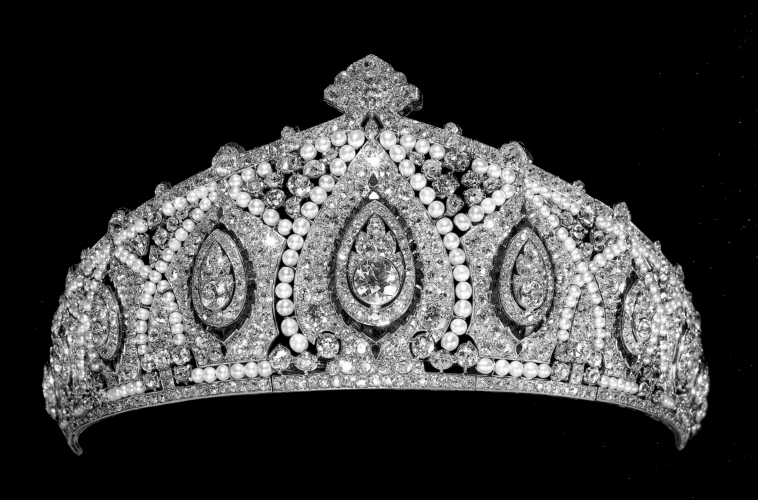

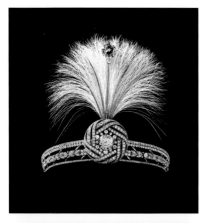

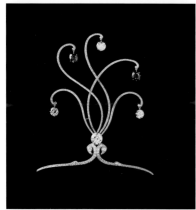
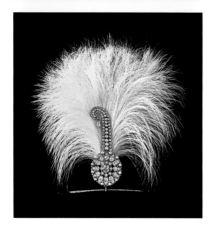
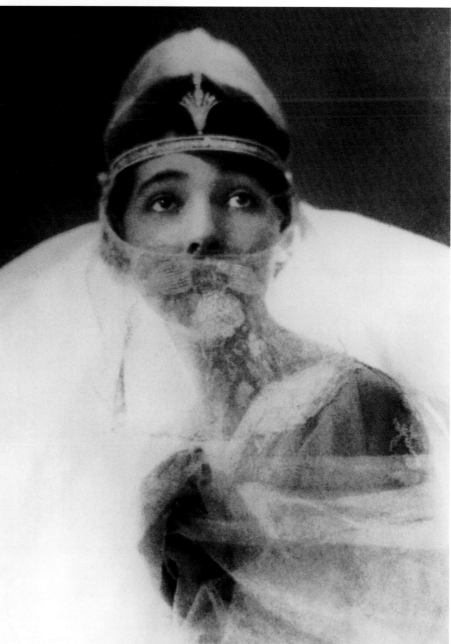

Tiaras with aigrettes

Cartier Paris, 1912
Photographs, 1912

Cartier Paris Archives
Inv. 028062430, 031301824, 031781824, 029942430

Advertising photograph

Photograph by Adolph de Meyer
Vogue, May 1918, p. 44

Condé Nast Archives

Head ornament

Cartier New York, c. 1924
Platinum, gold, diamonds, feathers
The headband, feathers, and mobile
diamonds are recent additions.
17 × 14 cm

Cartier Collection
Inv. HO 34 C24

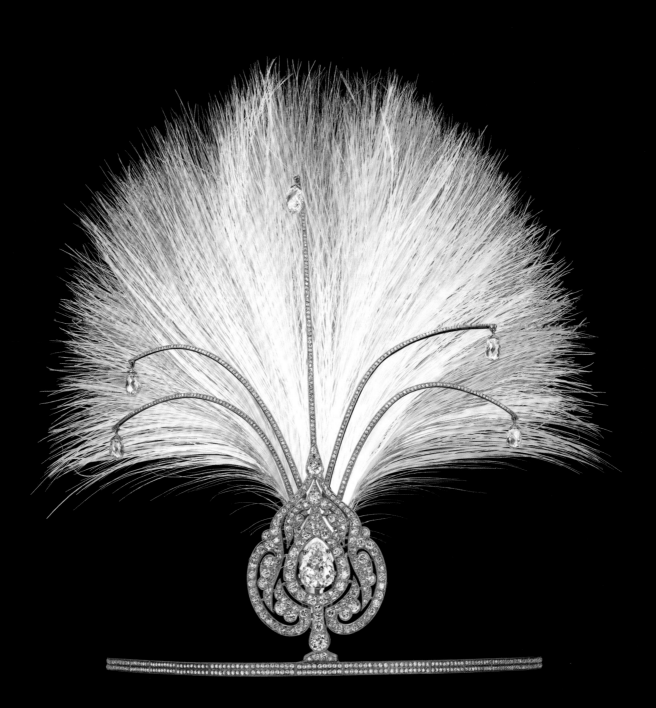

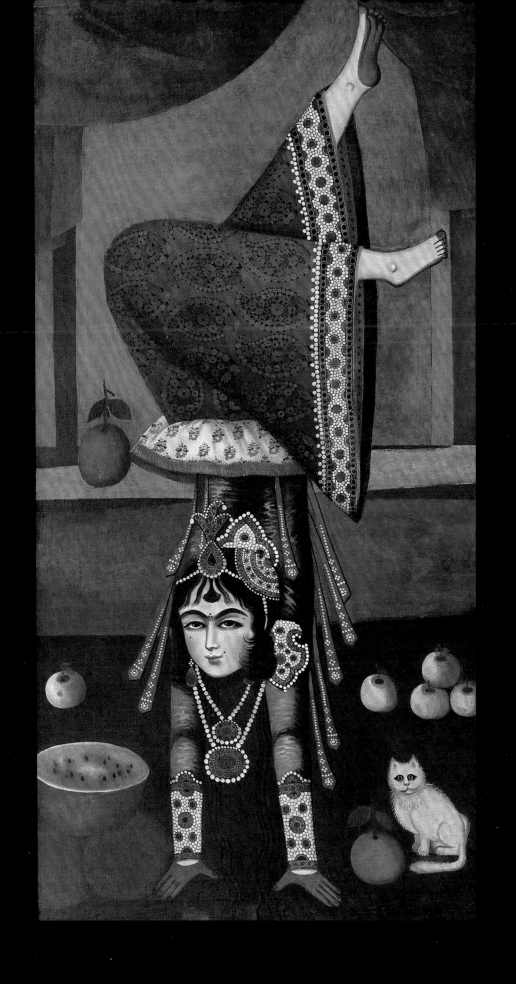

Female tumbler

Iran, early 19th century
Oil on canvas
160.7 × 85.7 cm

The Hossein Afshar Collection
at the Museum of Fine Arts, Houston
Inv. TR:395-2015

Tiara

Cartier London, special order, 1936
Platinum, turquoise, diamonds
Height: 4.8 cm

Cartier Collection
Inv. HO 06 A 36

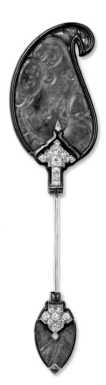

Jabot cliquet pin

Cartier Paris, c. 1925
Platinum, onyx, rubies,
diamonds, enamel
13 × 3.2 cm
LA Private Collection

Brooch

Cartier Paris, 1954
Platinum, gold, emeralds, rubies,
sapphires, diamonds
7.55 × 3.8 cm
Adel Ali Bin Ali Collection

Oriental palm cliquet pin

Cartier Paris, 1925
Gold, platinum, jade, diamonds,
rubies, enamel
9.35 × 2.33 cm
Formerly in Mrs. William K. Vanderbilt collection
Cartier Collection, inv. CL 244 A25

Necklace

Cartier Paris, 1957
Special order, Prince Rainier of Monaco
Gold, semi-precious stones
Monaco Princely Palace Collection

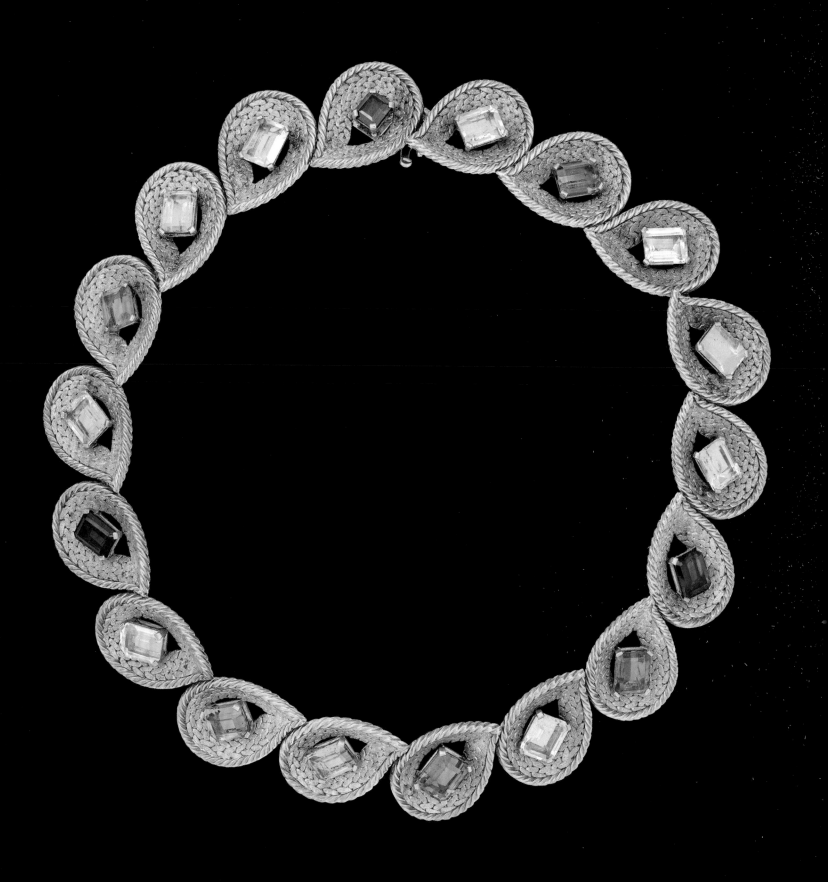

T. VII.

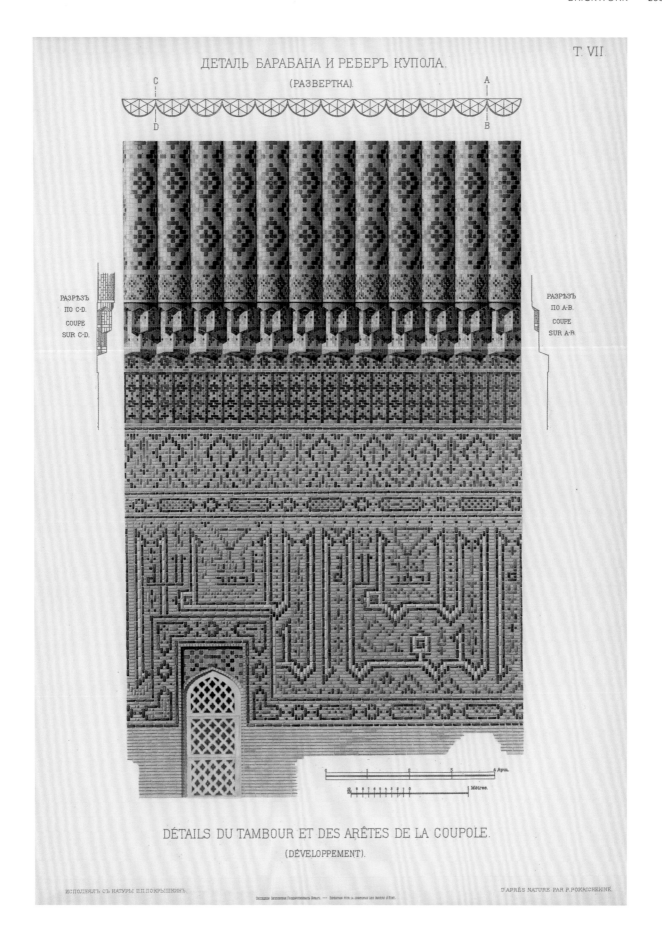

ДЕТАЛЬ БАРАБАНА И РЕБЕРЪ КУПОЛА.

(РАЗВЕРТКА).

РАЗРѢЗЪ
ПО C-D.
COUPE
SUR C-D.

РАЗРѢЗЪ
ПО A-B.
COUPE
SUR A-B.

DÉTAILS DU TAMBOUR ET DES ARÊTES DE LA COUPOLE.

(DÉVELOPPEMENT).

ИСПОЛНИЛЪ СЪ НАТУРЫ П.П.ПОКРЫШКИНЪ. D'APRÈS NATURE PAR P.POKRICHEKINE.

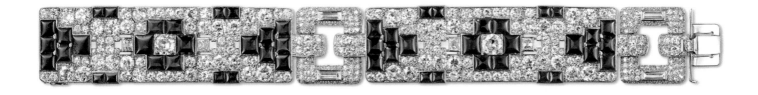

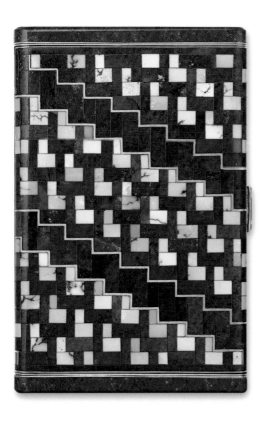

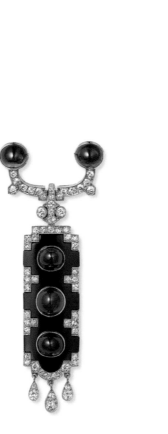

Les Mosquées de Samarcande, pl. 7

Nikolai Ivanovich Veselovskii et al.
St. Petersburg, 1905

Cartier Paris Archives
Inv. BibCart/442

Strap bracelet

Cartier Paris, special order, 1928
Platinum, diamonds, sapphires
2.08 × 17 cm

Cartier Collection
Inv. BT 93 A28

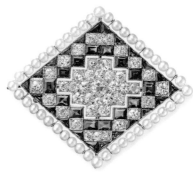

Cigarette case

Cartier Paris, 1930
Gold, lapis lazuli, turquoise,
sapphire, diamonds
8.6 × 5.6 × 1.9 cm

Cartier Collection
Inv. CC 91 A30

Cliquet pin

Cartier Paris, 1920
Platinum, onyx, diamonds,
sapphires, coral
10 × 3.2 × 0.3 cm

Cartier Collection
Inv. CL 49 A20

Brooch

Cartier New York, 1920
Platinum, diamonds,
sapphires, onyx
7.3 × 2.9 cm

Cartier Collection
Inv. CL 07 A20

Lozenge brooch

Cartier Paris, 1912
Platinum, diamonds,
sapphires, natural pearls
4.64 × 3.89 cm

Cartier Collection
Inv. CL 249 A12

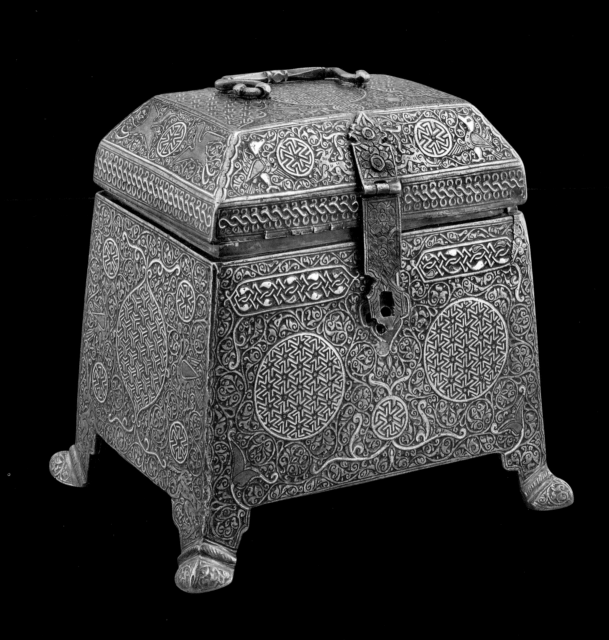

Casket

Iran, 14th century
Copper alloy, silver
12.8 × 13.7 × 10.8 cm

Musée du Louvre, Paris,
département des Arts de l'Islam
Raymond Koechlin bequest, 1932
Inv. K 3440

Cigarette case

Cartier Paris, 1926
Gold, enamel, diamonds
11 × 8 × 1.2 cm

Private collection, London/Monaco

Cigarette case

Cartier Paris, 1928
Gold, enamel, agate, sapphires
8.8 × 6 × 1.4 cm

Sold to Sir Jey Singh,
Maharaja of Alwar, 1929
Cartier Collection
Inv. CC 73 A28

Cigarette case

Cartier Paris, 1928
Gold, enamel, sapphire
8.3 × 7.3 × 1.7 cm

Cartier Collection
Inv. CC 81 A28

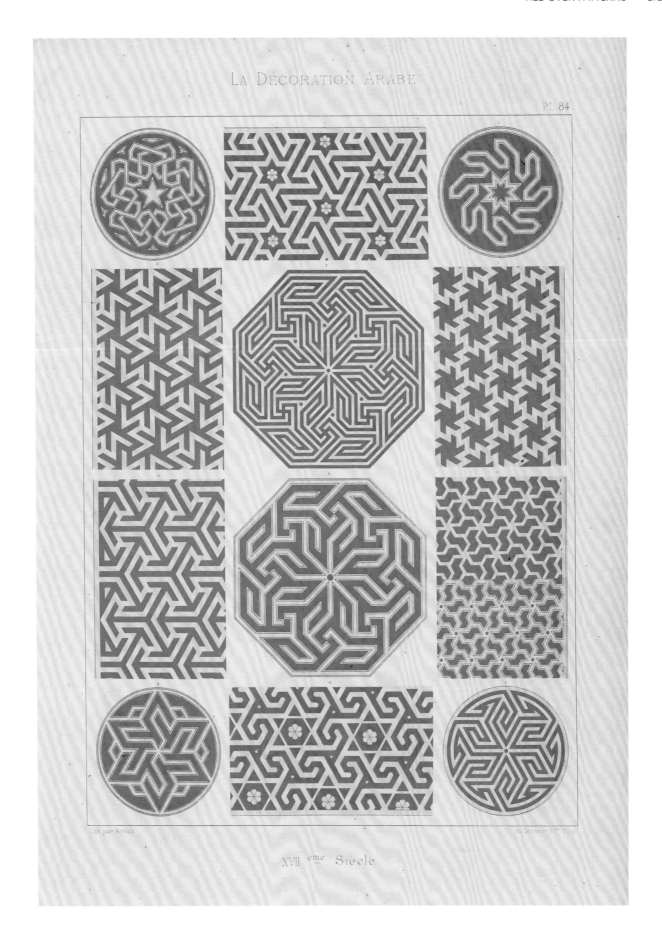

La Décoration Arabe, pl. 84

Émile Prisse d'Avennes
André Daly fils & Cie, Paris, 1885

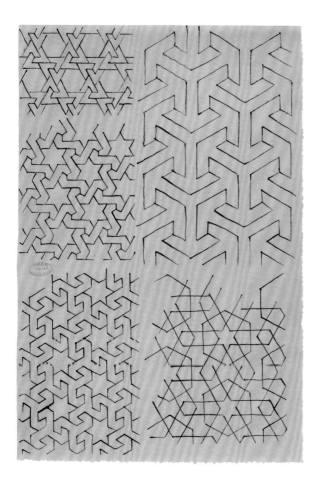

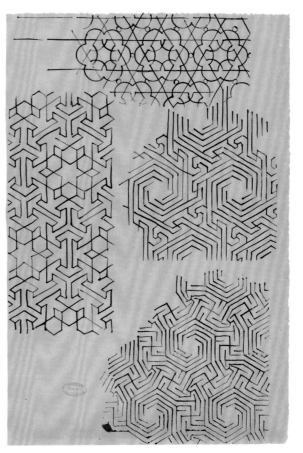

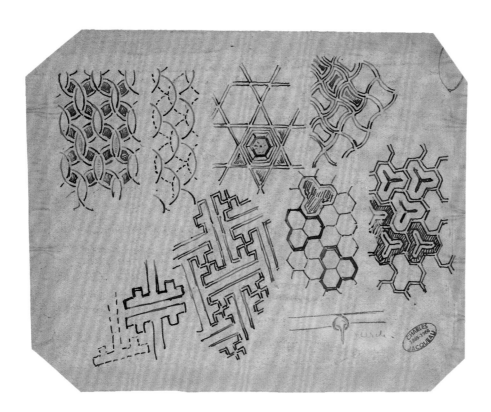

Studies of Islamic motifs

Charles Jacqueau
Black ink on tracing paper
26.8 × 18.3 cm
Black ink on tracing paper
27.2 × 18.3 cm

Graphite and black ink
on beige tracing paper
13.6 × 17.1 cm

Petit Palais, Paris,
gift of the Jacqueau family, 1998
Inv. PPJAC02839, PPJAC02842, PPJAC02920

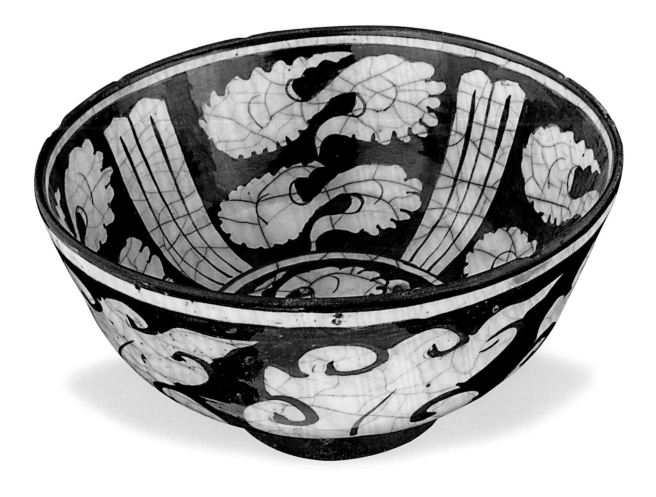

Cup with "tchi" clouds

Tabriz, Iran, 15th century
Ceramic
21 × 11 cm

Musée du Louvre, Paris,
département des Arts de l'Islam
On loan from the Musée des Arts Décoratifs
Gift of Jules Maciet, 1907
Inv. AD 13778

Necklace

Cartier London, special order, 1932
Platinum, diamonds, emerald
Height of the central motif: 8.8 cm

Cartier Collection
Inv. NE 25 A32

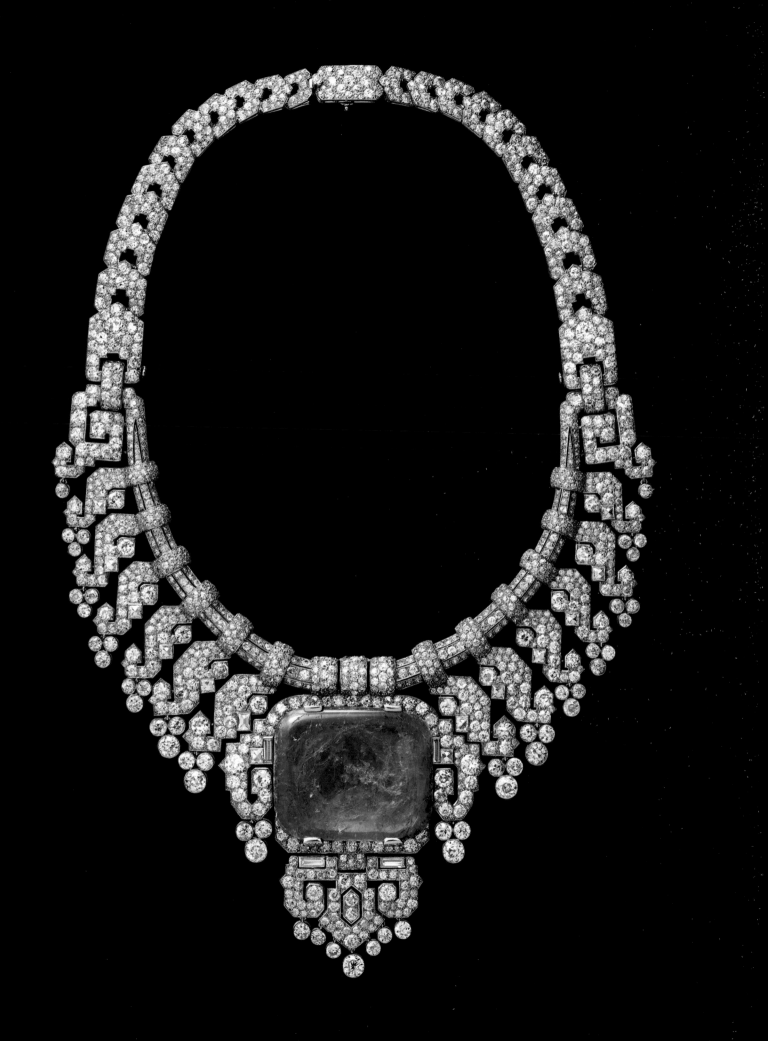

Clip with duck heads

Probably Isfahan, Iran, 18th-19th century
Steel, gold, turquoise
9 × 3 cm

Musée des Arts Décoratifs, Paris
Inv. 37888

Design for a pendant

Cartier Paris, 1922
Graphite and gouache
on tracing paper
20 × 11 cm

Cartier Paris Archives
Inv. ST22/47

Brooch

Cartier New York, special order, 1928
Platinum, diamonds
15 × 4.25 cm

Cartier Collection
Inv. CL 178 A28

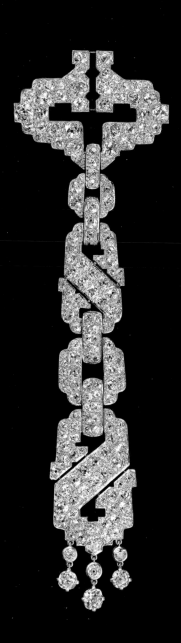

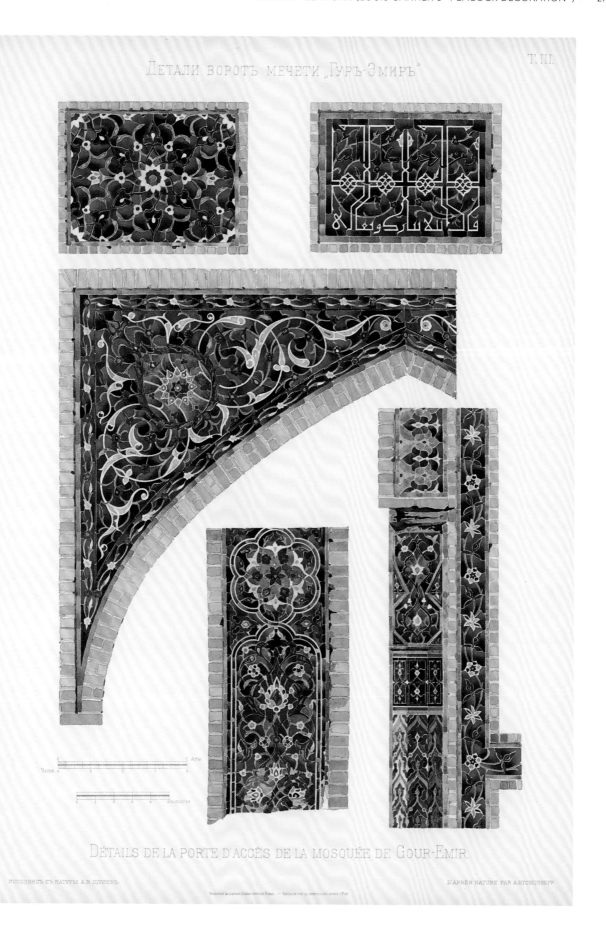

Детали воротъ мечети „Гуръ-Эмиръ"

T. III.

Détails de la porte d'accès de la mosquée de Gour-Emir.

Исполнялъ съ натуры А. В. Щусевъ. D'après nature par A. Stchusseff.

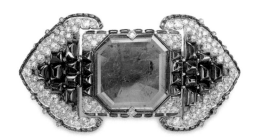

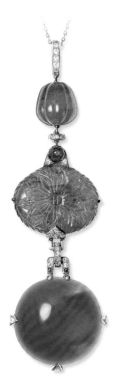

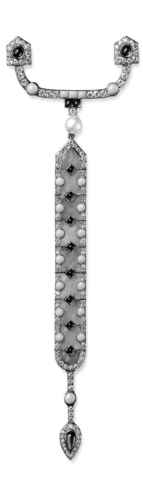

Les Mosquées de Samarcande, pl. 3

Nikolai Ivanovich Veselovskii et al.
St. Petersburg, 1905

Cartier Paris Archives
Inv. BibCart/442

Pendant

Cartier Paris, special order, 1923
Platinum, sapphires, emeralds, diamonds
9.9 × 3.0 × 1.85 cm

Cartier Collection
Inv. NE 24 A23

Buckle brooch

Cartier Paris, 1922
Platinum, emeralds, sapphires,
diamonds
8.50 × 4.35 cm

LA Private Collection

Dome ring

Cartier New York, 1968
Gold, turquoise, jade
3.6 × 2.8 cm

Cartier Collection
Inv. RG 38 A68

Brooch pendant

Cartier Paris, 1913
Platinum, jade, sapphires, turquoise,
diamonds, pearl
12.3 × 3.9 cm

Cartier Collection
Inv. CL 193 A13

Cigarette case

Cartier Paris, c. 1929
Gold, platinum, nephrite, lapis lazuli,
turquoise, diamonds
9.05 × 5.8 × 1.8 cm

Formerly in the collection
of Prince and Princess Sadruddin Aga Khan
LA Private Collection

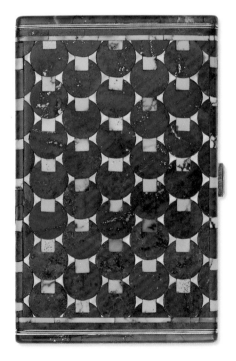

Tile

Iznik, Turkey, 17th century
Ceramic
14 × 28.5 × 1.7 cm

Musée du Louvre, Paris,
département des Arts de l'Islam
Purchased in 1895,
formerly in the Sorlin-Dorigny Collection
Inv. OA 3919/805

Three tiles from a wall panel

Damascus, Syria, 1550-1600
Ceramic
30 × 26.4 × 2.5 cm

Musée du Louvre, Paris,
département des Arts de l'Islam
Chandon de Briailles bequest, 1955
Inv. MAO 311a,b,c

Drawing for a belt buckle

Charles Jacqueau
Graphite and gouache on tracing paper
5 × 10.8 cm

Petit Palais, Paris,
gift of the Jacqueau family, 1998
Inv. PPJAC00875

Drawing for a ring

Charles Jacqueau
Graphite, gouache, black ink
on beige tracing paper
19.2 × 13.4 cm

Petit Palais, Paris,
gift of the Jacqueau family, 1998
PPJAC02341

Cigarette case

Cartier Paris, 1927
Gold, platinum, enamel,
lacquer, diamond
8.6 × 5.9 × 1.5 cm

Cartier Collection
Inv. CC 37 A27

Cigarette case

Cartier Paris, 1930
Gold, lapis lazuli, turquoise, diamond
8.7 × 5.6 × 1.9 cm

Cartier Collection
Inv. CC 47 A30

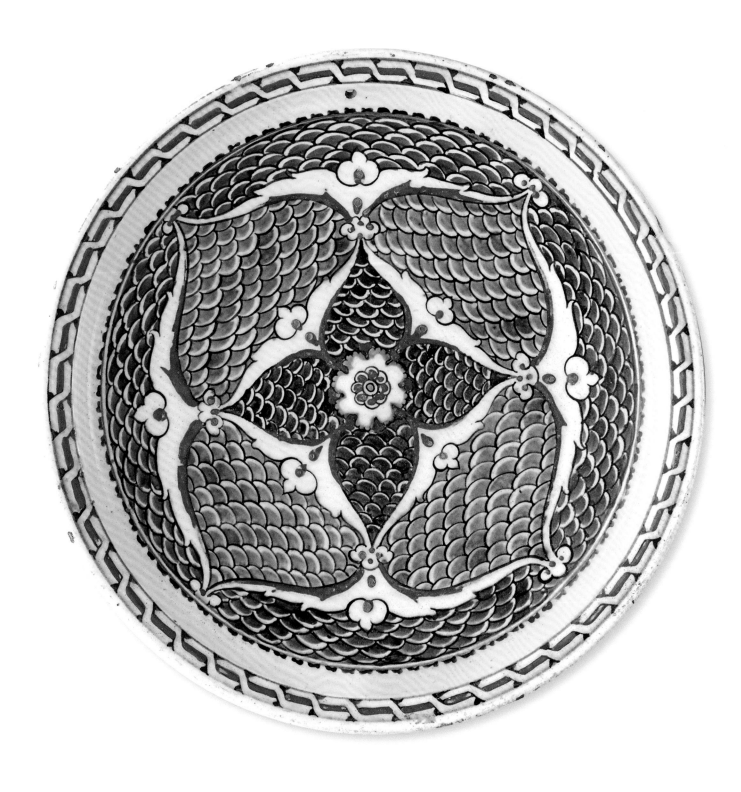

Dish

Iznik, Turkey, 1575-1580
Ceramic
4.9 × 29.7 × 0.6 cm

Musée du Louvre, Paris,
département des Arts de l'Islam
Acquired in 1866 by the Musée de Cluny,
formerly Salzmann Collection
Inv. OA 7880/28, p. 253

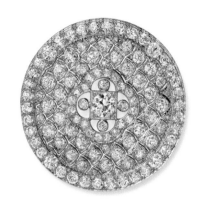

Brooch

Cartier Paris, special order, 1926
Platinum, diamonds
Diam. 4 cm
Cartier Collection

Inv. CL 240 A26

Drawing for a Persian pendant

Charles Jacqueau
Graphite, black and blue ink
on vellum tracing paper
7.9 x 7 cm

Petit Palais, Paris
Gift of the Jacqueau family, 1998
Inv. PPJAC01225

Cigarette case

Cartier Paris, c. 1928
Gold, turquoise, lapis lazuli, sapphires
8.4 × 5.8 × 1.5 cm

Formerly in the collection of Prince
and Princess Sadruddin Aga Khan
LA Private Collection

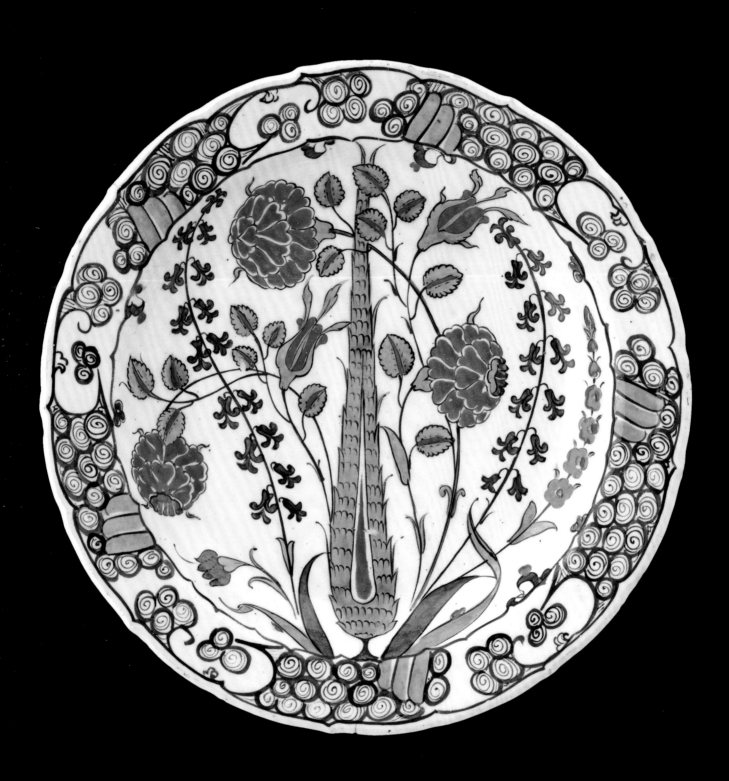

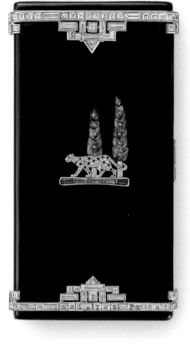

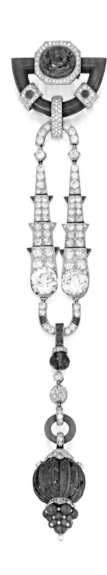

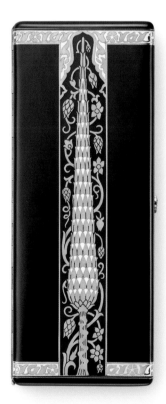

Dish

Iznik, c. 1575
Ceramic
6 × 30 cm

Musée du Louvre, Paris,
département des Arts de l'Islam
On loan from the Musée des Arts Décoratifs
Michel Tardit bequest, 1938
Inv. AD 32668

Shoulder brooch

Cartier New York, c. 1925
Platinum, emeralds, diamonds,
coral, pearls
18 × 3.47 cm

LA Private Collection

This piece was created from two broches
from about 1925, which were assembled
at a later date. This setting is not
documented in the Cartier archives.

Panther vanity case

Cartier Paris, 1927
Gold, platinum, diamonds,
emeralds, rubies, onyx, enamel
9.5 × 5 × 1.5 cm

Cartier Collection
Inv. VC 43 A27

Vanity case

Cartier London, 1927
Gold, platinum, diamonds, enamel
11 × 4.5 cm

Cartier Collection

053580

Design for a bracelet

Cartier Paris, 2013
Graphite and gouache
on tracing paper
29.7 × 21 cm

Cartier Paris Archives
Inv. JOA-053580

Bracelet

Cartier, 2011
Platinum, diamonds
Approx. 2.4 × 18.1 cm

Private collection

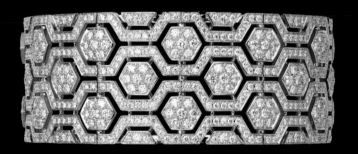

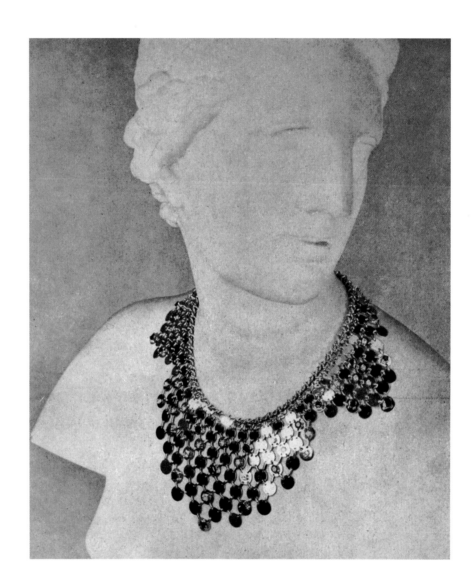

Necklace

Cartier Paris, 1946,
transformed in 1948
Gold, diamonds, and colored stones
"Le style oriental des bijoux nouveaux"
Femina, Spring 1948, p. 99
Photograph by Crespi
Cartier Documentation, Paris

Caption in *Femina*: "… a sumptuous
necklace of gold sequins set with brilliants
and colored stones." The stones were
removed from their settings after the
photograph was published in 1948.

Necklace

Cartier Paris, c. 2000
Gold, diamonds
42 × 8.5 cm
Cartier Collection
Inv. ST-NE 22 C2000

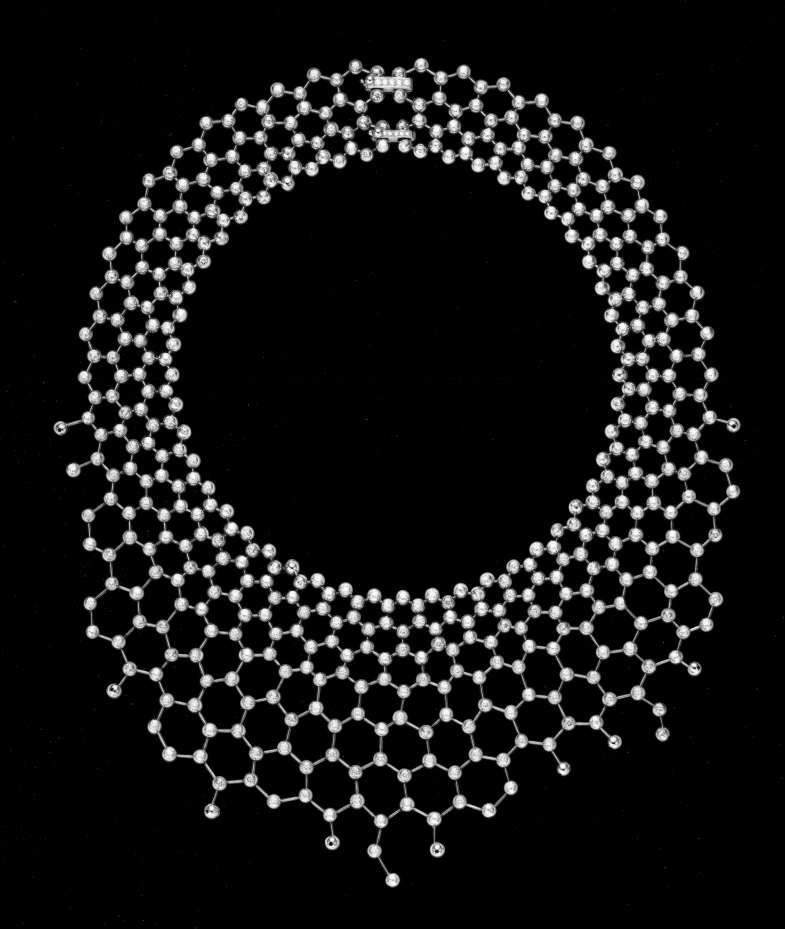

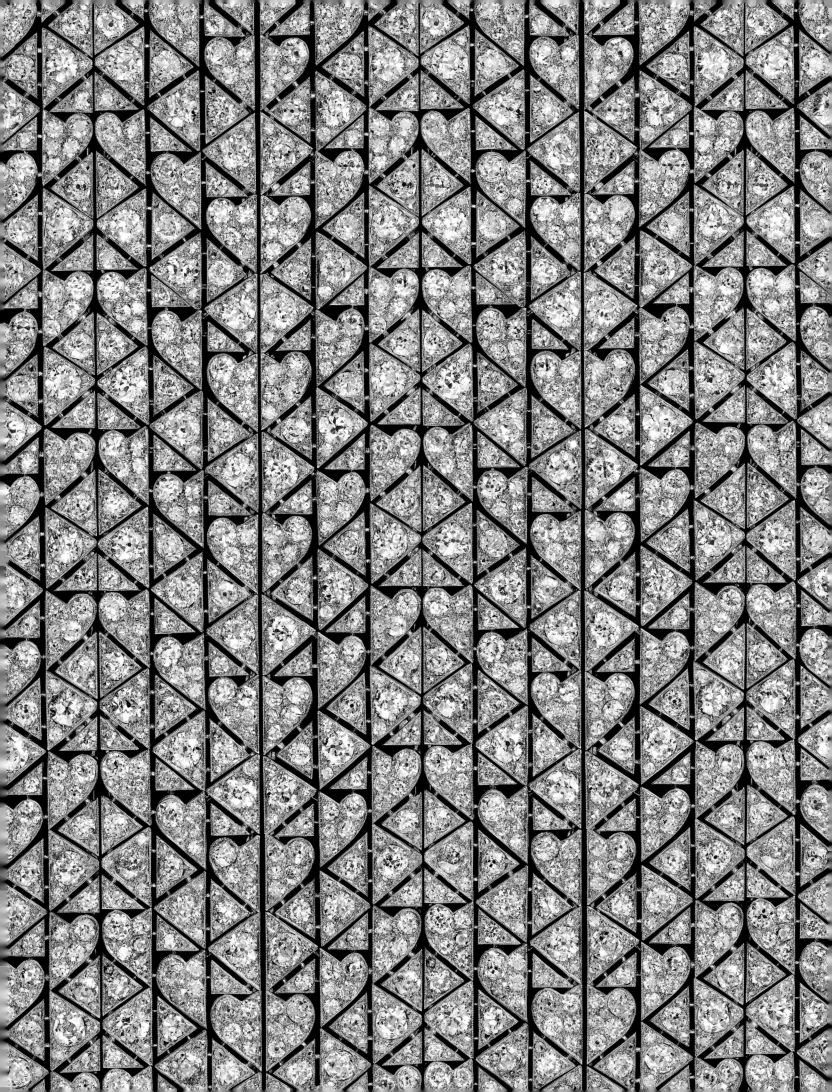

APPENDICES

Montage from a detail
of a bandeau
1904
(see p. 255)

1.

2.a

2.b

3.a

3.b

3.c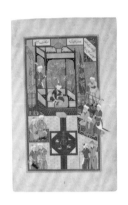

4.a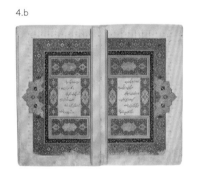

4.b

LOUIS CARTIER'S PERSONAL COLLECTION OF ISLAMIC ART: CATALOGUE RAISONNÉ

JUDITH HENON-RAYNAUD

The collection is organized according to material classification, then by the date of entry/recorded existence in the collection.

With the exception of works for which we found invoices or a dated indication in the stock books, the date of entry into the collection indicates the existence of the work at a given date, generally determined from dated photographs or publications.

This list does not reflect the entire collection, yet it is nonetheless the most complete list to date. It is based on sources derived from publications, the Cartier Archives, the Charles Jacqueau archives at the Petit Palais, and private archives.

The dimensions indicated for paintings refer to the entire folio. The transcription of proper names has been simplified. In regard to Basil Robinson's inventory, see p. 73.

I would like to thank Monique Buresi and Marie-José Castor, scientific documentalists in the Musée du Louvre, département des Arts de l'Islam; without their work, this catalogue would not have been possible.

Abbreviations: ARCH.: archives; LIB.: library; CAT.: catalogue; COLL.: collection; PROV.: provenance

MANUSCRIPTS

1912

1. *Khamsa* (Quintet) of Nizami

Herat, Afghanistan, c. 1415–1417
Ink, opaque watercolor, gold,
and silver on paper
26.3 × 16.4 cm
The Hossein Afshar Collection
at the Museum of Fine Arts, Houston
Inv. 462.2015

PROV.: library of Sultan Shah Rukh (r. 1405–1447); Louis Cartier coll. in 1912; public auction in 1996; Hossein Afshar coll.*
CARTIER PARIS ARCH.: lost negatives nos. 4534 to 4550 from 1930
LIB.: Marteau and Vever, 1913, pl. LVII, no. 63; London, 1931, no.539 A, pl. XXXII B and C and pl. XXXIII A and B; New York, 1933, p. 27, fig. 16; *Oriental and European Rugs [...]*, Bonhams, London, 1996, no. 491; Ghiasian, 2018, p. 41; Houston, 2019, cat. 26 a-b.

2. *Guy u-Chawgan*
(The ball and the polo stick)
of 'Arifi

Text copied by Mir 'Ali al-Husayni
Herat, Afghanistan, 1523
a. Binding: stamped and gilded red leather
b. Manuscript: ink, opaque watercolor,
and gold on paper
22.9 × 15.3 cm
Harvard Art Museums/
Arthur M. Sackler Museum
Gift of John Goelet
Inv. 1958.79

PROV.: Jahangir, Mughal emperor; Fath 'Ali Shah Qajar; Louis Cartier coll. in 1912; Claude Cartier coll.; sold to the museum in 1957

CARTIER PARIS ARCH.: negatives DOC34/001423040 c. 1912 and lost negatives nos. 4615 to 4618 from 1930
PRIVATE ARCH.: no. 19** on Robinson's list
LIB.: Martin, 1912, vol. 1, fig. 27, p. 53; Marteau and Vever, 1913, pl. LXVIII, no. 86; London, 1931, no. 541 C; Shreve Simpson, 1980, no. 15, pp. 54–55

3. *Bustan* (The Orchard) of Sa'di

Made for Sultan 'Abd al-'Aziz (1540–1550)
Text copied by Mir 'Ali al-Husayni
Painted by Bishndas and Shaykh Zada
Uzbekistan, Bukhara, text 1531–1532;
paintings c. 1620
a. Binding: stamped and gilded leather
b, c. Manuscript: ink, opaque watercolor,
and gold on paper
28.9 × 18.4 × 3.5 cm
Harvard Art Museums/
Arthur M. Sackler Museum
Gift of Philip Hofer in memory
of Frances L. Hofer
Inv. 1979.20

PROV.: Mughal emperors Akbar, Shah Jahan, and Jahangir; Louis Cartier coll. in 1912; estate sale 1962; purchased by Philip Hofer
CARTIER PARIS ARCH.: negatives CD06/SN12430, DOC34/001373040, DOC34/001383040, DOC34/001393040, DOC34/001403040, DOC34/001413040, c. 1912, and lost negatives nos. 5063 to 5068 from 28/09/1931
PRIVATE ARCH.: no. 16 on Robinson's list
LIB.: Martin, 1912, vol. 1, fig. 28, p. 55; Marteau and Vever, 1913, pl. LXXIII, no. 93; Louis Cartier sales catalogue, Drouot, 1–2/03/1962, lot 38, pl. V

1914

4. *Diwan* of Hafiz

Cover attributed to Sultan Muhammad
Iran, Tabriz, c. 1527
a. Binding: leather, lacquer on paper
Manuscript: ink, opaque watercolor,
gold, and silver on paper
Binding: 29.21 × 19.05 × 3.5 cm
Harvard Art Museums/
Arthur M. Sackler Museum
Gift of Mr. and Mrs. Stuart Cary Welch, Jr.
Inv. 1964.149

PROV.: Arthur Sambon coll.; purchased by Louis Cartier at the Sambon sale, 1914; Claude Cartier coll.; sold by Claude Cartier to Stuart Cary Welch, 1957
CARTIER PARIS ARCH.: lost negatives nos. 3426 to 3435 from 1928 and 4551 to 4562 from 1930
PRIVATE ARCH.: no. 21** on Robinson's list
LIB.: *Catalogue des objets d'art [...] formant la collection de M. Arthur Sambon*, Paris, Impr. Georges Petit, 1914, no. 189, pp. 48–50; London, 1931, no. 546 C; Binyon and Wilkinson, 1933, p. 128; Pope, 1939, vol. X, pls. 972 and 977

This manuscript originally included five paintings. Although it remained complete while in Louis Cartier's collection, it was later broken up, probably during World War II. The paintings are now dispersed among several institutions; the location of one painting remains known.

b. Illuminated frontispiece
Harvard Art Museums/
Arthur M. Sackler Museum
Gift of the Welch family in memory
of Philip Hofer
Inv. 1984.750.1 and 2

* I would like to thank Aimée Froom
for the information concerning this manuscript.

4.c
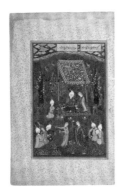

4.d
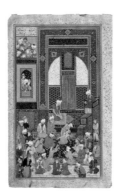

4.e
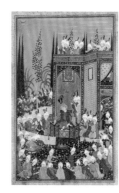

4.f
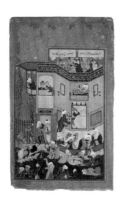

4.g
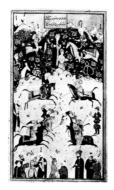

5.

6.
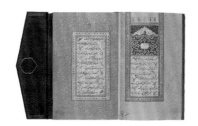

7.a

7.b
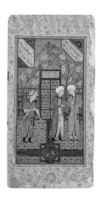

8.a

8.b
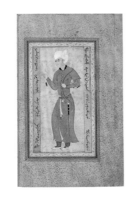

c. Lovers' picnic, folio 67 r
 Attributed to Sultan Muhammad
 19 × 12.4 cm
 Harvard Art Museums/
 Arthur M. Sackler Museum
 Gift of Stuart Cary Welch in memory
 of Edith Iselin Gilbert Welch
 Inv. 2007.183.1 and 2
 LIB.: Sakisian, 1929, pl. LXXXI, fig. 146 (ill.)

d. Incident in a Mosque, folio 77 r
 Signed: Shaykh Zada
 29 × 18.2 cm
 Harvard Art Museums/
 Arthur M. Sackler Museum
 Gift of Stuart Cary Welch, Jr.
 Inv. 1999.300.1 and 2
 LIB.: Sakisian, 1929, pl. LXX, fig. 121 (ill.);
 Pope, 1939, vol. X, pl. 895

e. The Feast of 'Id at the end of Ramadan,
 folio 86 r
 Signed: Sultan Muhammad
 29 × 18.3 cm
 Arthur M. Sackler Gallery, Smithsonian
 Institution, Washington, D.C.:
 The Art and History Collection
 Inv. LTS1995.2.42
 LIB.: Sakisian, 1929, pl. LXXXI, fig. 145; Pope,
 1939, vol. X, pl. 900; Soudavar, 1992, p. 161

f. Earthly drunkenness, folio 135 r
 Signed: Sultan Muhammad
 28.7 × 35.5 cm
 Harvard Art Museums/Arthur M. Sackler
 Museum and the Metropolitan
 Museum of Art
 Gift of Mr. and Mrs. Stuart Cary Welch,
 in honor of the students of Harvard
 University and Radcliffe College
 Owned jointly by Harvard Art Museums
 and the Metropolitan Museum of Art
 Inv. 988.460.1 and 2 (Harvard) and
 1988.430 (Met)
 LIB.: Sakisian, 1929, pl. LXXX, fig. 144 (ill.);
 London, 1931, no. 546 C

g. Polo scene
 Shaykh Zada?
 Location unknown; probably disappeared
 during World War II
 LIB.: London, 1931, no. 127a, pl. LXXXIII B

1921, 1922, AND 1933

5. Qur'an

 Shiraz, Iran, 16th century
 Ink, opaque watercolor, and gold
 on paper
 30 × 19.4 cm
 Location unknown

 PROV.: Louis Cartier coll. in 1921;
 public auction in 2016
 CARTIER PARIS ARCH.: negatives
 DOC460/005901318 and DOC184/
 009452430 c. 1921
 LIB.: Art of the Islamic and Indian Worlds,
 Christie's, 20/10/2016, lot 22
 This Qur'an may not have formed part
 of the Louis Cartier collection (see p. 69).

6. Collection of mystical poems
 by 'Umar ibn al-Faridh

 Signed by Sultan 'Ali al-Mashhadi
 Herat, Afghanistan, 1476
 Binding: stamped and gilded leather
 Manuscript: ink, opaque watercolor,
 gold, and silver on paper
 22 × 14 cm
 Al Thani Collection
 Inv. BELC85/D

 PROV.: Martin coll. in 1912; Louis Cartier coll.
 in 1922; estate sale 1962; public auction in
 2015; purchased by Al Thani collection in 2017
 CARTIER PARIS ARCH.: negatives
 DOC439/015161318, DOC439/015171318,
 DOC439/01517bis1318 from 27/09/1922,
 DOC439/015471318, DOC439/015481318,
 DOC439/015491318 from 27/10/1922
 JACQUEAU ARCH.: albumen prints,
 PPJACPH99-6 to 10
 PRIVATE ARCH.: no. 17 on Robinson's list
 LIB.: Martin 1912, vol. 2, pl. 246; Louis Cartier
 sales catalogue, Drouot, 1-2/03/1962, lot
 37; Arts d'Orient, Pfis, Artcurial, 17/12/2015,
 no. 157 ; Pekin 2018, vol. 3, p. 428-429, no. 166

7. Twelve folios from an anthology
 of poetry

 Calligraphy attributed to Mir 'Ali Haravi
 Bukhara, Uzbekistan, c. 1550
 Ink, opaque watercolor, and gold
 on paper
 13.6 × 26.3 cm (calligraphy)
 Harvard Art Museums/
 Arthur M. Sackler Museum
 Gift of John Goelet
 Inv. 1958.63 to 1958.74

 PROV.: Louis Cartier coll. in 1933; Claude
 Cartier coll.; sold to museum in 1957
 PRIVATE ARCH.: nos. 5 and 11–13*
 on Robinson's list
 LIB.: New York, 1933, pp. 39–40; Shreve
 Simpson, 1980, no. 25, pp. 74–78, 115

DATE OF ENTRY INTO COLLECTION UNKNOWN

8. Book of paintings
 and calligraphy

 Calligraphy by Mir 'Ali, 'Ali Riza,
 and Muhammad Husayn al-Tabrizi
 Bukhara, Uzbekistan, 16th century
a. Binding: stamped, cut-out and gilded
 leather, cut-out and colored papers
b. Manuscript: ink, opaque watercolor,
 and gold on paper
 27 × 17.8 cm
 Harvard Art Museums/
 Arthur M. Sackler Museum
 Gift of John Goelet
 Inv. 1958.78, 1958.78.1, 1958.78 B,
 1958.78.3

 PROV.: Louis Cartier coll., date of entry
 unknown; Claude Cartier coll.;
 sold to museum in 1957
 PRIVATE ARCH.: nos. 18*/1 to 5 on Robinson's list
 LIB.: Shreve Simpson, 1980, nos. 86 to 88,
 p. 116

9. Collection of poetry including
 95 folios, binding decorated
 with tree and bird motifs

 Iran, 16th century
 21 × 15 cm
 Location unknown

 PROV.: Louis Cartier coll., date of entry
 unknown; estate sale 1962
 LIB.: Livres précieux provenant
 de la bibliothèque Louis Cartier, Paris,
 Hôtel Drouot, 01–02/03/1962, lot 39
 (no ill.)

10.
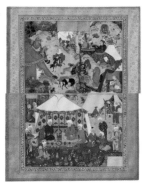

11.
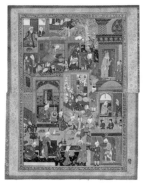

12.
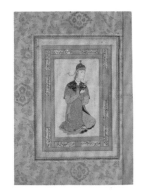

13.
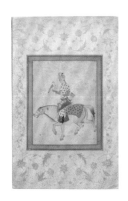

14.
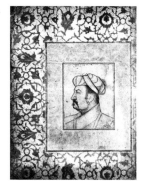

15.
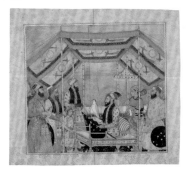

16.
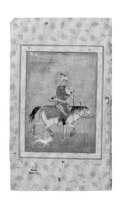

17.
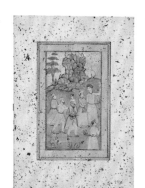

18.
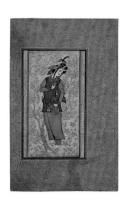

19.
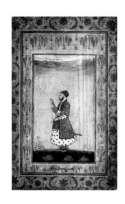

20.
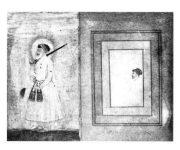

21.
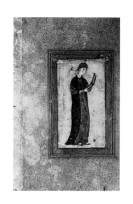

SINGLE PAGES

1912–1913

10. Nomadic encampment

Formerly attributed to Mir Sayyid 'Ali
Tabriz, Iran, c. 1540
Ink, opaque watercolor, gold,
and silver on paper
33.4 × 26.5 cm
Harvard Art Museums/
Arthur M. Sackler Museum
Gift of John Goelet
Inv. 1958.75

PROV.: Louis Cartier coll. c. 1912 (at this date,
the paintings had not been remounted);
Claude Cartier coll.; sold to museum in 1957
(the paintings were remounted with their
intervening border removed at the suggestion
of S. Cary Welch)
CARTIER PARIS ARCH.: negatives
DOC70/001122430 and DOC70/001132430 c. 1912
JACQUEAU ARCH.: albumen print PPJACPH99-11
PRIVATE ARCH.: nos. 6 and 8** on Robinson's list
LIB.: Sakisian, 1929, pl. LXXXV, fig. 152;
New York, 1933, pp. 39–40, pls. 21, 22;
Pope, 1939, vol. X, pls. 908A and 909A;
Shreve Simpson, 1980, no. 17, pp. 58–61

11. Nighttime in a city

Formerly attributed to Mir Sayyid 'Ali
Tabriz, Iran, c. 1540
Ink, opaque watercolor, gold,
and silver on paper
33.9 × 26.9 cm
Harvard Art Museums/
Arthur M. Sackler Museum
Gift of John Goelet
Inv. 1958.76

PROV.: Louis Cartier coll. c. 1912 (at this date,
the paintings had not been remounted);
Claude Cartier coll.; sold to museum in 1957
(the paintings were remounted with their
intervening border removed at the suggestion
of S. Cary Welch)
CARTIER PARIS ARCH.: negatives
DOC70/001112430 and DOC70/001142430,
c. 1912
PRIVATE ARCH.: nos. 7 and 9** on Robinson's list
LIB.: Sakisian, 1929, pl. CVI, fig. 190; New
York, 1933, pls. 23 and 24; Pope, 1939, vol. X,
pls. 908 B and 909B; Shreve Simpson, 1980,
pp. 13, 58–61 and no. 18

12. Seated princess

Attributed to Mirza 'Ali
Tabriz, Iran, c. 1540
Ink, opaque watercolor,
and gold on paper
39.7 × 28 cm
Harvard Art Museums/
Arthur M. Sackler Museum
Gift of John Goelet
Inv. 1958.60

PROV.: formerly Ducoté coll., Paris;
Louis Cartier coll. in 1912; Claude Cartier coll.;
sold to museum in 1957
CARTIER PARIS ARCH.: negatives
DOC509_027271318 from 25/05/1926
JACQUEAU ARCH.: albumen print, not inventoried
PRIVATE ARCH.: no. 2** on Robinson's list
LIB.: Sarre and Martin, Tafel 24 cat. 669;
Martin, 1912, vol. II, pl. 100C; Marteau and
Vever, 1913, pl. CXVIII, no. 144; Kühnel, 1923,
pl. 57 (ill.); Sakisian, 1929, pl. XXXVIII, fig.
60 (ill.); London, 1931, no. 555; Pope, 1939,
vol. X, pl. 902; Shreve Simpson, 1980, no. 19,
pp. 62–63

13. Falconer on horseback

Deccan, India, late 16th century
Ink, opaque watercolor, gold,
and silver on paper
39.3 × 25.1 cm
Fondation Custodia, Paris, purchase, 1973
Inv. 1973-T.3

PROV.: Louis Cartier coll. in 1912; sold by
Claude Cartier to Stuart Cary Welch, 1957
PRIVATE ARCH.: no. 26 on Robinson's list
LIB.: Marteau and Vever, 1913, pl. CXXXI,
no. 172; Catalogue of [...] Miniatures [...].
The Property of Cary Welch, New York,
Sotheby & Co., 12/12/1972, no. 198; Paris, 1986,
no. 41, pp. 32–33, pl. VII and p. 37

14. Portrait of Akbar

India, c. 1625
Inscribed: Akbar Padishah
Ink on paper
Location unknown

PROV.: Louis Cartier coll. in 1912; sold by
Claude Cartier to Stuart Cary Welch, 1957
CARTIER PARIS ARCH.: negative
DOC182/009472430 from 1921
PRIVATE ARCH.: no. 29 on Robinson's list
LIB.: Marteau and Vever, 1913, pl. CLXXIII,
no. 249 under the name of Akbar; Brown, 1975,
pl. XXI under the name of Jahangir

15. Darbar of Emperor Aurangzeb

Attributed to Bichitr
India, c. 1660–1685
Ink, opaque watercolor,
and gold on paper
19.1 × 21.4 cm
Museum of Islamic Art, Doha,
purchase, 2007
Inv. MS.54.2007

PROV.: Louis Cartier coll. in 1912; sold by
Claude Cartier to Stuart Cary Welch, 1957
PRIVATE ARCH.: no. 30* on Robinson's list
LIB.: Marteau and Vever, 1913, pl. XX, no. 20;
Welch, 1959, no. 16, p. 143, pl. 11, fig. 19;
Welch, 1978, p. 38, pl. 37; Williamstown,
Baltimore, and Boston, 1978, pp. 169–170

16. Portrait of Iraj, third son of King Fereydun of Persia

India, late 16th century
Ink, opaque watercolor,
and gold on paper
38.5 × 24 cm
Location unknown

PROV.: coll. Kerimov (stamp in Cyrillic
on the margin, read by M. Burési);
Louis Cartier coll. in 1912; sold by Claude
Cartier to Stuart Cary Welch, 1957;
George P. Bickford coll. (1960–1985)
CARTIER PARIS ARCH.: negatives
DOC60/001883040 c. 1913
and DOC68/010233040 from 1921
PRIVATE ARCH.: no. 26 bis on Robinson's list?
LIB.: Brown, 1975, pl. XIII; Czuma, 1975, no. 44;
Indian, Tibetan, Nepalese Thai, Khmer and
Javanese Art, including Indian Miniatures,
Sotheby's, New York, 20–21/09/1985, lot 446;
Indian and Southeast Asian Art, Christie's,
New York, 19/03/2013, lot 279

1921

17. Joseph and his brothers in a landscape setting

Calligraphy by Muhammad Husayn
Kashmiri "Zarin Qalam"
Allahabad, India, c. 1600–1605 (painting);
c. 1700 (margins)
Ink, opaque watercolor, and gold on paper
28.7 × 20.9 cm
Cleveland Museum of Art,
Cleveland, 2013
Inv. I-2013-7592/49

PROV.: made for Prince Salim; Louis Cartier
coll. in 1921; sold by Claude Cartier to Stuart
Cary Welch, 1957; Adrienne Minassian,
New York, until July 1969; Catherine
and Ralph Benkaim; sold to the museum
in 2013
CARTIER PARIS ARCH.: negative
DOC184/009482430 from 1921
PRIVATE ARCH.: no. 35 on Robinson's list
(1 of the 5 Indian miniatures representing
"Scenes in the life of saints. 17th–18th c.")
LIB.: Cleveland, 2016, pp. 76–77,
and cat. no. 33, p. 320

18. Standing page with cup and bottle

Isfahan, Iran, c. 1620
Ink, opaque watercolor, and gold on paper
33.8 × 21.7 cm
Harvard Art Museums/
Arthur M. Sackler Museum
Gift of John Goelet
Inv. 1958.77

PROV.: Louis Cartier coll. in 1921;
Claude Cartier coll.; sold to museum in 1957
CARTIER PARIS ARCH.: negative
DOC184/009502430 from 1921
PRIVATE ARCH.: no. 10* on Robinson's list
LIB.: Shreve Simpson, 1980, no. 34, pp. 92–93

19. Portrait of a falconer

Inscribed: Ibrahim Khan
ibn 'Alim Dan Khan
India, 17th century
Location unknown

PROV.: Louis Cartier coll. in 1921; sold by
Claude Cartier to Stuart Cary Welch, 1957
CARTIER PARIS ARCH.: negative
DOC68/010153040 from 1921
PRIVATE ARCH.: no. 32 on Robinson's list

20. Portrait of Shah Jahan and unfinished portrait of an unidentified dignitary

India, 17th century
Location unknown

PROV.: Louis Cartier coll. in 1921
CARTIER PARIS ARCH.: negative
DOC184/009492430 from 1921

1926–1929

21. Princess reading

Iran, c. 1540
Ink, opaque watercolor,
and gold on paper
Location unknown

22.

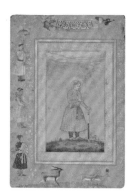

23.

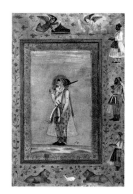

24.

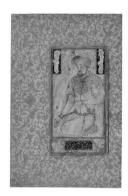

25.

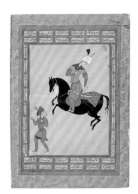

26.

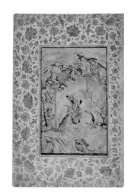

27.

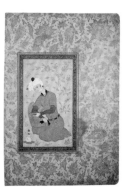

28.

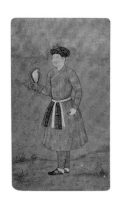

29.

30.

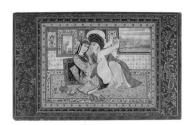

PROV.: Louis Cartier coll. in 1926
CARTIER PARIS ARCH.: negative
DOC509/027261318 from 25/05/1926
LIB.: New York, 1933, p. 37, pl. 25

22. Portrait of the elderly Akbar

Page from Shah Jahan's last album
India, c. 1650
Ink, opaque watercolor,
and gold on paper
36.8 × 25 cm
Aga Khan Museum, Toronto
Inv. AKM149

PROV.: may have been purchased from
Demotte in 1927, according to G. Migeon
(see p. 78, note 116); Louis Cartier coll.
in 1927?; sold by Claude Cartier to Stuart
Cary Welch, 1957; sold to Sadruddin
Aga Khan between 1975 and 1982
PRIVATE ARCH.: no. 24* on Robinson's list
LIB.: Welch, 1963, no. 17, p. 231, pl. 11, fig. 17;
Brown, 1975, pl. XXVI

23. Portrait of Shah Jahan in old age

Signed: Hashim
India, c. 1645–1650
Ink, opaque watercolor, and gold on
paper
36.4 × 24.7 cm
Harvard Art Museums/
Arthur M. Sackler Museum
Gift of Stuart Cary Welch, 1999
Inv. 1999.299

PROV.: may have been purchased from
Demotte in 1927, according to G. Migeon
(see p. 78, note 116); Louis Cartier coll. in 1927?;
sold by Claude Cartier to Stuart Cary Welch, 1957
PRIVATE ARCH.: no. 23* on Robinson's list
LIB.: Welch, 1963, no. 18, p. 231, pl. 12, fig. 18;
Williamstown, Baltimore, and Boston, 1978,
pp. 127–129, fig. 45

24. Portrait of Sultan Husayn Mirza Bayqara

Painting formerly attributed to Behzad
Herat, Afghanistan, c. 1480–1510
Ink, opaque watercolor, and gold on paper
34.3 × 32.7 cm
Harvard Art Museums/
Arthur M. Sackler Museum
Gift of Stuart Cary Welch
Inv. 1958.59

PROV.: believed to have been part of an album
compiled in Istanbul, probably for Sultan

Ahmed I (1603-1617); F. R. Martin coll.;
Louis Cartier coll. in 1929; sold by Claude
Cartier to Stuart Cary Welch, 1957
PRIVATE ARCH.: no. 1* on Robinson's list
LIB.: Martin, 1912, vol. II, pl. 81; Sarre and
Martin, 1912, p. 26, cat. no. 677; Sakisian, 1929,
pl. XXXVII, fig. 59 (ill.); London, 1931, no. 492;
New York, 1933, p. 33; Shreve Simpson, 1980,
pp. 10, 34, 51, no. 26, pp. 76–77

1933–1939

25. Horseman and his page

Painting attributed to Qadimi
Mashhad, Iran, c. 1560
Ink, opaque watercolor, and gold on paper
38.5 × 27 cm
Harvard Art Museums/
Arthur M. Sackler Museum
Gift of John Goelet
Inv. 1958.62

PROV.: Louis Cartier coll. in 1933; Claude
Cartier coll.; sold to museum in 1957
PRIVATE ARCH.: no. 4** on Robinson's list
LIB.: New York, 1933, p. 37, fig. 26; Shreve
Simpson, 1980, no. 22, pp. 68–69

26. Hunters near a stream

Signed: Riza-e 'Abbassi
for his son Muhammad Bakir
Isfahan, Iran, c. 1625
Ink, opaque watercolor, and gold on paper
33.9 × 22.5 cm
Brooklyn (NY), Brooklyn Museum
Inv. 35.1027

PROV.: Louis Cartier coll. in 1939; sold by
Claude Cartier to Stuart Cary Welch, 1957?
PRIVATE ARCH.: no. 36 on Robinson's list?
LIB.: Pope, 1939, vol. X, pl. 917

DATE OF ENTRY INTO COLLECTION UNKNOWN

27. Youth with a golden pillow

Attributed to Mirza 'Ali
Mashhad, Iran, c. 1560
Ink, opaque watercolor, and gold on paper
34.8 × 23.2 cm
Harvard Art Museums/
Arthur M. Sackler Museum
Gift of John Goelet
Inv. 1958.61

PROV.: Louis Cartier coll., date of entry
unknown; Claude Cartier coll.;
sold to museum in 1957
PRIVATE ARCH.: no. 3* on Robinson's list
LIB.: Shreve Simpson, 1980, no. 20, pp. 64–65

28. Khan 'Alam with a sparrow hawk

Attributed to Govardhan
India, c. 1610–1620
31.2 × 23.9 cm
Harvard Art Museums/
Arthur M. Sackler Museum
Gift of Stuart Cary Welch, 1999
Inv. 1999.293

PROV.: Louis Cartier coll., date of entry
unknown; sold by Claude Cartier to Stuart
Cary Welch, 1957
PRIVATE ARCH.: no. 31 on Robinson's list
LIB.: Brown, 1975, pl. XVII, fig. 2

29. Woman playing a zither

Attributed to Govardhan
India, c. 1610
Ink, opaque watercolor, and gold on paper
27 × 18.1 cm
Harvard Art Museums/
Arthur M. Sackler Museum
Gift of Edith I. Welch, in memory
of Stuart Cary Welch
Inv. 2011.538

PROV.: Louis Cartier coll., date of entry
unknown; sold by Claude Cartier to Stuart
Cary Welch, 1957
PRIVATE ARCH.: no. 38 on Robinson's list
LIB.: Welch and Masteller, 2004, no. 25
pp. 98–100

30. Lovers

Isfahan, Iran, c. 1700
Ink, opaque watercolor on paper
20.4 × 32.7 cm
Harvard Art Museums/
Arthur M. Sackler Museum
Gift of Stuart Cary Welch
Inv. 1958.80

PROV.: Louis Cartier coll., date of entry
unknown; sold by Claude Cartier to Stuart
Cary Welch, 1957.
PRIVATE ARCH.: no. 53 on Robinson's list
LIB.: Shreve Simpson, 1980, no. 109,
p. 118

PAINTINGS NOT IDENTIFIED ON ROBINSON'S LIST

This list includes the Indian works
acquired by S. C. Welch from Claude
Cartier in 1957; the location of these
works is unknown at present. It may
include the paintings previously cited,
although the descriptions are not
sufficient to definitively establish
this connection. This list in not included
in the numbering of Louis Cartier's
collection.

Religious manuscript in Arabic,
written in Maghrebi script

Illuminated, good condition
PRIVATE ARCH.: no. 20 on Robinson's list

Page of calligraphy with
cut-outs, illuminated frontispiece

PRIVATE ARCH.: no. 22 on Robinson's list

Portrait of Akbar (?) with other
figures in the margin

PRIVATE ARCH.: no. 25* on Robinson's list

Mughal prince, colored drawing

PRIVATE ARCH.: no. 27 on Robinson's list

31.a

31.b

32.

33.

34.

35.
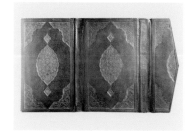

36.a
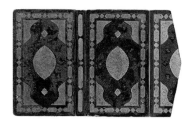

36.b
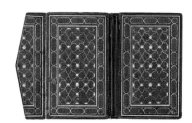

37.
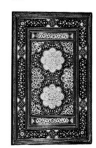
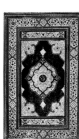

39.
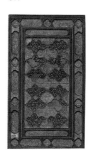
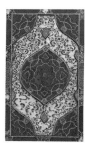

Portrait of an elderly courtesan

PRIVATE ARCH.: no. 28 on Robinson's list

Lion hunting

India, 18th century
PRIVATE ARCH.: no. 33 on Robinson's list

Nawab Said Khan Bahadur

India, 18th century
PRIVATE ARCH.: no. 34 on Robinson's list

18th-century drawings:
dervishes, ascetics, etc.

India, 18th century
PRIVATE ARCH.: no. 35 on Robinson's list

Two paintings of royal hunts

India, 17th century
PRIVATE ARCH.: no. 37 on Robinson's list
The first may correspond
to the painting LC no. 26.
The second may be the painting Inv. 35.1027
in the Brooklyn Museum.

Prince and servant on a terrace

India, 18th century
PRIVATE ARCH.: no. 39 on Robinson's list

Women's festival

India, 18th century
PRIVATE ARCH.: no. 40 on Robinson's list

Woman holding a falcon

India, 18th century
PRIVATE ARCH.: no. 41 on Robinson's list

Iskandar comforting Dara

Kashmir, India, 17th–18th century
PRIVATE ARCH.: no. 42 on Robinson's list

Krishna playing the flute
between two milkmaids

India, 18th century
PRIVATE ARCH.: no. 43 on Robinson's list

Artisans at work

India, 18th–19th century
PRIVATE ARCH.: no. 44 on Robinson's list

Panoramic miniature

India, 18th century
PRIVATE ARCH.: no. 45 on Robinson's list

Women bathing

India, 18th–19th century
PRIVATE ARCH.: no. 46 on Robinson's list

Picnic

India, 18th century
PRIVATE ARCH.: no. 47 on Robinson's list

Prince on a terrace
with servants

India, 18th century
PRIVATE ARCH.: no. 48 on Robinson's list

Two small miniatures: ascetics
and a panther with prey

India, 18th century
PRIVATE ARCH.: no. 49 on Robinson's list

Three mediocre miniatures

India, 18th–19th century
PRIVATE ARCH.: no. 50 on Robinson's list

Women sharpening knives

India, 18th–19th century
PRIVATE ARCH.: no. 51 on Robinson's list

Woman on a terrace
with two servants

India, c. 1740
PRIVATE ARCH.: no. 52 on Robinson's list

Composite sheep

India, 19th century
PRIVATE ARCH.: no. 54 on Robinson's list

Assembly

India, 18th–19th century
PRIVATE ARCH.: no. 55 on Robinson's list

Decorative double page

Goffering, collage, and cut-outs
PRIVATE ARCH.: no. 56 on Robinson's list.
Not seen in Paris.

BOOK BINDINGS

1912–1913

31 to 35. Five bindings
(outer covers and flaps,
with inner covers for the 31)

Iran or Turkey, 16th century
Embossed, chased, and gilded leather
Locations unknown

PROV.: Louis Cartier coll. c. 1913
CARTIER PARIS ARCH.: negatives:
DOC48/001213040, DOC48/001223040,
DOC48/001233040, and DOC71/001242430
DOC73/2752430 and DOC27/2763040
DOC73/002742430 and DOC26/002773040
DOC73/002782430 and DOC26/002803040
DOC73/002792430 and DOC26/002813040
c. 1913

1931

36. Binding
(flaps, outer and inner covers)

Iran, 16th century
Outside: cut-out, colored and gilded
leather on background of colored paper
Inside: cut-out leather on colored
background
30.48 × 9.21 cm
Harvard Art Museums / Arthur M. Sackler
Museum, gift of Stuart Cary Welch, 1960
Inv. 1960.673

PROV.: Louis Cartier coll. in 1931; sold by
Claude Cartier to Stuart Cary Welch, 1957
PRIVATE ARCH.: nos. 14–15 on Robinson's list
LIB.: London, 1931, no. 126 H, p. 82

37. Binding (inner covers)

Iran, 16th century
Inside: cut-out leather on blue
and green paper background
25 × 15.5 cm
Location unknown

PROV.: Louis Cartier coll. in 1931
LIB.: London 1931, no. 127 D, p. 82 (no ill.);
Pope, 1939, vol. X, pl. 967A and B
and vol. III, p. 1984

1933

38. Binding

Circa 1520
Location unknown

PROV.: Louis Cartier coll. in 1933
LIB.: New York, 1933, p. 52 (no ill.)

1935

39. Binding (outer and inner covers)

Iran, early 17th century
Outside: cut-out and gilded leather
on ground of colored paper
Inside: cut-out leather on ground
of colored paper
Harvard Art Museums /
Arthur M. Sackler Museum
Gift of Stuart Cary Welch
Inv. 1958.82

PROV.: Louis Cartier coll. in 1935; sold by
Claude Cartier to Stuart Cary Welch, 1957
PRIVATE ARCH.: nos. 14–15 on Robinson's list
JACQUEAU ARCH.: albumen print PPJACPH99-4
and 5
LIB.: Sakisian, 1935, fig. 9, p. 231; Sakisian,
1937, p. 218 and fig. 6, p. 221; New York
and Cambridge, 1973, no. 13, p. 95, fig. 146.

40.

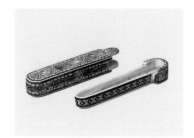

41.

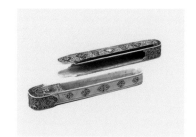

42.

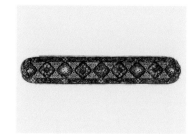

43.

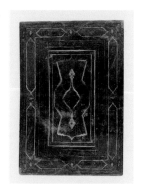

44.

45.

46.

47.

48.

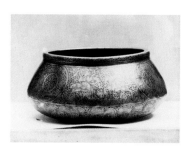

49.

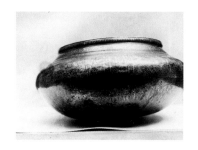

51.

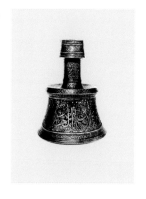

52.

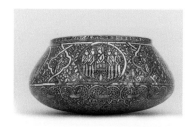

IVORY AND MOTHER-OF-PEARL

1912

40. Pen box in the name of Shah 'Abbas

Deccan, India, late 16th/early 17th century
Carved walrus ivory, engraved and inlaid
with gold, turquoise, and black paste
2.1 × 12.2 × 2.5 cm
Musée du Louvre, Paris, département
des Arts de l'Islam
Inv. RFML.AI.2018.36.1

41. Pen box said to have belonged to "Mirza Muhammad Munshi"

Deccan, India, late 16th/early 17th century
Carved walrus ivory, engraved and inlaid
with gold, turquoise, black paste, and silk
Ink well: copper alloy, gold leaf,
and turquoise
3 × 23 × 4 cm
Musée du Louvre, Paris,
département des Arts de l'Islam
Inv. RFML.AI.2010.36.2

For nos. 40 and 41:
PROV.: Louis Cartier coll. in 1912 until his death
in 1942; auctioned in 2012; private French coll.
2012-2018
CARTIER PARIS ARCH.: negatives
RFML.AI.2018.36.1: DOC333/001011824,
DOC333/001021824 from 1912
RFML.AI.2018.36.2: DOC453/004811318,

DOC182/009062430,
DOC182/009072430 from 1921
JACQUEAU ARCH.: albumen prints
RFML.AI.2018.36.1: PPJACPH99-32
and PPJACPH99-33, RFML.AI.2018.36.2:
PPJACPH99-34, PPJACPH99-35,
PPJACPH99-36
LIB.: London, 1931, no. 278 U; Paris, 1938,
no. 246 (RFML.AI.2018.36.2); sold in
Paris, Drouot, Bailly-Pommery and Voutier,
Successions, tutelles & à divers, June 22, 2012,
nos. 296 and 297; Henon-Raynaud, 2019, p. 14

42. Pen box lid

Deccan, India, 17th century
Carved walrus ivory, engraved and inlaid
with gold, turquoise, and black paste
21 × 3.8 cm
The Metropolitan Museum of Art,
New York
Gift of J. Pierpont Morgan, 1917
Inv. 17.190.020

PROV.: Louis Cartier coll. in 1912;
purchased by Morgan on May 18, 1912
Cartier ARCH.: negative DOC333/001001824
from 1912
Morgan Library ARCH.: Cartier invoice
dated Dec. 20, 1912, Inv. ARC 1310

1922–1923

43. Fragment of a box or mirror case

Iran, 19th century
Wood and marquetry of stained wood,
ivory, and metal (*khatamkari*)
Location unknown

PROV.: Louis Cartier coll. in 1922
CARTIER PARIS ARCH.: negative
DOC439/015201318 from 27/09/1922
JACQUEAU ARCH.: albumen print PPJACO2866
to 2871 and PPJACPH99-2

44. Mother-of-pearl dish

Gujarat, India, 17th century
Mother-of-pearl, metal, and wood
Location unknown

PROV.: Louis Cartier coll. in 1923
CARTIER PARIS ARCH.: negative
DOC100/017012430 and DOC101/017022430
from 13/03/1923

45. Fragment of a box or *jali*

India, 17th century?
Location unknown

PROV.: Louis Cartier coll.,
date of entry unknown
JACQUEAU ARCH.: albumen print PPJACPH99-49

METAL

1922–1923

46. Sword belt and duck-shaped buckle

Iran or India, 18th–19th century
Copper alloy, mother-of-pearl,
gold, emeralds
94.5 × 22 cm
Location unknown

PROV.: Louis Cartier coll. in 1922
CARTIER PARIS ARCH.: negatives
DOC89/013792430 from 29/05/1922
and DOC96/015922430 from 23/12/1922
LIB.: London, 1931, no. 350 M

47. Torch stand

Iran, late 16th century
Cast copper alloy, chased, engraved,
and inlaid with black paste
Location unknown

PROV.: Louis Cartier coll. in 1923
CARTIER PARIS ARCH.: negative
DOC10/016703040 from 1/03/1923

48. Bowl with decoration of mounted riders

Fars, Iran, 13th–14th century
Copper alloy inlaid with gold and silver
Location unknown

PROV.: Louis Cartier coll. in 1923
CARTIER PARIS ARCH.: negatives
DOC99/016742430 and DOC99/016762430
from 01/03/1923

49. Bowl with epigraphic decoration

Fars, Iran, 13th–14th century
Copper alloy inlaid with gold and silver
Location unknown

PROV.: Louis Cartier coll. in 1923
CARTIER PARIS ARCH.: negatives
DOC99/016732430 and DOC99/016752430
from 01/03/1923

1931

50. Pendant

According to the 1931 catalogue:
Iran, 18th century
"Gold, old-cut diamonds, rubies, and
pearls, two pieces with loop and hook"
16.5 cm
Location unknown

PROV.: Louis Cartier coll. in 1931
LIB.: London, 1931, no. 351 C (no ill.)

DATE OF ENTRY INTO COLLECTION UNKNOWN

51. Candlestick with epigraphic decoration

Iran, 16th century
Cast bronze, openwork pattern,
engraved and inlaid with black paste
24.7 cm
Location unknown

PROV.: Louis Cartier coll., date of entry
unknown; put up for public auction in 1979
LIB.: *Art d'Orient*, Drouot Rive-Gauche, Paris,
18–19/12/1979, lot. 78 (ill.)

52. Bowl

Fars, Iran, 1350–1375
Copper alloy, inlaid with gold and silver
12.5, diam: 25 cm
Museum of Islamic Art, Doha
Inv. MW.481.2007

PROV.: Louis Cartier coll., date of entry
unknown; Claude Cartier coll.; estate sale
in 1979; Nuhad es-Said coll. from an unknown
date until its purchase by the Doha museum
in 2007 *
LIB.: London, 1931, no. 226 F; Pope, 1939, vol. IX,
pl. 1372; *Art d'Orient*, Drouot Rive-Gauche,
Paris, 18–19/12/1979, lot. 70 (ill.); Allan, 1982,
no. 24 pp. 106–109

* I would like to thank Mounia Chekhab-Abudaya
and Tara Desjardins for the information
concerning this piece.

53.
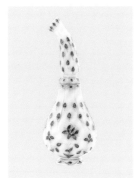

54.
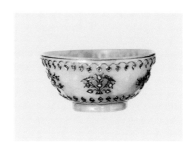

55.
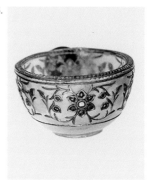

56.
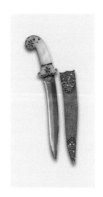

57.
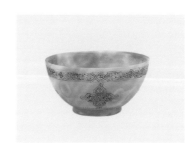

58.
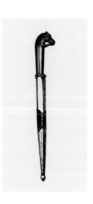

59.
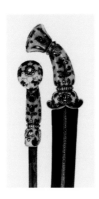

61.
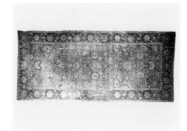

62.
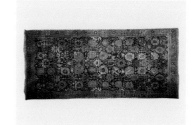

63.
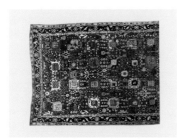

INLAID HARDSTONES

1912

53. Sprinkler

India, first half of 17th century
Jade, inlaid with gold, rubies,
and emeralds (*kundan*)
17.5 cm
Museum of Islamic Art, Doha,
purchase, 2003
Inv. JE.169.2003

PROV.: Louis Fould (until 1860); duc de Morny
(until 1865); Édouard Fould (until 1869);
vicomte de Vogüe (until 1910); Seligmann;
Louis Cartier coll. in 1912; purchased by
the Doha Museum at public auction in 2002
CARTIER PARIS ARCH.: invoice from Seligmann
(23, place Vendôme) from 22/06/1912;
negatives DOC352_013461824 and
DOC352_013471824 from 10/05/1922
JACQUEAU ARCH.: albumen print PPJACPH99-
31(A) and (B)
LIB.: Chabouillet, 1861, p. 182, no. 2496;
Arts of the Islamic World, London, Sotheby's,
25/04/2002, lot 106

1919

54. Jade bowl

India, 19th century
Jade, inlaid with gold, rubies,
and emeralds (*kundan*)
Location unknown

PROV.: purchased from Kraft in 1919
CARTIER PARIS ARCH.: negative
DOC465/013481318 from 10/05/1922
JACQUEAU ARCH.: albumen print glued
to cardboard PPJACPH99-30

1922

55. Rock crystal bowl

India, 19th century
Rock crystal inlaid with gemstones
and gold (*kundan*)
Location unknown

PROV.: purchased by Louis Cartier in 1922
Cartier ARCH.: negative DOC616/013490912
from 10/05/1922
JACQUEAU ARCH.: albumen print glued
to cardboard PPJACPH99-30

1925–1931

56. Dagger and sheath

Jaipur, India, 19th century
Jade, inlaid with gold, steel, rubies,
and emeralds (*kundan*)
Sheath: leather, cardboard, textile,
rubies, and emerald
Dagger length: 38 cm
Sheath length: 28 cm
The Mengdiexuan Collection, Hong Kong

PROV.: Louis Cartier coll. in 1925;
Claude Cartier coll.; estate sale in 1979;
Robert B. Hales; purchased at public auction
in 2020 by the Mengdiexuan Collection
CARTIER PARIS ARCH.: Register 2 AH 587.
Incorporated into the stock on March 7, 1922
and repurchased by Louis on January 6, 1926
JACQUEAU ARCH.: albumen print PPJACPH99-29
LIB.: *Importante argenterie européenne:
succession de Monsieur Claude Cartier
[...]*, Sotheby's Parke Monte Carlo Monaco,
27/11/1979, lot. 804 (ill.); Hales, 2013, p. 364,
no. 890; *Art of Islamic and Indian Works [...]*,
Christie's, London, 25/06/2020, lot 89

57. Wine Cup of Sultan Husayn Mirza Bayqara

Signed: Bihbud
Herat, Afghanistan, 1470
Agate, engraved decoration
5.5 × 11 cm
Arthur M. Sackler Gallery, Smithsonian
Institution, Washington, D.C.:
The Art and History Collection
Inv. LTS1995.2.27

PROV.: Armenag Bey Sakisian (found in
the Istanbul bazaar c. 1925); probably
purchased by Louis Cartier between 1925
and 1931; A. Soudavar
LIB.: Sakisian, 1925, t. 6, fasc. 3, pp. 274–279;
London, 1931, no. 193 Z; Wiet, 1933, pp. 47–48,

no. 52, pl. XXI; Pope, 1939, vol. IX, pl. 1455;
Los Angeles and Washington, 1989, pp. 272
and 360; Soudavar, 1992, pp. 92–93

58. Dagger with horse's head hilt

Jaipur, India, 19th century
Jade, inlaid with gold and rubies (*kundan*)
Dagger length: 28.5; sheath length: 23 cm
Location unknown

PROV.: Louis Cartier coll. in 1931;
Claude Cartier coll.; estate sale in 1979
CARTIER PARIS ARCH.: invoice from the
Kalebdjian Frères (12 rue de la Paix, Paris)
from 11/05/1931
LIB.: *Importante argenterie européenne:
succession de Monsieur Claude Cartier
[...]*, Sotheby's Parke Monte Carlo, Monaco,
27/11/1979, lot. 802 (ill.)

59. Dagger

Jaipur, India, 19th century
Jade, inlaid with steel, rubies, emeralds,
and diamonds (*kundan*)
37 cm
Location unknown

PROV.: Louis Cartier coll., date of entry
unknown; Claude Cartier coll.;
estate sale in 1979
JACQUEAU ARCH.: albumen print PPJACPH99-29
LIB.: *Importante argenterie européenne:
succession de Monsieur Claude Cartier
[...]*, Sotheby's Parke Monte Carlo, Monaco,
27/11/1979, lot. 803 (ill.)

60. Hookah stand with floral decoration

India, 19th century
Jade, inlaid with gold, rubies,
and emeralds (*kundan*)
18 cm
Location unknown

PROV.: Louis Cartier coll., date of entry unknown;
Claude Cartier coll.; estate sale in 1979
LIB.: *Importante argenterie européenne:
succession de Monsieur Claude Cartier
[...]*, Sotheby's Parke Monte Carlo, Monaco,
27/11/1979, lot. 801 (no ill.)

CARPETS

61. Carpet with a large palmette design and flowers on a pale red background

Iran, Isfahan?, 17th century
Wool
488 × 192 cm
Location unknown

PROV.: Louis Cartier coll. in 1925
CARTIER PARIS ARCH.: negatives
DOC18/024433040 from 24/10/1925
and DOC/82722430 from 05/02/1946
LIB.: London, 1931, p. 195, no. 312? (no ill.)

62. Vase carpet (beige, yellow, indigo and pink)

Iran, Kerman? 17th century
Wool
410 × 185 cm
Location unknown

PROV.: Louis Cartier coll. in 1931; Claude
Cartier coll.; estate sale in 1979
CARTIER PARIS ARCH.: negatives DOC/82732430,
DOC/82742430, DOC/82762430 from
05/02/1946
LIB.: London, 1931, p. 189, no. 300? (no ill.);
*[...] Succession de Monsieur Claude Cartier
[...]*, Sotheby's Parke Monte Carlo, Monaco,
25–27/11/1979, lot 170

63. Vase Carpet

Iran, 17th century
Wool
Location unknown

PROV.: Louis Cartier coll. in 1946
CARTIER PARIS ARCH.: negative DOC/82753040
from 05/02/1946

LOUIS CARTIER'S
REFERENCE LIBRARY

A selection of books on Islamic art and architecture and books referencing Islamic works, held in Louis Cartier's reference library and available to the designers. This library is still kept today in the Maison Cartier's Archives and designers' studio.

FRIEDRICH MAXIMILIAN HESSEMER, *Arabische und alt-italienische Bau-Verzierungen*, designs and patterns in color from Arabic and Italian sources, Berlin: Bei Dietrich Reimer, 1853.

OWEN JONES, *Grammaire de l'ornement illustrée d'exemples pris de divers styles d'ornement*, London: Day and Son Ltd., 1865.

MARIE DE LAUNAY, *L'Architecture ottomane*, work authorized by the Imperial Irade and published under the patronage of His Excellency Edhem Pacha, Constantinople: Centre for printing and lithography, 1873.

AUGUSTE DUPONT-AUBERVILLE, *L'Ornement des tissus, recueil historique et pratique*, Paris: Ducher et Cie, 1877.

ÉMILE PRISSE D'AVENNES, *L'Art arabe d'après les monuments du Kaire depuis le VIIᵉ siècle jusqu'à la fin du XVIIIᵉ siècle*, Paris: J. Savoy et Cie, 1877.

EUGENE COLLINOT, ADALBERT DE BEAUMONT, *Ornements arabes. Recueil de dessins pour l'art et l'industrie*, Paris: Canson libraire éditeur, 1883.

EUGENE COLLINOT, ADALBERT DE BEAUMONT, *Ornements turcs. Recueil de dessins pour l'art et l'industrie*, Paris: Canson libraire éditeur, 1883.

AUGUSTE RACINET, *L'Ornement polychrome*, Paris: Librairie Firmin Didot et Cie, c. 1883.

Objets d'art et de curiosité orientaux et européens, anciennes faïences de Perse, de Rhodes, de Damas etc. faïences et porcelaines variées, bronzes, cuivres et fers d'ancien travail oriental [...] appartenant à M. H. Kevorkian, sales catalogue, Paris: Hôtel Drouot, 1902.

GASTON MIGEON, *Exposition des arts musulmans au musée des Arts décoratifs*, Paris: Librairie centrale des beaux-arts, 1903.

A. L. BALDRY, *The Wallace Collection at Hertford House*, Paris, Berlin, New York: Groupi & Co, 1904.

ÉMILE MOLINIER, *La Collection du baron Albert Oppenheim, tableaux et objets d'art*, Paris: Librairie centrale des beaux-arts, 1904.

JEAN DU TAILLIS, *Le Maroc pittoresque*, Paris: Ernest Flammarion, 1905.

Les Mosquées de Samarcande, fasc. 1, St. Petersberg: Commission impériale archéologique, 1905.

PAUL EUDEL, *Dictionnaire des bijoux de l'Afrique du Nord*, Paris: Ernest Leroux éditeur, 1906.

GEORGES MARÇAIS, *L'Exposition d'art musulman d'Alger*, Paris: Albert Fontemoing, 1906.

FREDRIK ROBERT MARTIN, *A History of Oriental Carpets before 1880*, Vienna: Office of the Imperial Royal Austrian Court and State, 1906, 2 vols.

GASTON MIGEON, *Manuel d'art musulman. Arts plastiques et industriels*, vol. II, Paris: Librairie Alphonse Picard et Fils, 1907.

HENRI SALADIN, *Manuel d'art musulman. L'Architecture*, vol. I, Paris: Librairie Alphonse Picard et Fils, 1907.

THOMAS HOLBEIN HENDLEY, *Indian Jewellery*, London: W. Griggs, 1909.

Rudolf Neugebauer, *Handbuch der Orientalischen Teppichkunde*, Leipzig: Karl W. Hiersemann, 1909.

JOHN KIMBERLY MUMFORD, CHARLES TYSON YERKES, *The Yerkes Collection of Oriental Carpets*, Leipzig: Karl Hiersemann / New York: The Knapp Company / London: B.T. Batsford / Toronto: James Miln, 1910.

FRIEDRICH SARRE, *KONIA seldschukische Baudenkmäler*, Berlin: Verlag Von Ernst Wasmuth A. G., 1910.

FRIEDRICH SARRE, *ARDABIL Grabmoschee des Schech Safi*, Berlin: Verlag Von Ernst Wasmuth A. G., 1910.

Catalogue des perles, pierreries, bijoux et objets d'art précieux le tout ayant appartenu à S. M. le Sultan Abd-Ul-Hamid II, sales catalogue, Paris: Galerie George Petit, Hôtel Drouot, 1911.

FREDRICK ROBERT MARTIN, *The Miniature Painting and Painters of Persia, India and Turkey from the 8th to the 18th Century*, London: Bernard Quaritch, 1912, vols. I–II.

FRIEDRICH SARRE, FREDRICK ROBERT MARTIN, *Meisterwerke Muhammedanischer Kunst auf der Ausstellung München 1910*, Munich: F. Bruckmann A.-G., 1912.

Arte y decoración en España – Arquitectura – Arte decorativo, Barcelone, Casellas Moncanut, 1917, vol. I; 1919, vol. III; 1920, vol. IV.

Collection Manzi. Céramique, second sale, Paris, March 1919.

ARTHUR BYNE ARTHUR, MILDRED STAPLEY, *Decorated Wooden Ceilings in Spain. A Collection of Photographs and Measured Drawings with Descriptive Text*, New York, London: G. P. Putnam's Sons, 1920.

Catalogue des perles, pierreries, bijoux et objets d'art précieux le tout ayant appartenu à S. M. le Sultan Abd-Ul-Hamid II, sales catalogue, Paris: Galerie George Petit, 1920.

JOSEPH DE LA NÉZIÈRE, *Les Monuments mauresques du Maroc*, Paris: Éditions Albert Lévy, 1921.

JOSEPH DE LA NÉZIÈRE, *La Décoration marocaine*, Paris: Librairie des arts décoratifs, 1923.

HELMUT THEODORE BOSSERT, *L'Encyclopédie de l'ornement*, Berlin; Brussels; Paris: Éditions Albert Lévy, 1924.

ALEXANDRE RAYMOND, *L'Art islamique en Orient*, Part II, Constantinople: Librairie Raymond, 1924.

PROSPER RICARD, *Pour comprendre l'art musulman dans l'Afrique du Nord et en Espagne*, Paris: Hachette, 1924.

Collection Louis Gonse, sales catalogue, Paris: Hôtel Drouot, 1924.

GIULIO ARATA, *L'Architettura arabo-normanna e il rinascimento in Sicilia*, Milano: Casa editrice d'Arte Bestetti e Tumminelli, 1925.

HEINRICH GLÜCK, ERNST DIEZ, *Die Kunst des Islam*, Berlin: Propylaen Verlag, 1925.

OTTO FISCHER, *Die Kunst Indiens, Chinas und Japans*, Berlin: Im Propyläen Verlag, 1928.

Exposition française au Caire. France-Égypte, exhibition catalogue, 1929.

EDMOND PAUTY, *Les Palais et les maisons d'époque musulmane au Caire*,

Cairo: Imprimerie de l'Institut français d'archéologie orientale, 1933.

JACQUES CARTIER, *The Nawanagar Jewels*, réimprimé avec l'autorisation de Messrs. Rich & Cowan à partir de l'ouvrage *The Biography of Ranjitsinhji*, London: Rich & Cowan, 1934.

ARTHUR UPHAM POPE, *A Survey of Persian Art, from Prehistoric Times to the Present*, London; New York: Oxford University, 1938, vols. I–IX.

WILHEM BODE, *Anciens tapis d'Orient*, Paris: Bulin, no date.

WILLIAM BODE, *Vordeasiatische Knüpfteppiche*, Leipzig: Hermann Seeman Nachfolger, no date.

ALFRED DE CHAMPEAUX, *Portefeuille des arts décoratifs. Antiquité, Chine, Japon, Orient – Céramique – Ciselure – Orfèvrerie, ferronnerie – Tapisserie, broderie, tissus*, Paris: no date.

HENRI CLOUZOT, *Cuirs décorés, I: Cuirs exotiques, II: Cuirs de Cordoue*, Paris: Libraire des arts décoratifs A. Calavas, no date.

ERNST FLEMMING, *Les Tissus, documents choisis de décoration textile des origines au début du xixᵉ siècle*, Paris: no date.

FREDERIC HOTTENROTH, *Le Costume, les armes, ustensiles, outils des peuples anciens et modernes*, Paris: A. Guérinet, vol. I, no date.

LOUIS METMAN, *Le Bois, deuxième partie: xviiᵉ et xviiiᵉ siècles*, Paris: D.-A. Longuet, no date.

GABRIEL OLLIVIER, *Choix de lettres et documents historiques reproduits et commentés sur ordre de S.A.S. Rainer III prince souverain de Monaco*, Monaco: Archives of the Prince's Palace, no date.

ÉMILE PRISSE D'AVENNES, *La Décoration arabe [...], extraits du grand ouvrage L'Art arabe choisis, classés et arrangés par les éditeurs*, Paris: André Daly Fils & Cie, no date.

BIBLIOGRAPHY

ALLAN, 1982
James Wilson Allan, *Islamic Metalwork: The Nuhad Es-Said Collection*, London; Totowa, NJ: Sotheby, 1982.

ANDRADE AND BARY, 1991
Oswald de Andrade and Leslie Bary (1991), Cannibalist Manifesto, *Latin American Literary Review* 19 (38): 38–47.

ANDRADE, 1928
Oswald de Andrade (1928), Manifesto Antropófago, *Revista de Antropofagia* 1.

BACHET AND CARTIER, 2019
Olivier Bachet and Alain Cartier, *Cartier. Objets d'exception*, Paris: Palais Royal, 2019.

BARBIER, 2013
George Barbier, *Dessins sur les danses de Vaslav Nijinsky*, Paris: À la Belle Édition, 1913.

BAUDELAIRE, 1920
Charles Baudelaire, *Journaux intimes. Fusées. Mon cœur mis à nu*, text reprinted from the original manuscripts, Paris: Grès et Cie, 1920.

BEIJING, 2018
Treasures from the Al Thani Collection. Exhibitions Held in the Palace Museum, Beijing, exh. cat. Beijing, The Palace Museum, Amin Jaffer (ed.), London: Thomas Heneage Art Books, 2018, 3 vols.

BINYON AND WILKINSON, 1933
Laurence Binyon and J. V. S. Wilkinson, *Persian Miniature Painting: Including a Critical and Descriptive Catalogue of the Miniatures Exhibited at Burlington House*, exh. cat. London, 1931; New York and London: Oxford University Press, 1933.

BOSTON, 1913
Catalogue of a Collection of Jewels... created by Messieurs Cartier...from the Hindoo...Persian Arab...Russian and Chinese. On view at the Copley Palace, on Tuesday the fourth of November nineteen hundred and thirteen and four days following, exh. cat. Boston, Nov. 4, 1913.

BOUCHON, 2007
Chantal Bouchon, Voyage, ornement, industrie: Adalbert de Beaumont saisi par l'Orient, in Paris, 2007, pp. 242–249.

BOURGOIN, 1873
Jules Bourgoin, *Théorie de l'ornement*, Paris: A. Lévy, 1873.

BOURGOIN, 1879
Jules Bourgoin, *Les Éléments de l'art arabe. Le trait des entrelacs*, Paris: Firmin Didot et Cie, 1879.

BOURGOIN, 1880
Jules Bourgoin, *Grammaire élémentaire de l'ornement*, Paris: C. Delagrave, 1880.

BOURGOIN, 1901
Jules Bourgoin, *Études architectoniques et graphiques, mathématiques [...]*, Paris: C. Schmid, 1901.

BROWN, 1975
Percy Brown, *Indian Painting under the Mughals 1550 to 1750*, New York: Hacker Art Books, 1975.

CARCO, 1914
Francis Carco, La quinzaine artistique – Une exposition d'art persan, *L'Homme libre*, June 8, 1914, p. 2.

CARTIER BRICKELL, 2019
Francesca Cartier Brickell, *The Cartiers: The Untold Story of the Family Behind the Jewellery Empire*, New York: Ballantine Books, 2019.

CHABOUILLET, 1861
Anatole Chabouillet, *Description des antiquités et objets d'art composant le cabinet de M. Louis Fould*, Paris: J. Claye, printer-bookseller, 1861.

CHAILLE ET AL., 2018
François Chaille, Thierry Coudert, Pascale Lepeu, Violette Petit, Pierre Rainero, Jenny Rourke, Michael Spink, and Christophe Vachaudez, *La Collection Cartier. Joaillerie*, 2 vols., Styles and Design, Paris: Flammarion, 2018.

CLEVELAND, 2016
Sonya Rhie Quintanilla and Dominique DeLuca, *Mughal Paintings: Art and Stories – The Cleveland Museum of Art*, exh. cat. Cleveland Museum of Art, London: D. Giles Ltd., 2016.

COCTEAU AND IRIBE, 1910
Jean Cocteau and Paul Iribe, *Vaslav Nijinski*, Paris: Société générale d'impression, 1910.

CZUMA, 1975
Stanislaw Czuma, *Indian Art from the George Bickford Collection*, Cleveland: Cleveland Museum of Art, 1975.

DAVERIO, 1997
John Daverio, *Robert Schumann: Herald of a "New Poetic Age,"* New York: Oxford University Press, 1997.

DIAGHILEV, 2013
Serge Diaghilev, *L'Art, la musique et la danse. Lettres, écrits, entretiens*, Jean-Michel Nectoux, I.S. Zilberstein et V.A. Samkov (ed.), Pantin: CND/Paris: INHA, Vrin, 2013.

DIMAND, 1934
Maurice Sven Dimand, *A Guide to an Exhibition of Islamic Miniature Painting and Book Illumination*, New York: The Metropolitan Museum of Art, 1934.

DUBAI, 2019
Marchands de perles. Redécouverte d'une saga commerciale entre le Golfe et la France à l'aube du xxe siècle, exh. cat. Dubai Design District, dir. Guillaume Glorieux and Olivier Segura, Paris; Dubai: École Van Cleef & Arpels and the French Institute of the United Arab Emirates, 2019.

FALCONE, 1999
Francesca Falcone (1999), The evolution of the Arabesque in dance, *Dance Chronicle* 22 (1): 71–117.

FLOOD, 2016
Finbarr Barry Flood, The flaw in the carpet: Disjunctive continuities and Riegl's arabesque, in *Histories of Ornament: From Global to Local*, ed. Gülru Necipoğlu and Alina Payne, Princeton: Princeton University Press, 2016, pp. 82–93.

FONTANA, 2007
Maria Vittoria Fontana, Islamic influence on the production of ceramics in Venice and Padua, in *Venice and the Islamic World, 828-1797*, exh. cat. Metropolitan Museum of Art, New York, dir. Stefano Carboni, New York: Yale University Press, 2007, pp. 280–293.

FRANK, 2017
Isabelle J. Frank, Owen Jones's Theory of Ornament, in *Ornament and European Modernism: From Art Practice to Art History*, ed. Loretta Vandi, New York: Routledge, 2017, pp. 9–36.

GAYET, 1893
Albert Gayet, *L'Art arabe*, Paris: Librairies-imprimeries réunies, 1893.

GHIASIAN, 2018
Mohammad Reza Ghiasian, *Lives of the Prophets: The Illustrations to Hafiz-i Abru's "Assembly of Chronicles,"* Leiden: Brill, 2018.

GIRAULT DE PRANGEY, 1846
Joseph Philibert Girault de Prangey, *Monuments arabes d'Égypte, de Syrie et d'Asie Mineure dessinés et mesurés de 1842 à 1845*, Paris: Girault de Prangey, 1846.

GURDJIEFF, 1950
George Gurdjieff, *Beelzebub's Tales
to his Grandson*, New York: Harcourt,
Brace & Co., 1950.

HALES, 2013
Robert Hales, *Islamic and Oriental
Arms and Armour: A Lifetime's Passion*,
England: Robert Hales C. I. Ltd., 2013.

HAMMOND, 1995
Sandra Noll Hammond (1995),
Ballet's technical heritage:
The Grammaire of Léopold Adice,
Dance Research 13 (1): 33–58.

HENDLEY, 1909
Thomas Holbein Hendley, *Indian
Jewellery*, extracted from *The Journal
of Indian Art, 1906–1909*, London, 1909.

HENON-RAYNAUD, 2018
Judith Henon-Raynaud, Les vicissitudes
des collections islamiques au musée
du Louvre, in *D'une rive à l'autre
de la Méditerranée occidentale. Hier,
aujourd'hui et demain*, Brignon: Éditions
de la Fenestrelle, 2010, pp. 171–175.

HENON-RAYNAUD, 2019
Judith Hénon-Raynaud, Les plumiers
de Shah Abbas et de son grand vizir,
"Grande Galerie," *Le Journal du Louvre*
47, Paris: Musée du Louvre Éditions/
Flammarion, 2019, pp. 14–15.

HOUSTON, 2019
Aimée Froom (ed.), *Bestowing Beauty:
Masterpieces from Persian Lands from
the Hossein Afshar Collection*, exh. cat.
Museum of Fine Arts, Houston, 2019.

JACOB AND HENDLEY, [1886] 2008
Sir S. S. Jacob and Thomas Holbein
Hendley, *Jeypore Enamels*, London:
W. Griggs, 1886; New Delhi: Aryan Books
International, 2008.

JAFFER, 2007
Amin Jaffer, *Fastes occidentaux
de maharajahs, créations européennes
pour l'Inde princière*, Paris: Citadelles
& Mazenod, 2007.

JAFFER, 2013
Amin Jaffer, *Beyond Extravagance:
A Royal Collection of Gems and Jewels
(The Al-Thani Collection)*, New York:
Assouline Publishing, 2013; 2019.

JONES, 1856
Owen Jones, *The Grammar of
Ornament*, London: Day & Son, 1856.

JONES, 1865
Owen Jones, *Grammaire de
l'ornement*, London: Day & Son;
Paris: Cagnon, 1865.

KÜHNEL, 1923
Ernst Kühnel, *Miniaturmalerei im
islamischen Orient*, Berlin: Bruno
Cassirer, 1923, 2nd ed.

LABRUSSE, 1997
Rémi Labrusse, Paris, capitale des arts
de l'Islam? Quelques aperçus sur
la formation des collections françaises
d'art islamique au tournant du siècle,
*Bulletin de la Société de l'histoire
de l'art français*, 1997 [1998],
pp. 275–310.

LABRUSSE, 2012
Rémi Labrusse, Science et barbarie:
l'antipositivisme de Jules Bourgoin,
in Paris, 2012, pp. 189–207.

LABRUSSE, 2016
Rémi Labrusse, Grammars of ornament:
Dematerialization and embodiment
from Owen Jones to Paul Klee,
in *Histories of Ornament: From
Global to Local*, ed. Gülru Necipoğlu
and Alina Payne, Princeton: Princeton
University Press, 2016, pp. 320–333,
notes pp. 404–406.

LABRUSSE, 2018
Rémi Labrusse, *Face au chaos.
Pensées de l'ornement à l'âge
de l'industrie*, Dijon: Les Presses
du réel, 2018.

LERMER AND SHALEM, 2010
Andrea Lermer and Avinoam Shalem
(eds.), *After One Hundred Years:
The 1910 Exhibition "Meisterwerke
muhammedanischer Kunst"
Reconsidered*, Leiden; Boston:
Brill, 2010.

LEVYKIN, 2009
Alexey Konstantinovich Levykin,
*The Tsars and the East: Gifts from
Turkey and Iran in the Moscow Kremlin*,
London: Thames and Hudson, 2009.

LISBON, 2019
Jessica Hallet (ed.), *The Rise of Islamic
Art 1869–1939*, exh. cat. Museu Calouste
Gulbenkian, Lisbon, 2019.

LONDON, 1912
*Messrs Cartier respectfully invite
their patrons to inspect an exhibition
of Oriental Jewels and Objets d'Art
recently collected in India for one week
from Tuesday the 28th May.
175 New Bond Street*, exh. cat.
London, May 28, 1912.

LONDON, 1931
*Catalogue of the International
Exhibition of Persian Art*, exh. cat. Royal
Academy of Arts, London, 1931.

LONDON, BURLINGTON HOUSE, 1931
*Persian Art: An Illustrated Souvenir
of the Exhibition of Persian Art
at Burlington House London*, London:
Hudson & Kearns, 1931, 2nd ed.

LONDON, 2009
Anna M. F. Jackson and Amin Jaffer,
*Maharajah: The Splendour of India's
Royal Courts*, exh. cat. Victoria
and Albert Museum, London:
V&A Publishing, 2009.

LOS ANGELES
AND WASHINGTON, 1989
*Timur and the Princely Vision: Persian
Art and Culture in the Fifteenth Century*,
exh. cat. Los Angeles County Museum
of Art, Washington, DC: Smithsonian
Institution Press, Arthur M. Sackler
Gallery, 1989.

LUGAND, 2018
Cécile Lugand, Jean-Baptiste Tavernier
(1605–1689): une vie de négoce entre
l'Europe et l'Asie, PhD Thesis, École
des arts joailliers, Rennes 2 University,
dir. Guillaume Glorieux, 2018.

LUGANO, 2017
Elio Schenini et al., *On the Paths
of Enlightenment: The Myth of India
in Western Culture 1808–2017*, exh. cat.
Museo d'arte della Svizzera italiana,
Lugano; Turin: Skira, 2017.

MAKARIOU, 2012
Sophie Makariou (ed.), *Les Arts
de l'Islam au musée du Louvre*, Paris:
Louvre éditions and Hazan, 2012.

MARTEAU AND VEVER, 1913
Georges Marteau and Henri Vever,
*Miniatures Persanes, tirées des
collections de MM. Henry d'Allemagne
[...] et exposées au Musée des arts
décoratifs, juin-octobre 1912*, Paris:
Bibliothèque d'art et d'archéologie, 1913.

MARTIN, 1912
Fredrik Robert Martin, *The Miniature
Painting and Painters of Persia, India
and Turkey, from the 8th to the 18th
Century*, London: B. Quaritch, 1912.

MERLET, 1929
Gilbert Merlet, Une demi-heure avec
un prince de la joaillerie moderne,
Monsieur Jacques Cartier, *Le Magazine
égyptien*, March 9, 1929, pp. 26–27.

MIGEON, 1907
Gaston Migeon, *Manuel d'art musulman.
Arts plastiques et industriels*, vol. 2,
Paris: Librairie Alphonse Picard et Fils, 1907.

MIGEON, 1927
Gaston Migeon, *Manuel d'art musulman.
Arts plastiques et industriels*, vol. 2,
Paris: Auguste Picard, 2nd ed. revised
and updated, 1927.

MIGEON AND SALADIN, 1907
Gaston Migeon and Henri Saladin,
Manuel d'art musulman, 2 vols., Paris:
Alphonse Picard & Fils, 1907.

MUMFORD AND YERKES, 1910
John Kimberly Mumford and Charles
Tyson Yerkes, *The Yerkes Collection
of Oriental Carpets*, Leipzig: Karl
Hiersemann; New York: The Knapp
Company; London: B. T. Batsford;
Toronto: James Miln, 1910.

NADELHOFFER, [1984] 2007
Hans Nadelhoffer, *Cartier*, Paris: Éditions
du Regard, 1984; 2007 [English edition:
Hans Nadelhoffer, *Cartier*, London:
Chronicle Books, 2007].

NASIRI-MOGHADDAM, 2004
Nader Nasiri-Moghaddam, *L'Archéologie
française en Perse et les antiquités
nationales (1884–1914)*, Paris: Payot, 2004.

NECIPOĞLU, 1995
Gülru Necipoğlu, Ornamentalism and
orientalism: The nineteenth- and early
twentieth-century European literature,
in *The Topkapi Scroll: Geometry and
Ornament in Islamic Architecture*, Gülru
Necipoğlu, Santa Monica, CA: Getty
Center Publication Programs, 1995,
pp. 61–71.

NECTOUX, 2013
Jean-Michel Nectoux, I. S. Zilberstein,
and V. A. Samkov, *Serge Diaghilev: L'Art,
la musique et la danse. Lettres, écrits,
entretiens*. Paris: CND, INHA, Vrin, 2013.

NEW YORK, 1913
Catalogue of a Collection of Jewels... created by Messieurs Cartier...from the Hindoo...Persian Arab...Russian and Chinese. On view at 712-5th Ave. N.Y. on Tuesday the eleventh of November nineteen hundred and thirteen and four days following. New York, november 11, 1913.

NEW YORK, 1933
Maurice Sven Dimand, *A Guide to an Exhibition of Islamic Miniature Painting and Book Illumination*, Metropolitan Museum of Art, New York, Southworth Press, 1933.

NEW YORK, 1997
Helen C. Evans and William D. Wixom (eds.), *The Glory of Byzantium: Art and Culture of the Middle Byzantine Era, A.D. 843–1261*, exh. cat. Metropolitan Museum of Art, New York, 1997.

NEW YORK AND CAMBRIDGE, 1973
Anthony Welch, *Shah 'Abbas and the Arts of Isfahan*, exh. cat. Asia Society Museum, New York; Fogg Art Museum, Harvard University, Cambridge MA, New York: Asia Society, 1973.

NEW YORK, LONDON, AND CHICAGO, 1997–2000
Judy Rudoe and Stewart Johnson, *Cartier 1900–1939*, exh. cat. Metropolitan Museum of Art, New York, 1997; British Museum, London, 1997–1998; Field Museum, Chicago, 1999–2000, New York: Abrams, 1997.

PARIS, 1903
Gaston Migeon, Max van Berchem, and Clément Huart, *Exposition des arts musulmans*, exh. cat. Union centrale des arts décoratifs, Pavillon de Marsan, Paris: Société française d'imprimerie et de librairie, 1903.

PARIS, 1913
Exposition d'un choix de bijoux persans, hindous & thibétains adaptés aux modes nouvelles, Paris: Cartier, June 2, 1913.

PARIS, 1938
Les Arts de l'Iran: l'Ancienne Perse et Bagdad, exh. cat. Bibliothèque nationale de France, Paris, 1938.

PARIS, 1986
Sven Gahlin and Mària van Berge-Gerbaud, *L'Inde des légendes et des réalités: miniatures indiennes et persanes de la Fondation Custodia, collection Frits Lugt*, exh. cat. Paris: Institut Néerlandais, 1986.

PARIS, 2007
Rémi Labrusse (ed.), *Purs décors? Arts de l'Islam, regards du xxᵉ siècle*, exh. cat. Musée des Arts Décoratifs, Paris: Les Arts décoratifs and Musée du Louvre éditions, 2007.

PARIS, 2009
Mathias Auclair and Pierre Vidal, assisted by Jean-Michel Vinciguerra, *Les Ballets russes*, exh. cat. Bibliothèque-musée de l'Opéra, Paris: Gourcuff Gradenigo and BnF, 2009.

PARIS, 2012
Maryse Bideault, Sébastien Chauffour, Estelle Thibault, and Mercedes Volait,

Jules Bourgoin (1838–1908). L'obsession du trait, exh. cat. Institut national d'histoire de l'art, Paris, 2012.

PARIS, 2013
Laure Dalon and Laurent Salomé, *Cartier. Le style et l'histoire*, exh. cat. Salon d'honneur du Grand Palais, Paris: Rmn-GP, 2013. [English edition: *Cartier: Style and History*, Paris: Rmn-GP, 2013]

PARIS, 2016
Mathias Auclair, Sarah Barbedette, and Stéphane Barsacq (eds.), *Bakst. Des Ballets russes à la haute couture*, exh. cat. Bibliothèque-musée de l'Opéra, Paris: BnF, Albin Michel, 2016.

PARIS, 2017
Amin Jaffer and Amina Taha Hussein-Okada (eds.), *Des Grands Moghols aux maharajahs, joyaux de la collection Al-Thani*, exh. cat. Grand Palais, Paris: RMN-GP, 2017.

PARIS, 2018
Guillaume Glorieux (ed.), *Le Fabuleux Destin des diamants de Tavernier. Du Grand Moghol au Roi-Soleil*, exh. cat. École des arts joailliers, Paris, 2018.

PARIS, 2019
Charlotte Maury (ed.), *Le Goût de l'Orient. Georges Marteau collectionneur*, exh. cat. Musée du Louvre, Paris: Louvre éditions, In Fine, 2019.

PELTRE, 2006
Christine Peltre, *Les Arts de l'Islam. Itinéraire d'une redécouverte*, Paris: Gallimard, 2006.

PICCOLPASSO, 1879
Cipriano Durantino Piccolpasso, *I tre libri dell'arte del vasajo: nei quali si tratta non solo la pratica, ma brevemente tutti i secreti di essa cosa che persino al dì d'oggi è stata sempre tenuta ascosta* (1556–1559), Pesaro: Nobili, 1879.

POPE, 1939
Arthur Upham Pope (ed.), *A Survey of Persian Art: From Prehistoric Times to the Present*, vol. X, pls. 812–890, London; New York: Oxford University Press, 1939.

POSSÉMÉ, 2007
Évelyne Possémé, De la copie à l'interprétation. La marque de l'Islam dans les arts décoratifs en France au tournant du xixᵉ et du xxᵉ siècle, in Paris, 2007, pp. 230–238.

PRISSE D'AVENNES, 1877
Émile Prisse d'Avennes, *L'Art arabe d'après les monuments du Kaire*, Paris: J. Savoy et Cie, 1877.

ROXBURGH, 2000
David J. Roxburgh, Au Bonheur des Amateurs: Collecting and Exhibiting Islamic Art, ca. 1880–1910, *Ars Orientalis, Exhibiting the Middle East: Collections and Perceptions of Islamic Art*, no. 30, Washington, DC: Smithsonian Institution, 2000, pp. 9–38.

RUGIADI, 2019
Martina Rugiadi, Framing an Islamic Art,

in *Monumental Journey: The Daguerreotypes of Girault de Prangey*, ed. Stephen C. Pinson, exh. cat. Metropolitan Museum of Art, New York, 2019, pp. 157–163.

SAKISIAN, 1925
Arménag Bey Sakisian (1925), À propos d'une coupe de vin en agate au nom du sultan Timouride Hussein Baïcara, *Syria* 6 (3): 274–279.

SAKISIAN, 1929
Arménag Bey Sakisian, *La Miniature persane du xiiᵉ au xviiᵉ siècle*, Paris; Bruxelles: G. van Oest, 1929.

SAKISIAN, 1935
Arménag Sakisian (1935), Les tapis de Perse à la lumière des arts du livre (Continuation), *Artibus Asiae* 5 (2/4): 222–235.

SAKISIAN, 1937
Arménag Sakisian (1937), La reliure persane au xvᵉ siècle, sous les Turcomans, *Artibus Asiae* 7 (1/4): 210–223.

SALOMÉ, 2013
Laurent Salomé, Cartier and Modernity, in Paris, 2013, pp. 43–47.

SARRE AND MARTIN, 1912
Friedrich Sarre and Fredrik Robert Martin, *Die Ausstellung von Meisterwerken muhammedanischer Kunst in München, 1910*, Munich: F. Bruckmann, 1911–1912.

SCHUBART, 1806
Christian Friedrich Daniel Schubart, *Ideen zu einer Ästhetik der Tonkunst*, Vienna: J. V. Degen, 1806.

SHREVE SIMPSON, 1980
Marianna Shreve Simpson, *Arab and Persian Painting in the Fogg Art Museum*, Cambridge, MA: Fogg Art Museum, 1980.

SILVA SANTA-CRUZ, 2017
Noelia Silva Santa-Cruz (2017), The Siculo-Arabic Ivories and their Spreading to al-Andalus, *Journal of Transcultural Medieval Studies* 4 (1–2): 147–190.

SOUDAVAR, 1992
Abolala Soudavar, *Art of the Persian Courts: Selections from the Art and History Trust Collection*, New York: Rizzoli, 1992.

STRONGE, 2001
Susan Stronge (2001), Cartier and the East, *Jewellery Studies* 9: 65–77.

TAVERNIER, [1676] 1882
Jean-Baptiste Tavernier, *Les Six voyages de Jean-Baptiste Tavernier qu'il a fait en Turquie, en Perse et aux Indes*, 2 vols., Paris: G. Clouzier and C. Barbin, 1676; M. Dreyfous, 1882; English translation, 1889.

THIBAULT, 2012
Estelle Thibault, La grammaire élémentaire de l'ornement. Modèles linguistiques et enjeux pédagogiques, in Paris, 2012, pp. 231–280.

TROELENBERG, 2010
Eva-Maria Troelenberg, Beyond stasis – on how to read historical objects, in *The Future of Tradition – The Tradition*

of Future: 100 years after the exhibition
Masterpieces of Muhammadan Art in
Munich, ed. Chris Dercon, León Krempel,
and Avinoam Shalem, exh. cat. Haus
der Kunst, Munich: Prestel, 2010,
pp. 111–114.

UNTRACHT, 1997
Oppi Untracht, Traditional Jewelry
of India, New York: Harry N. Abrams Inc.,
1997.

VIVET-PECLET, 2019
Christine Vivet-Peclet, Les Demotte,
marchands d'art inclassables au début
du xxe siècle, PhD Thesis in History of
Art, University of Poitiers and the École
du Louvre, dir. Claire Barbillon
and Dominique de Font-Réaulx, 2019.

VOLAIT, 2012A
Mercedes Volait, Compagnonnages
dans le milieu des amateurs d'art
islamique et des artisans d'Égypte
et de Syrie, in Paris, 2012, pp. 61–75.

VOLAIT, 2012B
Mercedes Volait, Maisons de France
au Caire. Le remploi de grands décors
mamelouks et ottomans dans une
architecture moderne, Cairo: Institut
français d'archéologie orientale, 2012.

VOLAIT, 2020
Mercedes Volait, Le remploi de grands
décors mamlouks et ottomans
dans l'œuvre construit d'Ambroise
Baudry en Égypte et en France,
in À l'orientale: Collecting, Displaying
and Appropriating Islamic Art
and Architecture in the Nineteenth
and Early Twentieth Centuries,
ed. Francine Giese et al., Leiden;
Boston: Brill, 2020, pp. 82–91.

WELCH, 1959
Stuart Cary Welch, Early Mughal
Miniature Paintings from Two Private
Collections shown at the Fogg Art
Museum, Ars Orientalis, no. 3, 1959,
pp. 133–146.

WELCH, 1963
Stuart Cary Welch, Mughal and Deccani
Miniature Paintings from a Private
Collection, Ars Orientalis, no. 5, 1963,
pp. 221–233.

WELCH, 1973
Anthony Welch, Shah 'Abbas and
the Arts of Isfahan, exh. cat., Asia
Society Museum, New York, 1973.

WELCH, 1978
Stuart Cary Welch, Peinture impériale
moghole, Paris: Le Chêne, 1978.

WELCH AND MASTELLER, 2004
Stuart Cary Welch and Kim Masteller,

From Mind, Heart, and Hand: Persian,
Turkish, and Indian Drawings from
the Stuart Cary Welch Collection,
New Haven: Yale University Press, 2004.

WIET, 1933
Gaston Wiet, L'Exposition persane
de 1931, Cairo: Imprimerie de l'Institut
français d'archéologie orientale, 1933.

WILLIAMSTOWN, BALTIMORE,
AND BOSTON, 1978
The Grand Mogul Imperial Painting
in India 1600–1660, exh. cat. Sterling
and Francine Clark Art Institute,
Williamstown; Walters Art Gallery,
Baltimore; Museum of Fine Arts,
Boston, dir. Milo Cleveland Beach,
with contributions by Stuart Cary Welch
and Glenn D. Lowry, Williamstown,
MA: Sterling and Francine Clark Art
Institute, 1978.

WOOD, 2000
Barry D. Wood, "A Great Symphony
of Pure Form": The 1931 International
Exhibition of Persian Art and Its Influence,
Ars Orientalis, Exhibiting the Middle
East: Collections and Perceptions
of Islamic Art, no. 30, 2000, pp. 113–130.

ZARAS, 2019
Eleni Zaras, L'exposition parisienne
de "miniatures persanes," in Paris, 2019,
pp. 78–79.

SALES CATALOGUES

1860
Objets d'art antiquités et tableaux
de feu M. Louis Fould, Charles Pillet
(experts Roussel and Laneuville), Paris,
June 4, 1860, and subsequent days.

1869
Collection de M. Édouard Fould.
Objets d'art et de haute curiosité,
tableaux anciens et modernes, Pillet
and Mannheim, Paris, April 5–9, 1869.

1877
Objets d'art et d'ameublement, meuble
de salon remarquable, très-belles
tapisseries, Pillet and Mannheim, Paris,
May 18–19, 1877.

1914
Catalogue des objets d'art et de haute
curiosité de l'Antiquité, du Moyen Âge,
de la Renaissance et autres [...] formant
la collection de M. Arthur Sambon,
Galerie Georges Petit, Paris, May 25–28,
1914.

1962 A
Livres précieux provenant de la
bibliothèque Louis Cartier, Hôtel Drouot,
Paris, March 1–2, 1962.

PARIS, 1962 B
Succession de Mr Louis Cartier.
Estampes et laques d'Extrême-Orient,
M. Étienne Ader, MM. A. and G. Portier,
Paris, March 15–16, 1962.

1972
Catalogue of Fine Indian and Persian
Miniatures and a Manuscript Selected
from the Well-known Collection
of Cary Welch and sold by his Order,
Sotheby's, London, Dec. 12, 1972.

1979
Importante argenterie européenne:
succession de Monsieur Claude Cartier
provenant de la collection de ses
parents Monsieur et Madame Louis
Cartier, Sotheby Parke Bernet, Monte
Carlo, Monaco, Nov. 27, 1979.

1979
Art d'Orient, C. Boisgirard and
A. de Heeckeren, Paris, Drouot,
Dec. 18–19, 1979.

1985
Indian, Tibetan, Nepalese Thai, Khmer
and Javanese Art, including Indian
Miniatures, Sotheby's, New York,
Sep. 20–21, 1985.

1996
Oriental and European Rugs and
Carpets and Islamic Works of Art,
Bonhams, London, Oct. 17–18,
1995, International Association
of Auctioneers, 1996.

2002
Arts of the Islamic World, Sotheby's,
London, April 25, 2002.

2013
Indian and Southeast Asian Art,
Christie's, New York, March 19, 2013.

2015
Arts d'Orient, Artcurial, Paris,
Dec. 17, 2015.

2016
Art of the Islamic and Indian Worlds,
Christie's, London, Oct. 20, 2016.

2019
Dessins anciens et modernes, tableaux
anciens et modernes, collection
de montres et de boîtes anciennes,
sculptures, mobilier et arts décoratifs
du xxe siècle, bel ensemble d'un
mobilier de Paul Follot provenant d'un
appartement parisien, Ferri; Drouot-
Richelieu, Paris, June 5, 2019.

2020
Art of the Islamic and Indian Worlds
including Oriental Rugs and Carpets,
Christie's, June 25, 2020.

INDEX

ACKNOWLEDGEMENTS

The Musée des Arts Décoratifs would like to extend thanks to the Maison Cartier for its support and generosity, with a special mention for Pierre Ralnero and Renée Frank.

Our thanks go first of all to the Maison Cartier Heritage teams:

ARCHIVES

Violette Petit
Director of Archives and Documentation

Aude Barry
Historical Archives Project Manager

Sophie Brahic
Historical Archives Project Manager

Gaëlle Naegellen
Contemporary Archives Project Manager

Jenny Rourke
London Archives Manager

Marina Wright
New York Archives Manager

César Imbert
Archives and Documentation Coordinator

CARTIER COLLECTION

Pascale Lepeu
Curator

Cassandra Alvarez
Documentation and Curatorial Coordinator

Isabelle Brunner
Senior Project Manager

Nadia Cretignier
Director of Operations

Agathe Gounod
Logistic and Stock Coordinator

Caroline Kranz
Deputy Curator

Isabelle Nicora
Executive Assistant

Laurence Robert
Expert Jeweler and Restorer

EXHIBITIONS

Renée Frank
Director of Exhibition Projects

Hélène Godard
Exhibitions Production Manager

Maria Collareda
Exhibitions Organization Coordinator

Anne Lamarque
Publications and Cultural Mediation Project Manager

Anne Dubus
Exhibitions Project Coordinator

Miryam Alaoui

We also warmly thank:

CARTIER INTERNATIONAL
Arnaud Carrez
Emmanuelle Guillon, Valérie Nowak,
Charlotte Bordes-Pastorelli,
Alix de Izaguirre, Quetch Le Moult,
Florence Marin-Granger,
Aleksandar Pavlovic

CARTIER FRANCE
Corinne Le Foll
Mélina Marsaleix
Amel Berkani, Étienne Cruset,
Vivien Grenier, Rita Ibn Souda El Morri,
Olivia Phlippoteau

CARTIER NORTH AMERICA
Mercedes Abramo
Isabelle Verzeroli
Ehab Ammar, Carter Berman,
Gregory Bishop, Shannon Burton,
Dorothée Charles, Fleur Damon,
Christine Goppel

CARTIER TRADITION
Chloé Tonon-Krommenacker
Thierry Bousquet
Pierre Carcaillon

And
Carmen Dubois
Katarzyna Koczyk

We warmly thank the team of the Musée du Louvre, in particular Yannick Lintz, Monique Burési, and Marie-José Castor.

We are extremely grateful to the institutions and collectors who, through their generous loans, have made this exhibition possible:

ANTWERP
Fabrice Gros

AUSTIN, TEXAS
The Harry Ransom Center
Stephen Enniss
Elizabeth Garver
Ester Harrison

CAMBRIDGE, MASSACHUSETTS
Harvard Art Museums
Martha Tedeschi
Amy Brauer
Nicole Linderman

DALLAS
The Keir Collection of Islamic Art
on loan to the Dallas Museum of Art

DOHA
Museum of Islamic Art
Julia Gonnella
Tara Desjardin
Mounia Chekhab-Abudaya
Sarah Anne Boyd

DOHA
Adel Ali Bin Ali

ÉCOUEN
Musée National de la Renaissance
Thierry Crépin-Leblond
Julie Rohou
Laure Roset

HONG KONG
Mengdiexuan Collection

HOUSTON
The Museum of Fine Arts
Gary Tinterow
Aimée Froom
Jennifer Levy
HOUSTON
Abolala Soudavar

LONDON
Royal Collection Trust
Tim Knox
Caroline de Guitaut
The Duke and Duchess of Gloucester

MONACO
Monaco Princely Palace Collection

MUNICH
Münchner Stadtmuseum
Frauke von der Haar
Barbara Schertel

NEW YORK
The Metropolitan Museum of Art
Max Hollein
Navina Najat Haidar
Emily Fosse
Caitlin Corrigan
Annick des Roches

NEW YORK AND PARIS
Layla S. Diba

PARIS
Bibliothèque Nationale de France
Laurence Engel
Laura Cartolaro

PARIS
Fondation Custodia
Ger Luijten
Mariska De Jonge
Maud Guichané

PARIS
Galerie Ary Jan
Mathias and
Catherine Ary Jan

PARIS
Musée du Louvre
Laurence des Cars
Jean-Luc Martinez
Yannick Lintz
Isabelle Luche
Milena Planche
Mathilde Debelle

PARIS
Petit Palais, Musée des Beaux-Arts
de la Ville de Paris
Christophe Leribault
Clara Roca
Claire Martin
Hubert Cavaniol

SAN ANTONIO
McNay Art Museum
Richard Aste
R. Scott Blackshire

TOKYO
Albion Art Jewellery Institute

VERSAILLES
Château – Domaine National de Versailles
Catherine Pégard
Laurent Salomé
Frédérique Lacaille

WASHINGTON, D.C.
Freer Gallery of Art
and Arthur M. Sackler Gallery
Chase F. Robinson
Massumeh Farhad
Simon Rettig
Rebecca Merritt
Danielle Bennett

WASHINGTON, D.C.
Hillwood Estate Museums and Gardens
Kate Markert
Wilfried Zeisler
Nancy Swallow
Megan Martinelli

As well as those who prefer to remain
anonymous.

We are grateful to all those who,
through their expert advice,
documentation and valuable support,
contributed to the preparation
of the exhibition and its catalogue.

Violaine d'Astorg, Olivier Bachet,
Hélène Bendejacq, Yolande Borget,
Polly Cancro and the team at the
Morgan Library, Moya Carey, Catherine
Cariou, Alain Cartier, Raphaëlle Cartier,
François Curiel, Sarah Davies, Sarah
Davis, Flavia Deakin, Rachel Desouza,
Richard Edgecumbe, François Farges,
Émilie Foyer, Francesca Galloway, Jean
Ghika, Florent Guérif, Jessica Hallett,
Maureen Huault-Gavaudo, Amin Jaffer,
Lida Katib, Ulrike al-Khamis, Thomas
Lentz, Joe Levine, Mary McWilliams,
Leslee Michelsen, Luc Piralla, Élodie
Pomet, Claudia Pörschmann, Venetia
Porter, Bita Pourvash, Ève-Amélie Proust,
Fanny Roilette, Judy Rudoe, Piers
Secunda, Daniel Shaffer, Lee Siegelson,
Eleanor Sims, Maud Siron, Christopher
Stewart, Susan Stronge, Rose Thomas,
Julie Valade, Frédérique Vernet,
Stefan Weber, and Thomas Welch.

At Les Arts Décoratifs, we warmly thank:
The Curatorial Department, in particular
Véronique Ayroles, Denis Bruna,
Marie-Sophie Carron de la Carrière,
Anne Forray-Carlier, Bénédicte Gady,
Audrey Gay-Mazuel, Marion Neveu,
Jean-Luc Olivié, Cloé Pitiot, Sébastien
Quéquet, Béatrice Quette, Hélène
Renaudin, and Marie-Pierre Ribère;
The Publications and Images
Department, in particular Iris Aleluia,
Pauline Derosereuil, and Marion Servant;
The Collections Department, in particular
Florence Bertin, Catherine Didelot,
Benoît Jenne, Emmanuelle Garcin,
and Cécile Huguet;
The Library, in particular Laure Haberschill;
The Education and Culture Department;
The Communications Department,
in particular François Régis Clochcau,
Anne-Solène Delfolie, Fabien Escalona,
Isabelle Mendoza, Alizée Ternisien,
and Isabelle Waquet;
The Development Department,

in particular Nathalie Coulon,
Mélite de Foucaud, and Laetitia Ziller;
The Administrative and Financial
Department, in particular Viviane
Besombes, Nour Mouhaidine,
and Juliette Bimbaud;
In the Director's Office, Liliia Polscha;
In the Managing Director's Office,
Sophie Malville.

At the Dallas Museum of Art,
we warmly thank:
The Curatorial Department,
in particular Martha MacLeod;
The Conservation Department,
in particular Fran Baas, Laura Eva
Hartman, and Elena Torok;
The Collections Department,
in particular Mike Hill, John Lendvay,
and Isabel Stauffer;
The Marketing and Communications
Department, in particular Jill Bernstein,
Trey Burns, Clara Cobb, Lizz DeLera,
and Lillian Michel;
The Exhibitions and Interpretation
Department, in particular Kate Aoki,
Amandine Bandelier, Lance Lander,
Jaelyn Le, Emily Schiller, Peter Skow,
Veronica Treviño, and Queta Watson;
The Education Department, in particular
Kathleen Alleman, Jacqueline Allen,
Mary Ann Bonet, Stacey Lizotte,
and Jenny Stone;
The Development Department,
in particular Selena Anguiano,
Lauren Hembree, Susan McIntyre,
Sarah Sutton, and Reese Threadgill;
The Information Technology Department,
in particular Giselle Castro-Brightenburg,
Brad Flowers, Brian MacElhose, Paul
Molinari, Chad Redmon, and Amir Tabei;
Facility Operations and Security,
in particular Ken Bennett
and Shalamar Jackson;
The Museum Store, in particular
Alison Silliman.
And finally, an especially heartfelt
thanks to the interns who performed
research and provided assistance and
support: Mya Adams, Nicholas de Godoy
Lopes, Meagan Howard, Diana Luber,
Elizabeth Palms, and Rebecca Singerman.

First published
in the United Kingdom in 2021 by
Thames & Hudson Ltd,
181A High Holborn,
London WC1V 7QX

First published in the United States
of America in 2022 by
Thames & Hudson Inc., 500 Fifth Avenue,
New York, New York 10110

British Library Cataloguing-
in-Publication Data
A catalogue record for this book
is available from the British Library

Library of Congress Control Number
2021942679

ISBN 978-0-500-02479-9

Printed and bound
by Graphicom, Verona, Italy.
Color separations by Atelier
Frédéric Claudel, Paris, France.